AfroCentric Style

A CELEBRATION OF
BLACKNESS
& IDENTITY
in POP CULTURE

AfroCentric
Style

SHIRLEY NEAL

AMISTAD
An Imprint of HarperCollinsPublishers

FIRST EDITION

Designed by Leah Carlson-Stanisic and Sandy Lawrence

Library of Congress Cataloging-in-Publication Data has been applied for.

ISBN 978-0-06-308083-6

24 25 26 27 28 TC 10 9 8 7 6 5 4 3 2 1

Contents

Introduction

Not only is pop culture everywhere, but it's like I blinked, and everything went Black! There are now Black superheroes, Starship *Enterprise* captains, James Bonds, Little Mermaids, and Spelling Bee champs. Even the word "Black" is now capitalized. And just like Beyoncé "Cowboy" Carter piqued interest in the legacy of Black cowgirls, I, too, love to expose hidden stories about Black identity and history in mainstream pop culture. Take Franklin, for instance, the first Black character in the *Peanuts* comic strip. I was right there with a whole lot of folks anxiously awaiting the much-hyped *Snoopy Presents: Welcome Home, Franklin* set to premiere during Black History Month in 2024. But even though Franklin's appearance had social media buzzing, I'd venture to say that most don't know this pop icon's fascinating backstory, which goes beyond the hashtag and what we saw on TV, and is sooo rich in Black history.

What's evident from the film's start is that Franklin is a smart Black kid who moves into the *Peanuts'* gang's predominantly white neighborhood and has difficulty making friends. Kids pass him by when he tries to strike up conversations. Even after he rehearses what he'll say to make them warm up to him, none of the kids—not even Snoopy—will.

But then, one day, after a dramatic "finish" at a big Soap Box Derby toward the end of the film, Franklin and Charlie Brown become BFFs, and together, they win over the other kids for a happy ending. It's a heartwarming story for sure, but there's also lot to learn about Black history that gets missed if you don't know the backstory.

You see, Franklin first came on the scene waaayyy back in 1968 at the height of the civil rights movement. In fact, it was shortly after the assassination of the Reverand Dr. Martin Luther King Jr. in 1968, when racial tensions had reached a boiling point. Harriet Glickman—a white,

Los Angeles–based schoolteacher—had grown tired after years of witnessing discrimination, segregation, and hatred. Dr. King's assassination was the tipping point for her to write a letter to Charles M. Schulz asking him to "integrate" his popular *Peanuts* comic strip because she believed it could "help shape American attitudes on race."

Even though Schulz supported civil rights, he was initially resistant to accommodate her request. He wrote back that he and his illustrator peers feared that by creating Black characters for their comics, they'd risk "patronizing our Negro friends." But after some back-and-forth correspondence, Harriet kept insisting, Schulz eventually relented, and Franklin made his first appearance in print on July 31, 1968, becoming the first Black or minority character to appear in any major mainstream comic strip.

Schulz's bold move to integrate comic strips in 1968 was met with praise, and yet he got it all wrong when he premiered Franklin on TV. Franklin's storyline in a 1973 Thanksgiving special called *A Charlie Brown Thanksgiving* still had Franklin segregated from the other kids—sitting all alone on one side of the dinner table. *Really?*

Schulz claimed years later that his intent was never to ostracize the Black character, but you best believe it sparked a lot of controversy at the time.

Flash forward five decades later to 2024. Franklin's much-publicized return featured a table scene like the one in the Thanksgiving special, only this time at a pizza shop where all the *Peanuts* characters go to celebrate after the big derby. With the country so polarized and divisive, would history repeat itself?

Well, like before, Franklin expects to sit alone during the victory celebration. But this time, as he walks toward a table, Linus flips the script and says, "Hey, Franklin! We saved you a seat over here!"

Whew! That subtle yet powerful make-good moment in the 2024 film righted a wrong and had social media celebrating. But what I love most about that scene and, in fact the entire show, is that it gave people—Black, white, Brown, no matter—an opportunity to learn how the Black impact on pop culture can serve as a conduit to help us all learn something about Black identity and history, which is exactly the impetus for my writing this book.

I've packed *AfroCentric Style: A Celebration of Blackness & Identity in Pop Culture* with more than one hundred attention-grabbing photos that highlight the Black influence on some of the most viral mainstream pop culture moments, movements, missteps, and memes that have received attention around the globe—particularly in the areas of FASHION, HAIR, and BEAUTY—and that provide a deeper understanding and appreciation of Black history and creative expression.

But like in Franklin's case, it's the little-known backstories and meaningful lessons about Black identity and history that we can draw from mainstream pop culture that I hope will elevate thinking and have people saying, *Wow! I never knew that!* Or fondly saying, *Oh yeah, I remember that!*

I wrote *AfroCentric Style* to appeal to every generation and skin tone because, as the great novelist Ralph Ellison once said, the Black experience is part of the experience of all Americans.

So, please don't just look at the pictures and captions. Read the book from cover to cover. Share it with—better yet, gift it to—everyone you know who is interested in celebrating Blackness and Black identity in pop culture.

Most importantly—enjoy!

Shirley

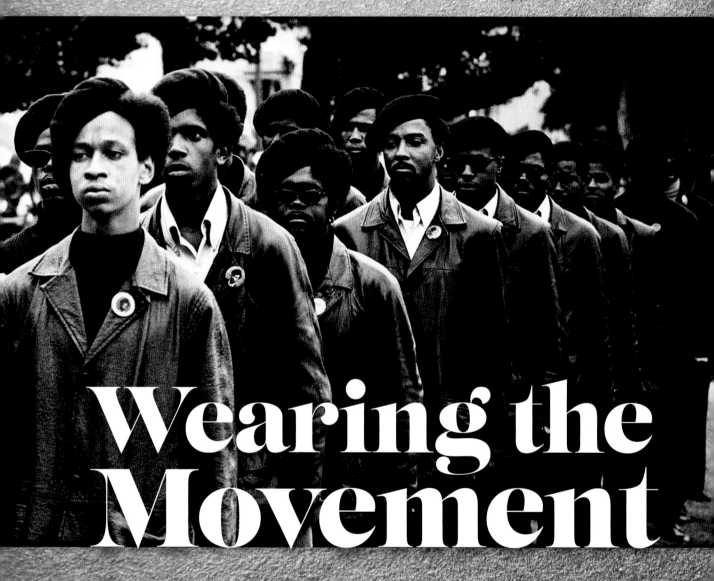

Wearing the Movement

Hoodies on the House floor.
Git Woke tees. Race on red carpets.
Black Panther berets.

The Black influence on fashion activism in mainstream pop culture is undeniable, unending, and unapologetic.

We wear our pain, rage, and emotions on our sleeves, across our chests, and through our fashion style to sound off! It's never been enough just to verbalize—"Black Lives Matter," "We Shall Overcome," "Power to the People," or "No Justice, No Peace"—because history has taught us that social injustice statements without visual reinforcement can easily get twisted or fall on deaf ears. But when we "Wear the Movement," our meme-able messages are amplified without ever needing to say a word.

Some fashion statements remain seared in our collective memories, while others are easily ignored. Is it because they spark conversations?

Inform our Black identities? Offer us windows to better understand Black culture and history? From where I sit, the answer is all the above. But don't be fooled—not all fashion statements are as they appear. Case in point—one of the most talked-about fashion statements in American pop culture history was when an image surfaced on social media of Beyoncé performing at the 2016 Super Bowl alongside a snap of Michael Jackson performing at the 1993 Super Bowl. At first glance it appeared the queen was honoring a king. But heed the words of Phaedrus, who once said, "Things are not always as they seem; the first appearance deceives many."

Before hip-hop titans Dr. Dre, Snoop, and Mary J. Blige showed out during the Super Bowl Halftime Show in 2022 and before Riri's 2023 Halftime Show drew TV audiences so big that it made Guinness World Records history as the Largest TV Audience for a Super Bowl Half-Time Performance EVER, Michael Jackson's

Panthers line up at a Free Huey rally in DeFremery Park, Oakland, California, July 28, 1968.

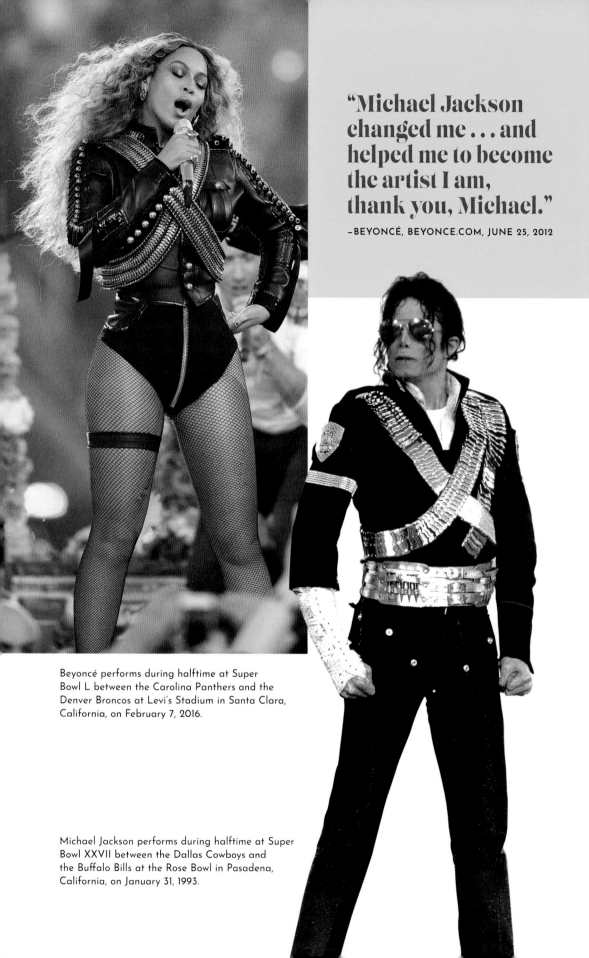

"Michael Jackson changed me ... and helped me to become the artist I am, thank you, Michael."

—BEYONCÉ, BEYONCE.COM, JUNE 25, 2012

Beyoncé performs during the Halftime Show of the Denver Broncos vs. Carolina Panthers Super Bowl at Levi's Stadium, Santa Clara, California, 2016.

Beyoncé performs during halftime at Super Bowl L between the Carolina Panthers and the Denver Broncos at Levi's Stadium in Santa Clara, California, on February 7, 2016.

Michael Jackson performs during halftime at Super Bowl XXVII between the Dallas Cowboys and the Buffalo Bills at the Rose Bowl in Pasadena, California, on January 31, 1993.

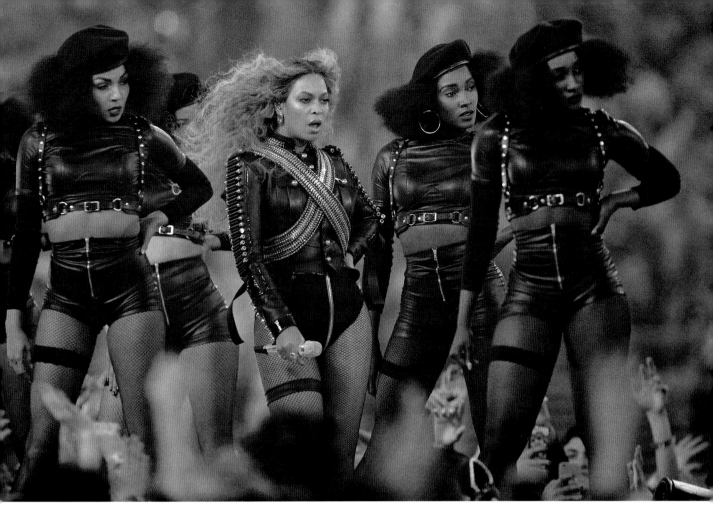

1993 performance is credited with rescuing the once-dying event known for marching bands and plummeting ratings and turning it into must-see TV. Michael raised the bar and opened the door for the NFL to attract all the other megastar headliners—most notably, sister Janet (2004), Prince (2007), Madonna (2012), Katy Perry (2015), Lady Gaga (2017), J-Lo (2020), and, of course, Beyoncé (2016), who credits Michael Jackson as her greatest musical influence.

Two decades after the King of Pop performed at Super Bowl XXVII, the Queen of Pop channeled her idol during her heavily hyped performance at Super Bowl L. From head to toe, Beyoncé had his look down pat—rocking a custom-made replica of Michael's trademark military-style jacket. She wore the same harness, thick gold bands around the chest, metal studs

down the side, even the bling—a near-identical match. People thought her look was solely a salute to her idol, but no, no, no!

Whereas Michael swapped out his militaristic ensemble for a less imposing look as the show progressed, then surrounded himself with 3,500 children from all nationalities for a heartfelt "Heal the World" grand finale—Beyoncé stayed on message throughout her fifteen or so minutes of fame.

Flanked by the fiercest-looking army of female backup dancers—all Black, dressed in black, sporting Angela Davis-style black Afros and killer black berets reminiscent of the Black Panther Party (BPP) of the sixties and seventies—Beyoncé used her platform, politics, and revolutionary fashion style to send a clear message.

Form[ation] & Fashion

Just weeks before Beyoncé's powerful Super Bowl halftime performance, police were acquitted for fatally gunning down yet another Black man—twenty-six-year-old Mario Woods—just miles away from Levi's Stadium in Santa Clara, California. It followed an ongoing pattern of unjustifiable police violence against Black men in America where almost daily footage of recurring instances surfaced—not because it was a new thing but because cell phone videos made it easier to prove what Black folks had been saying for decades. This pattern of systemic racism was finally receiving national attention.

Queen Bey, who had for a long time been called out for not owning her Blackness, had a reckoning. First off—on the eve of her Super Bowl performance, she surprised fans by dropping her new politically charged "Formation" single and music video that referenced Hurricane Katrina and featured images of her clinging atop a sinking New Orleans police car. Scenes with white cops lined up against a Black teen were intercut with graffiti that read "Stop Shooting Us." Her lyrics spoke to her "Negro nose," her "baby's Afro hair," race, class, Black Girl Magic, and Black self-love. Moments after its release, people went nuts—tweeting, posting, praising, and leaving many shaking their heads about Beyoncé's brave but controversial new release. There was so much online traffic that the internet all but shut down. Visitors to Beyonce.com that night saw: CURRENTLY EXPERIENCING TECHNICAL DIFFICULTY. PLEASE STAND BY.

Nearly twenty-four hours later, Beyoncé erupted on the field, leading her dancers in an army-like formation on the nation's biggest stage. Her jaw-dropping performance with a Black Power vibe and Black Panther fashion style celebrated Black culture and brought to the fore her condemnation of racism in America. Climaxed by forming a human "X" homage to slain civil rights activist Malcolm X, Beyoncé had placed race front and center in the living rooms of close to 111 million TV viewers.

The Queen of Pop—who, by the way, as of 2023, is the most decorated Grammy winner in the organization's history—may not have been billed as the headliner for the show, but her overpowering presence at that event at that time was no coincidence. Consider this: She was the opening act at the fiftieth anniversary of the Super Bowl, which was also the fiftieth anniversary of the Black PANTHER Party. The Denver Broncos faced off with the Carolina PANTHERS, and she knew she'd have the country's biggest media platform at her disposal to impact a diverse audience who may not otherwise have access to her message. Coincidence? Not!

Much of the Black community applauded Beyoncé's performance and fashion activism, calling it "a celebration of Blackness" and "the uplift we needed!" But not everyone was on board with her ferociously pro-Black fashion statement. Backlash from the conservative Fox TV network was swift. Local marshals on-site were said to have turned their backs on her performance. During a February 8, 2016, *Fox & Friends* appearance on the Fox News Channel, Rudy Giuliani, the former mayor of New York

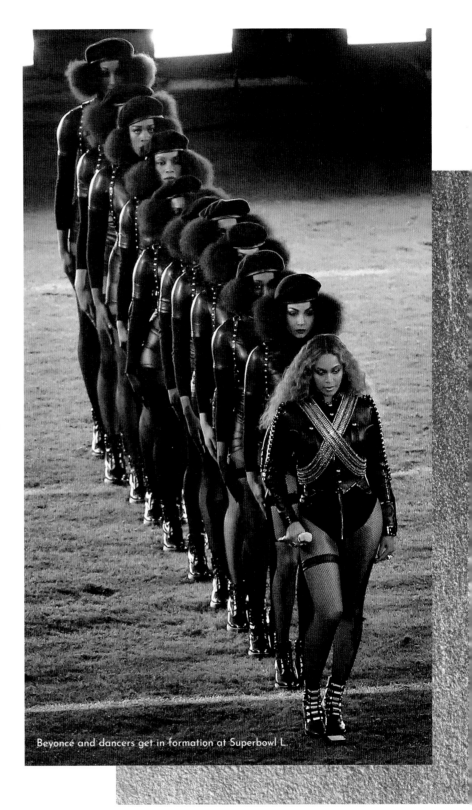

Beyoncé and dancers get in formation at Superbowl L.

"We are sick and tired of the killings of young men and women in our communities."

—BEYONCÉ, INSTAGRAM, JULY 7, 2016

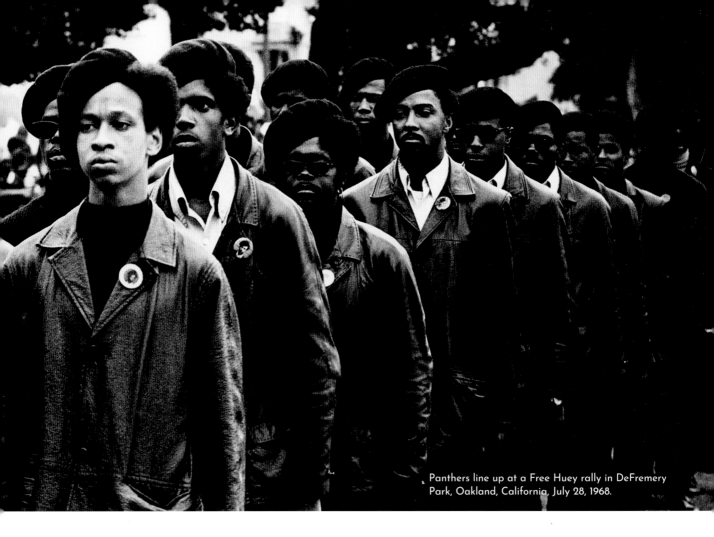

Panthers line up at a Free Huey rally in DeFremery Park, Oakland, California, July 28, 1968.

City, branded the Halftime Show "ridiculous" and "anti-police." Mainstream fans not used to Beyoncé's outspokenness on matters of race were left confused. So much so that the TV series *Saturday Night Live* created a hilarious skit from the perspective of disillusioned white fans called "The Day Beyoncé Turned Black."

Despite the mixed reviews she received, Beyoncé succeeded in getting us to dialogue about race at a time of heightened racial tensions in our country and putting a spotlight on the Black Panther Party for a new generation of activists who often don the organization's distinctive and cool style—Afros, black leather jackets, and berets—without knowing much if anything about their legacy beyond fashion.

The Black Panther Party

The Black Panther Party for Self-Defense was founded on October 15, 1966—nearly eight months after the assassination of Malcolm X—by student activists Bobby Seale and Huey P. Newton as a grassroots organization advocating for Black communities to have the freedom and power to take control of their own destiny, including combatting police violence. At the root of their early activism were protests, programs, and a "Ten Point Plan" that called for social awareness, gender equality, employment and housing for Black people, an end to war, and the forming of coalitions that would fight for a greater degree of economic justice for all people of color.

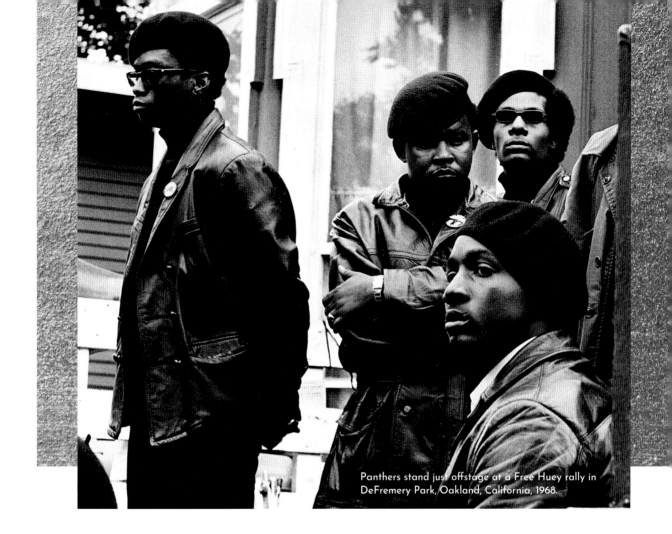

Panthers stand just offstage at a Free Huey rally in DeFremery Park, Oakland, California, 1968.

Starting with just six members, the party was headquartered in the most impoverished Black area in Oakland, California. After the 1968 assassination of the Reverand Dr. Martin Luther King Jr. in Memphis, Tennessee, the organization grew faster than Seale and Newton ever expected, with membership expanding to more than ten thousand and chapters in major American cities. But with the party's growth came controversy. The Panthers were no longer looked upon as a grassroots social safety net for the community. FBI director J. Edgar Hoover labeled them as a militant organization and "the greatest threat to the country's internal security." To paraphrase the words of former Georgia congressman Julian Bond, they condemn what they don't know about.

Yes, it's true—they openly carried loaded weapons as the law allowed. Yes, they supported violence. If memory serves me and history is our benchmark, they shot back only in self-defense against violence inflicted on them and the Black community.

Where I grew up in Cleveland, Ohio, there was a relatively large Black Panther Party presence. I'll never forget the time when I was about thirteen or fourteen years old, riding along in our family car, when I saw a group of Black men huddled together wearing black leather jackets, black berets, and dark sunglasses when the sun wasn't even shining. I shouted from our car, "Hey, there goes some Black Panthers!" as if they were some kind of superheroes. On some level, they were. They'd built a community center in the area, organized free breakfast programs

for kids, and were constantly present when the police were otherwise AWOL. I didn't quite understand everything the Black Panther Party stood for at the time because the media didn't cover their positive impact. I just knew they were on *our* side, looking out for *us*.

"Hey, little sister," the brothers shouted back at me while thrusting their Black Power fists in the air as our family car passed by.

In retrospect, I liked that I could recognize this organized and disciplined brotherhood just from their undeniable street style, which was precisely the BPP's plan!

In the book *Power to the People: The World of the Black Panthers*, Seale explained that the Panthers' fashion style—adopted to show solidarity—came about after he first spotted Newton wearing a sporty leather jacket, black slacks, and a blue shirt to a meeting.

"Hey, Huey," he said. "That should be our uniform."

It was the late sixties. The two men reasoned that just about everyone owned a leather jacket or coat—or could easily get one. So why not make it part of their uniform? The jackets didn't have to be of the same style; they just had to be black and leather.

The following evening, the student activists watched a movie about the French underground resistance to Hitler's occupation, where two of the characters in the film were wearing berets. "Huey, let's wear berets, man," Seale offered.

They likened wearing black berets in their fight against a war of racial injustice to the Green Berets wearing theirs to fight the war in Vietnam. The beret quickly became one of the BPP's most recognizable fashion statements,

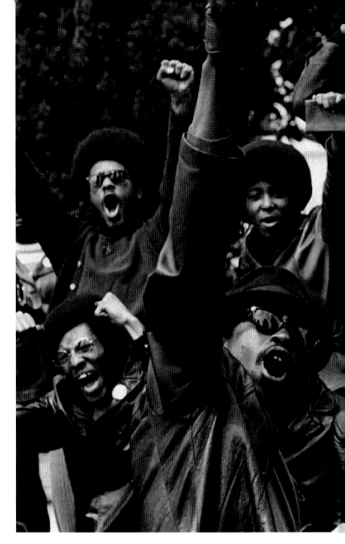

Above: Panthers raise fists and cheer as Bobby Seale speaks, Berkeley, California, 1968.

Top right: Black Panther action film actor Michael B. Jordan "Fights the Power" in an homage to the Black Panther Party posing for the March 2018 British issue of GQ. With this look, his intent was to link the fictional universe of Wakanda with the historical activism of the Black Panther Party.

given even more weight when punctuated by a raised clenched fist.

Although the Black Panther Party evolved over the years from a community-based social action network to a more militant brand, their influence is still relevant today, more than a half century later, with new, young, Black thought leaders still fighting to end racial discrimination and recurring incidences of police brutality in Black communities.

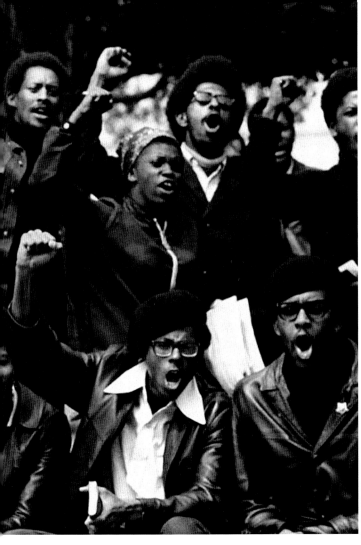

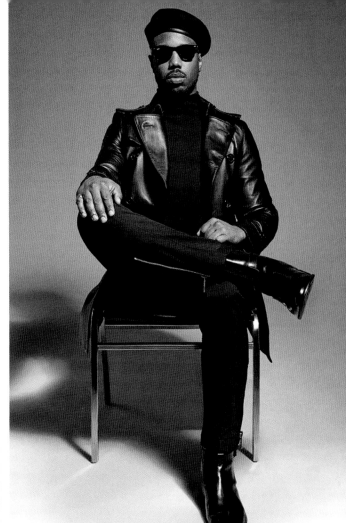

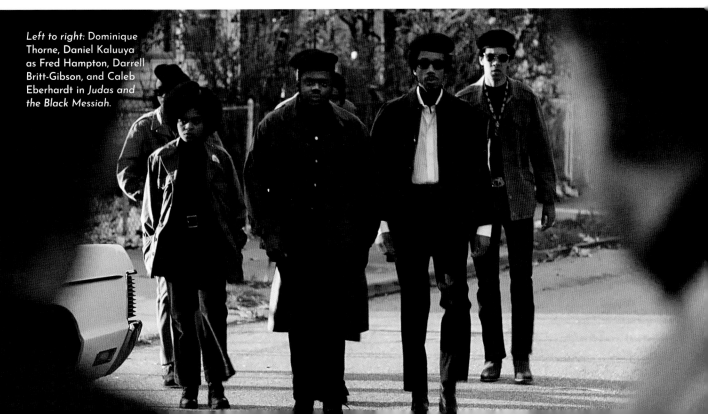

Left to right: Dominique Thorne, Daniel Kaluuya as Fred Hampton, Darrell Britt-Gibson, and Caleb Eberhardt in *Judas and the Black Messiah*.

Bobby Rush, Deputy Minister of Defense (*left*), and Fred Hampton, Deputy Chairman of the Illinois Black Panther Party (*right*), posing at the party's headquarters, 1969.

SSDD: SAME STORY, DIFFERENT DAY.

Wearing the Black Panther Party-inspired fashions as a nod to the BPP helped this new gen keep the fight for Black equality alive in a revolution that seems to never go away.

There was that time Rihanna appeared to memorialize the BPP when she arrived at the Dior fashion show wearing a swagged-out black leather beret tilted on her head, blackout shades, a black coat, and a stoic look. Likewise, Dej Loaf, T.I., and others wore Black Panther-inspired looks on red carpets, at concerts, and on magazine covers, sparking a new interest and trend in fashion activism. And who can forget Michael B. Jordan's BPP-inspired look in GQ? GREATNESS!

According to Jeffrey O. G. Ogbar's *Black Power*, not long after Seale and Newton developed the Black Panther Party fashion style, questions arose as to whether the emphasis on the BPP's "look" was becoming a distraction from their message and the real racial problems plaguing American society. So they shed the leather jackets for more "normal" wear that everyone in the community could access. Still, their signature berets remained a part of their unofficial uniform.

Chalese Antoinette Jones, the costumer for the film *Judas and the Black Messiah*—based on how an FBI informant helped the organization plan the assassination of Chicago Panther Party chairman and cofounder Fred Hampton—nailed it.

In an interview with GQ magazine, Jones shared that while researching the film, she discovered images of the Panthers sporting camo jackets rather than leather and chose to dress the actors in them to keep an air of authenticity to the film.

Hampton was only twenty-one when he was killed while sleeping in his Chicago apartment on December 4, 1969. When cofounder Bobby Rush picked up the mantle to lead the Illinois branch of the Panther Party, he, too, ditched the signature attire but kept the glasses and the fight-the-power mentality and drive.

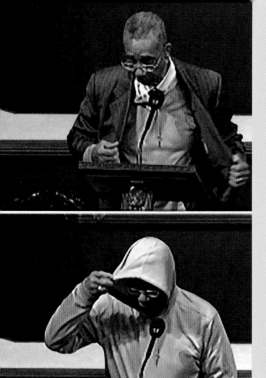
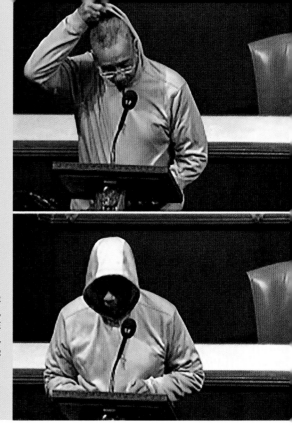

"Just because someone wears a hoodie does not make them a hoodlum."

—BOBBY RUSH, FORMER CONGRESSMAN (D-IL), SPEECH IN THE HOUSE OF REPRESENTATIVES, MARCH 28, 2012

HOODIE IN THE HOUSE? Images captured from video of Congressman Bobby Rush (D-IL), who uncovers a hoodie while making a case to end racial profiling. Soon after, he was escorted off the chamber floor for "violating House regulations on decorum."

Little did the new Chicago Panther Party leader know then that he'd become a US congressman and need to rely on fashion as a weapon to fight for the same injustices faced in the seventies still rampant forty years later.

On March 28, 2012, the former Black Panther leader turned congressman approached the speaker podium in the House of Representatives' hallowed chambers at the US Capitol dressed in a stylish gray suit. A few moments into his speech, the sixty-six-year-old stripped off his tailored jacket to reveal a gray hoodie, which he pulled over his head before making an impassioned plea calling for an end to racial profiling.

Despite constant interruptions from the chamber's presiding Speaker demanding that he stop his rhetoric, the congressman replaced his everyday glasses with sunglasses and continued his remarks. Rush, who is also an ordained minister, went so far as to recite scripture—Luke 4:18-20—about freeing the oppressed.

The House Speaker still wasn't having it!

"The member is no longer recognized," Gregg Harper scoffed, striking his gavel against the wood.

Rush was eventually escorted from the chamber by the Sergeant at Arms not for his message but supposedly for his fashion activism that violated "House regulations on decorum."

Seeing the scene play out on video, one might question if the congressman's message was lost in his theatrics of the moment. But Rush will tell anybody and everybody that his wearing a hoodie in the House was not a stunt. Having lost his son to gun violence, Rush's passionate fashion protest to draw attention to racial profiling and rectify a pattern of injustice toward Black boys and men was deeply personal. The tipping point that caused him to act on his outrage that day can be summed up in two words: TRAYVON MARTIN.

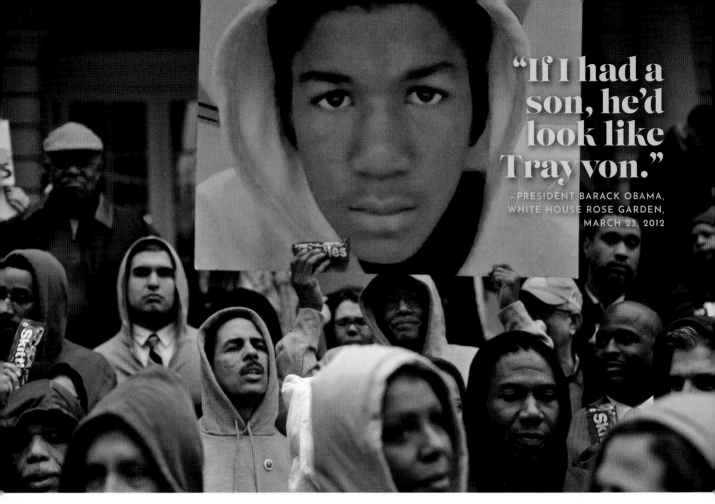

"If I had a
son, he'd
look like
Trayvon."
—PRESIDENT BARACK OBAMA,
WHITE HOUSE ROSE GARDEN,
MARCH 23, 2012

Members of the New York City Council wear hoodie sweatshirts as they stand together on the steps of City Hall in New York, March 28, 2012, during a news conference and call to action for justice in the February 26 killing of seventeen-year-old Trayvon Martin in Sanford, Florida.

Black Child in a Hoodie

Trayvon Martin was wearing a hoodie on the afternoon of February 26, 2012.

While carrying a bag of Skittles candy and an iced tea on his way home from a

Zimmerman stated to police that he mistook the "suspicious-looking" Black teen for a burglar and killed him in self-defense as defined under Florida's Stand Your Ground law.

Trayvon's tragic death incensed the Black community that called for Zimmerman's arrest

"The hoodie is just a distraction. . . . The killing of young Black men has never changed all that much, with or without hoodies."—TONI MORRISON, NOVELIST, *INTERVIEW* MAGAZINE, MAY 1, 2012

convenience store in Sanford, Florida, the unarmed seventeen-year-old was shot in the chest by George Zimmerman, a white-Hispanic neighborhood "watchman."

and pleaded with others in Congress to join Rush by using their powers to demand justice.

On the opposite side of the spectrum were conservatives like journalist and talk show host

Black Lives Matter protestor at Detroit's Public Safety Headquarters on May 30, 2020, following the death of George Floyd.

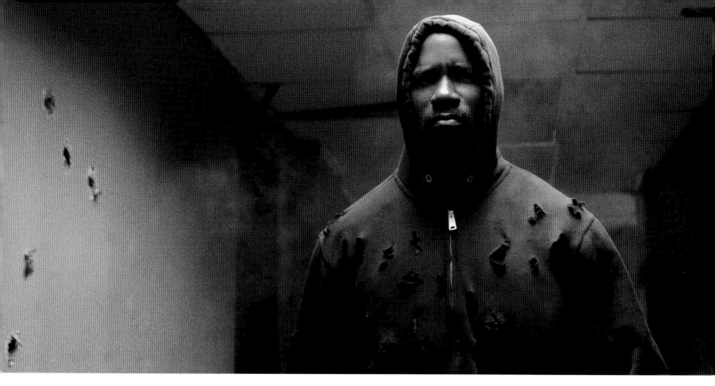

Actor Mike Colter, from a scene in Marvel's *Luke Cage* series, wears a bulletproof hoodie, 2016.

Following Trayvon's death, hoodie politics were so raw and polarizing that they even moved a sitting president—Barack Obama, who had refrained from commenting on race issues—to speak publicly about the tragedy.

The controversial fashion statement that made Trayvon a target of systemic racism in American society became a cultural symbol of unity as a nation banded together wearing hoodies, carrying Skittles during Black Lives Matter protests, and making "We Are Trayvon" a badge of honor.

Pastors and church members wore hoodies in the pulpit and pews on Hoodie Sunday—unofficially declared for March 25, 2012. The city of New York hosted a Million Hoodie March where hundreds rallied to honor Trayvon, support his family, and call for the arrest of Zimmerman, who still had not been charged for shooting the unarmed teen.

Everyday citizens worldwide used the power of social media to post selfies with the hashtags #HoodiesUp and #IamNotASuspect. They wore tees and carried signs bearing Trayvon's hooded image and marched peacefully in the streets to send the same message that got a congressman escorted off the floor in the Capitol: a hoodie does not make someone a criminal.

Hollywood's outrage over the death of Trayvon was palpable. Academy Award-winner Jamie Foxx, who was among the first celebrities to speak out, used fashion as his megaphone to call for justice online, on red carpets, on TV, and on his blog. He posted pictures of himself wearing a hoodie and vowed to stay in the fight.

Celebrity pop justice in support of Trayvon swelled by the fifth anniversary of his death, as more A-listers posted selfies wearing hoodie sweatshirts with T-R-A-Y-V-O-N lettering and a message of their commitment.

Marvel Television updated its Luke Cage superhero hoodie to have bulletproof superpowers. The homage to Trayvon was meant to show that "heroes can wear hoodies"—including Black boys and men. However, Mike Colter, the actor who portrays Cage, publicly shared his emotional journey to come to terms with wearing a hoodie for his character on the Netflix TV series.

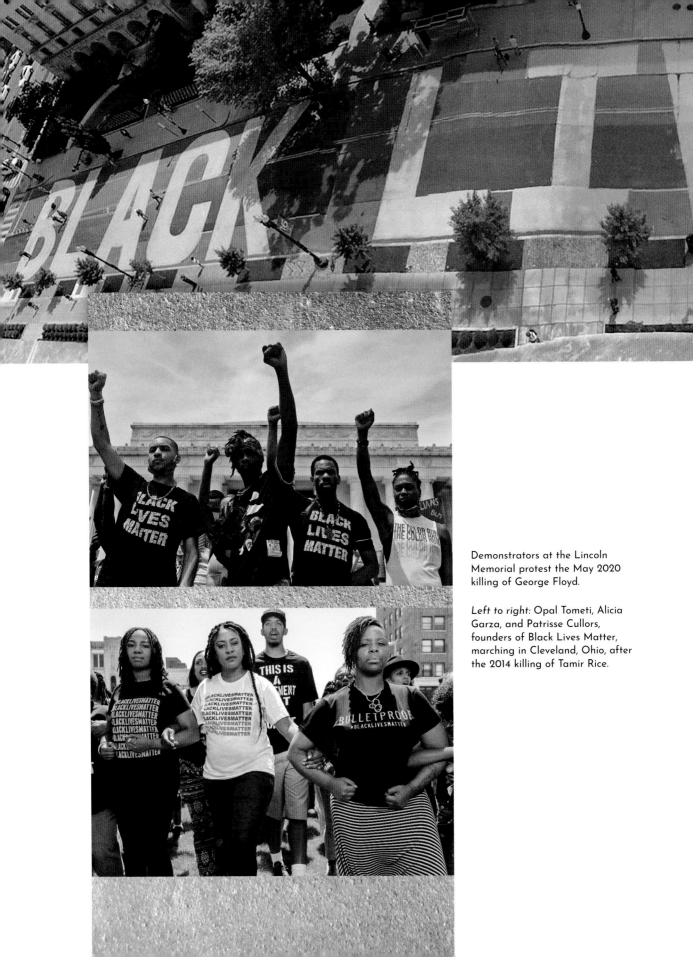

Demonstrators at the Lincoln Memorial protest the May 2020 killing of George Floyd.

Left to right: Opal Tometi, Alicia Garza, and Patrisse Cullors, founders of Black Lives Matter, marching in Cleveland, Ohio, after the 2014 killing of Tamir Rice.

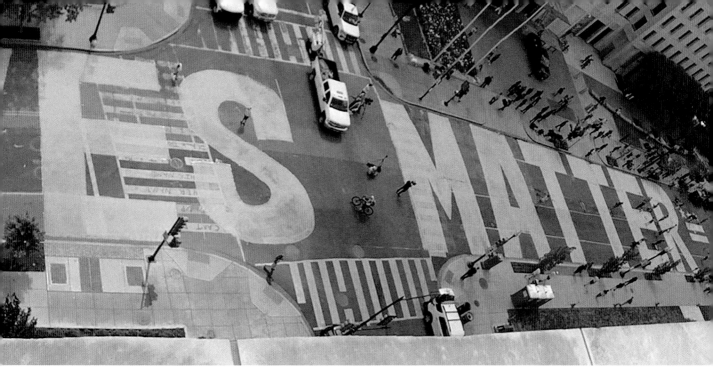

A Black Lives Matter mural installed by the Washington, DC, Department of Public Works.

On July 13, 2013, it took a six-person jury just two days to render a not guilty verdict for Zimmerman on all counts, including second-degree murder and manslaughter charges for the 2012 death of Trayvon Martin.

Black America was OUTRAGED but NOT SURPRISED.

When Patrisse Cullors went on Facebook to check out reactions to Zimmerman's acquittal, she found a post from her friend Alicia Garza who had penned a "Love Letter to Black People." The post included the phrase "Our Lives Matter." Those three words resonated with Patrisse, who shared the post, adding BLACK LIVES MATTER. After teaming with Opal Tometi, another activist friend, the three women added a hashtag to the powerful phrase, created a website, and just like that, #BlackLivesMatter (BLM)—a new social justice platform to deal with anti-Black racism—was born. They knew they were on to something by the end of that year when the hashtag had been used five thousand times—a lot back in 2013.

Using all the socials, #BlackLivesMatter galvanized a new generation of activists calling for an end to police brutality, racial inequities, and white supremacy, as security and eyewitness videos captured even more tragic and unjust deaths of Black men at the hands of white police officers. Among them, eighteen-year-old Michael Brown Jr. and Eric Garner, whose haunting last words, "I can't breathe," were repeated eleven times while police held him face down on the ground in a choke hold. As calls for police accountability grew, so did the BLM movement's mission. The three founders dropped the hashtag and expanded their activism from street protests, rallies, and social media to create a global civil rights movement with chapters throughout the US, Canada, and the UK. Their new mission also called for acquiring political power to transform conditions in underserved Black communities.

Another sure sign their message got out big time appeared overnight in BIG letters: thirty-five feet wide, forty feet high—the length of three and a half football fields. Letters so big, they could be seen from space!

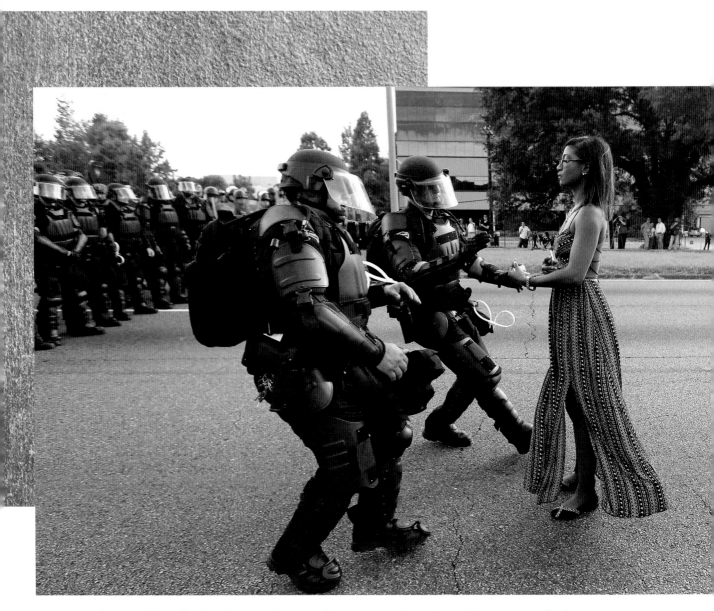

Ieshia Evans faces off with police at a July 9, 2016, demonstration in Baton Rouge, Louisiana, over the shooting death of Alton Sterling. The photo of the mother and registered nurse standing calmly and posing no obvious threat went viral on social media with thousands of views.

Following multiple days and nights of what analysts and the press, including the *Washington Post*, calculated to be the "largest protest movement in U.S. history," with between fifteen and sixteen million people taking to the streets in the US alone in support of Black Lives Matter—the BLM lettering on the streets of DC leading up to the White House appeared seemingly like magic at the rising of the sun on Friday, June 5.

Painted in just eight hours overnight by the DC Department of Public Works—with the blessings of DC mayor Muriel Bowser—the street mural was commissioned to honor protestors who had peacefully assembled earlier in the week.

Four months later, in October 2020, the Sixteenth Street mural was transformed into a permanent full-scale monument stretching between H Street NW and K Street NW. The DC City Council symbolically christened it Black Lives Matter Plaza.

The BLM movement, on the grassroots level—unlike the BPP who fought the same injustices in the sixties and seventies—never had a "uniform" or unique fashion style to reinforce solidarity. However, fashion was central to the movement. It was all about identity and personal style for the primarily young modern-day activists. "Wearing the Movement" routinely consisted of a white or black tee with the last words or pictures of police violence victims featured in the design. Occasionally, protestors simply went with Black Lives Matter prominently scrawled across their chests as they pumped their fists like the BPP and marched for justice.

There were exceptions of course.

Dressed in Our Best to Protest

One of the most powerful fashion statements of protest in the Black Lives Matter environment didn't feature slogans or victims' names, images, or last words. Yet, it made an unspeakable impact that was hard to ignore.

Reuters photographer Jonathan Bachman captured the viral photo of Ieshia Evans facing off against state troopers at a protest over the shooting of Alton Sterling. Sterling was killed while being arrested by white police in Baton Rouge, Louisiana, on July 5, 2016.

Unlike the officers outfitted in full riot gear, appearing to rush Ieshia with the same excessive force used on Alton, the thirty-five-year-old practical nurse chose not to protest dressed for battle. Instead, she wore a nonconfrontational flowy summer dress and ballet slippers in her calm, expressionless standoff with the heavily armed police squad. Her respectable fashion statement captured in the iconic photo gained widespread attention.

I applaud Ieshia for her tenaciousness because, in my day, we were taught, "Never look 'em in the eyes." But Ieshia did! For good reason. In a Facebook post, she explained that she faced off with the troopers dressed the way she did to be able to look her five-year-old son in the eyes and tell him that she fought for his freedom and rights.

Gabriel Garmon, a Harlem-based wardrobe stylist, was of the same mind as Ieshia following the death of George Floyd in 2020. He wanted to protest but respectfully, much like the Dr. King-led marches of the 1960s, and chose to

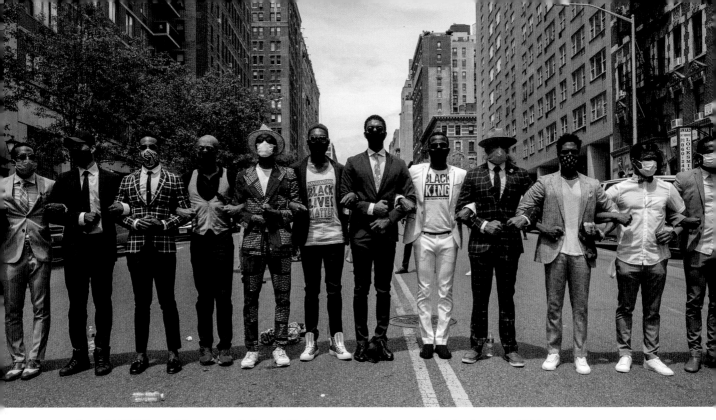

Peaceful Well Dressed Protest march through Harlem to support the victims of police brutality, 2020.

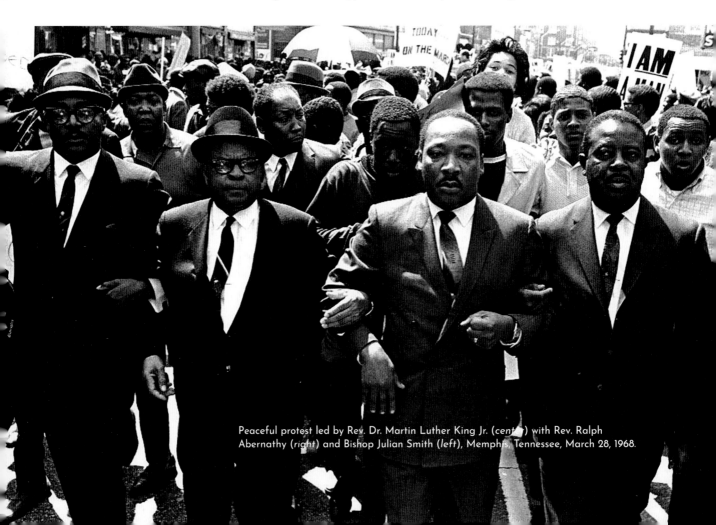

Peaceful protest led by Rev. Dr. Martin Luther King Jr. (*center*) with Rev. Ralph Abernathy (*right*) and Bishop Julian Smith (*left*), Memphis, Tennessee, March 28, 1968.

place fashion at the center of his activism. So, along with two other fashion industry veterans—Brandon Murphy and Harold James Alexander—Gabriel put out a call on social media for one hundred Black men to "dress their best" and join them in a peaceful march and mass memorial service through Harlem on June 4, 2020, at 10:00 a.m.

Gabriel's post encouraged participants to adhere to their dress code as a sign of respect for Floyd, other victims like Ahmaud Arbery and Breonna Taylor, and the families of those whose lives were lost to reckless violence and police brutality.

More than one thousand marchers showed up, dressed to the nines in three-piece suits, African prints, and dress jackets that exposed Black Lives Matter tees. They marched peacefully down Harlem's Adam Clayton Powell Jr. Boulevard toward Central Park.

The crowd of mostly men—mostly Black—included fathers, sons, young, elderly, gay, and straight, all united for a cause.

Despite those who voiced strong opposition to the concept ahead of the march stating, "We shouldn't have to dress up," "We shouldn't have to put on suits," and "We shouldn't have to be a certain way in order for us to get respect," Gabriel Garmon's ambitious effort went off peacefully without a hitch.

Gabriel's intention was not to support the concept of respectability politics as we know it today, where Black people are asked to fit into white America's definition of what is acceptable, like being asked to refrain from dressing "too Afrocentric" in the workplace or wearing our hair natural. No, no—these young activists were staging a new age dignity to an old-school

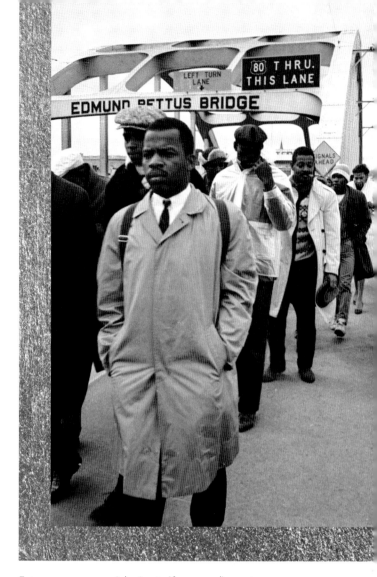

Future-congressman John Lewis (*foreground*) crossing the Edmund Pettus Bridge in Selma, Alabama, on Bloody Sunday, March 7, 1965, wearing the respectable fashion expected of nonviolent protestors.

strategy of pride and resistance, where the men wore suits and ties and the women wore pearls and their Sunday best in a peaceable rather than aggressive style.

At the cusp of the civil rights era, the call for protestors to "dress their best" was not done to be considered fashionable but more as a necessity to advance their agenda. President Clinton touched on the strategy when he delivered the eulogy for Congressman John Lewis and spoke of Lewis being a fashionable

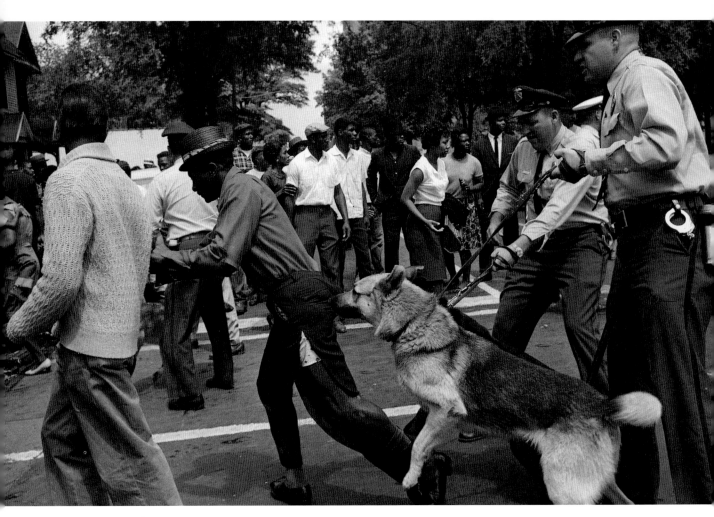

Minnie Kennedy wore a white blouse and held a handbag, just in case she needed to use it as a weapon. Police officers used both dogs and fire hoses to break up the rally.

protestor who famously "got in a lot of good trouble along the way."

"So, he's getting ready to march from Selma to Montgomery," Clinton recalled. "He had a trench coat and a backpack. Now young people would probably think that's no big deal, but there weren't that many backpacks back then, and you never saw anybody in a trench coat looking halfway dressed up with a backpack."

What Lewis and others wore in protest for voting rights—fully aware they may be dirtied or bloodied after clashes with police—were political statements that resonated louder than they could have ever voiced.

Their crisp white shirts, ties, black suits, and hats were strategically worn to demand

that America respect them as citizens.

The first time I entirely wrapped my head around this concept of civil "suits" happened while attending my uncle's wake. He was a deacon at the Sixteenth Street Baptist Church in Birmingham, Alabama, where the four little Black girls were killed during the tragic bombing by the KKK in 1964.

It was at the funeral home where I met Minnie Kennedy, an aging civil rights activist whose image was captured in an iconic photo of police siccing their dogs on peaceful demonstrators during a nonviolent protest on May 3, 1963, in Alabama at a Birmingham park.

That's her in the middle of the melee, wearing her Sunday best with a purse across her arm.

She peacefully protested but was prepared to use that purse to defend herself if need be.

"We were told to wear our Sunday Best. Dresses, neatly pressed blouses, skirts—even pearls if we had them."

—MINNIE KENNEDY

Intellectually, I understood the premise of respectability fashion activism, as Miss Minnie explained it. Still, I had a hard time wrapping my head around the passive-aggressive nature of carrying handbags as weapons if things got out of hand. To wit, she said, "Sure, we were nonviolent. But we weren't stupid. We had to protect ourselves!"

Thankfully, Miss Minnie didn't have to use her purse to fight off the dogs or anyone else that day. However, she got arrested by nightfall and jailed that Easter weekend along with Dr. King.

Warriors like Miss Minnie, Dr. King, Coretta Scott King, Lewis, and countless others of that era knew that dressing with dignity rather than as a disrupter would allow them to control their messaging better. Fashion served as one of their greatest nonviolent weapons for the movement.

Many Black millennials never bought into that strategy.

I'll never forget the time when a young, outspoken supporter of social justice movements asked me, "What good is respectability fashion dressing for nonviolent demonstrators if they were still being subjected to vicious guard dog attacks, brutal beatings, and battered by water

hoses? What did it get us?" To which I answered, "It got us the Voting Rights Act of 1965. It got us the Civil Rights Act of 1964. It placed the issue of Black inequality on a national stage."

On the flip side, a more radical protest for the same racial inequalities in the US was thrust onto a world stage when two athletes used fashion to make their powerful statement.

Power Dressing & the Black Glove

Regardless of age, I'd venture to say few people in the world have never seen the image of sprinters Tommie Smith and John Carlos raising their black-gloved fists at what is considered one of the biggest protests in American sports history.

The historic moment captured on October 16, 1968, at the Olympic Games in Mexico City came at the height of the freedom movement in the US. Two of the fastest sprinters in the world took their places on the victory stand after winning gold and bronze medals in the 200-meter race. As "The Star-Spangled Banner" played, Smith and Carlos raised their clenched, black-gloved fists in a defiant Black Power salute to protest the racial injustice of Black people in the US. Smith's glove fit tightly around his raised right hand—Carlos wore his on his left hand because he forgot to bring his gloves to the stand. Peter Norman, the white silver medalist from Australia sharing the podium, was the one who came up with the idea of the two activist athletes splitting the one pair.

Back then, and for a half century later, there has been a pattern in US history where after

Black athletes win titles or break records, they are referred to as our "American Heroes!" But let them take a knee, refuse to go to the Vietnam War, or raise a fist to protest racial injustice—they get canceled, stripped of their titles, thrown off their teams, frozen out, or, in the instance of Smith and Carlos, they were no longer referred to as Americans who won bronze and gold at the Olympics, but as "those Negroes" and "Black-skinned storm troopers." The Olympians were booed from the field for their actions, subjected to death threats, suspended from the Olympic team, and given just forty-eight hours to leave Mexico City. As tragic as their story is, the media coverage then and now hasn't always been accurate. The fact that they were stripped of their medals is not historically correct, nor that the games took place during the summer. And very rarely do the history books offer the meaning behind their full fashion statement.

I got my first insider's look at the historic protest back in 1989 when I executive produced a syndicated TV sports series called *The Other Side of Victory*. The show, hosted by tennis legend and activist Arthur Ashe, profiled Black athletes and the issues that affected them on and off the field. In one episode, we featured an interview with Arthur's close friend Harry Edwards, who was an activist, sociologist, and the founder of the Olympic Project for Human Rights (OPHR)—the organization behind a Black boycott of the Mexico City Olympic Games and the fisted glove protest. While both actions aimed to bring worldwide attention to racism and inequality in the US, the boycott never happened. But that historic moment on the victory stand that changed not only the lives of Smith and Carlos but ultimately shifted

political views about the Black community was deeply personal for Arthur. He had been very vocal about the Mexico City protest, having publicly said, "Prominent Black athletes have a responsibility to champion the cause of their race." So, when it came time to edit our episode about the athletes and Edwards's role in the protest, Arthur was adamant about which version of Smith and Carlos's famous photo we would feature. He felt that cropping the image as it's done in most printed media undercut what the protest was all about.

Arthur insisted we start with a close-up of the athletes' feet and then tilt slowly to their clenched fists.

If you look closely at the photo, you can see why.

Tommie Smith and John Carlos received their medals shoeless. In a 1968 interview he gave to Howard Cosell—a sports announcer at ABC—Smith explained, "The black socks with no shoes stood for Black poverty in racist America." He said, of their raised fists, "My raised right hand stood for the power in Black America. Carlos's raised left hand stood for the unity of Black America. Together they formed an arch of unity and power. The black scarf around my neck stood for Black pride."

Carlos's tracksuit top was unzipped to show solidarity with all blue-collar workers in the US. As he accepted his medal, Carlos said his necklace of beads was "for those individuals that were lynched, or killed, and that no one said a prayer for, that were hung and tarred. It was for those thrown off the side of the boats in the Middle Passage." The athletes' bowed heads were in remembrance of the fallen warriors in the Black liberation struggle in America—

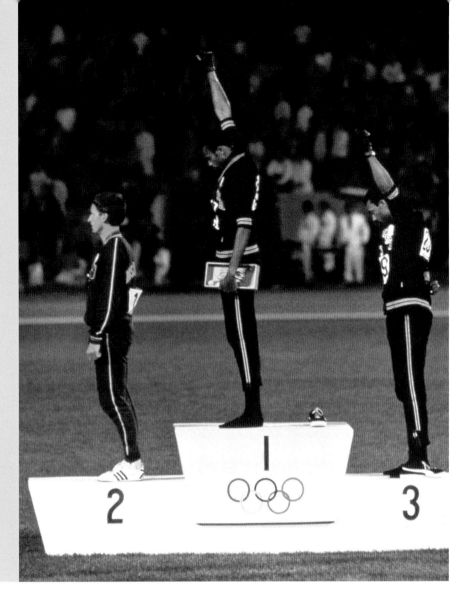

> ## "We need to linger on the full picture to get the full picture."
>
> —ARTHUR ASHE, IN CONVERSATION WITH THE AUTHOR, CIRCA 1989

Left to right: Olympians Peter Norman, Tommie Smith, and John Carlos on the victory stand at the 1968 Olympics; the iconic photo captured one of the most controversial moments in American sports history.

Malcolm X, Rev. Dr. Martin Luther King Jr., and others.

And while the raised gloved fists are what get the most attention, Smith wrote in his autobiography, *Silent Gesture,* published nearly thirty years after the historical moment, that the tight fist was not a "Black Power" salute per se but rather a "human rights" salute.

The actions of those two warriors helped shape a movement, paving the way for modern-day athlete activists to use their platforms and fashion choices to spotlight injustice.

Athletes Making Points for Black Lives

We know from history that most socially conscious athletes have no problem putting conscience over commerce when using their clout, fame, visibility, and influence to speak out on issues where their voices can effect change. We've seen it with Tommie Smith and John Carlos in Mexico City. It was true of Paul Robeson, Muhammad Ali, Jim Brown, Curt Flood, Kareem Abdul-Jabbar, Wilma

Rudolph, Bill Russell, Wyomia Tyus, and famously, Colin Kaepernick.

In the era of Black Lives Matter, a long roster of athletes accepts that their roles must go beyond just being sports heroes to young fans from the same communities where they grew up. They posit that if these young people can march in the streets and use social media to speak up and speak out—it's their responsibility to do the same without fear of fines, lost endorsements or contracts, or ejections from games. After all, scripture tells us in Luke 12:48: "To whom much is given, much will be required."

NBA ballers LeBron James and Dwayne Wade were teammates on the Miami Heat in 2012, playing in a game only a few miles away from where Trayvon Martin was shot and killed. Two days later, while everyone verbalized their outrage, LeBron and his teammates chose fashion to express their condolences while showing their commitment to supporting and seeking justice for Trayvon.

LeBron gathered his teammates at the hotel ahead of their game against the Detroit Pistons to pose for a photo of them wearing hoodies. They kept their hands in their pockets with heads bowed—intentionally hidden from view—suggesting that any of them could have been Trayvon. LeBron posted the photo on Twitter (now X) with the hashtags: #WeAreTrayvonMartin, #Hoodies, #Stereotyped, and #WeWantJustice.

The post was repeatedly shared online, with over one thousand likes and eleven thousand retweets that day ahead of the March 23, 2012, game. Miami Heat coach Erik Spoelstra called his team's actions "a powerful move."

Inquiring minds, though, questioned why after LeBron opened the door to speak out on social justice issues, he remained silent when white police killed yet another unarmed Black child in his own backyard.

On November 22, 2014, twelve-year-old Tamir Rice was shot dead by police near LeBron's Akron hometown. The baller who'd recently returned to the Cleveland Cavaliers to earn the city an NBA championship had nothing to say publicly about the alleged unlawful killing when the community was in an uproar. Conversely, NFL wide receiver Andrew Hawkins refused to be silent. He literally wore his anger on his sleeve, walking into the Cleveland Browns stadium wearing a "Justice for Tamir Rice and John Crawford III" T-shirt to protest the fatal shooting of not only Tamir but also a twenty-two-year-old Black man in Beavercreek, Ohio. Both victims were thought by police to be carrying real guns but actually had toy weapons.

LeBron's failure to speak out about yet another Black victim of police violence— particularly one shot on a playground just miles from where the Cavs played—ultimately prompted a #NoJusticeNoLeBron Twitter campaign to surface with calls for him to sit out games until the US Department of Justice weighed in on the case. As a Cleveland native, I, too, wondered, *What's up, LeBron?*

Eventually, I got my answer.

Tamir's mother wasn't looking for the NBA All-Star to sit out games like his detractors demanded. The only thing she supposedly requested was that LeBron "put a shirt on or something" to show solidarity for the outrage, which is exactly what he did. The next time an incident came up, he got all the facts, then took

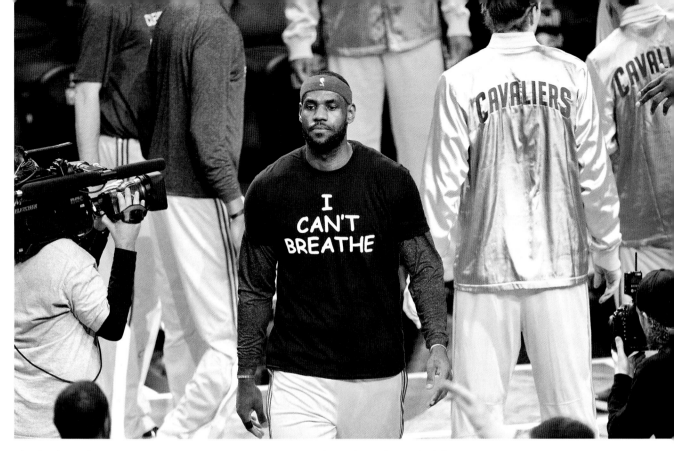

Cleveland Cavaliers forward LeBron James wears an "I Can't Breathe" T-shirt to honor the fallen Eric Garner as James is introduced before the start of the game against the Brooklyn Nets at Barclays Center in New York City, December 8, 2014.

"For me, I've always been a guy who's took pride in knowledge of every situation that I've ever spoke on. And to be honest, I haven't really been on top of this issue, so it's hard for me to comment."

—LEBRON JAMES, ASSOCIATED PRESS, DECEMBER 30, 2015

his fashion activism to the largest platform he knew—the sacred maple wood court floor.

Cavaliers LeBron and Kyrie Irving and Brooklyn Nets Jarrett Jack and Kevin Garnett wore warm-up jerseys ahead of their December 8, 2014, game in New York bearing the messages, "I Can't Breathe," "Black Lives Matter," and "Justice for All." This after six nights of nationwide protest after a grand jury announced the officer involved in Eric Garner's death would not be indicted. Eric Garner was the forty-three-year-old Black man who died after being placed in an NYPD-banned

choke hold when he refused to be handcuffed for allegedly selling loose, untaxed cigarettes. LeBron and the other athletes' social justice fashion statements were so powerful they overshadowed the presence of British royalty, Prince William and Kate Middleton, who were seated courtside. I remember it well. What a moment!

Still, the real game changer for the activist NBA athletes came following the death of George Floyd in 2020.

While America and the rest of the world were on lockdown from COVID-19, and NBA teams

Love Us

I Am a Man

Speak Up

Hear Us

Anti-Racist

Listen

Justice

Stand Up

Enough

Vote

Peace

Liberation

Freedom

Equality

Education Reform

How Many More?

Say Their Names

PREFERRED HONOR THE GIFT MESSAGING

Systemic Racism

Police Reform

I Can't Breathe

No Justice, No Peace

Break the Cycle

Strange Fruit

By Any Means

Power to the People

Equality

Am I Next?

were isolated in a "bubble," they found a way to burst through long enough and far-reaching enough to show their outrage and support. From the All-Stars to the coaches, they knelt on one knee wearing Black Lives Matter messaging stenciled across their chests with their fists pumped high.

In solidarity with its players, the NBA released a list of approved social justice messages the ballers could wear on the backs of their jerseys instead of their names.

The NBA's positive step toward progress, which was meant to support the athlete activists and the Black Lives Matter movement, was met with lukewarm reactions among many fans who saw the move as "spreading hate and segregation" rather than unity.

LeBron and Anthony Davis were among the superstar players who TKO'd the NBA's list and announced they would not wear the messages. They then challenged the organization to do more.

"It was no disrespect to the list that was handed down to all the players. I commend anyone that decides to put something on the back of their jersey. It's just something that didn't seriously resonate with my mission, with my goal."

–LEBRON JAMES, VIDEO CONFERENCE CALL
WITH REPORTERS, JULY 11, 2020

Not willing to sit on the sidelines waiting for action, LeBron teamed with fellow baller Russell Westbrook's Honor the Gift company and the NBA Players Association to create a collection of social justice shirts bearing messages that better addressed the injustices at the core of the athletes' protests. In a July 20, 2020, Twitter post, Westbrook shared that the collection was designed to allow players to "shed light on social injustice and honor the victims and families of those who continue to inspire us."

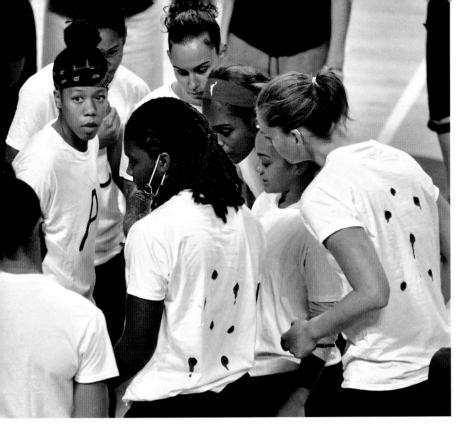

Sug Sutton (*left, with black headband*) stands with teammates (*clockwise*) Jacki Gemelos, Kiara Leslie, Emma Meesseman, Leilani Mitchell, and Myisha Hines-Allen of the Washington Mystics during the WNBA postponement announcement at Feld Entertainment Center on August 26, 2020, in Palmetto, Florida. The Washington Mystics are wearing white tees that spell out Jacob Blake on the front and have seven bullet holes on the back to protest the shooting in Kenosha, Wisconsin.

While the NBA successfully got the league's support to voice their protests through fashion, the road for the Women's National Basketball Association (WNBA) players was much bumpier.

Unlike the NBA athletes who were never fined or fired for breaking league dress codes, a group of New York Liberty players who dared to wear their activism on their warm-up tees was slapped with $500 fines for each team member who participated in Black Lives Matter–related protests and $5,000 for each team.

WNBA president Lisa Borders ultimately rescinded the fines, but only after the players refused to answer any questions during postgame press time except those related to Black Lives Matter.

The WNBA's loudest and most influential fashion statement came while in their isolation bubble where, like with the NBA, not even COVID could keep their message from coming out.

On August 23, 2020, as protests mounted on the streets across the country over the shooting of Jacob Blake—the twenty-nine-year-old Black father left paralyzed from the waist down from seven shots by a Wisconsin police officer— multiple WNBA teams postponed their games. Days later, members of the league's Washington Mystics each wore a different letter on their white

"Just because we are basketball players doesn't mean that's our only platform. We need to understand that when most of us go home, we still are Black, in the sense that our families matter."
—ARIEL ATKINS OF THE WASHINGTON MYSTICS, AUGUST 26, 2020

"It's quite sad that seven masks isn't enough for the amount of names, so hopefully, I'll get to the finals, and you can see all of them."

—NAOMI OSAKA, ON-COURT INTERVIEW, SEPTEMBER 5, 2020

tees that collectively spelled J-A-C-O-B B-L-A-K-E on the front. On the back of each of the shirts were seven red "bullet holes" to represent the seven times Blake was shot in the back.

During this period of social change, politics in sports were not limited to the WNBA's and NBA's collective protests. Athletes in nearly every sport used their high-profile platforms to advance social justice.

Football

In addition to Browns player Andrew Hawkins entering the stadium in Cleveland wearing a T-shirt with the phrase "Justice for Tamir Rice and John Crawford III," Tennessee Titans running back Derrick Henry received backlash when he wore a suit bearing the names of the victims of racially motivated violence ahead of his team's 2020 season opener.

Racing

Bubba Wallace, who made history as the first Black driver in the NASCAR Cup's top tier, famously denounced police brutality against Black men by wearing Black Lives Matter tees during his competitions and protested to remove the Confederate flag logo on his racing car.

In the same sport, racer Lewis Hamilton got banned by Formula One for wearing an "Arrest the Cops who Killed Breonna Taylor" tee at the Tuscan Grand Prix. Breonna Taylor, a Black EMT worker, was shot and killed by Louisville police officers during a botched raid on her apartment.

Hockey

In the sport known for its slow push for diversity, Matt Dumba wore a hoodie on the ice to introduce a new players' initiative to combat racism in the sport.

Soccer

US major league soccer team captains wore Black Lives Matter armbands for each game during the MLS Is Back Tournament.

Tennis

And at the 2020 US Open, twenty-two-year-old tennis phenom Naomi Osaka agreed to wear the required COVID-19 face masks during play toward a Grand Slam victory, only IF she could have each of her seven masks for seven days customized to honor Black victims of police brutality.

Naomi got to wear a different mask for the full seven days. Each bearing a different name: Breonna Taylor, Elijah McClain, Ahmaud Arbery, Philando Castile, Trayvon Martin, George Floyd, Tamir Rice.

The era produced a long list of athletes wearing their statements about racial injustice in the Black community, which grew as the number of Black victims shot or killed unjustly grew. From this new Git Woke climate of social change came a resurgence of activism from prominent celebrities who used fashion to speak out on various social issues, from Black Lives Matter and women's rights to voting awareness and the #MeToo movement.

The boldest and most iconic fashion statements from celebrities were made on—you guessed it—the Hollywood Red Carpet.

In Black pop culture, two red carpet fashion statement moments have undeniably ranked supreme, courtesy of actresses Issa Rae and Aunjanue Ellis-Taylor.

A True Aunjanue

I first met the 2022 Oscar nominee (for her role in *King Richard*) at the 2015 MIPCOM Television Festival in Cannes, France, where she was promoting BET's *The Book of Negroes*. I thought her work in the miniseries was stellar, and I had become an instant fan of this talent with such a formidable presence on-screen and yet so soft-spoken away from the cameras.

I'll never forget when she showed up for a press shoot wearing a Black Lives Matter tee. I was like, *What?! Whoa! How bold is that?!* It wasn't until later I learned that she was as devoted to social justice activism as she was to her acting career.

Actress Aunjanue Ellis-Taylor on the red carpet at the NAACP Image Awards on February 5, 2016.

In her most publicized protest, the outspoken actress took up the fight for her home state of Mississippi to retire its Confederate battle flag.

For years, resistance to the flag's removal was strong even after protests following George Floyd's death saw many other long-standing symbols of the Confederacy and white supremacy taken down, including state statues and monuments. Even NASCAR and the Marine Corps did away with racist symbols. But for the longest time, Mississippi would not budge.

Aunjanue had done her part to fight for change. She held rallies at the US Capitol on Flag Day, calling for the flag's removal. She penned an op-ed in *TIME* magazine stating she would no longer act in Mississippi until it "takes the flag down." And she asked other Mississippi-affiliated artists, including Oprah Winfrey and Morgan Freeman, to do the same.

When Mississippi state officials remained silent, Aunjanue used fashion to speak out on her industry's most powerful platform.

It took four long years of Aunjanue fighting the good fight. Then on June 30, 2020, the committed actress/activist learned that Mississippi governor Tate Reeves would sign a bill to finally retire the state's use of the flag.

Aunjanue's fashion protests, of course, weren't the sole agent of change. However, red carpet activism has repeatedly proven to be an effective outlet for Hollywood to make statements about hot-button issues that get the media's attention and then disseminate their messages to a worldwide audience.

Who & What Are You Wearing?

For a while, red carpet politics were causing a huge stir at some of Hollywood's biggest awards shows when celebs wore pins and ribbons that supported their favorite causes.

I recall the awards season in 2018 when instruction was given to red carpet reporters to refrain from asking nominees and guests "Who are you wearing?" for fear they'd use the opening to share their politics.

Actress Issa Rae stuns on the red carpet at the 2018 Council of Fashion Designers of America Fashion Awards at the Brooklyn Museum on June 4, 2018, in New York City. She is wearing a Pyer Moss jumpsuit that features a belt stitched with "Every Nigga Is a Star."

> ## "Me wearing a dress is a very small thing to do, but it is a way to start a conversation." —AUNJANUE ELLIS-TAYLOR, NBC BLK INTERVIEW, MAY 24, 2016

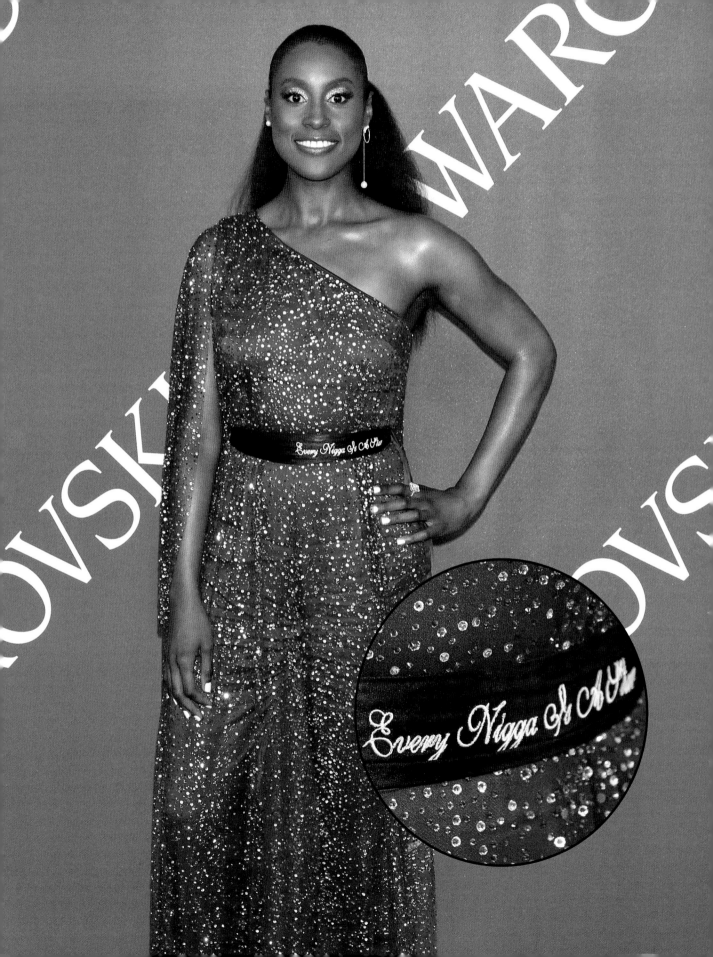

It may be just me, but I'm still not quite sure what one had to do with the other because celebs were going to find a way to use fashion to bring attention to the issues they care most about despite not being asked the proverbial question. As it turned out, some key Hollywood players, including Shonda Rhimes, Kerry Washington, and Eva Longoria, unified their fashions by wearing all black at the 2018 Golden Globes in support of the Time's Up movement—flipping the script from "Who are you wearing?" to "Why are you wearing black?"

Once the "Who are you wearing?" query from reporters was reinstated, Black Hollywood was locked and loaded with its retort. "I'm wearing only Black designers"—a nod to minority creatives marginalized in the fashion industry—was the response from A-list style stars in 2018, including Tracee Ellis Ross and Issa Rae.

Those familiar with Issa's breakout *Insecure* TV series, which she created and starred in, know that she never shied away from weaving controversial commentary into the wardrobe featured on the series.

Her fans know the fashion statements weren't there for shock value per se, but they did make us stop and question the meaning behind the messages that ranged from tees with "FBI Killed Fred Hampton" to a sweatshirt with the word "Nigga" stitched in blue.

And speaking of the N-word . . .

What may have overshadowed Issa's history-making appearance as the first Black woman to host the Council of Fashion Designers of America (CFDA) Awards—also known as the Oscars of the fashion industry—was the fashion statement she wore on the red carpet.

Tied around her waist over a beautiful midnight blue Swarovski-encrusted jumpsuit was a black sash belt with white stitching that read: "Every Nigga Is a Star."

You may have heard the phrase before—made famous by Jamaican singer, songwriter, and bass guitarist Boris Gardiner whose song "Every Nigger Is a Star" was first released in 1974. In 2015, the song was sampled on the opening track of Kendrick Lamar's *To Pimp a Butterfly*, and in 2016, the song opened the film *Moonlight*, which went on to win Best Picture honors at the Oscars. But when politically minded designer Kerby Jean-Raymond stitched the phrase into his belt design for Issa at the last minute—I'm sure it made a whole lot of folks like me go *Hmmm*?

In an interview with the *Hollywood Reporter*, the Pyer Moss founder explained that he wanted to bring attention to how Black people are too often portrayed as tragic figures. How there's never enough attention given to the everyday Black man or woman out there working, surviving, loving, and just being. Uh, I get that! But for those who don't get why he felt a need to use the N-word to get the message out, then check out chapter 2: "Raymond and Race on the Runway." The story of this self-proclaimed "fashion disrupter" is deep.

Kerby Jean-Raymond at Made Fashion Week Presents:
Lexus Lounge, New York, September 7, 2014.

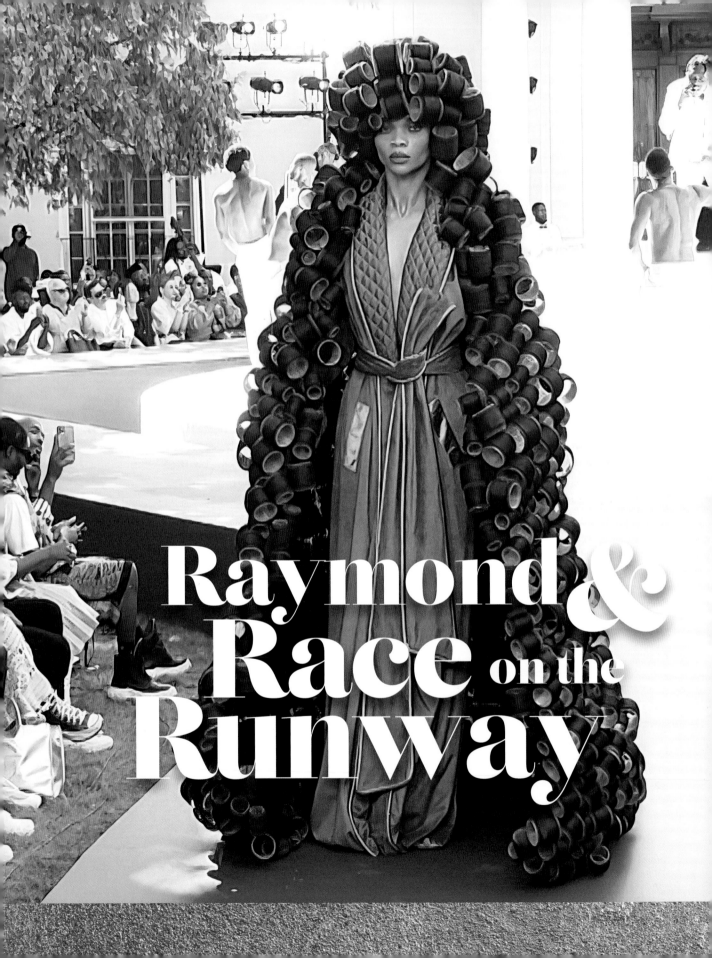

Raymond & Race on the Runway

We cheered. We celebrated.

We praise-danced when news came that the then–California state senator Kamala Harris would be sworn in as the forty-ninth vice president of the US—becoming the first African American, first woman, and first South Asian American to hold that title. And just like when Barack Obama became a "first," we wanted to protect her. We prayed the media would embrace her. Hoped she'd avoid controversy. Begged, *No drama, please*. But then, on January 10, a week and a half before Inauguration Day, came the leak of the February 2021 cover of *Vogue*. Ouch! It featured our soon-to-be VP dressed not in a luxury designer-tailored suit and pumps but quite casually wearing skinny jeans and her signature Converse Chucks. Oh yeah—her look created quite the vortex of public opinion across social media, with the most venom aimed at the magazine's editors. "Substandard," "disrespectful," and "suspiciously racist" were among the tamer rants. The VP-elect was even caught off guard, feeling "belittled" after seeing the cover on Twitter for the first time. Quite a few questioned though why she wore the look in front of cameras in the first place, writing, "Is this how she's gonna represent us Black folks?" On January 19—Inauguration Eve—we got our first look.

WHEW! We exhaled!

In a history-defining moment, Harris looked classy and stunning as she stood on the National Mall by the Lincoln Memorial Reflecting Pool to honor the four hundred thousand Americans who had lost their lives to COVID-19. Her tailored coat from Haitian American designer Kerby Jean-Raymond—founder of Pyer Moss (pronounced "Pierre Moss")—left many of us applauding her fashion style and designer choice.

"The coat signals what to expect from the new Vice President in terms of how she'll use

Saturday, July 10, 2021, in Irvington, New York, at a show staged at the Villa Lewaro mansion, the home built by African American entrepreneur Madam C. J. Walker in 1917. The show was themed around inventions by African Americans.

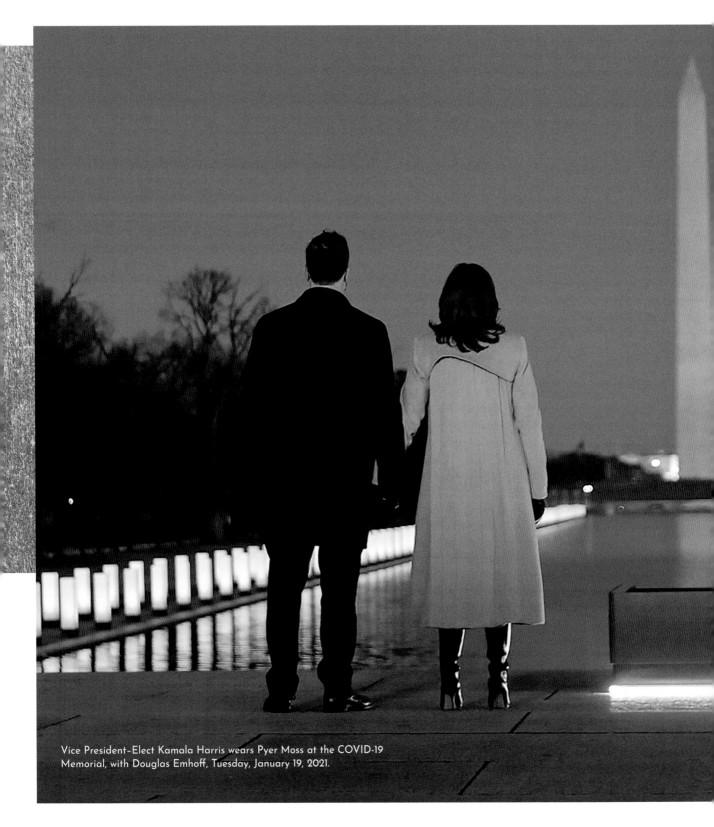

Vice President-Elect Kamala Harris wears Pyer Moss at the COVID-19
Memorial, with Douglas Emhoff, Tuesday, January 19, 2021.

her wardrobe to champion Black American creativity," wrote one commenter on Harris's Insta post that got nearly three million likes.

Choosing to wear a Kerby original was also fitting for the tribute to those who lost their lives to COVID, given that Pyer Moss was one of the first houses to stop production and convert their studio into a donation center for personal protective equipment (PPE) at the height of the pandemic. Kerby's label also donated $50,000 to support other minority and small businesses struggling to cover costs due to the pandemic.

In truth, the camel coat with the asymmetrically curved panel across the back shoulders and cascading pleats is one of the more subdued designs coming from one known for his hard-core martyrdom that's made him a multihyphenate fashion designer and disrupter.

You see, he's the same designer who stitched the N-word on Issa Rae's red carpet look.

What's most striking about this innovator and CFDA Fashion Fund Award recipient is how he blends art and activism to change how we think about fashion and race in America while educating us about Black people's contributions to American society. Brilliant!

In 2015, at his Spring/Summer 2016 show during New York Fashion Week, a model wore a shoe dipped in fake blood with the names of victims of violence at the hands of police written on it. Kerby had designed it in the nascent months of the Black Lives Matter movement to make a statement about racial inequities and the merciless killings of unarmed Black men and women. The model draped in curlers was part of his Fall/Winter 2021/22 Pyer Moss haute couture collection held at the iconic New York estate of Madam C. J. Walker. His intent was to remind us that Madam C. J. was a Black trailblazer we should never forget, who

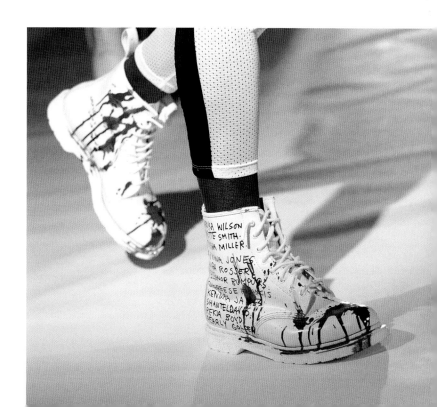

A model presents a creation for the Pyer Moss Spring/Summer 2016 collection during New York Fashion Week, New York, September 10, 2015.

popularized the press-and-curl technique and whose invention of a range of hair care products for Black people helped earn her status as America's first self-made female millionaire. With both presentations, Kerby did as he always does in his effort to make a lasting impact on our culture—he lured us in with his designs, then gave us a history lesson in the process.

The Brooklyn-born provocateur, who dreamed of being a sneaker designer, is all about using his platform for activism and promoting and preserving Black culture. For those who don't know much about him or his Pyer Moss label, which he describes as being "Black as Hell," I'll ease you into his story.

Pyer Moss, Part I

At the root of Kerby's more passive activism is what goes on in the world around him and his deeply personal experiences from just walking while Black. There was that time, for instance, in 2018, when Black men being unjustly targeted or killed by white police dominated the media. In a 2019 interview with *Women's Wear Daily*, Kerby shares that he had just finished playing basketball with some friends in Long Island, New York, when he spotted a white man walking down the street wearing a full-on American flag tracksuit. Feeling threatened, Kerby and the others did what a lot of us would've done. They crossed the road. Once in the car heading back to their Brooklyn neighborhood, Kerby couldn't shake that image of the white man wrapped in what was designed to be a symbol of our American freedom. It left him feeling "hurt and weird." So, he asked his boys, "Do you realize what we

all just did? Do you feel American like that?" The men—all Black—answered, "No!" That sense of alienation fueled Kerby to use his art and canvas to create something for the culture as he'd never done before. Something that would shift the narrative about what it means to be American and show it through an African American lens. Something that would put our stories and contributions that have otherwise been erased from history books back into mainstream culture.

By fusing fashion, art, music, and video with elements of popular American society like flags, Kerby created a fashion trilogy he called American, Also that celebrates our history and heroes while challenging social narratives.

American, Also: Ode to the Black Cowboy

For the first installment of his American, Also series, Kerby focused on one of the most archetypal symbols in American pop culture—the cowboy.

In typical Pyer Moss fashion, the subjects featured in Kerby's Ode to the Black Cowboy campaign look nothing like the American icons we've been conditioned to believe are the sole heirs of the Old West.

Before Beyoncé wowed us with the cowboy core culture at the 2024 Grammys and became the first Black woman to have a number one country album, *Cowboy Carter*, that whole Black cowboy theme was trending in 2018 with

Another day in the life of the Compton Cowboys as they casually ride through the city streets of their hometown—Richland Farms, Compton, California.

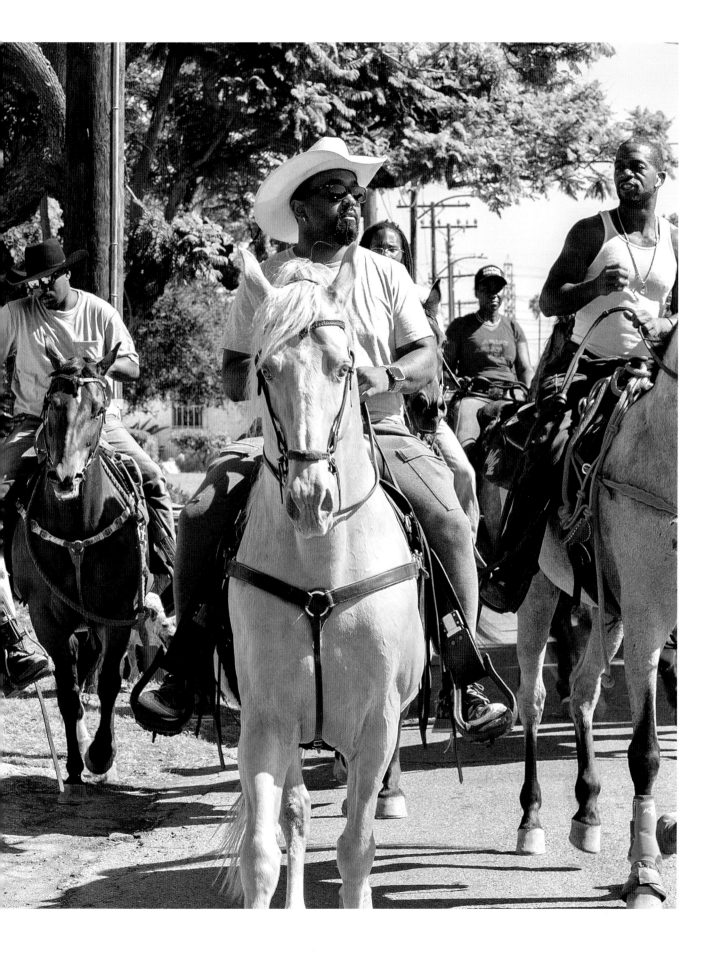

artists like Lil Nas X, Megan Thee Stallion, and Solange. Floyd Mayweather and Chris Paul showed up at NBA games dressed like they'd just walked out of a Marlboro commercial. There was even a YeeHaw Challenge that took TikTok by storm. But Kerby's Ode to the Black Cowboy wasn't created for trend's sake. It was a cultural campaign meant to recognize unsung heroes like the urban Black cowboys, leaders, organizers, and rebels working on the front lines to effect change in their communities. Kerby found them—not on "Old Town Roads" but instead in Compton, the southside of Chicago, Brooklyn, and Baltimore's urban streets.

With camera in hand, the fashion visionary set out on his culture trip to produce a series of short films that captured these overlooked American icons answering the polarizing question, "Do you feel American?"

"Yes, but—"

"Yes, but—"

"Yes, but—"

These cowboys weren't waiting for society's approval of how they should fit the profile of what an American should look like. They were too busy providing local youth with safe alternatives to the streets, safe spaces from violence, ways to heal from racial trauma, and recovery from incarceration. Some, like the Compton Cowboys, whose motto is "Streets raised us; horses saved us," were known to saddle up for good causes like Black Lives Matter protests. But, for the most part, the superheroes featured in the Pyer Moss campaign have had their feet planted on the ground 24/7, using every means necessary to uplift their communities.

Through the eight themed short films scored by Raphael Saadiq, the urban cowboys spoke about self-preservation, self-policing, self-actualization, and self-righteousness—believing that those traits and all that they do for the culture and society as a whole earned them the right to proclaim that they are American, Also.

Along with the modern urban cowboys, the other muses who informed Kerby's mission and fashion collection were the pioneering Black cowboy legends whose existence in the Western frontier was glossed over for decades, even though historians state that one in four cowboys during the nineteenth century was Black.

I grew up watching Westerns because my dad was such a big fan. But like a lot of us of a certain age, the only cowboys I saw back in the day were Wyatt Earp, the Lone Ranger, and maybe a few others on TV and film whom Kerby refers to in a September 10, 2019, *Hollywood Reporter* interview as "John Wayne White."

Not even during Wantu Wazuri Week—the old-school equivalent of Black History Month, initiated in 1926 as Negro History Month thanks to Carter G. Woodson but not officially recognized until 1976—did I ever once hear about Black contributions or even our existence in the Wild West.

For those five days, once a year, every year, we learned only about the same Black heroes I call the Big Five—George Washington Carver, Harriet Tubman, Rev. Dr. Martin Luther King Jr., Benjamin Banneker, and Frederick Douglass.

Textbooks and lesson plans in my schools had us pretty much expunged from the American frontier. There was no mention of Bass Reeves, the first Black deputy US marshal west of the Mississippi, who is known to have captured three thousand of the most wanted criminals without

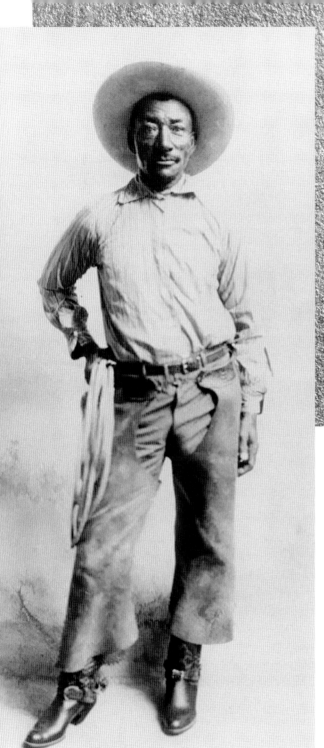

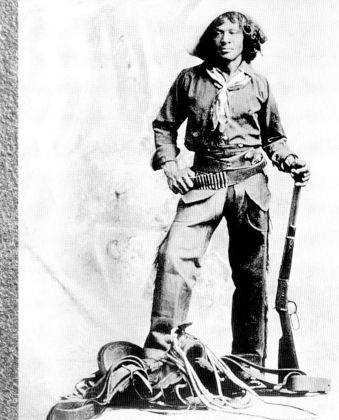

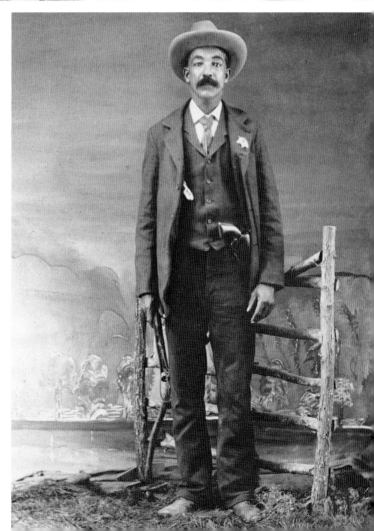

Clockwise: Rodeo Hall of Famer Bill Pickett, Nat Love in 1876 in South Dakota, US Marshal Bass Reeves.

ever being wounded and is said to have inspired the Lone Ranger character on TV. You may know him now thanks to David Oyelowo, the lead actor and an executive producer behind the streaming TV series *Lawmen: Bass Reeves.*

Nothing was taught about Nat Love, the formerly enslaved man who became one of the most prominent Black men in the West, earning the title Deadwood Dick after winning a shoot-out contest in Deadwood. And most notably missing from the discussions was Bill Pickett, the Black rodeo star who became famous for inventing "bulldogging"—a rodeo event that involves chasing a steer on a horse. Once the cowboy gets close enough, he leaps out of the saddle, grabs the steer's horns in each hand, and then wrestles the steer to the ground.

Pickett was not only a pioneer but the baddest of the bad Black cowboys of his day and our first Black US superhero. He was the first African American inducted into the National Rodeo Cowboy Hall of Fame in 1971 and the Pro Rodeo Hall of Fame in 1989. The US Post Office posthumously honored Pickett in its Legends of the West stamp series in 1994.

I was an avid collector of any stamp that honored Black folks. So, of course, I couldn't wait to get my hands on the Bill Pickett stamp. But what I got was very different from what my mom got in the mail. As it turns out, the artist who painted the stamp used the wrong image for him. The first printing erroneously featured Bill's brother, Ben.

After Pickett's family pointed out the error, the Postal Service corrected and released the revised stamp that same year.

Before the mainstream recognized Pickett's accomplishments, the cowboy legend did get

his due from the Black community. Lu Vason organized the first Bill Pickett Invitational Rodeo in 1984. The veteran Black cowboy launched the event to honor Pickett and create a venue for others who couldn't compete in the white rodeos where they were censored or not scored fairly because of their race.

I attended my first Bill Pickett Invitational Rodeo on its thirty-fifth anniversary in 2019 with some friends who aren't just actors on TV, but real-life roping, riding, modern-day Black cowboys. Yeeesss!! The tradition continues. Through their various nonprofit foundations, "Hollywood" Black cowboys James Pickens Jr., Obba Babatunde, and Glynn Turman are the next generation keeping cowboy culture alive

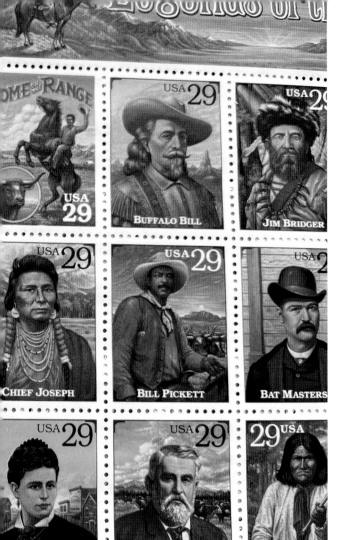

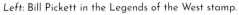

Left: Bill Pickett in the Legends of the West stamp.

Right: The image of Ben Pickett (Bill's brother) was erroneously printed on the Legends of the West stamp that was recalled by the US Post Office.

Below: Actors by day, cowboys for life. (*Left to right*) James Pickens Jr., Glynn Turman, and Obba Babatunde.

by hosting roping competitions and camps for at-risk youth and participating in rodeos to educate and promote to kids the honorable cowboy lifestyle they wouldn't otherwise be exposed to.

Kerby drew inspiration for his Ode to the Black Cowboy fashion collection from the modern-day, urban, and pioneering Black cowboys. It was also his first long-standing collaboration with Reebok.

For someone who, according to a 2019 Associated Press story, once believed runway shows were "boring and elitist," Kerby gained an early reputation for mounting productions as engaging as his fashions. Ode to the Black Cowboy was no exception.

Picture this—an all-Black gospel choir like the one you hear in a Southern Baptist church service singing a medley of Black empowerment anthems, starting with "Alright" from Compton native Kendrick Lamar, who incidentally became the first rapper to win a Pulitzer Prize for Music in 2018. "Alright" had become an anthem of sorts for Black Lives Matter marches around the country and for the Compton Cowboys, who blared it while riding horseback during their peaceful protest rides.

The mood at Kerby's runway show became more intense as the choir performed Gil Scott-Heron's "Home Is Where the Hatred Is" and Bruce Springsteen's "Born in the U.S.A." At the same time, models strutted one by one wearing

New York Fashion Week, February 10, 2018. Model sports Pyer Moss Western style.

classic leather patchwork jackets, neckerchiefs, wide-leg chaps-like pants, and wide-brim hats emblazoned with the words "As USA as U." Some models were draped with renditions of the American and African American flags.

Through his presentation, which was equal parts fashion, art, and video, Kerby aimed to drive home the message that the history of Black people in the West can no longer be ignored, nor can the contributions of Black cowboys then, now, or in the future, because, after all, they are "American, Also," and there is power in Black truth.

While Ode to the Black Cowboy was a conversation starter for Kerby's quest to use fashion and art to preserve the culture by uplifting our stories, his American, Also: Lesson 2 shifted focus from cowboy culture to Black love and the Black family.

American, Also: Lesson 2: The Black Family

Triggered by the racial strife and injustices within and against the Black community in just the last half century, Kerby started to ponder what life would be like for Black people without the looming threats of racism—in a world where Black men could walk the streets without fear of being profiled or harassed. He said in the September 10, 2019, *Hollywood Reporter* interview that he wanted to change the narrative about what people presume it means to be, look, and act Black, while also dispelling the media-generated myths that Black families are "cracked up and cracked out."

To get the full impact of his celebration of Blackness and Black joy, love, and family, Kerby collabed with an artist of like mind—Derrick Adams, whose paintings also celebrate Black

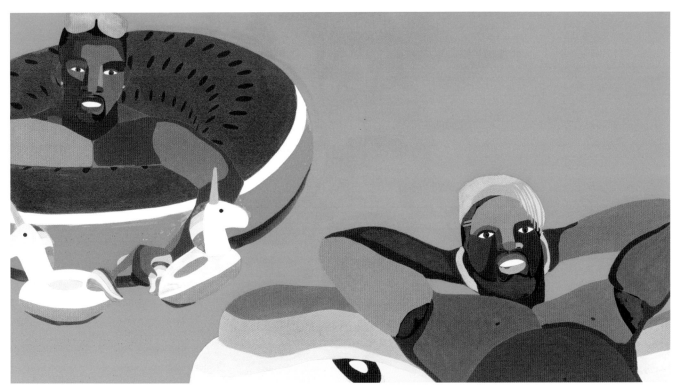

Art from Derrick Adams's Floater series includes (*top to bottom*) *Floater No. 66* (2018); *Floater No. 52 (two kids and a woman)* (2017); *Floater No. 36* (2017).

"When black people are spoken about in the media, it's always in a really sensationalized way. Either you're really extraordinary or really bad and terrible—either way, you're a statistic. I wanted to fill in the blanks."

–KERBY JEAN-RAYMOND, *VOGUE BUSINESS,*
JANUARY 28, 2019

identity and the Black experience in America and bust some insane myths like Black people don't swim.

Former LA Dodgers general manager Al Campanis, who got in hot water for saying Black people are not buoyant, perpetuated some of that good-ole-boy fake news about Black folks near water.

David Isom breaks the color line in his city's segregated pool.

The reason fewer Black people from our parents' and grandparents' generations swam back in the day was because the public pools were segregated up until the late 1950s and were not built in Black neighborhoods. But that didn't stop nineteen-year-old David Isom from breaking the color line at a segregated Florida pool on June 8, 1955.

He was met favorably that day, as if he were any other citizen, when he attempted to take a swim. No muss, no fuss as he took a cool swim with more than forty white people in the pool. But once he left the grounds, the city manager allegedly ordered the pool to be closed because "a n**ger had used the facilities."

Unlike the urban myths about Las Vegas pools being drained after Sammy Davis Jr. dared to swim in one or Dorothy Dandridge dipped her toe in one, we know for sure that the Isom story is true. But again, that was during the time of segregation throughout the country. Pools were off-limits for us.

Today, pools are everywhere, and we're everywhere, swimming and displaying the "radical joy" the Adams/Kerby collaboration created in the Pyer Moss collection that Vogue fashion director

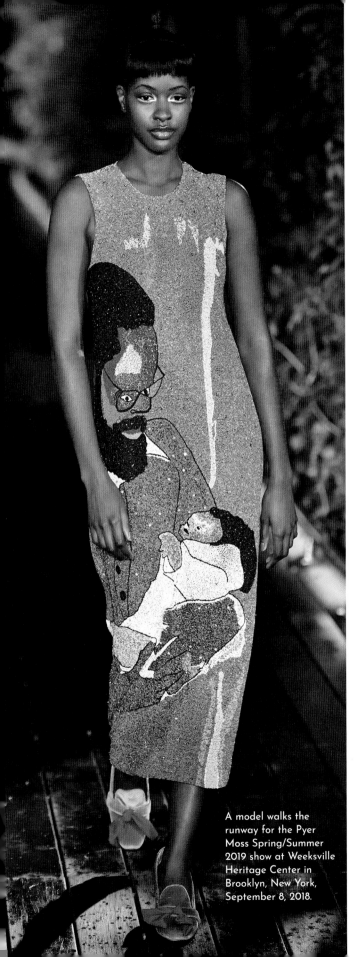

A model walks the runway for the Pyer Moss Spring/Summer 2019 show at Weeksville Heritage Center in Brooklyn, New York, September 8, 2018.

Virginia Smith called "the most memorable, goose-bumps-inducing moment of the season."

Because Kerby had sat out participating one year during New York Fashion Week, the anticipation and buzz swirling around the unveiling of his line was high. Buyers, reporters, and other designers were all talking it up, then—BOOM. Kerby opted out of mounting his show on the main stages in Manhattan. Instead, he directed people to a less-visited location.

Only on Kerby's neighborhood turf would buyers and the media get to see what this prolific designer and storyteller had to show and what new messages he wanted to send.

Come, they did! They flocked to the site by bus, at night, in the rain, sitting outside clutching umbrellas at a show staged in one of America's first free Black communities—Weeksville.

Founded in 1838 by James Weeks, eleven years after slavery ended in New York, Weeksville once had more African American property owners than anywhere else in the country. It had its own cemetery, churches, school—the whole lot! It was the perfect backdrop for celebrating the Black family and Black culture.

Those who made the trek to Weeksville got more than a fashion show—they got a bonus Black history lesson.

Kerby opened his Ode to the Black Family presentation with a Black model walking regally down a lowly lit pathway wearing a white Madonna-like gown while clutching a young Black child's hand. An all-Black gospel choir dressed in white sang Roberta Flack and Donny Hathaway's "Be Real Black for Me." Then model after model wore Kerby designs, bearing

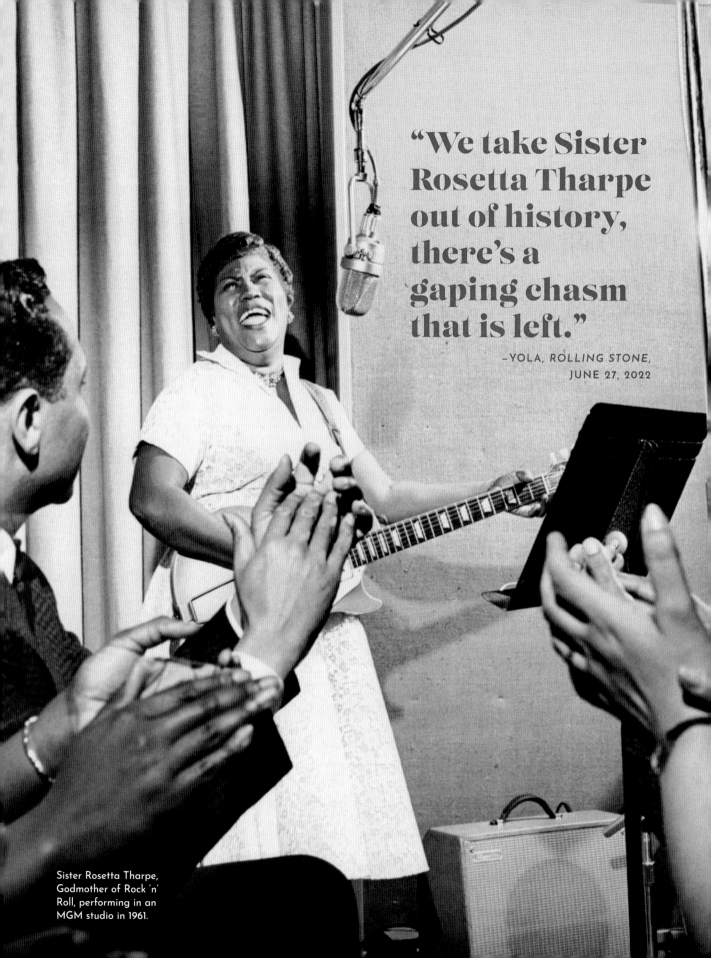

"We take Sister Rosetta Tharpe out of history, there's a gaping chasm that is left."

—YOLA, *ROLLING STONE*, JUNE 27, 2022

Sister Rosetta Tharpe, Godmother of Rock 'n' Roll, performing in an MGM studio in 1961.

Derrick Adams's artwork that paid homage to Black family units at leisure—barbecuing, swimming, a Black dad cuddling his baby.

Black culture was on full display.

Kerby and Derrick's art-meets-fashion presentation was tasteful, moving, and stunning. But what's a Kerby show without a little in-your-face messaging?

At one point, as the choir sang Aretha's "Ain't No Way," a male model walked down the pathway wearing a sash with "See Us Now" stitching. Another wore a "Stop Calling 911 on the Culture" tee in reference to how Black folks feel about being labeled "guilty until proven innocent" by racists just for going about doing daily activities like walking, driving, or hanging out at a playground.

Social media got a good look at the latter tee when actress and now-Harvard-grad Yara Shahidi wore one to a 2018 Los Angeles Lakers basketball game and then posted a pic on Instagram. The woke icon's post got nearly two hundred thousand likes.

The final installment of Kerby's three-part American, Also series highlighting the untold stories of African Americans' major contributions to American culture was all about giving props to the strength and power of Black women.

American, Also; Lesson 3:
Ode to Black Music Legends (Sister)

At the center of his Ode to Black Music Legends tribute was Sister Rosetta Tharpe—the pioneering recording artist who was the first to bring gospel music to the mainstream, hence the show's title, Sister.

I admittedly knew very little about the barrier-breaking legend before watching Kerby's runway presentation online. If you had asked me

before to name singing guitarists in the Rock and Roll Hall of Fame, the immediate ones who would've come to mind were Chuck Berry, Jimi Hendrix, and maybe Elvis Presley. But Rosetta Tharpe? Rock not gospel? No way! Yet that "Queer Black woman in the church," as a spoken word artist referred to her in the show, is the one who set the foundation for all of the rock 'n' rollers mentioned above, as well as Little Richard and countless others.

A guitar prodigy by age six, Sister Rosetta was among the first to use electric guitar distortion.

She made a name for herself in the 1930s with her signature sound that melded gospel with Delta blues and New Orleans jazz. Mixing the two at that time was met with controversy. Still, Rosetta kept right on pluckin' and singin'. By the time she hit age thirty, she was a superstar.

Her singing and revolutionary guitar playing got Sister Rosetta posthumously inducted into the International Gospel Music Hall of Fame, the Blues Hall of Fame, and, in 2018, the Rock and Roll Hall of Fame. A HUGE DEAL!

In 1998, the woman who left her stamp on the music world got a stamp of her own when she was recognized by the US Postal Service with her own thirty-two-cent stamp as part of its Legends of American Music series. The series also honored the contributions of Bessie Smith, Ethel Waters, Ma Rainey, Mahalia Jackson, and others.

Acclaimed singer-songwriter Yola, who played Rosetta Tharpe in the 2022 Elvis biopic and has been outspoken about the inclusion of Black women in the country and rock genres, left us with something to ponder about the singing

legend. In a June 2022 interview with *Rolling Stone*, Yola challenged us to imagine what the industry would be like without Sister Rosetta's contributions.

For his third American, Also installment, Kerby once again moved miles away from the Manhattan catwalks to unveil his much-anticipated line. This time, he had everyone head to the historic Kings Theatre in the Flatbush area of Brooklyn—considered one of the most culturally rich Black neighborhoods in New York.

"I feel like Black women are often erased from things, and I wanted to do this specifically for Black women."

–KERBY JEAN-RAYMOND, ASSOCIATED PRESS, SEPTEMBER 9, 2019

Word of the show drew more than four thousand spectators to the 2,500-seat theater, with an estimated one thousand more lined up hoping to get inside. And these weren't just fashion insiders and front-row regulars in attendance. They were everyday people who wanted to see a show guaranteed to be as much about Black identity and culture as it would be about fashion.

Kerby didn't disappoint. He kicked off the show with an oration that called out the 1619 arrival of the first enslaved people in America. His sixty-piece Pyer Moss Tabernacle Drip Choir

Drenched in the Blood performed music from women only—Anita Baker's "Sweet Love," Tina Turner's "Proud Mary," plus songs from Queen Latifah, Cardi B, Whitney Houston, Missy Elliott, Megan Thee Stallion, and, of course, Rosetta Tharpe. As in each installment of his American, Also series, Kerby put Black history, culture, and identity in the spotlight.

For Sister, Kerby collaborated with another visual artist—Richard Phillips. Richard made headlines in 2018 when he was exonerated of homicide charges for a crime he didn't commit and yet served forty-five years in a Michigan prison.

That axiom "all things happen for a reason" proved true in Richard's case. While in prison, he cultivated his artistic talents to keep himself from worrying about his kids and to "stay sane." His paintings of landscapes, musicians, and portraits of famous people caught Kerby's eye. So including Richard's art in his designs was a no-brainer.

Kerby's collaboration with Richard didn't just highlight the artist's amazing work but drew attention to the injustice plaguing incarcerated Black men in the US prison system.

The whole time Kerby created his American, Also fashion lines, he was filming behind-the-scenes footage to compile in a documentary he premiered as a drive-in theater offering during COVID-19. It was the first screening in the industry to adhere to social distancing measures.

I have loved how Kerby's American, Also series helped us appreciate Black culture, better understand Black history, and tie us to our identity. Yet it was his more in-your-face earlier activism that made him a martyr in the fashion industry. Why? Because he was unafraid and

unapologetic when talking about race on the runway.

Pyer Moss, Part II—
Race on the Runways

Almost daily, soon after the 2016 presidential election, Twitter was aflutter with images of Black men dying at the hands of police and the officers getting away with it. In a 2019 interview with Gerard Adams posted to YouTube, "How to Disrupt Any Industry—The Untold Story of Kerby Jean-Raymond," Kerby likened the madness he witnessed to "watching Black people in the zoo situation." That thinking led him to create his Ota Benga collection.

Ota Benga was a twenty-three-year-old African pygmy caged for public amusement in the Monkey House at the Bronx Zoo. True story!

The most popular version of Ota's tragic life suggests that he was brought to America from his African home in the Congo to be part of an exhibit at the World's Fair. Once the fair ended, he was sent back to his tribe, only to find that they had been annihilated by the first genocide in that region. Ota was brought back to the States and tasked with cleaning cages at the Brooklyn Zoo. When the zoo director noticed him getting more attention than the monkeys, he caged Ota like an animal and created a new exhibit, making Ota the main attraction.

The time was 1906. There was little outrage over what had been done to a Black man.

Ota Benga.

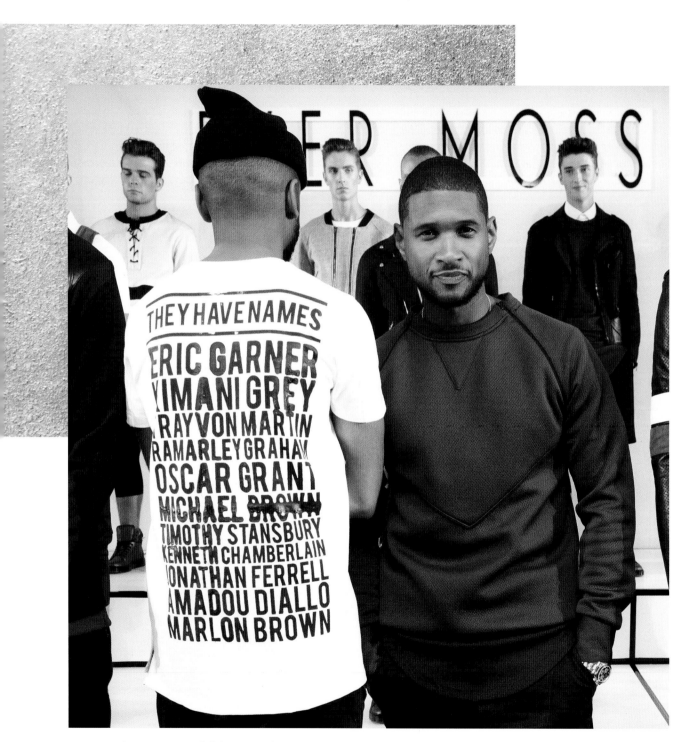

Kerby Jean-Raymond (*left*) wears "They Have Names" tee on-site at his Spring/Summer 2015 show, with Usher (*right*), Mills Studios, New York City, September 7, 2014.

Sadly, in twenty-first-century America, there was still little outrage for what was happening to our Black men. A brotha couldn't walk the streets without fear of being profiled, harassed, jailed, or mercilessly slain by police who ultimately get acquitted.

Ota became the muse for Kerby's collection that he called Ota, Meet Saartjie—an homage to Ota and Sara Baartman, the South African woman who was also a victim of colonial spectacle.

Kerby's Ota-inspired line spoke to the harrowing theme of captivity. It didn't feature the cliché animal print or monkey symbolism. What Kerby did do, though, was juxtapose Ota's story with the modern-day prison system and police brutality that needed to be addressed. The straps and buckles he had on some models were to reference how Ota was being kept in restraints at the zoo.

One model strutted down the runway wearing a shirt with an abstract image of Ota and the words, "Suffer no more." Kerby's message? We shouldn't be making these mistakes.

From the first light cue, models walked down the runway in step to "Nobody Knows the Trouble I've Seen," "Home Is Where the Hatred Is," and "Everything's Got to Get Better."

Unfortunately, things for Kerby didn't get better. After his presentation, things got worse.

Reaction to his works was divided. Some praised his bold statement about a broken system. Others cried foul. Kerby received death threats for being the first to bring race to the hallowed fashion runways.

Things got worse in Black communities too. Michael Brown, an unarmed eighteen-year-old Black man, was shot and killed by white police officers in Ferguson, Missouri.

To channel his rage and give voice to the dozens of other Michael Browns, Kerby designed a "They Have Names" T-shirt bearing the names of thirteen high-profile victims killed by police. The plan was to create enough tees for his models to wear down the runway as he introduced his menswear collection.

As the body count of Black men dying unjust deaths at the hands of police increased, the fashion community remained silent. Kerby feared they wouldn't accept his pop justice on the runway, so he chose not to release the T-shirts to the general public. He destroyed them—all but one, which he wore at the close of his 2015 fashion presentation.

Kerby hadn't counted on an outpouring of demand for his polarizing shirts once a snap went viral online. So, like any entrepreneur-genius, Kerby reversed his thought and released his "They Have Names" shirts commercially, with all proceeds going to the ACLU—which he matched by 100 percent. His bold move to disrupt fashion industry norms became the turning point of his fashion runway wokeness. He stood his ground.

But then came more deaths. More rage.

One night, as he was "walking while Black" in his Brooklyn neighborhood, Kerby was met by three NYPD officers who mistook the black cast on his arm for a weapon.

Kerby nearly lost his life that fateful night when he found himself staring down the barrels of three Glocks—locked and loaded.

The incident proved to be Kerby's trigger to amp up his activism on the runway. It was time to show the world that Black Lives Matter was more than a hashtag.

The Pyer Moss Black Lives Matter Collection

In 2015, a white police officer shot Walter Scott, an unarmed fifty-year-old Black man fleeing from a traffic stop. Freddie Gray, a twenty-five-year-old Black man, died after suffering a spinal injury while handcuffed and shackled in a police van. Frankly, Black America and the world were incensed by the killings and blatant disregard for Black lives.

For his part, Kerby did some shooting of his own.

With a couple of iPhones and Canons, the designer, with no film experience, created a gripping fifteen-minute video about police brutality. It was to be shown at his next runway event.

He intercut familiar footage of unarmed men killed at the hands of police with interviews from victims' families. A few celebrities like Usher were also sprinkled throughout the frames.

Ahead of the screening, word about the video's content leaked, so Kerby's venue pulled out. Likewise, one of his buyers chose to drop his line. Rather than dial back, he doubled down on his activism. He located a different venue and made the video not just the centerpiece but the opening attraction of his runway show.

Much to the ire of some, the buyers were relegated to sit in the back rows; Kerby had reserved front-row seating for community members and victims' families. His fifteen-minute video was screened before a single fashion was displayed.

Oh, to have been a fly on the wall that day!

Early reviews reported that some media in the room gasped and murmured at a lot of the images, later applauding the video, calling it "moving," while others deemed it "unreal" and "unnecessary."

Looking at Kerby's video with my filmmaker's eye, I found his first film effort powerful! And I applaud him for not just focusing on cops doing badly but also challenging thought by raising theories that police brutality directly results from the lack of empathy in our society and how that lack of understanding of our culture is dangerous.

But wait—the video was just the opening act. Kerby had a whole line to unveil.

In a 2015 interview with the Associated Press, Kerby revealed that he was so focused on the message that right up to the time to start his presentation, he wasn't even sure he wanted to show his Black Lives Matter collection. But he did. The haunting and timely collection featured splattered blood on sneakers and "Breathe, Breathe, Breathe" smeared in fake blood on the back of a jacket, referencing Eric Garner's "I can't breathe" plea.

On the plus side, Kerby received a lot of accolades for taking a stand by creating a brand not for entertainment but for awareness. Still, his politically charged presentation and collection resulted in revenue losses well into the six figures when retailers pushed back.

The collection was never made available for purchase. But anyone who wants to see it can do so in its permanent home at the Smithsonian National Museum of African American History and Culture in Washington, DC.

A model poses on the runway during the Pyer Moss fashion show during Spring 2016 New York Fashion Week at the Altman Building in New York City, September 10, 2015.

And remember Kerby's "They Have Names" tees? Well, sadly, there was a need for a sequel. In 2017, Kerby designed an "Even More Names" version of his tee specifically for quarterback Colin Kaepernick to wear as part of his 2017 GQ cover shoot. A year earlier, Colin faced backlash for his courageous decision to take a stand against police brutality by kneeling as the National Anthem played at NFL games. GQ recognized him as Citizen of the Year, and he was photographed proudly wearing his politics on his tee.

When you look at the success of Kerby's collections that focus on Black Lives Matter, Black women singing legends, Black cowboys, Ota Benga, and Black innovators, he'll be the first to tell you that none of them or his Pyer Moss brand, for that matter, would have been possible had he not gotten one of his designs onto the back of a music icon.

In "How to Disrupt Any Industry—The Untold Story of Kerby Jean-Raymond," Kerby said, "All you needed was a celebrity wearing your shit, and it was a wrap!"

He didn't get just any celebrity—

He got Rihanna, the Queen of Hip-Hop to High-Fashion Royalty.

"The sad part is how hard it was to try to pick and fit the names on the shirt. It was too many to fill up both sides, and keep in mind these are just people killed by police since I made the last one in 2015."

—KERBY JEAN-RAYMOND, INSTAGRAM, NOVEMBER 13, 2017

Rihanna wears a Pyer Moss camouflage jacket to My Studio nightclub in Los Angeles, 2013.

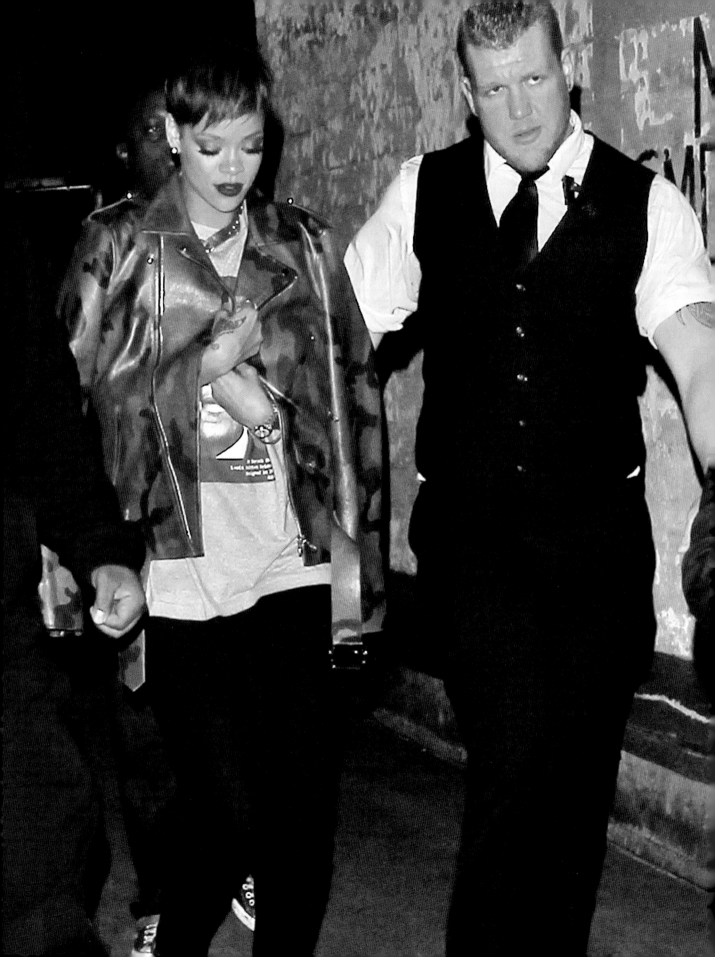

Hip Hop & High Fashion

There's no denying that rappers
and hip-hoppers have had a long-lasting
love affair with luxury brands.

Just think about how often we've heard Fendi, Gucci, and Prada dropped in rap lyrics. In the eighties, Grand Master Flash shouted out Calvin Klein. Tupac and the Notorious B.I.G. sang the praises of Versace. And Lil' Kim name-dropped labels in her lyrics— not to mention airbrushing the iconic Louis Vuitton LV logo all over her body! Many years down the line, the Louis Vuitton–loving Kanye West—who now goes by Ye—went so far as to brand himself Martin Louie the King Jr. These rhymers weren't just singing about luxury fashion brands; the artists wore them. ALL. THE. TIME. Even when they weren't wearing clothes!

Just as rappers and hip-hop icons were flaunting their success to the community and mainstream, the high-fashion labels were enjoying the extra "cha-ching" from the free advertising they got every time their brands popped up in a rap video. Hip-hop had been hijacked. High fashion had lured young fashion-conscious hip-hoppers and rappers, forcing the Wu-tangs, FUBUs, and Cross Colours out of business entirely or on long hiatuses before they got back in the game. The luxury brands were making money off these fashion ambassadors whose music they didn't even respect. That is until a group of business-savvy, fashion-conscious hip-hop and rap creatives decided it was high time high-fashion brands stopped raping the culture. They made the bold move to not just get a foothold in the high-end brands' world but to dominate it on their terms.

Lil' Kim showed her love for Louis Vuitton by having the logo painted all over her body in an iconic 1999 David LaChapelle photo.

I love the snap of who I consider to be three of the Kings of Hip-Hop to High-Fashion Royalty. It was taken in 2006 at the Xbox Oasis Party in Las Vegas.

Standing on the far right is Grammy Award–winning rapper, songwriter, and entrepreneur Pharrell Williams. Even though he'd been making music for decades and cofounded the Billionaire Boys Club clothing brand, I, like many boomer mainstreamers, didn't really take notice of his boundary-pushing hip-hop-meets-luxury fashion style until 2014. That's when he stepped out on the red carpet at the Grammys wearing that Smokey the Bear, Dudley Do Right–looking Vivienne Westwood hat. Remember that? It had the internet buzzing—gaining Pharrell more than sixteen thousand Twitter followers overnight. It even caught the eye of the Arby's fast-food chain, whose corporate logo closely resembles his hat. They tweeted, "Hey @Pharrell, can we have our hat back? #GRAMMYS" LOL! They got over eighty thousand retweets. Talk about the power of social media!

Soon after that, the fast-food chain purchased the hat at auction for a whopping $44,100, with the money going to From One Hand to AnOTHER—an organization Pharrell founded in 2008 that, according to its website, gives children "the tools and resources to meet their unique potential."

Standing beside Pharrell in the snap is the host of the pool party—multiple Grammy Award–winning beat-maker and fashion entrepreneur Ye. His Yeezy fashion line, runway shows, surprise Sunday services during Paris Fashion Week in 2020, and his stratospheric Jeen-Yuhs marketing power are what helped to earn him a spot among hip-hop fashion royalty

and a seat on the *Forbes* World's Billionaires List. He arrived there not because of his music but in large part thanks to his decade-long Yeezy sneakers deal with Adidas. But as hard as he worked to get on the list, he dropped off fast due to his string of racist and antisemitic comments. Adidas ended their partnership in 2022. Regardless of the rapper's self-inflicted financial downfall, Ye's genius, creative talents, and achievements are totally undeniable.

Next to Ye in the iconic photo is the unsung designer, entrepreneur, and game changer who laid the groundwork for Ye, Pharrell, and even Jay-Z and Diddy to make the transition from hip-hop to high fashion—Virgil Abloh.

Virgil Abloh

In 2018, the fashion icon who turned hoodies, sneakers, and other street-style staples into coveted luxury goods made history when he partnered with Louis Vuitton—becoming the first African American artistic director to take the reins of a major French luxury fashion house.

The Ghanaian American's fashion journey started while attending college in Chicago with best friend, Ye. The two had an affinity for luxury brands and even interned together at Fendi's headquarters in Rome for a while in 2009. Virgil not only loved fashion—he lived and breathed it. He started styling and designing for his close friend once Ye became famous as a rapper. At first, it was merchandising and album art, then fashion. Remember all those signature blazers and hoodies we saw Ye sporting for a time? Yep—Virgil!

First, he served as Ye's creative consultant, then in 2012, Virgil launched his Pyrex Vision

Xbox Oasis Pool Party hosted by Kanye West, Las Vegas, Nevada, September 8, 2007. *Left to right:* Virgil Abloh, Kanye West (a.k.a. Ye), and Pharrell Williams.

collection, a luxury line that quickly became the hottest streetwear brand of its time. That same year, he launched OFF-WHITE—with its trademark diagonal stripe patterns. The Milan, Italy-based, high-priced luxury streetwear-meets-couture clothing brand was one of only a few hip-hop-inspired brands to successfully cross over to high fashion. Eventually, Virgil brought his avant-garde, urban style to Louis Vuitton—the world's largest luxury brand—where he didn't just put his toe in high fashion; he ultimately took the helm of the Menswear Division in 2018 as its artistic director—one of

the highest positions at a fashion house.

While the achievement was historic and contributed to his becoming one of *TIME* magazine's 100 Most Influential People in the World the same year, inquiring minds like mine wondered if the urban transplant from Chi-town could make a successful transition to a luxury European fashion house while staying true to his Blackness.

Short answer: Yes! He stayed true to his Blackness.

Virgil's debut Louis Vuitton Spring/ Summer 2019 men's collection featured photos

LOUIS VUITTON

Young children in Virgil Abloh's first Louis Vuitton campaign ads in 2019 were to represent "purity of infancy, still unaffected by preordained perceptions of gender, color, and creed," according to a 2019 *Teen Vogue* article.

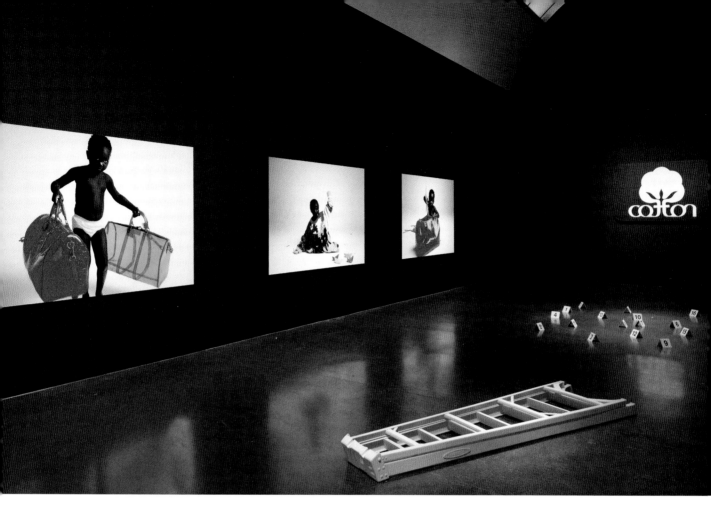

Installation view of Virgil Abloh's *Figures of Speech* at the Museum of Contemporary Art Chicago, 2019.

of really young, really, really, really Black models wearing really, really colorful sweaters with *Wizard of Oz*–like motifs, proving his commitment to the culture and pushing the boundaries of creativity.

Officially called Dark Side of the Rainbow, Virgil unofficially labeled the ad "Unapologetic Black Imagination on Display."

In a series of Virgil Abloh essays reprinted by *Grazia* in 2021, the LV designer shares that the themes he uses in his campaigns are meant to "mirror his own image of men of color who in the future might be able to mirror themselves in the historical reflection of luxury as any white boy down the street."

Fashion elites like Naomi Campbell attended the actual runway show where Virgil unveiled his inaugural LV line. They wanted to support him and bear witness to Black pop culture history in the making. Longtime friend and mentor Ye sat smack in the front row. In fact, a snap of an emotional Virgil and his mentor in a bro-hug after the show was shared and recirculated on the Gram with nearly ninety thousand views.

Meanwhile, more than four thousand miles away from the LV runways in Paris, where Virgil was prepping his next collection, a fashion exhibit was being mounted in his hometown at the Museum of Contemporary Art Chicago.

Figures of Speech was designed to highlight different aspects of Virgil's career from Yeezus to Nike—an ode of sorts to streetwear fans who followed the designer's impressive rise from street-style hip-hop to high fashion.

In the exhibit, Virgil drove the point home that streetwear is a movement—not a fashion trend.

With a focus still on Black boyhood, there was that symbolic *Wizard of Oz* ad with the model gazing off in the distance with a hand reaching toward the sky. There was also a three-year-old dark-complected model wearing colorful pieces from the collection representing "hope." On the floor next to the exhibition was a symbol of tragedy—sixteen yellow crime scene markers, the same number of shots fired by a Chicago police officer that killed Laquan McDonald in 2014. The piece was appropriately titled *Options* to address gun violence in the Black community.

He stayed true to his Blackness.

What's more—the exhibit included rugs Virgil designed for IKEA, sneakers he crafted for Nike, album covers he conceptualized for Ye, and clothing he made for OFF-WHITE and Louis Vuitton. But what I found most culturally compelling was what the curators called *Black Gaze*, which included a large image of the familiar cotton logo set against a stark black background to make it really pop! Next to it was the portrait of a Black woman carrying a bag of cotton. What initially came to mind was what the nineteenth-century economist Karl Marx wrote in *The Poverty of Philosophy* as early as 1847: "Without slavery, we have no cotton." Makes sense, right?

From as far back as the 1800s, my enslaved forefathers were forced to pick cotton in the sweltering hot fields. So, whenever I see that cotton symbol, I think of slavery and the blood, sweat, and tears our ancestors shed to bring wealth and power to the American economy. By juxtaposing the cotton symbol with the Black woman carrying baggage, Virgil showed a hyperawareness that he was creating products to sell in the same marketplace that Black people were once sold through. Again, very, very deep!

Incorporating symbols of our dark past into fashion to shed light on an aspect of Black history was a theme throughout Virgil's Fall/Winter 2021 LV collection, which he christened Ebonics.

I love that Virgil was committed to keeping Black culture front and center of his collections, but I must say that the name he chose for his new line was a bit off-putting.

From jump street, the word "Ebonics" has never sat well with me. I can remember when the term was coined in 1973 by a group of Black scholars. They blended the words "ebony" (a.k.a. Black) and "phonics" to suggest "Black speech." The term took on a negative connotation in 1996 when the school board in Oakland, California, stated that rather than teaching Black students standard or academic English, they would allow Ebonics to be their primary language.

When I first heard that it was the name of Virgil's collection, I was like, *Hunh? What? That's*

Novelist James Baldwin sprawls across the bed in his New York apartment to jot down notes.

nuts! But in a brilliantly written eighty-page manifesto, Virgil explained that the creative concept behind his Ebonics collection was to explore the symbolism behind how we dress and how we make presumptions based on how people dress and look.

His theme for his collection was also a bit autobiographical in that it focused on being away from home in a far-off land. The Chicago native, living and working in Paris, got his inspiration from one of our most revered Black novelists, James Baldwin, and his famous "Stranger in the Village."

Stranger in the Village

James Arthur Baldwin was a prolific voice in the American civil rights movement and, coincidentally, one of my favorite essayists, playwrights, and novelists. His writings often spoke of his experiences as a Black man living in 1960s white America. *Notes of a Native Son*, *The Fire Next Time*, and *Go Tell It on the Mountain* are still considered American classics. The latter was one of the first pieces of literature that focused on the struggles of Black people living in the US.

TV streamer Netflix helped introduce Baldwin to a new gen audience through a documentary it released in 2016 called *I Am Not Your Negro*, which ultimately earned an Academy Award nomination. Inspired by Baldwin's unfinished manuscript, "Remember This House," the documentary examines race in modern America.

Three years later, on the verge of a breakdown, Baldwin relocated again to a tiny village in the Swiss Alps, where he soon discovered that the white people living there had never seen a Black man before. Feeling like a stranger in the village prompted him to write his powerful "Stranger in the Village" essay about his experiences, which also served as a metaphor for the history of race relations in the US.

When I first read James Baldwin's "Stranger in the Village" in college, I remember being struck by how he contrasted being called "Neger" by European kids in the Swiss village who didn't know any better versus being called "a Nigger" in the US during the civil rights era by those who knew exactly why they were using the racist term.

Using Baldwin's essay as a theme to debut his autobiographical collection, Virgil reflected in his show notes on how he, too, felt like a transplant from America to Europe, or in his words—as a "Black artist in a world of art created from a white European perspective."

In 2021, COVID-19 limited gatherings and forced Virgil to forgo a lavish runway presentation for the debut of his line, so he unveiled it via a short film directed by Wu Tsang, with performances by old-school rappers Mos Def and Saul Williams. Seeing it on film was no less effective and still became one of the most talked-about fashion moments of the year.

Sadly, it was to be one of the last runway shows that the fashion superstar staged.

News of Virgil's death in 2021 rocked the fashion world.

The influential designer, collaborator, image maker, and innovator was forty-one when he lost his private battle with cardiac angiosarcoma—a rare cancer.

I was still fine-tuning this chapter—waiting for reviews of his Miami show where he would unveil his 2022 LV menswear collection—when I first learned of Virgil's death.

November 24, 2021, six days before the show, Virgil posted, "Miami, I have an idea . . ." Four days later, he'd left us.

LV confirmed that the show would go on as planned before the barrier-breaking designer's death. However, what was meant to be a highly anticipated star-studded fashion show became a celebration of life, poignantly titled Virgil Was Here.

> **"There's no limit. . . . Life is so short that you can't waste even a day subscribing to what someone thinks you can do versus knowing what you can do."**
>
> —VIRGIL ABLOH, DELIVERED POSTHUMOUSLY DURING HIS FINAL LV FASHION COLLECTION SHOW IN MIAMI, NOVEMBER 30, 2021

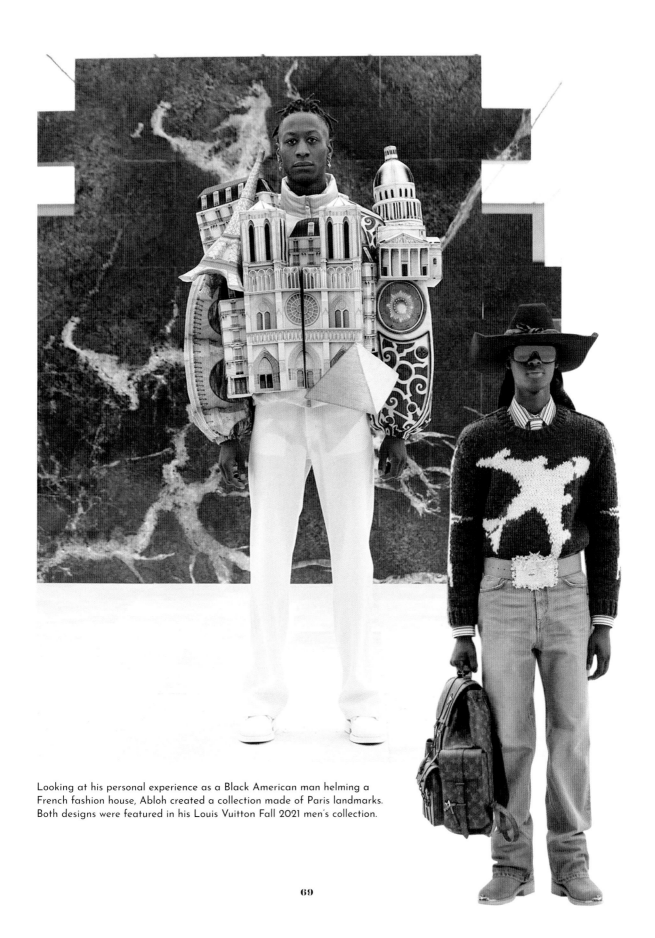

Looking at his personal experience as a Black American man helming a French fashion house, Abloh created a collection made of Paris landmarks. Both designs were featured in his Louis Vuitton Fall 2021 men's collection.

"Virgil was here" written in the sky during the November 30, 2021, Louis Vuitton fashion show.

Seeing "Virgil was here" written in the sky in neon lights was as powerful as Virgil's last message delivered in his own words to close out the show.

The menswear creative director position at Louis Vuitton remained unfilled for nearly two years following Virgil's death until another hip-hop-loving visionary and cultural icon was selected to fill Virgil's shoes—Pharrell Williams.

The appointment was actually quite prophetic. You see, months before his death, Virgil had appeared on a podcast where he spoke hypothetically about the next candidate to run a luxury house.

He said, "What I would be more impressed by is if the next candidate for a house, the next head designer, has this multidisciplinary background—comes from not a fashion school, and thinks in a different dimension. Let him get a shot."

The podcast was called OTHERtone. The originator and host of the podcast was—you guessed it—Pharrell Williams.

So, to the many critics who questioned why Pharrell got the LV menswear creative director position without fashion school experience—well, there you go!

For the most part, when Pharrell—whom fashion legend Dapper Dan referred to as luxury fashion's "next Black hope," in a February 14, 2023, Instagram post—stepped into Virgil's role at LV in 2023, the Twittersphere was Happy, Happy, Happy!!!

The Grammy winner and fashion icon had proven himself worthy.

Unsurprisingly, his debut collection for LV revolved around love and community. There to cheer him on from the front row was quite a bit of star power, including Beyoncé, Jay-Z, Zendaya, Jared Leto, Kim Kardashian, A$AP Rocky, and Robyn Rihanna Fenty, who had made fashion history at LVMH (Louis Vuitton Moet Hennessy) four years earlier when she launched Fenty Fashion House, becoming the first Black woman to head up a luxury fashion house and the first woman to create a brand with the group. Yesss! She's a force!

And when you think about the fact that the Grammy Award-winning artist, fashion designer, and beauty mogul supposedly once sold clothes

on the streets in her native Barbados and now is a member of the Billionaires Club—the youngest self-made billionaire, at thirty-four—you can have faith in the old adage "dreams come true if you only believe."

I applaud our modern-day hip-hop fashion royalty for all their achievements. But of course, if we wanna go way, waaayyy back—we must give props to one other American-born Black designer who was truly among the first to make a splash in European high fashion. His works also influenced hip-hop street style in the early eighties, though many of his fashion lines didn't sit well with a lot of Black folks.

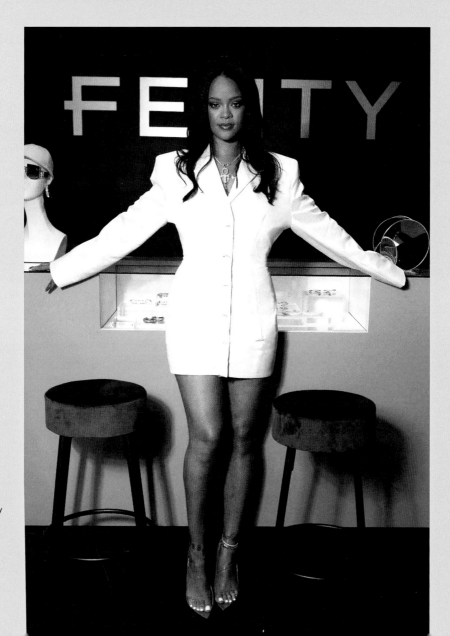

Rihanna hosts the Fenty Luxury pop-up launch, Paris, France, May 22, 2019.

Patrick Kelly

Patrick Kelly, a talented young Black boy from the Deep South, became the first American admitted to France's prestigious Chambre Syndicale de la Haute Couture—the crème de la crème for fashion designers. Patrick didn't use models, Ebonics, or symbols of cotton to advance cultural conversations about Black identity or address racial issues. Instead, he adorned his fashions with his signature buttons and bows. More importantly, he took an overt road of using many of his designs to address racial issues—which kept him in the media for all the wrong reasons.

Un hunh. Uh yeah—that's blackface on the dresses on display.

Patrick Kelly was a creative who could care less about what critics thought of his signature style of incorporating racist tropes and iconography into his collections.

But before you pass judgment—you should know that despite using so many cringeworthy, politically incorrect symbols in his designs, Kelly was considered a highly respected trailblazing designer in Parisian fashion society and, yes, even hip-hop culture.

Born in Vicksburg, Mississippi, in 1954, Kelly's interest in fashion design came at a young age after looking through his grandmother's fashion magazines and finding zero, nada, zilch images of Black women. Even at age six, Kelly deduced

I Love Fashion Scandal evening dress from Patrick Kelly's Fall/Winter 1986 collection.

something was wrong with that picture. So he vowed to change it.

Growing up in the shadows of Jim Crow, Kelly had painful stereotypes constantly around him. You know the ones: oversized red lips, Mammy images, Black people eating watermelon and fried chicken, bugged-out eyes, and so on, and so on, and so on.

As Kelly got older—rather than rebuke the racist depictions, he collected them.

I understood where he was coming from. What Kelly did by collecting this controversial imagery in the eighties blew up big time in the nineties. Black Americana (code for racist objects) had become a quite lucrative and, dare I say, "honorable" hobby. Even I got caught up in it. Like Kelly, I collected some of every kind of Black cultural relic from the past: Uncle Ben ads, Mammy cookie jars, Aunt Jemima salt and pepper shakers, canisters— the whole lot, including a pair of authentic slave shackles that I got from Goree Island in Senegal, West Africa. Oh yeah, they were authentic chains used to enslave one of our ancestors.

I often tell the story of one visitor to my home asking me if, by collecting these things, I was investing in heritage or hate. In line with Kelly's defense, I argued that my Black memorabilia purchases weren't for shock value or resale at an auction for profit but instead as a reminder of how far we African Americans have come. To this day, I still believe that if these painful relics of the past are out there, they need to be in Black hands.

Woman's dress with fourteen pins.

Patrick Kelly
handmade baby
doll brooch. Set of
three. Circa 1980s.

When Kelly moved to Paris in 1980, searching for creative freedom, he brought his Black memorabilia collection and southern swag with him. Constantly looking for ways to intentionally exploit his traditions while on European soil, he cooked fried chicken for his friends and peppered conversations with "honey chile," especially when speaking with white folks.

Early in his relocation to Paris, Kelly purchased over six hundred thousand plastic Black baby dolls from a dime store. He would sit in his studio attaching pins to their backs, then boldly hand them out to buyers—those who attended his runway shows and sometimes just everyday people walking down the streets. He defended these unofficial calling cards as his way of sharing a part of his Black history and heritage. Can you imagine being handed one of these back in the eighties, or one of his cellophane lips? Would you have been amused or outraged?

I recall how, in 1987, former talk show host David Letterman was embarrassed to receive the lips on air as a gift from legendary actress Bette Davis. She was not only a friend of Kelly but also a fan of his designs, which she wore on that May 26 episode.

In terms of Kelly's actual fashion style, the expat often included cartoonlike blackface images with bugged-out eyes and big red lips in his haute couture collections. It became another part of his signature style and, ultimately, a major part of his legacy.

Not unexpectedly, Black folks in the States got easily offended as the images harkened back to the days of Al Jolson, Bert Williams, and Lew Dockstader.

In these fractured times, we've grown less tolerant of anyone using the demeaning symbol. In fact, there's a whole cancel culture for luxury brands, politicians, TV news anchors, and comedians who promote blackface. Whether accidental or intentional, our beloved Beyoncé and Drake weren't immune from getting slammed for wearing, selling, or promoting anything that had anything to do with blackface, even if in jest. But in the eighties

and nineties, Patrick went there! He got away with confronting these images on the other side of the pond. Europeans thought he was just mimicking their loveable Golliwog character—a children's book favorite from the fifties.

The doll-like character that cartoonist Florence Kate Upton created had jet-black skin, bugged-out eyes, kinky hair, and clown-like lips—intentionally designed to be ugly. Soon, the character was everywhere: toys, ads, food packaging, and more literature. Its popularity came during a racist time, so little was done about banning the image from pop culture. So this begs the oft-asked question: Didn't Kelly know the images were racist?

Of course he knew! After all, he grew up in the South.

Appearing to fashion his signature blackface logo after the Golliwog was Kelly's deliberate

way of confronting racism, not contributing to it as even some Black folks have criticized.

I wonder—do those who think Kelly's collections were racist believe that those of us who love his designs are racists too? The short answer is NO! I can't say I'd wear them in public today, but I loved them for their whimsy and style back in the day, and I'm far from being a racist.

I get how, in the 1980s and 1990s, living, working, and surviving in the world's fashion capital, Kelly unashamedly believed it was necessary to acknowledge these symbols in our history to move forward.

Even as he chose to use some of the most demeaning images in his collections and presentations—like having watermelons on the heads of models as they strutted down his runways or holding stereotypical fans and

Left: Book cover of *The Adventures of Two Dutch Dolls* by Bertha and Florence Kate Upton, 1895.

Above right: Patrick Kelly made blackface his brand and often sported the cartoon image in his own wardrobe as well as his haute couture collection.

"I want my clothes to make you smile."

–PATRICK KELLY IN *PATRICK KELLY: THE AMERICAN IN PARIS* (2021)

Designer Patrick Kelly at fashion designers party against AIDS, Paris, France, October 26, 1988.

Patrick Kelly *Runway of Love* exhibit
at the Philadelphia Museum of Art.

Above: Aaliyah, Tommy Hilfiger ad, 1997.

Left: T-Boz, Chilli, and Lisa "Left Eye" Lopes of TLC, Seventh Annual Soul Train Music Awards, 1993.

patches on dresses—Kelly's designs were high-end, classic, and effective in getting people talking about race.

Not all buyers were on board with Kelly's free use of these demeaning images in his designs. Many retailers wanted nothing to do with him as long as he included racist imagery. Some of his investors threatened to pull their support if he didn't remove them from his designs. But Kelly never budged. He kept right on designing clothes with blackface figures and watermelon hats. He kept right on handing out his Black baby pins, talking like a country dude, and wearing his oversized denim overalls—another carryover from his Mississippi roots.

Though the hip-hop community wasn't trying to add any more negativity to their bad rap—they were already being called bad influences, thugs, pimps, and drug pushers—they dug Kelly's overalls style and started copying it.

TLC—the top-selling American female group of all time and known for their trendsetting style—wore colorful Patrick Kelly-inspired overalls on magazine spreads, at concerts, and for so many of their promotions. Ditto Aaliyah, who sported the look in her memorable fashion campaign for the designer brand Tommy Hilfiger.

Years later, Prince commissioned Patrick Kelly to create a look for his Love Sexy Tour, and Chance the Rapper remixed the look in the early 2000s as his signature style.

Patrick Kelly died due to complications from AIDS in 1990 at the age of thirty-five on New Year's Day. Though he only had one toe in rap culture, he, like Virgil Abloh, brought some level of Black history through his journeys between hip-hop and European high fashion.

In contrast—instead of bringing hip-hop to high-end European couture, one designer brother flipped the script and brought high-end brands to hip-hop. This larger-than-life fearless designer made it happen in the most nonconventional way.

Dapper Dan

Daniel Day, a.k.a. Dapper Dan, Harlem Hustler, and King of the Knockoffs, made his mark in the fashion world in the early eighties and nineties, having established the first luxury fashion house in Harlem in 1982. The former professional gambler is credited with introducing high-end fashion elements to designs he created for the who's who of the hip-hop world, including LL Cool J, Salt-N-Pepa, Big Daddy Kane, and Jam Master Jay. His splashy custom designs were created using the logos of luxury brands. But there was just one tiny flaw in his plan. He never told the luxury brands he was "borrowing" their logos. Didn't he know the legal risks?

"Sure, but I'm a gambler."

—DAPPER DAN, *THE NEW YORKER*, MARCH 18, 2013

The retailer and fashion outlaw started his fashion journey in the midsixties and seventies.

It was a turbulent time of campus protests, the Vietnam War, the Watergate scandal, and the nationwide search for fugitive Angela Davis.

All the while, the Black is Beautiful movement was underway, and the level of Black pride had catapulted. Brothers wore dashikis and other prints to show their Black pride and pay homage to their African roots.

Dan's interest in the African-inspired fashion trends of the time was high when he traveled to the continent in search of his true culture. While there, he hoped to buy up as much African fabric as he could bring home. But soon after landing on the shores of Africa, Dan was shocked to see that all the really cool Africans were wearing mostly Western styles. These weren't just any off-the-rack clothes from big chain retailers but impeccably made custom suits.

While in Liberia, Dan had the good fortune to meet up with a local tailor making the most exquisite luxury suits from scratch. Though he was in total awe of the Liberian's craftsmanship, Dan felt the brother could've done a tad more to make the designs pop. So he worked with the tailor, instructing him to add a little something here, take away a little something from there, do this, do that. Before he knew it—BAM, they had collaborated on pumping out a look that was so fly Dan knew it would wow his customers back in the States. The suits had a bit of an African cultural flair but also European touches, with just enough Harlem street style.

Dan was sure his buyers would love the looks. He was right. No one else in Harlem was making custom suits like these. Anybody and everybody who could afford them wanted the look—from celebrities and athletes to number runners, hustlers, and especially the rap world.

This untapped market for high-end fashions targeting urban patrons—especially up-and-coming rappers—was a potential cash cow for

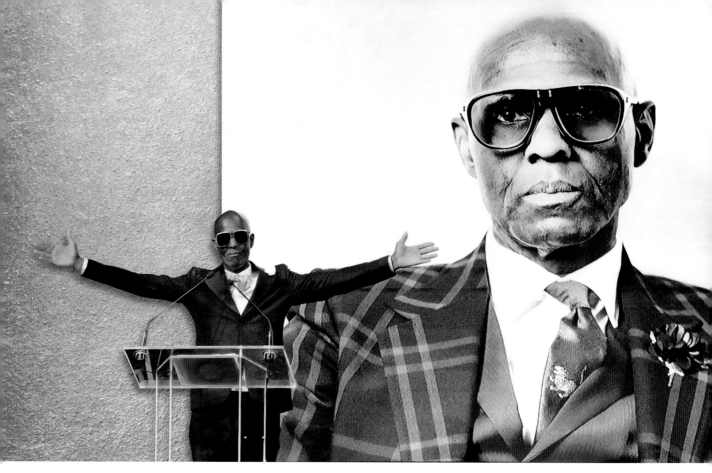

Fashion icon Dapper Dan accepts Harlem Fashion Row's Lifetime Maverick Award at the HFR fashion show and awards ceremony before the start of New York Fashion Week.

big luxury lines. But the high-fashion designers saw rappers and hip-hoppers as being too negative at that time and wanted no part in targeting this demographic. Dan turned that negativity into opportunity. He created a niche for hip-hop to meet high fashion and was suddenly off to the races.

After seeing one brother carrying a pouch with a luxury logo, he deduced that he could make a killing by creating full-on outfits with designer labels. And so he did! To accentuate his next-level, groundbreaking creations, Dan started integrating trademarked logos from LV, Gucci, and Fendi into his custom-made designs for his most loyal customers.

He worked closely with the hip-hop community to understand the meaning behind their lyrics so that he could incorporate the

messages in their music into his custom designs.

Rappers Eric B. & Rakim were so blown away by Dan's co-opted looks they even wore one of his "knock-ups," as Dan preferred to call them, on the cover of their *Follow the Leader* debut album—with the Gucci logo prominently displayed.

Dan writes in his memoir, *Made in Harlem*, that "they'd just signed a record deal with Russell Simmons at Island Def Jam and wanted to make a powerful statement." In fact, it was Rakim who first drew a lot of Dan's customers from the music world.

Having successfully seized a demographic hungry for hip-hop high-fashion styles, Dan was making a killing with sales and orders. The demand for his designs kept his Dapper Dan Boutique, located on the main drag of 125th

Street in Harlem, going 24/7 for ten years straight until one day—it wasn't.

Fendi's trademark infringement case against Dapper Dan forced him to close his doors in 1992. It was a gut-wrenching blow but not enough to keep Dapper Dan down for long.

Dan stopped incorporating the designer labels but continued making and selling clothes underground. Then in 2017, thanks to a twist of fate, the Rip-Off King got his comeuppance. Observe Exhibit A: Olympic gold medalist Diane Dixon.

In 1989, Olympic gold medalist sprinter Diane Dixon wore a custom-sleeved Dapper Dan bomber jacket with an appropriated LV luxury label that he got blasted for using without LV approval. A model walking the runway for Gucci's Cruise 2018 collection sported a style that is an overt knock-off of the look the knock-up king created twenty-eight years earlier—before he got shut down for allegedly knocking off high-end label logos. Are you with me?

Gucci later claimed they intended to cite the look as an homage to Dan, which didn't come until after Diane called them out on Instagram when she posted the images side by side with the headline: "As Fashion Repeats We Must Give Credit to the Originators! Shout Out to Dapper Dan!"

Diane's post got 1,300 likes within hours— that, along with the immediate outcry on

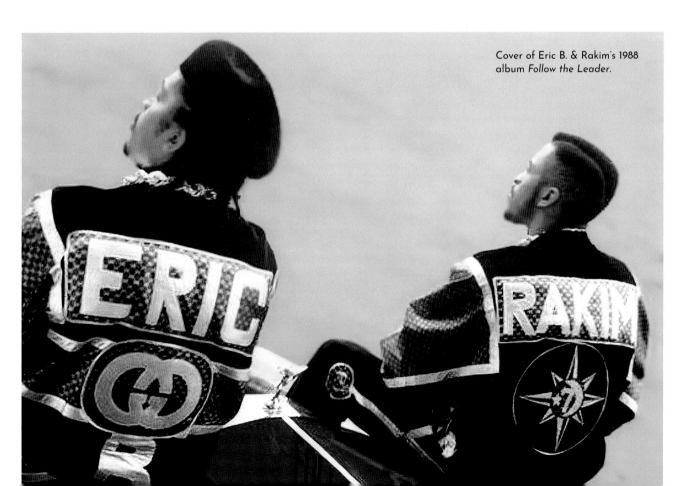

Cover of Eric B. & Rakim's 1988 album *Follow the Leader.*

Black Twitter, helped change Dan's fate. Soon his story morphed from controversy to collaboration, with the two parties reaching an agreement that had Gucci financing and Dapper Dan designing the Gucci X Dapper Dan collection that launched in 2017. Game changer!

Rappers could go back to wearing his looks, and everyone—from Beyoncé and Diddy to Nas, Tracee Ellis Ross, and Rick Ross (no relation, of course)—was rocking his designs and showing him love and support.

Dapper Dan had finally gotten the attention he earned and deserved; that also came in the form of lifetime achievement awards, commendations, and the like, including the Geoffrey Beene Lifetime Achievement Award—one of the highest honors presented by his peers through the CFDA. He not only became the first person of color to receive the award but the first to win who had never curated a formal runway show. How's that for tenacity, resilience, and faith?

While Patrick and Virgil used their platforms and life experiences to pay homage to Black history and the culture, Dapper Dan will forever be lauded for leading European high-fashion brands to elevate hip-hop culture—which in and of itself *is* Black culture.

Olympic gold medalist Diane Dixon wears a Dapper Dan/Gucci jacket in 1989.

"They raided me so much; they raided me broke. But I was determined to return to the status I once had."

—DAPPER DAN, *CRAIN'S NEW YORK BUSINESS*, SEPTEMBER 5, 2019

Below: A model walks the runway at the Gucci Cruise 2018 show at Palazzo Pitti, Florence, Italy, May 29, 2017.

Above: Rick Ross arrives at the 2019 MTV Video Music Awards held at the Prudential Center, Newark, New Jersey, August 26, 2019.

Left: Tracee Ellis Ross hosts the American Music Awards, Los Angeles, October 9, 2018.

Patterns of Pride, African Style

Traditional kente cloth—with its bright multicolored loomed fibers of cotton and silk—has a royal history dating back hundreds of years.

In the modern-day Afro-pop space, kente cloth has become *the* cultural fabric of choice for celebrities, athletes, activists, clergy, Afrocentric politicians, HBCU grads, and even the Second Gentleman. You'd likely be hard-pressed to name a Black person you know who hasn't worn a kente shawl, dress, cummerbund, cap, stole, backpack, or other African accessories as a badge of honor during Black History Month, a graduation ceremony, church service, Kwanzaa, an Afrocentric wedding, or some other African-themed occasion. Not just any African textile, but specifically kente. Once reserved to be worn exclusively by African royalty, kente has increasingly served as a symbol of our cultural pride and Blackness.

Vice President Kamala Harris looks on as Second Gentleman Douglas Emhoff receives a kente robe during a visit with Osabarimba Kwesi Atta II at the Emintsimadze Palace in Cape Coast, Ghana.

Jaw-dropping doesn't begin to describe how I felt seeing Amanda Gorman, one of our greatest pop culture icons, on the cover of the May 2021 edition of *Vogue* wearing a stunning full-length kente gown. She looked strong. Confident. Powerful. Full of pride—which is precisely what wearing kente tends to do.

Just as Amanda—the award-winning writer, activist, and youngest inaugural poet in US history—blew us away with the powerful words she delivered at the inauguration of President Joe Biden and the country's first Black vice president, Kamala Harris, Amanda exuded a sense of confidence that oozed from every seam of the kente pattern of pride she donned on the cover of *Vogue*—designed by Virgil Abloh for Louis Vuitton. In my mind, the style icon was telling the world, "I am what I wear! Proudly Black with a rich, royal, African heritage!"

Virgil's inspiration for the off-the-shoulder

Left: On July 30, 2019, US Speaker of the House Nancy Pelosi poses for a photograph after presenting a gift to the paramount chief of Cape Coast, Osabarimba Kwesi Atta II, during her visit to a Ghanaian palace once used as a trading post from where the enslaved would be taken to America.

Opposite: Amanda Gorman, at age twenty-three, became the first poet to grace the cover of *Vogue,* May 2021.

gown came from seeing a picture of his Ghanaian grandmother, who frequently dressed in kente cloth, even though his family roots were not from the Asante kingdom where kente patterns originated. Did it matter? To some trollers on social media, the answer was yes. More than a few slammed Virgil for misappropriation. But judging by the popularity of the cloth for African Americans with lineages all over western Africa, it really didn't matter if he was of the Ewe or Akan Asante ethnicity as long as African culture was being elevated.

Still, the question of who wears kente makes one wonder how this particular pattern has come to hold such significance to people of African descent over the years. Does wearing it give us a greater connection to our African heritage? What makes it *ours*? Does kente carry the same symbolic weight if it's not authentically loomed in Ghana but rather mass-produced outside of Africa? And here's the burning question: Why do we cry foul—

when kente is used to make political fashion statements—but only sometimes?

The Politics of Kente

On January 30, 2018, during President Trump's first State of the Union address, fifty-five Congressional Black Caucus (CBC) members donned kente shawls around their necks. Not just to flaunt Afrocentric style but as a SHOW OF SOLIDARITY and a silent rebuke of Trump referring to some African nations as "shithole countries." We didn't seem to mind the fashion statement then. We got their message, even if Trump didn't.

In July 2019, the then House Speaker Nancy Pelosi (D-CA) led a thirteen-person delegation of CBC members—including two whom Trump mockingly suggested should "go back where they came from"—on a pilgrimage to Ghana in recognition of the four hundredth anniversary of the arrival of enslaved Africans in Virginia.

Rep. Bobby Rush (*left*) leads the Congressional Black Caucus in prayer at Rep. Elijah Cummings's casket.

While at the event dubbed the Year of Return, Nancy Pelosi wore the national kente cloth of Ghana as a SHOW OF RESPECT while making a presentation to Osabarimba Kwesi Atta II. We didn't mind that fashion style either. We applauded the gesture.

There was also that moving tribute in October 2019 from CBC members who wore kente as a SHOW OF REVERENCE for esteemed congressman Elijah E. Cummings (D-MD), while his body lay in state at the US Capitol—an honor bestowed to only a few dozen politicians, presidents, and military leaders throughout US history. On that day, we shared the CBC's united grief.

But then came the big elephant in the room.

The optics from the June 8, 2020, event in the US Capitol, where a small group of Democratic Congress members wore kente stoles and knelt for eight minutes and forty-six seconds—initially thought to be the length of time that former Minneapolis police officer Derek Chauvin knelt on the neck of George Floyd before he died—left most of us shaking our heads.

Not only did kente trend across social media that entire day but the well-intentioned gesture by the members of Congress, meant to pay tribute to Floyd and all Black lives lost to police brutality, drew a strong and immediate reaction.

"Tasteless!"

"A distraction."

"Cultural appropriation!"

"We are not your props!"

"Wakandan chess set?"

"A little traumatizing to see."

"Seriously?"

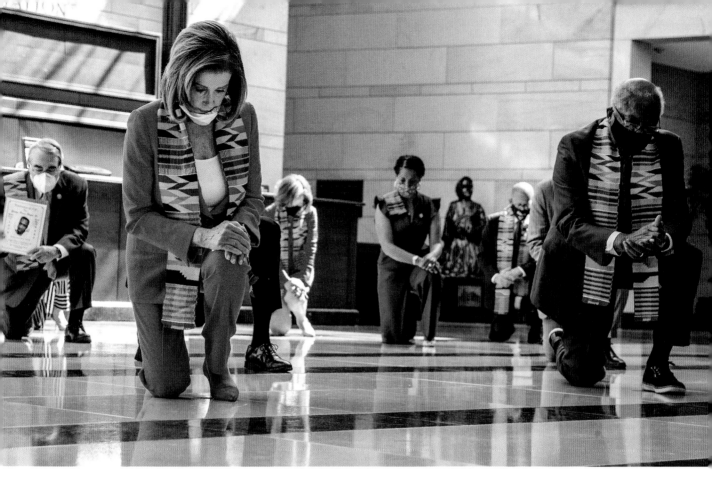

Former Speaker of the House Nancy Pelosi (D-CA) and other members of Congress kneel to observe moments of silence at the Capitol's Emancipation Hall on June 8, 2020, and read the names of George Floyd and others killed during police interactions.

"Wakanda mess is this?"

Truthfully, the backlash had less to do with kneeling than with the actual act of wearing kente. Most critics understood the symmetry of the action. They had already accepted the images of Austin police kneeling in silence with Black Lives Matter protestors. They had accepted Fairfield police officers kneeling during a Taking a Knee for Justice Prayer service in Fairfield, California. They had also accepted the LAPD taking a knee with clergy and marchers demanding justice for George Floyd. But it was hard to wrap their heads around why our sacred kente cloth was part of Congress' kneeling in a solidarity spectacle.

Former CBC chairwoman and now LA mayor Karen Bass went on record to shed some light.

> **"The significance of the Kente cloth is our African heritage and for those of you without that heritage who are acting in solidarity. That is the significance . . . our origins and respecting our past."**
>
> —KAREN BASS (D-CA), FORMER CHAIRWOMAN OF THE CBC, *USA TODAY*, JUNE 6, 2020

Fair enough, yet not enough.

People wanted change, not theatrics. But because the optics overshadowed the intent, we missed that change was already in the works.

Congress had initially staged the event to introduce meaningful legislation to support the very ones most offended by their act—Black lives.

Asantehene Otumfuo Osei Tutu II, the sixteenth king of the Asantes, wears a royal kente cloth pattern only to be worn by kings. He sits next to the Golden Stool that is never to touch the ground and can only be touched by a king.

The new George Floyd Justice in Policing Act would make it easier to prosecute law enforcement, end immunity protections for police, and ban no-knock warrants—like those used by officers in the killing of Breonna Taylor, the EMT wrongfully shot dead after three detectives burst into her apartment in the middle of the night—and choke holds, like the one used on George Floyd. The bill would prohibit racial profiling and establish a national registry of misconduct, requiring states to put law enforcement on blast for the improper use of force. They were baby steps. But progress.

When Ghanaians who created kente weighed in, it was clear they were less bothered by the CBC's actions than African Americans. Rather than rebuke the actions of the members of Congress, they chose to support their efforts. In fact, as a show of solidarity, Ghana's president, H. E. Nano Akufo-Addo, commissioned master weavers in his country to create a custom-designed kente sash to honor George Floyd. The sash was sent to the Floyd

family in Houston following his funeral, along with a personal letter from the president and condolences from Africa.

So here's the thing—if Ghanaians weren't otherwise bothered by Congress' so-called misuse of kente cloth, then why should anyone else be?

To better understand and appreciate kente's ties to Black identity and why the cloth is such a hotbed for conversation requires we take a deep dive back in time.

Kente 101

The word "kente" (pronounced ken-tay) comes from the word "kenten," which means basket or handwoven cloth, and is indigenous to the Asante kingdom in what is now Ghana, West Africa—but also neighboring Togo, given the number of Ewe people who settled there in the sixteenth century.

Ghanaian folklore handed down for centuries tells us that a single spider inspired the most intricately woven kente.

It is widely believed in Ghanaian lore that this particular spider's webs were so detailed that they caught the eye of two young weavers from the Bonwire region of Ghana. After spending hours observing the spider's webs, the men were so fascinated by the intricacies of the patterns they adapted the designs as their own, calling them *kente-nwen-ntoma*.

Accurate or romanticized, the legend has been handed down for generations throughout the Ghanaian Bonwire village, where today half the population is still involved in making the cloth.

In life, as in fiction, the intricate pattern was worn during the seventeenth century exclusively by Nana Osei Tutu I, the *asantehene* (king), and represented the soul of the Ashanti. From then on, kente became synonymous with power, prestige, and tradition.

With new kings came redesigns. Even today, some of the most unique kente patterns that could take up to two years or more to weave are created specifically for Ashanti royalty and continue to symbolize power and status.

On the world stage, kente wasn't popularized until 1957, after Ghana's American-educated prime minister led the country to its independence from British rule. Kwame Nkrumah proudly donned full-on kente regalia during his diplomatic meetings abroad. Images of him wearing the colorful toga-like robes generated massive press, including in *Ebony*, the *New York Times*, *Life*, and most notably, *TIME* magazine, which captured a memorable pop culture moment in 1958 when President Eisenhower appeared to be checking out Nkrumah's kente robe with great interest during his White House visit to the US. It's as if

Prime minister of Ghana Kwame Nkrumah (*right*) and Dwight D. Eisenhower (*left*) at the White House in 1958.

he was thinking, *Man, what in the world do you call that?!*

Not long after Kwame Nkrumah assumed the presidency of Ghana in 1960, he began to strip away all vestiges of British colonial rule, calling for unity in fashion, culture, and way of life. This included his order for the nation to detribalize. He declared kente the national dress to be made accessible to everyone in the country who could afford it.

Ghana's Olympic team proudly wore the fabric as part of their uniform at the 1964 Tokyo Olympics opening ceremony. It was pretty impressive!

Left: At the 1964 Olympics opening ceremony, the athletes representing Ghana parade along the tracks, wearing robes the same color as their flag; behind them the public in the terraces watch the ceremony, Tokyo, October 10, 1964.

Right: Two friends, dressed for a church celebration, with James Barnor's car, Accra, Ghana, 1970s.

Throughout the Gold Coast, Ghanaian photojournalist fashion photographer James Barnor—the first to shoot and process images of Ghana in color—captured some of the most stunning photographs of Ghanaians wearing kente in everyday life. He even called himself Lucky Jim because he was always in the right place at the right time to photograph the right people.

Just as Barnor was gaining notoriety, capturing Ghana's cosmopolitan society for the first time in full color, Africa was increasingly on the minds of Black Americans as Marcus Garvey's "Back to Africa" movement had picked up steam. Black scholars, students, political figures, and other intelligentsia that included

Maya Angelou, W. E. B. Du Bois, and Richard Wright, who'd grown weary of the lack of freedom in the US, felt that wearing kente or any other African fabric wasn't enough to show their Black pride and connection to the land of their ancestors. So they chose to answer the Ghanaian president's Pan-Africanist call to return home to reclaim their identity.

This ex-pat movement to Ghana happened long before Stevie Wonder ever thought of relocating there in 1994 and then again in 2021, before eventually gaining his dual citizenship in 2024. In a 2021 interview with Oprah Winfrey, Stevie shared that his desire to spend his remaining years in Africa was based on wanting to reconnect with his ancestral roots and protect his grandchildren from "the racial injustice and prejudice" Black Americans were experiencing.

My desire to visit the home of the kente cloth came in 2007, not for political reasons but to celebrate the country's fiftieth year of independence from colonial rule.

The capital city of Accra was abuzz with locals and visitors from all over the world, including, at that time, the largest contingency of African Americans.

At an open-air marketplace, I spotted an aged master weaver hidden from the foot traffic behind one of the vendor stalls. He was seated at an oversized handmade loom. The pulleys controlling the spools holding the thread were thin but still rugged. I watched as he carefully stretched strands of colorful silk and cotton

American boxing
champion Cassius
Marcellus Clay
(Muhammad Ali),
Ghana, June 3, 1964.

across the loom, tightening each thread with his hands to create the most stunning patterns.

As he mentored another young weaver, the kente master took the time to explain to me how each colorful thread he weaved held different meanings: **BLACK** for maturity and spiritual energy; **BLUE** for harmony, love, and good fortune; **GREEN** for spiritual renewal, prosperity, and spiritual rejuvenation; **GOLD** for wealth, status, and elegance; **GRAY** for healing and cleansing; **WHITE** for purification and healing; **SILVER** for serenity; **RED** for nobility, sacrifice, and struggle; **PURPLE** and **MAROON** for healing and Mother Earth; **YELLOW** for royalty, wealth, spirituality, and fertility.

The loomed four-inch-wide strips would later be stitched together like patchwork to create a complete garment.

Though hundreds of kente patterns exist that anyone can wear, some are still reserved only to be worn by dignitaries and a select few.

Muhammad Ali was part of that select few when he made Ghana the first stop of his highly publicized tour of the continent soon after the country gained its independence. He had only

recently changed his name from Cassius Clay to Muhammad Ali after his conversion to Islam and was all about connecting with his African identity.

During that 1964 visit, President Nkrumah presented the champ with a rare ceremonial kente. It wasn't just any kente pattern, but the Oyokoman design explicitly created for Ashanti royalty. Images of Ali wearing the royal kente made headlines around the world.

Since then, gifting customized kente regalia to world-famous icons and dignitaries became a tradition for Ghanaians, like the cloth given to South African ANC president Nelson Mandela in 1988 and the kente stole he wore during his visit to Harlem's Africa Square in 1990 that was captured in an iconic photo that appeared on the cover of *TIME* magazine.

It mattered little if the recipients of the royal cloths were not of African descent. Need proof? In 1998, President and First Lady Clinton were given an *adweneasa* kente, meaning "my skill is exhausted," suggesting that the weaver used all he had to make the cloth special.

And though he wasn't an official king in the true sense of the word when he embarked on

his 1992 trip to the continent, the King of Pop, Michael Jackson, was ultimately crowned an honorary king of Sani in a West African village near Ghana. The image of his appointment while wearing kente made headlines in America, landing him on the covers of *Ebony* and *Jet* magazines with impressive and rare six- and eight-page coverage respectively.

While in Ghana in 2023 to make a documentary about the Gold Coast, Hollywood heartthrob Idris Elba, whose mom is from Ghana and whose dad is from Sierra Leone, was gifted a kente full-length wrap by the asantehene, Otumfuo Osei Tutu II. Idris looked stunning of course. He shared on a March 2023 episode of *The Late Show with Stephen Colbert* that when greeting the king, it's tradition to expose the shoulder a bit before shaking the king's hand. He teased that it made him nervous thinking, *What if I accidentally drop the cloth? I'd be exposing my boxers.* LOL.

Another high profiler receiving much press for wearing kente cloth during his trip to Africa was the subject of more controversy than conversation on social media before and after he donned the pattern of pride.

The drama began in 2017. Colin Kaepernick, the NFL quarterback who had been summarily canceled for kneeling at NFL games during the National Anthem, had not yet written his children's book about being adopted, so he wasn't sure about his specific ancestral roots. However, he gave us our first hint of his interest in his African lineage when pictures of him wearing K-I-N-T-E, not K-E-N-T-E, on his jersey during a practice game surfaced on social.

The reference, of course, was to Kunta Kinte, the runaway slave in Alex Haley's *Roots*,

Top: President and First Lady Clinton wear kente presented to them by President Rawlings of Ghana, March 3, 1998.

Bottom: Michael Jackson was crowned an honorary king of Sani in a West African village near Ghana in 1992.

Idris Elba at the Manhyia Palace in Kumasi, Ghana, for the Akwasidae Festival.

Free agent quarterback Colin Kaepernick, wearing a Kunta Kinte tee, participates in a workout for NFL football scouts and media in Riverdale, Georgia, November 16, 2019.

inspired by the author's family lineage. Nothing wrong with that, right?

So here's where things got crazy. A 2011 tweet from Colin wishing everyone a "Happy 4th of July" and encouraging all to "Have a nice day" was unearthed after he posted a 2017 Fourth of July tweet with a different tone.

"How can we truly celebrate independence on a day that intentionally robbed our ancestors?"

— COLIN KAEPERNICK, TWITTER, JULY 4, 2017

Three years later, Colin's 2020 Fourth of July Twitter post sparked even more controversy. In it, he urged Black people to reject Fourth of July celebrations of "white supremacy" but instead to look forward to liberation for all. His strong words included a video narrated by James Earl Jones and featured images of the KKK, lynchings, and police brutality.

The loudest reactions to Colin's 2020 tweet were cries of hypocrisy leveled at the free agent claiming that he was all happy and patriotic when he first signed with the San Francisco 49ers but bitter after he failed to get a contract.

So, what really changed Colin's tone?

This: America was increasingly witnessing images of officer-involved killings of unarmed Black men caught on video. It's what first led Colin to protest on the field by kneeling during the National Anthem. But then something else happened.

Through DNA testing, Colin traced his ancestral roots to Ghana and helped expand how he viewed himself and Africa. He was never quite the same, as most Black people who discover their African ancestral lineage can attest. "Knowing where you're from is critical to knowing who you are" remains a mantra of AfricanAncestry.com—the only company that can trace our ancestry back to a specific present-day African country and ethnic group dating back more than five hundred years.

After Colin traveled to Ghana, he urged

other Americans to trace their roots and visit the countries of their origins.

It's unclear how many heeded Colin's message of rejecting celebrations of American independence. However, many African Americans have followed his lead in tracing their roots to Africa—over one million!

I can vouch for how finding the missing pieces of one's identity is a transformative and powerful experience. I used AfricanAncestry.com to trace my maternal roots to the Kru tribe of modern-day Liberia and the Mende of Sierra Leone.

After receiving confirmation of my lineage, I couldn't wait to visit and reconnect with the roots of my people. So I tagged along with actor Isaiah Washington, who had traced his lineage to Sierra Leone and was initiated as a paramount chief. During our life-changing visit to our African homeland in 2008, Isaiah made history, becoming the first African American to receive dual citizenship through positive DNA results.

I memorialized Isaiah and my journey in a documentary I produced called *Isaiah Washington's Passport to Sierra Leone* and in an article I penned for *Ebony* magazine about our trip. The combination of the two led hundreds if not thousands of other Diasporans to not only trace their African ancestry but to look to secure dual citizenship in Sierra Leone, Nigeria, and, more frequently, Ghana.

Take a guess at what many Black Americans who received dual citizenship in Ghana chose to wear for the ceremonies.

That's right, kente!

Ex-pat family receiving citizenship in Ghana.

Sojourns to Africa by so many families and high-profile Black people who participated in the Year of Return initiative to Ghana helped draw attention to the country and its national kente cloth.

Still, the country's most high-profile visitor, Barack Obama, gave Ghana and its cloth traditions their most significant popularity boost when he traveled there in the summer of 2009—his first trip to the continent since he was elected as the first Black president of the US.

During his highly publicized visit, President Obama was met with the usual pomp and circumstance deserving of any US dignitary.

Traditional kente was everywhere.

But what was most notable for this US president was that the Ghanaians designed a rare commemorative kente cloth that would honor his American and Kenyan heritage—made available to anyone lucky enough to get their hands on the limited-edition fabric.

Commemorative cloths presented by governments to foreign dignitaries were especially common in sub-Saharan African countries. But none has been more cherished than the "Obama Cloth."

The Obama Commemorative Cloth

The kente-inspired design using the colors of the US flag—red, white, and blue—featured President Obama's portrait and the word "Akwaaba," meaning "welcome."

Important cultural symbols like the "Gye Nyame," from the Adinkra, which means "except for God," and Ashanti stools representing tradition and authority were also a part of the design.

I couldn't be in Ghana for President Obama's homecoming, so I sent a TV crew from the Africa Channel network that I helped launch in the US to cover his historic visit and nab me one of the cloths.

That commemorative African kente cloth is still one of my greatest treasures. When I first received it, people asked, "What are you going to do with it?"

"Save it. Treasure it. Frame it," I said.

Initially, I thought everyone fortunate enough to own that piece of Afrocentric pop culture history would do the same.

WRONG!

Best known for playing Drucilla Winters on the popular *The Young and the Restless* soap opera and as a cast member on the TV drama *Diagnosis Murder*, Victoria Rowell made an extremely bold fashion statement at the 2009 Emmy Awards when she stepped onto the red carpet wearing her custom-designed "Obama Dress." It didn't take long for Twitter fingers and the Black pop blogosphere to weigh in.

"Good sentiment, bad execution."

"Tacky."

"Foolish."

While no law says you can't create a wearable garment from a commemorative cloth, the actress had no idea that doing so would ruffle so many feathers.

Victoria later revealed to the press that she had planned to wear a completely different dress to the Emmys, but then three things weighed into her decision to make a fashion statement.

First off—that year's Emmy Awards took place when Congress was in a tug-of-war over Obamacare. The dress was meant to stress the need for healthcare for all, especially for indigent and low-income Americans.

Secondly, Victoria wore the dress to raise awareness about youth in foster care, where she was placed for eighteen years.

Speaking to *Jet* about her Rowell Foster Children's Positive Plan, she explained, "I do this because 600,000 foster children depend on it." By 2020, Black children continued to be disproportionately represented in foster care relative to the general population, according to a report by datacenter.kidscount.org.

Lastly, Victoria wanted to address the lack of inclusion for minorities in soap operas in daytime drama television. This long, hard fight had her filing a lawsuit in 2015 against CBS, Sony, and *The Young and the Restless* producers, alleging racial discrimination retaliation. The case was settled in 2017.

Kente Mania

Once kente fabric became mass-produced without actual looms, making the cloth more affordable, accessible, and commonplace, especially in the US, we went a little crazy

Howard University 2018 grads Milán Benn, Alicia Frierson, Nayo Campbell, and Kyra Young wearing kente.

with it. The pattern showed up on just about everything we owned—sneakers, backpacks, tablecloths—and not just for Black History Month or Kwanzaa—anytime and all the time!

It got so insane that internet satirist Sari Charley created an online video called "Add Some Kente," mocking how we'd taken wearing and using the fabric to the extreme.

I found the sketch that featured a Lamborghini draped in kente cloth and an image of Rambo wearing a kente sash that held his bullets—too funny! Especially when paired with lyrics suggesting we add some kente to our "Lambo" and "Rambo."

Of course, the Sari Charley vid was all in fun, but it's never a laughing matter whenever kente is used as a weapon to discriminate.

Kente Showdown

In 1992, kente made national headlines when a white judge ordered a Black lawyer to remove his kente cloth stole because it supposedly sent "hidden messages to jurors" during court proceedings where the attorney was representing a Black man accused of assault with intent to murder.

Lawyer John T. Harvey III's kente stole wasn't huge—only about sixty inches long, which he respectfully wore over his neatly tailored suit in the courtroom. Yet the DC Superior Court judge claimed the emblem of West African royalty and Black pride might "unduly influence jurors' cultural sensitivities," asking him to remove it or be slapped with a contempt charge and barred from the case.

Harvey refused to remove the stole, calling the judge's order an insult to Black people nationwide. He turned to the DC Court of Appeals to reverse the order, citing that it was his right to wear what he pleased—particularly a garment that held religious and cultural significance.

> **"An Orthodox Jew wears a yarmulke, an Indian wears a turban, and according to the case law, they can appear before this judge. What is the difference between a yarmulke or a turban and my stole?"**
>
> —JOHN T. HARVEY III, *THE NEW YORK TIMES*, JUNE 19, 1992

Harvey lost the fight, but he struck a chord for Black lawyers by helping to advance the conversation about where personal freedoms collide with court procedures.

Since the 1980s, Black students who wanted to honor their educational achievements and their African heritage have chosen to wear kente over their robes during commencement exercises. They took their lead from the great Pan-African scholar, W. E. B. Du Bois, who started the tradition in 1963 when he was photographed wearing a kente sash draped over his robe as he accepted his honorary degree from the University of Ghana.

Despite the long-standing trend for wearing kente at graduations, there've been several stories of young Black students being denied the right to graduate because they chose to wear the cultural pattern of pride. Among the most viral was that of eighteen-year-old high schooler Nyree Holmes. Wearing kente over his graduation robe got Nyree escorted out of the ceremonies by not one but three deputies. He posted the whole ordeal on his Twitter and Facebook pages, later explaining to the *Black Star* newspaper, "I wanted to wear my kente cloth as a representation of my pride in my ancestors. To display my cultural and religious heritage."

After Nyree's story blew up online, the Sacramento school he attended ultimately issued him an apology after speaking with his parents, and Nyree eventually did walk across the stage and receive his diploma.

While kente may be the most well-known and celebrated of the symbolic African textiles that African Americans have donned to show their pride during graduations, church services, weddings, and the whole nine—the ones we wear today are not generally produced on a loom. More often than not, they aren't even manufactured in Africa. This goes for kente and most other African patterns of pride.

Made in Africa?

When an African pattern is not handwoven or sun dyed and dried under the beating rays of the African sun, it's more likely a wax print that's been mass-produced in Asia. These wax prints are what we see the most in today's African styles.

So, here's the obvious question: Does wearing an imitation African print created outside of

W. E. B. Du Bois wore kente in 1963 to receive an honorary doctorate from the University of Ghana.

Actress Brandee Evans gets ready for the fifty-second NAACP Image Awards in Los Angeles on March 27, 2021.

Naturi Naughton at the 2015 BET Awards press room at the Microsoft Theater in Los Angeles on June 28, 2015.

Africa in a factory give us the same sense of African identity?

Truthfully, many don't even realize the African prints are not authentically from Africa, and those who do don't really care.

In the book *African Textiles and the Politics of Diasporic Identity-Making*, essayist Boatema Boateng shared the story of an Illinois-based vendor of Afrocentric goods who reported that some of her clients refused to buy kente cloth that's been authentically handwoven on a loom. They are so used to buying the wax prints they slam the genuine kente, claiming *it's* not the real deal. Go figure!

Aside from the reality that factory-produced imitations impact the business of traditional weavers, African Americans feel just as much Afrocentric pride wearing the mass-produced, more affordable wax prints as they would any other that are handwoven.

Besides, it's the wax prints that give us some of the most fabulous red carpet looks.

There was Beyoncé's to-die-for African print pantsuit she wore in 2019 to the UTA Artist Space in Beverly Hills. And who can forget when Brandee Evans upped her glam game by wearing a custom Albert Montris gown to the 2021 NAACP Awards? Simply STUNNING!

There are several companies in the textile marketplace distributing the bulk of machine-woven imitation African fabrics. Still, Dutch luxury company Vlisco is credited with popularizing the wax-printing process long before the trend exploded across Africa and over into China and Indonesia.

Vlisco founder Pieter Fentener van Vlissingen took no credit for creating the African designs in his wax prints, just improving the printing process of the batiks to create that shiny look on our African prints.

The company's most popular wax print is called Angelina—a design and fabric many of us have in our wardrobes today—inspired by the pattern on a nineteenth-century Ethiopian noblewoman's tunic.

In 2015, East Orange, New Jersey, teen Kyemah McEntyre, who fell in love with the Angelina print, wowed us when she posted a picture of her prom dress created with the fabric on Instagram.

We went nuts!

Celebs, from the likes of Nicki Minaj to

Mable and Jason Benning, New Breed Factory, Grand Street, Brooklyn.

Sanaa Lathan, retweeted the dress to their millions of followers. *Essence*, *Elle*, the *New York Times*, and *Teen Vogue* gave Kyemah some serious PR, setting off a trend of Afrocentric prom dresses.

Her "Prom Slayer Dress" eventually found its way into a touring museum exhibit called *African-Print Fashion Now! A Story of Taste, Globalization, and Style*.

Kyemah's second creation was a gown commissioned by actress Naturi Naughton that got even more love when the *Power* actress wore it to the 2015 BET Awards.

A version of that traditional Angelina pattern used by Kyemah to make modern designs first became popular in the US in the 1970s, when a

AUG · 67

Left: Mable Benning holding the very first dashiki made for New Breed.

Right: Jason Benning and others outside of the New Breed Factory on Grand Street in Brooklyn.

Brooklyn-based couple created a garment that later became an iconic and lasting symbol of Blackness, pop culture, and politics.

The Dashiki

Garments that resembled what we know today as dashikis (pronounced duh-shee-keys) had been worn as far back as the twelfth and thirteenth centuries by Nigeria's Hausa and Yoruba tribes. The garments, essentially tunics, were loose fitting, making it easier to endure the intense rays of the West African sun.

In the US, two years after we'd lost Malcolm X and race relations were at an all-time low, Jason Benning and his wife, Mable, were looking for opportunities to show pride in their Blackness beyond just wearing their hair natural or raising a Black Power fist. They liked the design of the African tunics but wanted to Westernize them with some Afrocentric flair.

So, from inside their modest Brooklyn apartment, they devised a plan. They would pattern their design after the traditional tunic but use African textiles. They scooped the neckline and added deep pockets below the waistline, then voila! The modern-day classic dashiki was born!

After teaming with Milton Clarke, William Smith, and Howard Davis, Jason and Mable mass-produced the dashikis under the New Breed Clothing, Ltd., label—a company by us, for us—pumping out the garment en masse.

The Bennings' marketing strategy for moving the garments into the community was simple: Position them to symbolize positive messages about Black culture, history, and politics.

Their plan worked. Sales were robust.

Over time, the dashiki became the dress of the struggle and a pop-cultural fashion garment for even the most passive Black activist looking to show pride in their African roots.

It was not unusual to see Stevie Wonder, Dick Gregory in the seventies, Queen Latifah, A Tribe Called Quest in the eighties, and Beyoncé in the 2000s wearing dashikis to express their

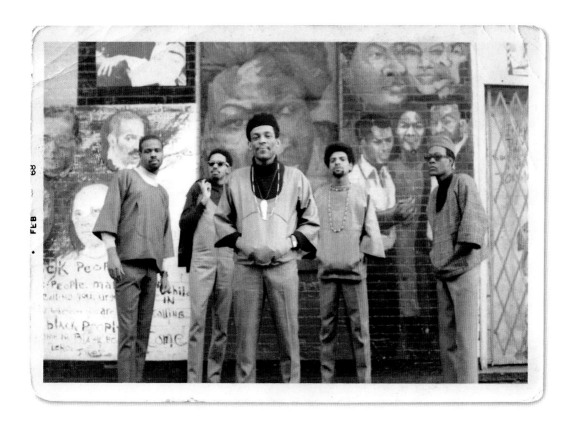

Afrocentric style. Even I had one. Yeeesss! That sixties style was meant to stay.

Like kente, Ankara textiles, mudcloth, and other African textiles, that same Angelina print has increasingly proved to be a source of inspiration for haute couture African designers in the new millennium, who create looks for their more Afrocentric-minded clients.

We can thank Michelle Obama for introducing us to many of these trendsetting creatives like Maki Oh, Mimi Plange, Duro Olowu, and Osei Duro. The First Lady was caught on camera multiple times wearing their African-inspired fashions.

Janet Jackson wowed us wearing her stunning African-inspired look commissioned from Cameroonian designer Claude Lavie Kameni for her 2018 "Made for Now" music video featuring Daddy Yankee. Solange Knowles is also a frequent wearer of African print designs on red carpets, on the streets, and onstage—designed mostly by Africans.

The sudden exposure of this savvy next generation of designers from Africa and the Diaspora grew primarily due to the popularity of international fashion weeks.

What used to be the "Big Four" shows coming out of London, Milan, New York, and Paris sparked the emergence of must-attend African fashion weeks in Lagos, Johannesburg, Dakar, Ghana—and it's still growing. Absent from most of these African fashion week presentations were clichéd safari and animal print themes. Thank God! However, in 2018, New York Fashion Week (NYFW)—the fashion industry's most prominent platform—had a heavy African native vibe going on.

Welcome to Wakanda

Like the rest of the world, the powers that be at NYFW had no idea that the fashion-savvy action film *Black Panther* would be the blockbuster hit it became when it scheduled Disney's and Marvel Studio's Welcome to Wakanda runway show to kick off its second week of events.

Models pose during the Marvel *Black Panther* fashion week celebration, Welcome to Wakanda, at Industria in New York on February 12, 2018.

In case you've been under a rock and know nothing about the blockbuster film directed by Ryan Coogler, here goes: The storyline follows T'Challa (played brilliantly by Chadwick Boseman) as he returns home to the African nation of Wakanda to take his rightful place as king after the death of his father. Almost immediately, he's drawn into conflict as tribes jockey for control over the nation's future. T'Challa is tasked with defeating his foes and leading his people to safety. Like the film that featured an all-Black cast and the most impressive Afrofuturistic costumes, the Welcome to Wakanda fashion presentation featured all-Black models wearing jaw-dropping fashions from famed designers Cushnie et Ochs, TOME, Sophie Theallet, Chromat, Brother Vellies, Ikiré Jones, and LaQuan Smith.

Each designer borrowed a page from legendary *Black Panther* costume designer Ruth Carter when they created runway looks that melded African tradition and empowerment into contemporary high fashions. So it's no surprise

that Welcome to Wakanda would be as much about paying homage to Carter as promoting the long-awaited film.

To her credit, Carter, who got her first Hollywood break designing streetwear for Spike Lee's *School Daze* in 1988, has designed costumes for Hollywood's most iconic films oozing with Afrocentric themes. They all celebrate Black pride, power, and history. Among them—*Selma*, *Roots*, *Coming to America*, and *Amistad*. In fact, of her forty-plus costume credits in film, more than ten were on Spike Lee joints, including *Do the Right Thing*, *Jungle Fever*, *Mo' Better Blues*, *Chi-Raq*, and *Malcolm X*, where she became the first African American to receive an Oscar nomination for costume design. She designed for a slew of other real-life superheroes, including Rev. Dr. Martin Luther King Jr., Coretta Scott King (*Selma*), and Tina Turner ("What's Love Got to Do with It?"). There was *B.A.P.S.* with costumes that were so over the top the movie became a cult classic, *The Five Heartbeats*, *The Meteor Man*, *Sparkle*,

Ruth E. Carter *Black Panther* exhibit, Art of Motion Picture Costume Design exhibition at the Fashion Institute of Design and Merchandising Museum, Los Angeles, 2019.

Baby Boy, and *How Stella Got Her Groove Back*, which featured more than sixty costume changes for Angela Bassett as Stella. And who can forget the goldfish shoes and Fly Guy's pimp costume in *I'm Gonna Git You Sucka*?

A true shero in her field, Carter was honored with a dozen or more exhibits throughout the US, showcasing her work and contributions to cinema, with her African-inspired *Black Panther* costumes always taking center stage.

Ruth Carter didn't just design the costumes for *Black Panther* from imagination or rely on stale stereotypes. She did her homework—traveling to more than twenty African countries, where she had a chance to observe the culture, dress, and traditions of various African ethnic tribes.

Myself an African globe-trotter, I could easily spot the influence of the Zulu and Xhosa tribes (South Africa), the Maasai (Kenya and Tanzania), the Ewe and Ashanti (Ghana), and the Yoruba (Nigeria). The robes, neck rings, hats, and accessories were authentically African but futuristic. Always elegant. Classy. Afrocentric.

In a 2023 interview with *Variety*, Carter revealed that the Dora Milaje (pronounced "DOR-ah muh-LAH-jay") costumes were the most expensive she'd ever made. The early prototypes didn't seem authentic enough.

"It needed to have strength, beauty and power," she said.

So she used the back skirts worn by the women of the Himba tribe for her influence.

Like the Himba, Carter soaked the skins and hides used in the leather skirts to "solidify the beauty, origin and purpose of the Dora Milaje costumes." Then she incorporated real African beads on the front. Her task was not only authenticity but to make each costume stunt-worthy, which required special molding and painting to look like the original elements used.

Looking at all of Carter's impeccable *Black Panther* designs, one might swear Wakanda existed. And that is precisely why she earned an Academy Award in 2019 for Best Costume Design—the first awarded to a costume designer of color.

> ## "The costumes collectively reflect the voice of the African Diaspora and how African Americans feel about their heritage."
>
> —RUTH E. CARTER, *HARPER'S BAZAAR*, FEBRUARY 2019

Then in 2023—drum roll, please—Carter earned her second Academy Award for costume design for the *Black Panther* sequel, *Wakanda Forever*, making her the first Black woman to win two of Hollywood's highest honors in any category. And not long after that, she became the second-ever costume designer to receive a star on the Hollywood Walk of Fame.

Her award-winning fashions, coupled with the overall excitement for both *Black Panther* films and their representation of Black culture, had a major influence on moviegoers worldwide, who showed up for *Black Panther*'s opening weekend dressed from head to toe in their African bests. Ready to slay, they donned authentic kente, Ankara, dashikis, tribal face paint, vibrant wax prints, tribal shirts, tees with Wakanda Forever lettering, and all manner of African attire. They then posted the images all over social media with the hashtag #WakandaCameToSlay!

Actress Janeshia Adams-Ginyard—who portrayed Nomble, one of the Dora Milaje in the *Black Panther* franchise—used her red carpet opportunity for *Wakanda Forever* to not only promote the Wakanda culture and fashion style but also pay tribute to the late actor Chadwick Boseman who brilliantly played T'Challa in the original *Black Panther* film.

Judging from how the fashion-forward *Black Panther* and its sequel transformed how we feel about Black pride, it proves that Afrocentric style will continue to thrive just like Wakanda. FOREVER.

Ruth Carter, winner of the Best Costume Design Award for *Black Panther* at the ninety-first Academy Awards (Oscars) presented by the Academy of Motion Picture Arts and Sciences, Hollywood, February 24, 2019.

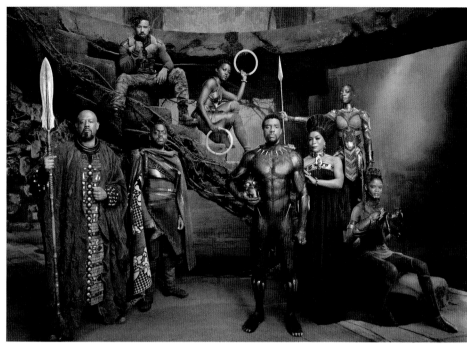

Top: Black Panther cast shot from the 2017 *"Black Panther* Preview: A Look Inside," *EW's* Comic-Con issue.

Bottom right: Actress Janeshia Adams-Ginyard, attends the premiere of Marvel's *Black Panther: Wakanda Forever* at the Dolby Theatre in Los Angeles, October 26, 2022.

Bottom left: Poster art from *Black Panther: Wakanda Forever.*

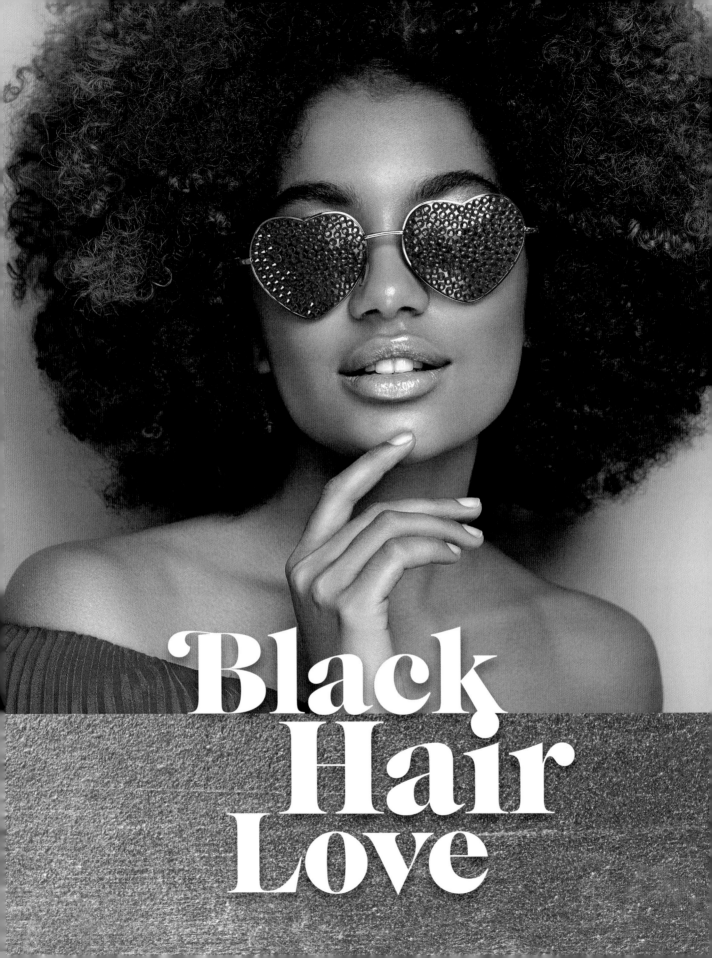

For decades, conversations swirling around hair—especially for Black women—have morphed from personal to political and, at times, have gotten outright outrageous.

Get a silk press—you're a *sellout*. Go natural? You're a *nappy-headed* (fill in the blank). Wear dreadlocks? You're told they smell like *patchouli oil and weed*. Oh yes! *Fashion Police* red carpet host Giuliana Rancic said it of Zendaya in 2015. These cruel and crazy notions have fueled the age-old dichotomy of good hair versus bad for more than a few decades. Sure, we can write them off as frivolous talk. But, in truth, these cruel and unfettered rants play with our psyche, contributing to our feelings of self-hate and self-love. They lead us to question our identities and shake the self-esteem of our already impressionable Black kids.

Who's the judge of an appropriate look for our hair anyway? The workplace? Schools? The military? Why is it that during an era where personal choice is an inalienable right, our Black hair—an extension of Black identity—is still such a touchy topic? Is that *natural*? To quote

Roberta Flack and Donny Hathaway, "Where Is the Love?"

Routinely, pop culture has played a major role in helping us love our crowns, dialogue about the controversies related to our hairstyle choices, and embrace our natural hair stories. At the top of my list is one "touching" moment that captured hearts everywhere and still makes my heart melt every time I see it. You know it! It's that cuteness-on-steroids image of five-year-old Jacob Philadelphia touching the hair of our forty-fourth president.

C'mon. If anybody other than a young Black boy asked a sitting Black president, "Can I touch it?" we would've said, "*What??!!*"

Jacob just had to *touch it* on his visit to the Oval Office in 2009 with his mom, brother, and father, former marine Carlton Philadelphia—who left his post on the National Security Council after two years. When Carlton asked

President Obama bends over so the son of a White House staff member can pat his head during a family visit to the Oval Office, May 8, 2009.

his son if he had a question for the president, Jacob didn't ask, "Why did you want to become president?" "What do you really do?" or "Can I have your autograph?" Instead, in a low, hushed, innocent tone, he said, "I want to know if your hair is like mine."

Since the Jim Crow era, Black folks have been sensitive about people patting our heads. But our supercool president and Dad-in-Chief invited Jacob to touch it to see for himself.

At first, Jacob hesitated. So President Obama lowered his head.

"Touch it, dude!" the president insisted. Jacob did.

Not even staff photographer Pete Souza saw that move coming, which explains why the

framing in the picture is so wacky, with Carlton's head partially out of frame.

Young Jacob confirmed with satisfaction, "Yes, it does feel the same."

The image of that single moment in the annals of pop culture history is still considered by the highest office in the land as one of the most iconic and beloved coming out of the White House. For the rest of us—it was a testament to the power of representation and a symbolic hope for the future.

Throughout President Obama's eight years in the White House, we witnessed his hair get grayer as the job became more intense. No surprise there. Otherwise, he made no drastic changes to his look. No 'fro like he sported

Obama White House family portrait.

during his college days. No shaved head. Just a clean-cut, respectable style that undoubtedly helped him be accepted by middle America—not that he should've needed to prove himself.

On the other hand, the women in the First Family had significant hair challenges during their eight years in the White House: Go natural or bone-straight?

Comedian Paul Mooney's words were right as far as the White House ladies were concerned.

The First Lady and Daughters—the most visible Black females in the country for nearly a decade—wore their hair straight during their time in the White House, primarily to fit the mold of what a First Family has traditionally looked like throughout history. Translation: make it more palatable for white communities. Can you imagine if they had gone natural during Obama's first presidential campaign? Do you really think he would have won had the First Lady worn her hair in braids, coils, or naturally curly?

"If your hair is relaxed, white people are relaxed. If your hair is nappy, they are not happy."

—COMEDIAN PAUL MOONEY, *GOOD HAIR* (2009)

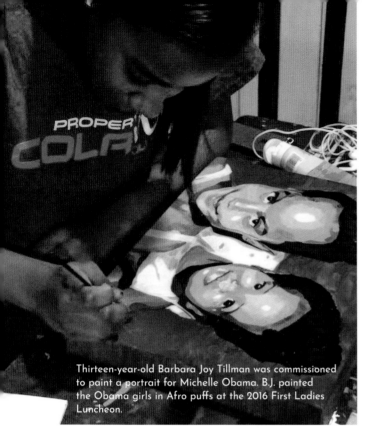

Thirteen-year-old Barbara Joy Tillman was commissioned to paint a portrait for Michelle Obama. B.J. painted the Obama girls in Afro puffs at the 2016 First Ladies Luncheon.

"He would not have won. It's true. It's sad and seems shallow, but it's true."

–CHIMAMANDA NGOZI ADICHIE, YOUTUBE INTERVIEW (2014)

I tend to agree with author Chimamanda.

Not surprisingly, FLOTUS's choice to play it straight didn't sit well with many sistas who criticized her for not fully accepting who she is. She got ragged on social media for her straight hair choices, with calls for her to step up and wear her natural hair as a role model for Black girls who need to learn to be true to themselves. Googling the topic of her straight hair during her time in the White House, I found a ton of comments, many on the verge of being disrespectful. I wondered, "Why can't they let our First Lady and her girls wear their hair the way they want, whenever they want?"

Thirteen-year-old Barbara Joy (B.J.) Tillman didn't need to see Sasha and Malia Obama with their natural hair. She required only her imagination.

When commissioned to paint a picture as a gift to First Lady Obama on her birthday, B.J. painted Afro puffs on Sasha and Malia to show how much they were like herself and other Black girls.

Truth be told, there were many times that Michelle, Malia, and Sasha revealed their natural hair texture in the public eye. They wore twists, buns, and coils and were unashamed and unapologetic.

But then, of course, when Malia sported natural twists on a trip to Rome, vicious right-wingers with an agenda were swift to call her "ghetto trash" and "unfit to represent America." But who takes them seriously anyway? On the flip side—the first time a snap of Michelle stepping off Air Force One from vacation wearing a ponytail in its natural textured glory hit social media, it went viral with nearly one hundred thousand tweets and over thirty thousand retweets. One fan wrote, "Seeing Michelle Obama's natural hair is life-changing."

In an April 2017 interview, Michelle's hairstylist spilled the beans that the First Lady went natural on that one photo because she had gotten her hair wet and so came the natural curls. Been there, done that! A lot of Black women can testify to having experienced that same story. I recall reading how Oprah told her trainer ahead of a marathon that she couldn't run one day because it was raining, and he couldn't understand what one thing had to do with the other.

In a May 2011 *Vogue* interview, Oprah said, "I cannot get my hair wet. What's wrong with you, white boy?!" What's hilarious is that she went on

to explain to him that if she were to run in the rain, her hair would "turn to stone!" LOL!

As the Obama ladies were trying to balance conforming for the benefit of the public eye yet being more themselves in their free time, the president had no idea the enormous pressure they had in grooming their hair over the course of the eight years they were in the White House. In a 2016 interview with Misty Copeland for *Glamour* magazine, he shared how it wasn't until he left office that, for the first time, he could appreciate their struggles.

"That pressure, I think historically, has always been harder on African American women than just about any other women," he said. "But it's part and parcel of a broader way in which we socialize and press women to constantly doubt themselves or define themselves in terms of a certain appearance."

Amen to that, Mr. President!

For her fifty-seventh birthday, on January 17, 2021, Michelle Obama racked up millions of likes within minutes for the black-and-white selfie she posted—free of makeup on her face and free of product in her naturally curly hair that filled the frame. Now, out of the White House, she wears her natural hair however she pleases.

As much as I applaud her for going natural, I still haven't been able to grasp fully what is so bad about Black women wearing their hair straight.

Give It to Me Straight?

Wearing my naturally kinky hair straight meant A LOT to me growing up. When my mom used to sit me between her knees to press it, I'd squirm the whole time because I was tender headed, and all her tugging would hurt my scalp.

It seemed she took forever to press through every tangle with her heavy metal hot comb

First Lady Michelle Obama brushes beach sand out of her daughter Malia's hair as younger daughter Sasha and White House staffers look on during a stop to pick up a take-out lunch of fried seafood at Nancy's Restaurant in Oak Bluffs, Massachusetts, on the island of Martha's Vineyard, August 26, 2009.

Whoopi Goldberg as a young Black girl in her self-titled one-woman show at the Lyceum Theatre, 1984.

that she heated on the stovetop. That putrid smell of burnt hair filled the kitchen.

Like a lot of kids in my day, I couldn't get a relaxer or any other chemical products on my hair until after I graduated from high school. It had something to do with growing up too fast. So, until then, only a hot comb could make it look silky.

My mom didn't buy into the false assumption that white is right and Black hair is bad. She pressed it because that's what parents did to make it easy for themselves to comb every day. Yet I must admit that for much of my childhood, I did want it to be flowy and long like I saw on women in magazines and the movies. Even on TV, they'd toss it around and twirl it. Did I want

wake up from her "black ugly dream, and my real hair, which was long and blond, would take the place of the kinky mass that Momma wouldn't let me straighten." But that was a different time too. Dr. Angelou later confirmed that while "kinky" may be synonymous with being Black, it's not synonymous with "ugly." Still, her point about being a Black girl wanting long, blond, straight hair to feel beautiful can't be ignored.

In the mideighties, Whoopi Goldberg used her stage act to find humor in that same sad commentary of how we struggled with standards of white beauty.

In 1984 she came out with her one-woman Broadway show *Whoopi Goldberg*, which

Whoopi played a seven- or nine-year-old who wears a white shirt on her head, pretending it's her "long luxurious blond hair."

to be white? No! I just wanted my hair long and straight. But don't judge me. I was just a kid, and it was a very different time—long before Moesha's braids and Thelma Evans's curly 'fro—before we had any substantial representation of Black girl hair on TV.

Millennials and Gen Zers today may have difficulty relating, but having that long, straight hair is all a lot of us fantasized about back in the day. It was a familiar narrative even among those you'd least suspect.

In her groundbreaking autobiography *I Know Why the Caged Bird Sings*, the unabashedly pro-Black Maya Angelou wrote about growing up in the thirties, hoping one day that she would

included a monologue where she acted out onstage what many of us girls did in private.

The first time I saw a clip of it, I was like, "You too?! I was that little girl!"

Whoopi played a seven- or nine-year-old who wears a white shirt on her head, pretending it's her "long luxurious blond hair."

"Ain't it pretty?" she asks the audience.

She starts swaying back and forth to show how it flows and even gets it in her eyes. Then she tells the other things she'll do to be white and find happiness, like putting Clorox on her skin. But her mother tells her that changing her hair and skin color won't change her identity. To further the point, her mom says, "Baby, if you

sittin' in a vat of Clorox till hell freezes over, you ain't gonna be nothing but Black."

Of course, as an adult, Whoopi eventually accepts her dreadlocked hair even if it doesn't "cas-sca-sca-dade down her back" or "blow helplessly in the wind."

In my case, I didn't want a white towel or blond hair. I was proud of my Blackness even at a young age. I didn't mind my hair being kinky; I just wanted it long. So, I used dark towels and shirts on my head to give the same long hair illusion.

I've never believed that a Black woman choosing to wear her naturally kinky hair straight automatically meant she had no sense of self-worth or was bowing to European standards. A lot of Black women like me enjoy mixing up our style. It's called preference. So we shouldn't be shamed or accused of racial treason for choosing to wear our hair straight— even when it's not our hair.

Un-Beweaveable

I'll never forget when I executive produced an interview on the Africa Channel with the legendary South African jazz musician Hugh Masekela. This larger-than-life musician and activist was a huge get for our fledgling network. He'd been performing for over six decades with a string of hits, including his Number 1 *Billboard* song, "Grazing in the Grass," which got him worldwide attention and praise. He collaborated with artists ranging from Harry Belafonte to Paul Simon. The man was an icon, and I was honored to be in his presence.

After the interview, my videographer asked me to pose for a snap with the music legend and the host who conducted the interview.

"My pleasure!" I said.

As I got up to position myself for the photo, Hugh started gazing at my head. Then his eyes met mine before looking again at my head. He frowned.

"Is that a weave?" he asked.

Wait. What?! Seriously?

"Are you wearing a weave?"

I sat on his words for a moment until I could fully absorb what he dared to ask. Then I did what I still do best. Avoid the question.

At the time, I didn't know he'd previously been vocal about his strong opinions of Black women wearing weaves.

While receiving an honorary doctorate in South Africa a few months earlier, Hugh shared his general disdain for the "dwindling sense of heritage among weave-wearing women." He lectured the students on how wearing our Black hair any way other than natural rejected African traditions—even going so far as to refuse to have his picture taken with the student weave wearers.

I understood his point on one level, but on another level, I didn't and still don't agree that weaving, perming, curling, or wearing our hair in any way other than its natural form means turning our back on our culture.

Besides, wasn't there a little presupposition on his part when he assumed that a sista with long hair was wearing a wig? Hmmm. Why couldn't it have been my hair?

He took the picture with me despite his doubts. But since I never gave him an answer about whether I was wearing a weave, he put the host between us, just in case. LOL.

What's crazy is a decade has passed since that interview, and Black women are still getting slammed for wearing straight hair weaves and wigs.

Getting Wiggy with It

As far back as 3000 BC, it was a status symbol for the elite to wear wigs. In Egypt, the more elaborate the wig, the more wealth and prestige you had. People who wore wigs were shown the highest degree of respect.

My, my, my—how times have changed!

In Afro pop culture, it's hard to ignore the unfortunate negative remarks made by Fox News commentator Bill O'Reilly back in 2017, stating on live TV that California representative Maxine Waters (D-CA) was wearing a "James Brown wig" when she made her anti-Trump comment on the House floor. The comment was rude, unnecessary, and racist.

Even though he apologized—but only after the backlash—the congresswoman brushed off his comments and went about her business, stating on MSNBC's *All In with Chris Hayes*, "I cannot be intimidated. I cannot be undermined. I cannot be thought to be afraid of Bill O'Reilly or anybody." And that was the end of that!

Despite the tragedy of that moment, I like that Black pop culture has given us a plethora of meme-able wig moments we didn't see coming that made us loud and proud or at least smile, like when a *RuPaul's Drag Race* winner stripped off her wig onstage in the middle of the competition or when Cardi B threw her wig into the crowd of fans while in concert.

In 2023, to coincide with Juneteenth, North Carolina news reporter Akilah Davis made national headlines leading off her news segment wearing a wig and then removing it by the end of the segment to reveal her sister locs. You go Girrrrl!

For ten years, she'd been braiding her hair every morning and putting a wig on top of it to appear "presentable" for her viewers. The routine was emotional and exhausting until the day she gave her declaration of freedom on air.

> **"Moving forward, this is how you'll see me on TV, and I'm hoping to inspire women and little girls struggling to embrace their roots. . . . I see you, sis, and I'm with you."**
>
> —AKILAH DAVIS, *PEOPLE*, JUNE 22, 2023

And who can forget Will Smith's date in an episode of *The Fresh Prince of Bel-Air*? After she shed her wig, Will asked her, "Now, what else on your body can I get at the mall?" Hilarious!

The wigs being yanked off in public today are nothing like those in my mom's day. Modern-day wigs are more stylish and durable and look amazingly natural, as if the hair was growing from our natural roots. What hasn't changed, though, is the notion that once a sista snatches her wig off, she's ready to take care of business!

Take, for instance, our girl Sha'Carri Richardson—the young track phenom known for wearing vibrant colored wigs during competition, like the one she wore for the 2023 Track and Field Championships in Oregon. Her wig color for that day was orange. Really bright orange. She had it tied in a stylish ponytail as she prepped on the track for the race, just seconds away from putting her feet

Black Panther (2018), directed by Ryan Coogler. *Left to right:* Lupita Nyong'o (as Nakia), Chadwick Boseman (as T'Challa/Black Panther), and Danai Gurira (as Okoye).

in the starting blocks, then suddenly—BAH BAM! She snatched it off and tossed it on the track. Sha'Carri was ready for business! And guess what? She won the national title that day and gained the support of a slew of fans who applauded her victory and her hair reveal on social media once the video went viral.

In the blockbuster superhero film *Black Panther*, none of the characters had straightened or processed hair. Zero. Zilch. Nada. It was all kinky, curly, shaved, covered, or nonexistent, and they didn't wear weaves or wigs—except once.

In one unforgettable scene, Okoye is asked by T'Challa to travel with him to South Korea. Their mission? To reclaim a stolen artifact before it gets sold on the black market. The two, along with Nakia, who has joined them, must wear disguises so as not to draw attention to themselves as members of the Wakandan elite. That meant a wig for Okoye, who hated the notion of covering up her shaved head.

"What's this?" she asked. "I don't wear wigs. I wear my bald glory."

Since the wig was meant to be part of her disguise, Okoye eventually consented—looking about as comfortable in it as a Black person at a Klan rally.

At one point, when things got ugly, and it looked as though T'Challa and Nakia were in danger, Okoye went into warrior mode. First, she ripped off the wig to regain her identity, then used it as a weapon to hurl her assailant off the balcony.

How often have we seen that for real in a street or schoolyard fight, where the wig wearer appears to get superhuman strength and warrior confidence after snatching their wig off their head?

Could it be that Okoye snatching off the wig was not only to throw the bad guy off-balance but also to serve as a metaphor for stripping away the world's ideas of beauty? Let that soak in for a minute.

That *Black Panther* wig moment was dramatic enough to inspire a Funko Pop collectible figure patterned after Okoye in the scene, complete with removable hair.

How to Get Away with Murder producer Shonda Rhimes took sistas wearing wigs to a whole other level. She attached purpose to the act in what has become one of TV's greatest Black Girl Magic moments.

In the fourth episode of the series, Annalise Keating, a Black, brilliant, cutthroat defense attorney and law professor at a prestigious Philadelphia law school, literally lets her hair down before confronting her husband for his alleged affair with a white undergrad.

Viola Davis, in the starring role—where she made history as the first Black woman to win the Emmy Award for Outstanding Lead Actress in a Drama Series—played the stand-out scene just right. Like we do—she sat in front of the mirror in her dimly lit bedroom, going through her nightly routine. She removed her makeup and eyelashes, lathered her face and hands, and carefully placed her straight-haired wig on the table.

Also, as we do—Annalise spent a minute touching the texture of her kinky natural hair while gazing in the mirror as if to say, "THIS is who I really am," no doubt prepping herself for battle.

When her husband, Sam, enters the room, he sees his wife wearing a silky robe. She looks relaxed, even glowing at first. But before Sam has a chance to speak, the forensic professor outright asks, "Why is your penis on a dead girl's phone?"

Oh yeah—that one act of power caught us all off guard. But here's the thing—despite her delivery of that powerful line, considered in a 2016 the *Cut* article as "the single greatest moment in Black Women Television History," it wasn't what Annalise said, or how she said it, that had us cheering in support of her teachable moment but that she took off her metaphorical armor to say it. That unforgettable scene showed the fight of a proud Black woman who stripped off her wig to regain her confidence and identity.

In real life, Viola Davis was equally unapologetic for loving her natural hair, which she proved when she premiered the look in public on the red carpet at Hollywood's highest-profile event—the 2012 Academy Awards.

Viola Davis as Annalise Keating in *How to Get Away with Murder* looks at her reflection after she takes off her wig.

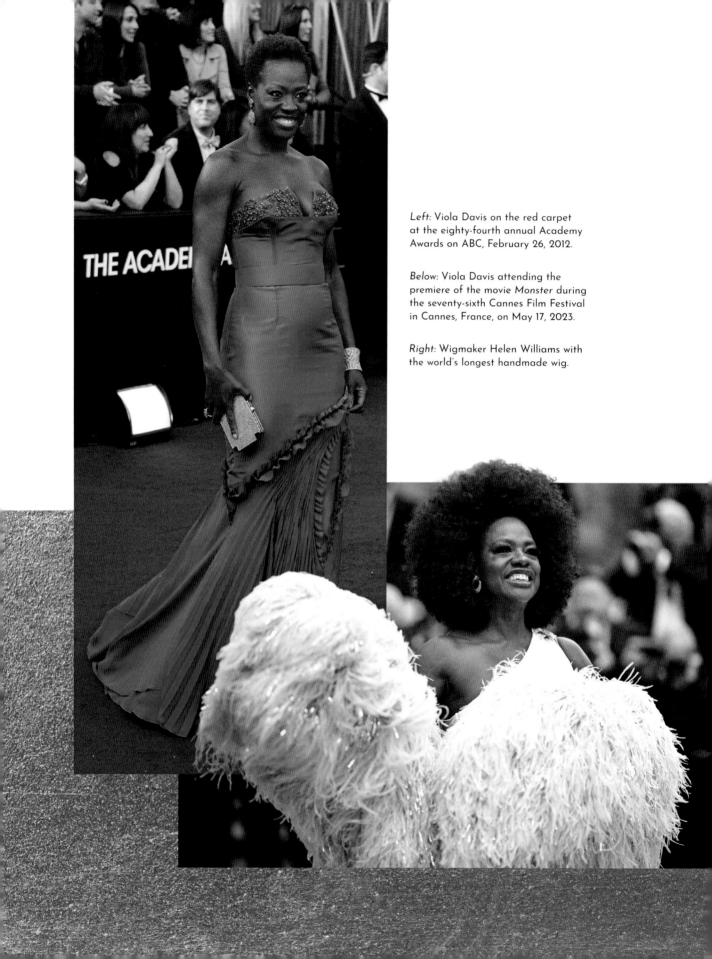

Left: Viola Davis on the red carpet at the eighty-fourth annual Academy Awards on ABC, February 26, 2012.

Below: Viola Davis attending the premiere of the movie *Monster* during the seventy-sixth Cannes Film Festival in Cannes, France, on May 17, 2023.

Right: Wigmaker Helen Williams with the world's longest handmade wig.

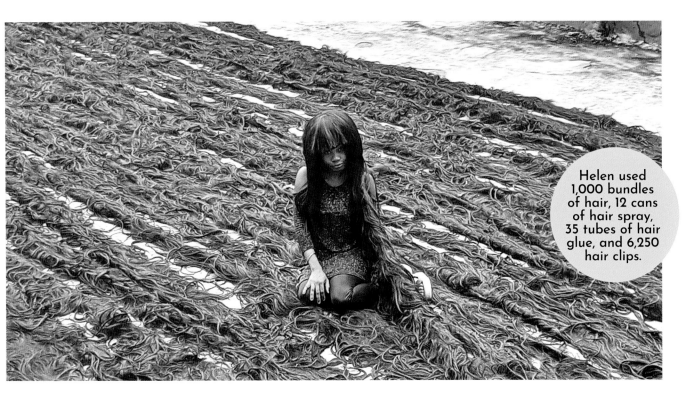

Helen used 1,000 bundles of hair, 12 cans of hair spray, 35 tubes of hair glue, and 6,250 hair clips.

Black bloggers were split over whether they supported her look, with most giving her the thumbs-up. But not talk show host Wendy Williams. On an episode of her eponymous daytime talk show, Wendy commented that Viola's natural hair was not "glamorous" or "formal" enough for the Academy Awards. *Really?* I say that because of the paradox of how we root for our sisters for wearing their culture while in the Black community but call them out for wearing their pride on their heads in public on a red carpet. Why is that?

It didn't matter. Viola didn't let hard-core haters faze her one bit. Instead, she doubled down on her look for the 2018 Golden Globes by blowing her hair all the way out to create her superlarge Afro-inspired hair love look—the same one captured on the November 2020 cover of *Glamour South Africa*.

On Instagram, Viola has stated, "I am not my hair. I am not this skin. I am the soul that lives within," a nod to India.Arie's Black woman's anthem, "I Am Not My Hair." The EGOT (recipient of an Emmy, Grammy, Oscar, and Tony) actress, producer, and *New York Times* bestselling author has been proudly sporting her beautiful natural hair look ever since. And quite royally, I might add.

In a snap of her at the 2023 Cannes Film Festival, she looked amazing—strutting down the walkway with her full natural coif. She oozed hair love. On the Gram, she posted that she "felt like a queen." The post got close to five hundred thousand likes (last I checked) and over ten thousand comments, including ones like, "you make [me] proud to have this chocolate skin!!!"

Now, before leaving this "Getting Wiggy with It" section, I MUST give props to Nigerian wigmaker Helen Williams. When you check out the snap of her sitting on the floor atop a wig that measures 351.28 meters (1,152 feet,

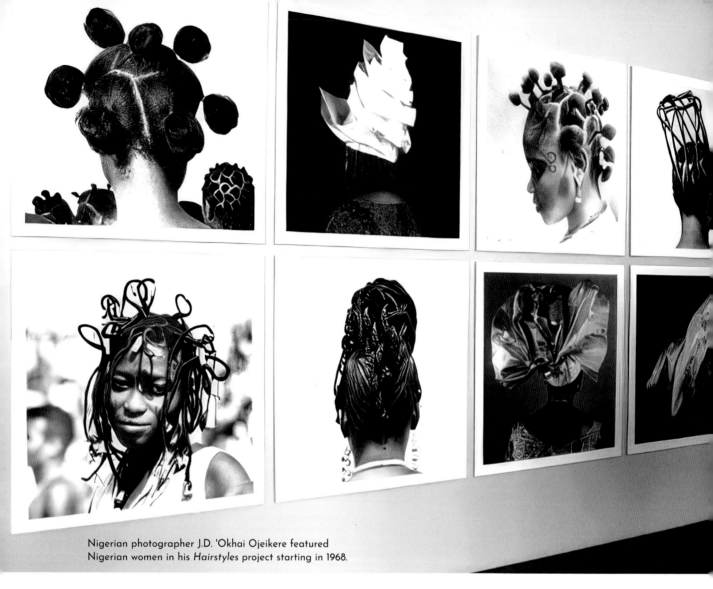

Nigerian photographer J.D. 'Okhai Ojeikere featured Nigerian women in his *Hairstyles* project starting in 1968.

5 inches), you'll know why! Guinness World Records certifies that she set the record for making the world's largest handmade wig.

"Finding the materials to make the longest wig was not an easy task," Helen said.

And that, my friends, is no lie!

No More "Lyes"

The resurgence of the natural hair movement trending in the new millennium harkens to a time nearly eight decades earlier when Black Nationalist, Marcus Garvey, urged Black people to embrace our natural hair and reclaim an African aesthetic.

One group of natural hair-wearing Harlem women did just as Garvey instructed.

It was the summer of 1963 after two white wig shop owners in downtown Brooklyn expanded their reach by opening a store in Harlem just blocks away from the Apollo Theater. Their sales strategy was to sell Black women "a dream of European beauty." The Committee for Racial Pride wanted no part of what they were selling in their hood. So, for two months, they picketed outside of the Wigs Parisian, withstanding rain and cold weather and carrying signs that read:

"Natural—Yes! Wigs—No!"

"Our Women Don't Look like Those Dummies in the Window."

"Do not remove the kinks from your hair—remove them from your brain."

— MARCUS GARVEY

"He's Got Straight Hair, but He's Still an Ape!"

One of their signs featured hand-drawn pictures of dark-complected women with large lips wearing blond wigs and the words: "We Don't Want Any Congo Blondes."

The Black press's coverage of the events helped sway the white owners to close the shop eventually. The whole event led to pioneering the "natural look" and launching the sixties Black Is Beautiful movement. Former Black Panther Kathleen Cleaver played a significant role in it. During a 1968 protest, she spoke out on the beauty of natural hair, stating, "All of us were born with our hair like this, and we just wear it like this because it's natural. The reason for it, you might say, is like a new awareness among Black people that their own natural physical appearance is beautiful and is pleasing to them."

Ironically, while African Americans were promoting the virtues of going natural and embracing our African roots, Black women in Africa were doing the exact opposite.

Once the West African country of Nigeria gained independence from British rule in 1960, women stepped away from their traditional Afrocentric 'dos in favor of wigs and straightened hair—made possible thanks to chemical hair relaxers that we're now told may contribute to an increased risk of uterine cancer if used repeatedly.

Fearing that the traditional African styles passed down over centuries would go away forever, Nigerian photographer J.D. 'Okhai Ojeikere began to capture them in a collection of stunning black-and-white photographs—thousands, in fact—now deemed a national treasure.

Ojeikere's exquisite images of tribal hairstyles captured close-up rear views of Nigerian women's coifs worn during religious ceremonies, cultural celebrations, and daily life.

If you've seen Beyoncé's *Black Is King*, Tracee Ellis Ross's Bantu braids, or *Black Panther*'s perfectly sculpted hair looks on the crowns of the women of Wakanda, then you've seen evidence of the Afrocentric hairstyles inspired by Ojeikere's *Hairstyles* series of photographs.

Hair Identity from Ashley A. Jones's *The Colorism Project*, 2016-18.

The Ojeikere of Modern Times

In the same vein as Ojeikere, but on a more contemporary level, artist and educator Ashley A. Jones uses her charcoal-on-wood sketches of everyday people, not models, to shake up and challenge us about what we think we know about the links between Black hair and identity.

By only showing the back of women's heads, her series allows us to contemplate the identity of the subjects with just the hair as clues.

In her classroom settings, Ashley reveals just one of ten images she's sketched for her *Hair Identity* series. She asks, "By just looking at her from behind, who could this woman be? Look at her hair texture. What does this woman do? What's her background? Her race?"

Ashley shared with me that there's always a common consensus among the Black and white students after they see the one image. Their conclusions?

"She looks like she's probably thirty, forty."

"She's African American."

"Her hair is kinky. She's gotta be Black."

At the end of their guessing game, Ashley does the big reveal.

"The woman is thirty-something years old. She's Jewish. She lives in Jonestown, Pennsylvania. She has nappy, textured hair that she doesn't know what to do with."

Based on their assumptions, Ashley's students unknowingly proved her point of how society tends to assume that "nappy" textured hair is Black hair, which, of course, carries a tremendous amount of stigma.

To the white people who guessed wrong, Ashley tells them, "I don't blame you all. This is what you're being told. But Black people? We know better."

It's easy to sit back and say, "I would've guessed right!" So, for kicks, see how you do with determining the age and race of three women in the images above from Ashley's *Hair Identity* series:

You guessed right if you said the one on the left is a midthirties Brazilian and Latina mixed

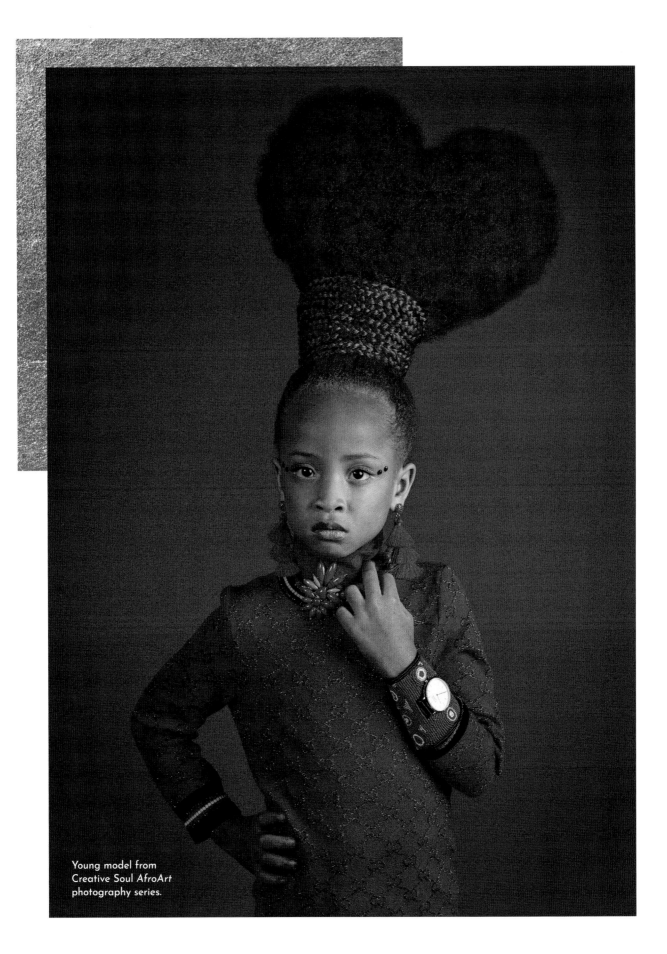

Young model from
Creative Soul AfroArt
photography series.

woman. In the middle is a seventeen-year-old African American woman. The last image is of a forty-one-year-old Caucasian woman.

Ashley uses all ten images—part of her overall *Colorism Project*—to explore the "good" hair versus "bad" hair controversies in Black culture and offer insights on how we can learn to accept and love the hair we have.

Afro art has proven to be a powerful and effective platform to empower Black kids as well as to fully embrace the uniqueness of our hair. It's been used successfully by husband-and-wife photographers Regis and Kahran Bethencourt of Creative Soul Photography, whose Afro art series blew up big time when it first hit social media. It featured some of the most stunning photographs of young children sporting creative hair looks that illustrate the story of our royal past, celebrate the glory of

the here and now, and even dare to forecast the future.

My favorite is of a young girl rocking a natural hair look shaped into a heart and adorned with a braid wrap. With her looking so regal, it's hard to miss the message of hair love. Black hair magic at its best!

When the Bethencourts first embarked on creating their Afro art series, they put out a call for Black models to submit photos. Those selected would be invited to their Atlanta studio for a photo shoot. Most of the kids chosen wore their natural hair in the pictures they submitted but showed up at the studio with it straight because they felt that's what it took to break into the business.

During and after the shoots, the young models were amazed at all the possible creative looks they could get with their natural hair. It made them feel empowered and beautiful, and they were no longer ashamed of their crowning glories. These kids often were the only ones in their class with natural hair. And we know that means it can open the door to BULLYING.

Since they were very young, identical twin sisters TK Wonder and Cipriana Quann were victims of bullying due to their hair and appearance. But once they became adults, they turned what was meant for evil into something inspirational by creating an online forum featuring pictures of their incredibly long natural locs.

It didn't take long for the images of these self-proclaimed Urban Bush Babies to go viral, with visitor counts on Instagram averaging

TK Wonder and Cipriana Quann at a Brooklyn screening of HBO's *Random Acts of Flyness*, New York, July 12, 2018.

128

Kelly Rowland (*center*) poses on the set of her "Crown" video created to inspire young women of all hair types to love their crowns.

350,000 per week. Soon, the influencers started adding affirmations and other messages to their blog, hoping to inspire and uplift other hair-shamed victims. It was important for them to break down stereotypes and negative perceptions about wearing natural hair—particularly for young girls.

Their message couldn't have come at a better time.

According to a 2019 Love Your Hair study commissioned by Dove, 65 percent of young girls viewed their hair as a form of self-expression, and 50 percent said their hair could make them feel self-conscious. It's that last stat that leads to bullying in schools.

Like the Urban Bush Babies, Dove had their own remedy for bullying too. In 2004, they created the Dove Self-Esteem Project to help millions of young people globally develop a positive relationship with how they look so they are not held back by appearance-related anxiety and can therefore realize their full potential.

Dove doubled down on their commitment to self-esteem education in 2019 by partnering with singer Kelly Rowland on her "Crown" video,

which also featured sixth graders of varying genders and races who'd been bullied about their hair or sent home from school for wearing natural hair extensions. Kelly's powerful anthem is intended to encourage and inspire girls of all shades and hair types to love the strands coming out of their heads.

Using kids to reach kids has proven effective in affirming the beauty of natural hair and getting hair love messages out.

Nine-year-old Willow Smith proved that point in 2010 when she released her "Whip My Hair" single on Jay-Z's Roc Nation label, right around the time natural hair bullying in schools and cyberspace was picking up steam. Once her song dropped and the video hit YouTube, it instantly got seven million views and became an anthem of sorts for young girls. Willow's message? Be strong. Be yourself.

There have been other songs directed at kids with similar themes, but among them, one tune took us by surprise.

It never made it to the *Billboard* charts, the radio station top one hundred, or any internet music service, but it had a major impact on kids and adults. Can you name this tune?

Chris Rock's 2009 documentary *Good Hair*.

I love something, yes, I do.
It's curly, and it's brown.
And it's right there.
You know what I love?
That's right, my hair.
I really love my hairrrrr!

When a video of this song surfaced, the person who sang it suddenly became an overnight internet sensation, getting more than one million views on YouTube and tens of thousands of shares on blogs, Twitter, and other sites.

Who's the rock star, you might ask? Gabrielle—formerly known as Segi.

Image of Gabrielle, formerly known as Segi, from "I Love My Hair" music video in season 41 of *Sesame Street*.

That single picture of a Black puppet rocking a natural hairstyle on *Sesame Street* should make every young Black child who has been teased or bullied about their natural hair want to shout, "That's me!"

It was in 2010, right around the time the second wave of the natural hair movement had resurfaced, that this young puppet—who was sassy, confident, loving her locks, and sporting all kinds of natural hairstyles—appeared.

Sesame Street head writer Joey Mazzarino was inspired to create Gabrielle after his adopted Ethiopian daughter asked why she didn't have "good hair." In an interview with *New York Magazine*, Joey shared, "We knew issues of skin color would come up, and then hair came up a bit last year. . . . I thought maybe it was an issue because she was being raised by white parents, and she sees us every day."

Back to the present—nearly ten years later Joey checked out Chris Rock's 2009 documentary *Good Hair* and realized Black hair was a larger issue than he'd ever imagined.

Truth be told, Chris Rock's comedy/doc did a lot to address decades of growing concerns about the link between Black hair and identity. Like Joey Mazzarino, Chris's daughter had also questioned her Black crown.

"Why don't I have good hair?" she asked her dad.

In *Good Hair*, Chris uses humor and real-life experiences to explore how natural hairstyles impact the self-esteem of Black people and their relationships, activities, and pocketbooks.

Reaching and teaching kids at a young age to love their hair was also a priority for Mattel—one of the country's biggest doll manufacturers—who in 1980 introduced the first Black Barbie (thirty-one years after the original Barbie) stylin' and profilin' with an Afro pick in her natural hair. This was not Francie, Barbie's dark-complected friend, or Christie, Barbie's first friend with Black features. This was a genuine Black Barbie.

I actually remember the promotion for the doll: "She's Black! She's beautiful! She's dynamite!"

Even though Black Barbie's 'fro was a little on the soft and curly side, Mattel did right by us, having a Black woman—Louvenia "Kitty" Black Perkins—create the look.

"When I designed it, I wanted her to be the complete opposite of the traditional blonde Barbie in that I wanted her to have different skin tones, and short, natural textured black hair."

—LOUVENIA "KITTY" BLACK PERKINS, MATTEL WEBSITE

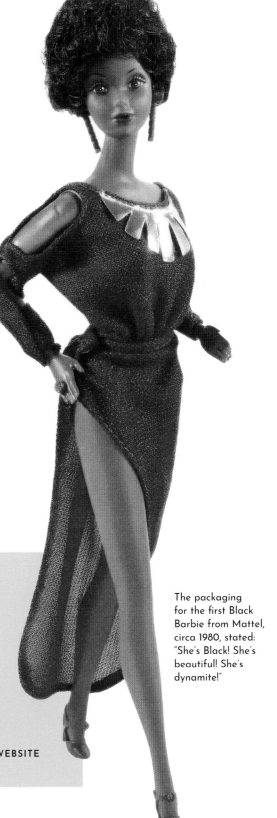

The packaging for the first Black Barbie from Mattel, circa 1980, stated: "She's Black! She's beautiful! She's dynamite!"

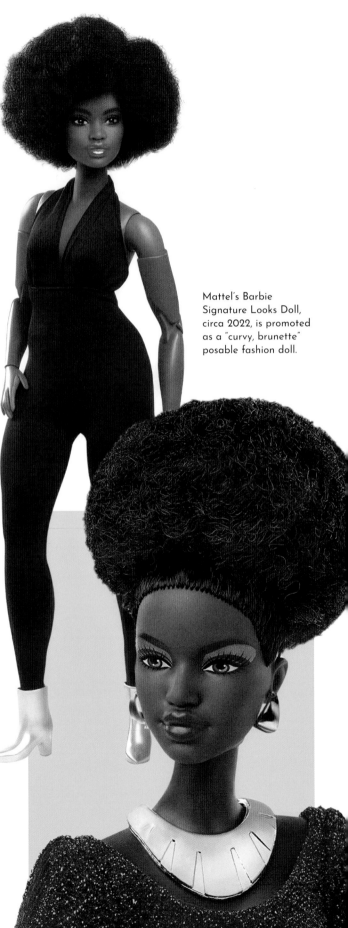

Louvenia's story is prominently featured in the 2024 Netflix Shondaland production, *Black Barbie: A Documentary*, which tells the story of how the first Black Barbie came to be in 1980 while examining the importance of representation and how dolls can be crucial to the formation of identity and imagination.

Thanks to Louvenia's influence, the doll was made to display "confidence, glamour, and sophistication," based on what Louvenia loved most about Diana Ross and the Supremes, who were in their wig-wearing prime at that time.

Forty years later, Mattel let Barbie go au naturel with a hair texture a little closer to our kinky curly reality.

Now, in the era of inclusivity, there's a whole line of Black Barbies sporting Afrocentric styles that are kinky, curly, straight, coiled, and even weaved with varying skin colors, shapes, and sizes.

I also applaud Mattel for releasing its series of Barbies that honor Black celebrities like **Tina Turner, Diana Ross, Zendaya, Yara Shahidi,** and **Laverne Cox;** a shero collection that features **Gabby Douglas** (the first Black female gymnast to win an individual gold medal for an all-around event), **Ava DuVernay** (with her trademark locs), and **Naomi Osaka** sporting her natural crown. Mattel's Inspiring Women series includes Barbies modeled after **Ella Fitzgerald, Rosa Parks, Maya Angelou,** and **Bessie Coleman** (the first female African American and Native

Mattel's Barbie Signature Looks Doll, circa 2022, is promoted as a "curvy, brunette" posable fashion doll.

The Afro'd Black Barbie released in 2020 was to commemorate the fortieth anniversary of the release of the first Black Barbie.

American aviator to obtain a pilot's license in the US), plus **Katherine Johnson**, whom many of us first learned about from the film *Hidden Figures*. She was the NASA mathematician and physicist who calculated the trajectory of the first American manned trip to space.

And while I'm on the topic of Black dolls, what few know is that long before Mattel, and even before people erroneously credited Marcus Garvey for being the first to market Black dolls to Black consumers, Rev. Dr. Richard Henry Boyd created and sold them way back in 1908. He wanted to address the need of young Black girls who wrote to Santa asking for dolls that looked like them.

The astute businessman partnered with a German doll company to create the darker-hued dolls.

After selling more than three thousand of them—mainly during the Christmas season—he renamed his thriving business the National Negro Doll Company.

And let's not forget the doll with the natural hair for us by us that got away from us.

You may have been one of the ten million *Shark Tank* viewers back in 2017 who saw the husband-and-wife team—Angelica and Jason Sweeting—pitching their Naturally Perfect Dolls toy line that they said would "change the standard of beauty one doll at a time."

The inspiration behind their Afrocentric doll line came from their daughter saying, "I'll never be beautiful. I need yellow hair and white skin, so I'll be beautiful."

Like a lot of America, I was rooting for the husband-and-wife doll designers to win that $200K prize—which they did. Well, sorta. So where are the dolls, right?

FUBU founder Daymond John, who agreed to invest the money to back the couple in exchange for a 30 percent stake in the company, had to pull out of the deal following what he called "due diligence." Nondisclosure agreements prevent us all from ever knowing what happened. Hmmm.

TV, Film & Black Lit Hair Love

More and more storylines on TV series like *Black-ish*, *Grown-ish*, and *This Is Us* delved into the issues that help our Black kids celebrate natural hair.

Children's books have been the most significant and accessible creative outlet for really young girls and boys to begin to love their tresses.

Titles like *I Love My Hair*, *Crowning Glory*, *Cornrows*, and *Nappy Hair*, meant to celebrate Black culture while giving Black kids a reason to love their hair, caused a lot of controversies when they got into the "wrong" hands.

Nappy Hair was written by Carolivia Herron, a sixty-something Black English professor with a grandmotherly demeanor who simply wanted to share stories from her family that would encourage young girls to love their natural textured hair.

She first wrote *Nappy Hair* as a chapter in an adult novel called *Asenath and the Origin of Nappy Hair*. It was meant to be just one of a series of folktales.

Soon after, the chapter about a young girl named Brenda whose grandfather consistently teased her about her nappy hair was released as a stand-alone book in 1997. Third graders in

Top: Cover art for the controversial *Nappy Hair* by Carolivia Herron.

Bottom: Cover art for *Crown: Ode to the Fresh Cut* by Derrick Barnes.

one predominantly Black Brooklyn classroom just couldn't get enough of it. So their white teacher came up with the idea to make copies of pages from the book they could take home.

As the old folks would say, "Why she wanna do that?"

Among the photocopied pages was the book's cover with the title *Nappy Hair* in big bold letters.

The teacher's photocopied pages also included illustrations and text of the young protagonist named Brenda, whose grandfather describes her as having the "nappiest, fuzziest, most screwed up, squeezed up, knotted hair." Oh yeah—parents weren't liking that. They

called the author a racist for creating such a book and choosing such a demeaning word as "nappy" for the title.

Carolivia never considered that writing *Nappy Hair* would lead parents to label her racist. She'd heard the term all her life and never took offense.

When reporters from the *Today* show, *Good Morning America*, and *Montel Williams* asked Carolivia what she thought about all the hoopla, she said, "I don't get it!" She defended that using the term "nappy" was meant to offer a celebration of Black textured hair, not a devaluation of it.

The parents who came down hardest on the author pounced even harder on the white teacher who photocopied the pages. Most believed she didn't have the proper perspective to teach their kids about loving their Black hair. The pressure was a bit much for the teacher, who ultimately resigned.

After reading the book that became a bestseller before it was banned in New York public schools and communities throughout the US, I'm pleased that the moral of the story is an important one. Brenda learns that her nappy hair is a gift from God, which is reason enough to celebrate. That message clearly explains why the kids loved the book so much. But you must go through quite a few rough "edges" to get to that resolution. So I can also see why the parents were more than a little up in arms.

It's fair to wonder if the teacher had been Black, would the backlash have been the same? Or was this a classic case of D-O-U-B-L-E S-T-A-N-D-A-R-D?

We tend to use the word "nappy" among ourselves, but it really does cut deep when

someone outside of the race says it, doesn't it? It's a lot like the other N-word. It can be rapped about, spoken on the regular, and sung all day long in music videos, but let someone use the word outside of the Black community, and they get canceled in a hurry.

Looking past the controversy behind the *Nappy Hair* title and the parent/schoolhouse drama, the book won multiple literary awards. Hopefully, it will continue to do what Carolivia intended from the onset—to inspire young girls to love their hair and, thereby, love themselves.

Since then, there've been a number of published children's books that help young kids to love their hair, including one called *Happy to Be Nappy*, written by bell hooks—one of Carolivia's loudest critics—with illustrations by Chris Raschka. The book was released one year after *Nappy Hair* and offered young readers a "more positive celebration of 'afro' hair."

The 2000s brought us several love-your-hair books for boys, too, like *Crown: An Ode to the Fresh Cut* by Derrick Barnes, illustrated by Gordon C. James, which won many awards in 2017, including a coveted Caldecott Honor. It's touted as "a celebration of the self-esteem, confidence, and swagger boys feel when they leave the barber's chair."

For adults, the question was never, "Is there a link between hair esteem and self-esteem?" We know there is. Instead, the big Q is how do we combat societal, internal, and relational forces that prevent us from embracing our natural crowns and feeling good about our Black identity?

Popular Black lit gave us three classic adult novels that beautifully address these hair love themes and spark important conversations from three uniquely different and opposing perspectives: an African woman trying to assimilate to life in America, an African American sista who desperately wants to appear desirable to her man but believes her Black features and kinky hair get in the way, and a Black woman with Eurocentric features

Halle Berry and Ruben Santiago-Hudson in a scene from *Their Eyes Were Watching God* (2005).

whose man uses her "good hair" to wield power over her.

On the surface, Toni Morrison's critically acclaimed *Song of Solomon* (1977) was about a man named Milkman who alienated and estranged himself from his family, community, and his historical and cultural roots. I like to zero in on Milkman's one-time lover Hagar, who offers us reason to pause and consider how much power we give others about something as personal as our hair.

Hagar is fully aware that her kinky hair and dark skin have made her undesirable to Milkman. In one pivotal conversation with her grandmother, she asks, "Why he don't like my hair?"

"It's his hair too," her grandmother snaps back. "He got to love it."

"He don't love it at all. He hates it," Hagar insists.

At one point, she's so distraught and depressed at the risk of losing him that she plots to have him killed. But once she accepts that she can never change her skin color to please him, she changes her mind and her hair, giving him what she thinks he wants: copper-colored hair cascading down her back, just like the white woman she spotted him with after their breakup.

If we're honest, many of us have done like Hagar—changing our hair for our man, job, or to conform to societal pressures. In essence, we're submitting to another power at the cost of our self-esteem.

Song of Solomon is a deep read constantly labeled inappropriate because of its explicit material and gut-wrenching reality. If you've never read this classic, you owe it to yourself to do just that. But spoiler alert: In the end,

Milkman finally comes around to appreciating Hagar. Before her death, Hagar finds peace with her racial identity because Toni Morrison devised her own standard of Black beauty rather than have Hagar fit into the white ideal of beauty.

I like that! Creating our own standard of beauty—loving our hair for what it is—is a valuable teaching moment for all of us!

On the flip side—in Zora Neale Hurston's *Their Eyes Were Watching God* (1937), the protagonist Janie is not dark like Hagar, but rather she's what the townspeople in her world call "yaller." Janie is proud of her European features and long hair—not because she wants to deny her Blackness but because it's hers. It's beautiful, and it's what first attracted Joe to her. But once Joe realizes his wife's self-esteem is tied to her hair, he demands that she keep it tied up in public, especially when she's around the store and post office that he runs. Why?

"Maybe he skeered some of de rest of us mens might touch it . . ." the townsmen wondered.

Nope. Janie's journey reveals that it is more profound than the townsmen thought. Joe, in fact, has used Janie's hair to control her.

My favorite part of this story comes after Joe dies and Janie announces his death. She walks over to the mirror and has what begins to look like one of those Annalise Keating moments. But it's not. She removes her scarf and lets her hair—that's been tied up and hidden from the world—finally cascade down her back. It's a compelling moment in the book, played out with perfection by Halle Berry in the film version produced by Oprah Winfrey.

The biggest takeaway in the two novels is how both protagonists found freedom embracing their natural hair.

The journey to finding hair love from a contemporary African perspective is best explored in Chimamanda Ngozi Adichie's award-winning novel *Americanah* (2013). While the dominant theme is race and love, there is a strong hair through-line "weaved" throughout.

Chimamanda's protagonist Ifemelu is a Nigerian student attending Princeton University on a fellowship who tries to assimilate to life in America—starting with her hair.

In preparation for her first job interview that she's uber qualified for, she's advised to take down her braids and have her hair straightened to look more "professional."

In one chapter, where Ifemelu is at the salon, the hairdresser accidentally singes the ends of her hair with a hot comb and then says, "Just a little burn. But look how pretty it is. Wow, girl, you've got that white-girl swing!"

Once Ifemelu leaves the salon, she's mad at her Nigerian self for even buying into the notion that she needs to change her look to fit in. Later, in her blog, she writes about how hair is a perfect metaphor for race in America. She makes the case that African American women are insane to go through such a torturous method of hair straightening just to get a job and look like what white America considers the standard of beauty.

Chimamanda uses Ifemelu's situation in the salon to make the point that when the ends of her hair were burned, something died inside of her that shouldn't have—a part of her identity—an interesting concept to ponder.

All three novels, written over a period spanning nearly eight decades, tackle hair love themes that are relevant today. They challenge us to think differently from varying perspectives.

Still, beyond these literary classics, pop culture's best modern-day hair love story is for adults *and* kids and offers a unique but welcomed Black Daddy perspective.

Once upon a time, in 2017, a former NFL player named Matthew Cherry was saddened by the bad rap Black fathers were getting in terms of stereotypes. They say that "we're deadbeats, we're not around."

"The people I know are extremely involved in their kids' lives."

–MATTHEW CHERRY, *THE NEW YORK TIMES*, FEBRUARY 7, 2020

After watching a bunch of viral videos of fathers styling their daughters' natural hair, Matthew set out on a mission to turn the deadbeat dad tide. He wanted to create positive images of Black fathers. So he turned to the platform that initially inspired him—social media.

Matthew launched a Kickstarter campaign to raise money to produce a short film showing how a girl dad helps his daughter love her hair.

As part of his call to action, Matthew added a picture of a father who, in retrospect, looked a tad bit cartoonish. That's when cocreator Karen Toliver stepped in with the suggestion that the image should be younger to make the point that modern-day Black fathers will do anything for their kids, just like the dads of our parents'

generation. She also wanted the young father to look more fly. She figured giving him locs would do the trick while sublimely showing acceptable norms for Black hair.

With the changes in place, the campaign took off. The initial goal was to raise $75,000. Instead, they set a record in short film financing on the platform, raising nearly $300,000. Yeeesss! Read that again. They grossed four times their original goal!

Once funded, Matthew and Karen got busy with the script and production.

If you still haven't seen the film or read the book *Hair Love* get to it. You owe yourself a favor to check them out.

The storyline follows a young Black father who helps out his frustrated seven-year-old daughter, Zuri, who is trying to comb her natural hair for the first time before visiting her mom in the hospital. The dad feels just as handicapped as his daughter as he tries to comb her naturally curly mane. But he does his best as a good dad.

Hit the pause button.

How many of us missed the point that while father and daughter were struggling to tame the daughter's hair, the mom completely lost hers from debilitating cancer that put her in the hospital? Breaks my heart!

The whole concept with the girl dad theme is touching on its own merit, but then, paired with

Scene from *Hair Love* (2019).

"This award is dedicated to Kobe Bryant. May we all have a second act as great as his was."

—MATTHEW CHERRY, ACCEPTANCE SPEECH AT ACADEMY AWARDS, 2020

Matthew A. Cherry and Karen Rupert Toliver on the red carpet after winning the Oscar for Best Animated Short Film for *Hair Love* at the Dolby Theatre in Hollywood, February 9, 2020.

a moving script and illustrations from Vashti Harrison—WOW! You can't help but be moved to tears.

Instead of just oohing and aaahing about the film, a part of Black Hollywood put its muscle behind it. Jordan Peele, Yara Shahidi, Gabrielle Union, Dwyane Wade, and Gabourey Sidibe were happy to endorse the film and serve as producers. Issa Rae also offered her support by voicing the role of young Zuri's mother.

Once production was completed, the seven-minute short screened in movie theaters worldwide ahead of *The Angry Birds Movie 2*, making it eligible for Oscar consideration.

The morning the nominations for the Academy Awards were to be announced—and I mean early morning, 5:30 a.m. morning—Matthew held a watch party at his home. Coincidentally, Issa Rae was the one to announce that the film had been nominated for Best Animated Short Film.

Well, it's no secret how that turned out! Ta-da!

We were so proud when Matthew Cherry accepted his Oscar and spoke at the ceremony about why the conversation about Black hair is so important and his wish to "normalize Black hair." He also gave a nod to former Laker Kobe Bryant. The latter had won the same award a year earlier and died tragically in 2020 in his real-life girl dad role with his daughter Gianna.

Matthew's acceptance speech also spoke to how the film and its Oscar win for him and Karen was an even greater win for Black men as fathers.

The win opened broader conversations about society's perception of Black hair. And for the Black community—and frankly, everyone—the film left us with one powerful message:

FAMILY LOVE AND HAIR LOVE ARE ALL TIED TO LOVING OURSELVES.

There've been a ton of cringeworthy
moments in the "Don't Touch My Hair"
space—on red carpets and award stages
as well as in schools, online, and TV.

They've shocked, angered, and left us shaking our heads. But then again, more often than not—they've left us with a new appreciation and respect for our crowning glories. In fact, I started to call this chapter something else, but when I thought about the movie *Nappily Ever After* starring Sanaa Lathan, I was reminded about how inspiring it is when bad experiences about our hair have happy endings. And so there you go!

Can you recall back in 2006 when there were so many stories about societal pressures to conform to beauty standards? Most of the time they were white beauty standards. Other times, so-called good Black hair versus bad Black hair standards. Straight versus kinky, permed versus natural—all within our own community. But then came that silver lining when India.Arie recorded "I Am Not My Hair." She wanted to remind Black women that our

hair doesn't have to be a political statement. It's just our hair.

> I am not my hair, I am not this skin
> I am not your ex-pec-tations no no
> I am not my hair, I am not this skin
> I am the soul that lives within
>
> —INDIA.ARIE, "I AM NOT MY HAIR."

It worked! Unofficially, Black women adopted the Grammy-nominated song as our hair anthem. Thank you, India!

In 2016, singer-songwriter Solange wasn't trying to make a hit, but she hit a chord with Black women when she wrote and released "Don't Touch My Hair." Personal encounters and even historical ones—like when enslavers rubbed our ancestors' hair for good luck—are what led her to release the song that makes the point our hair is not to be touched but respected by

others and ourselves. After all, our hair is an extension of our being and pride.

Solange successfully made her point! And that was a good thing! But then two months after releasing the track, comedian and actor Bill Murray allegedly committed the cardinal sin during a *Saturday Night Live* taping of putting his hands on Solange's 'fro not once or twice but THREE times without her permission. Aye Yai Yai!

That was a bad thing!

A year later *Evening Star* magazine photo-chopped Solange's intricately braided hair she styled in the shape of a round globe that towered above her crown for the cover of the magazine. She didn't find out that her hair was airbrushed until after the magazine went to press.

Lupita Nyong'o tells a similar story about her photo-chop on the cover of *Grazia* magazine.

Sadly, these stories don't have happy endings but fear not. I provide them only for context to show that times are a changing. Despite all the other crazy "Don't Touch My Hair" incidents I could write about, I won't include them here unless they have positive outcomes.

You're welcome!

The stories here have happy endings and have helped us to defend our proud Black hair-itage.

For instance, the story about DeAndre Arnold—the eighteen-year-old Black senior at Barbers Hill High School in Texas. Remember him? He was getting good grades. He never got into trouble. He never broke the rules. Yet, just days before graduation, he faced suspension due to the length of his dreadlocks.

DeAndre also got banned from attending his school prom and commencement ceremonies,

even after explaining that his refusal to cut his locs was because of his Trinidadian background.

Didn't matter. The school stood by its position.

Spoiler alert: DeAndre had the last laugh.

The time was 2020, the same year that athlete turned filmmaker Matthew Cherry was nominated for an Academy Award for his *Hair Love* animated short film, which he created to positively represent Black kids and normalize Black hair.

DeAndre's plight represented everything Cherry tried to do with his film. So he, along with actress Gabrielle Union and her husband, former NBA player Dwyane Wade, invited the victimized Texas teen and his family as their guests to a pre-Oscars dinner and to walk the red carpet at the 2020 Academy Awards. H-U-G-E!!!

The Oscars are still the hottest ticket in Hollywood if you can get an invite. I know A-listers and past recipients who can't always get tickets because of the limited seating capacity. Most years, they have to hope they get in through the Academy's ticket lottery. But DeAndre and his parents got in!

The young Black student who got **punished** for his hair not only walked the Oscars red carpet but got a shout-out onstage from Cherry during his acceptance speech for winning Best Animated Short for his film about **loving** our hair. Millions, including DeAndre's classmates and teachers—even the ones who banned him—were no doubt watching.

But wait! It gets better! After word of his predicament rippled through Hollywood, DeAndre also got invited to appear on an episode of the talk show *Ellen*.

In front of a TV audience of millions, DeAndre shared his unfiltered truth and

Standing on the red carpet at the ninety-second Academy Awards in Los Angeles (*left to right*): producer Bruce W. Smith; filmmaker Matthew A. Cherry; DeAndre Arnold; filmmaker Karen Rupert Toliver; DeAndre's mom, Sandy Arnold; and producer Everett Downing Jr.

disappointment with his school, wishing they had been more open to other cultures.

Ellen praised DeAndre for standing up for what he knew was right. And because she felt that the school didn't do right by him, she vowed to do it—on national TV.

With the support of Alicia Keys and Shutterfly, Ellen surprised DeAndre with a $20,000 scholarship to college.

Now, that's what I call a Nappily Ever After ending!

Then there was an incident on April 4, 2007.

Don Imus, the contentious radio talk show host, ignited a firestorm after making racially disparaging remarks about the Rutgers University women's basketball team. He insulted their appearance, blasted their tattoos, and called them "nappy-headed hos" live on air. *Really, Don?*

The Rutgers administration and women's basketball team blasted the shock jock's remarks as "despicable!" The Rev. Al Sharpton and then state senator Barack Obama called for Imus to

be taken off the airwaves. In the November 19, 2013, *Chicago Sun-Times*, Obama called Imus's remarks "divisive, hurtful, and offensive."

Far from being "nappy-headed hos," the Rutgers University bright lights are, as their coach C. Vivian Stringer pointed out during a nationally publicized press conference held the following day, "valedictorians, future doctors, musical prodigies, and leaders."

When Imus went low, the Rutgers coach went high, choosing diplomacy over revenge. She didn't request that Imus be fired. Instead, she agreed to meet with the misinformed radio host to set him and the record straight.

Imus apologized two days later on his show, calling himself "a good man who did a bad thing."

Whaddya know—his apology came after numerous sponsors, including General Motors, Staples, and other major companies, pulled their advertising from his show.

The shock jock's racist comments triggered a "what was meant for evil, God meant for good" celebratory moment.

After hearing Imus's remarks, my former employers—the family behind the Williams Group Holdings investment firm—made the financial commitment to become majority owners of the Los Angeles Sparks WNBA franchise. They had been contemplating the buy for some time, but their disgust over Imus's remarks caused them to pull the trigger when they did. The Williamses shared with me that their decision—made just days after the uproar—was also their way of "making women's sports more popular and more supported." So, there you go—another happy ending to a tragic story!

Melba Tolliver's story is equally inspiring. You see, in 1971, the TV news correspondent, who was the first African American to anchor a network news program at WABC-TV in New York, made national headlines when she was pulled off an assignment to cover the White House wedding of President Richard Nixon's daughter Tricia. This happened all because the transitioning naturalista had changed her straight hair into a natural kinky look.

Melba had been anchoring the 11:00 p.m. newscast at WABC for some time and was considered competent, professional, thorough, and accomplished—all the attributes of a star anchor. Ratings were high for her newscast. Through most of its run, she wore her hair straight. Once she changed her look, her white news producer didn't want to believe her kinky short cut was her natural hair.

After getting word about Melba's new 'do," the equally shocked white news director called to say she would not appear in any on-air coverage for the wedding.

Members of the Rutgers University women's basketball team appear at a news conference at the university in New Brunswick, New Jersey, April 10, 2007. *Left to right:* Rashidat Junaid, Myia McCurdy, Judith Brittany Ray, Epiphanny Prince, Dee Dee Jernigan.

Journalist Melba Tolliver, circa 1977, sitting at her WNBC desk in New York where she eventually went to work.

You know how today we talk about people getting "canceled"? Well, Melba's live coverage on the ground in DC at the White House Rose Garden in 1971 where Tricia's wedding was held—CANCELED. Melba's scheduled appearance in the studio following the wedding—CANCELED. Melba's live appearance the next day on the morning show following the wedding—CANCELED.

Once Melba returned to New York, she was told that if she didn't change her hair back, she couldn't return to her anchor chair or cover any on-location shoots unless she wore a hat or scarf. Now, keep in mind that while all of this was going on, Melba's change of hairstyle never changed her abilities, talent, or competence.

It took a leak to a local newspaper, coupled with fear from the WABC brass that the discrimination going on might go public, to get Melba rushed back on the air.

Woo-hoo—victory, on her own terms!

Forty years later, NBC news correspondent Simone Boyce told a story eerily similar to Melba's that started with her having to flat-iron her natural locks every day to fit the mold of what her then news director boss wanted it to look like on air. It wasn't until she realized how much the heat was destroying her hair and her self-esteem that Simone stopped the madness.

Along with her new look, she had a new attitude.

With diversity finally a priority in newsrooms across the country, Simone wanted to find a way to shine a spotlight on the anchors, meteorologists, and other pioneering journalists who are redefining what on-air beauty looks like. So, in 2019, during the National Association of Black Journalists (NABJ) Conference, Simone

"They said I looked less attractive—less feminine. But it was their standard of femininity, not mine."

—MELBA TOLLIVER, *THE NEW YORK TIMES*, FEBRUARY 18, 1973

National Association of Black Journalists members and leaders pose for a snap during the 2019 conference to celebrate being on air with their natural hair.

> "We won't apologize for loving our hair and we will not ask for permission to live and work authentically."
>
> —SIMONE BOYCE, TODAY.COM, AUGUST 28, 2019

invited twenty-five storytellers to stand side by side with her for a snap to celebrate their coils, braids, locs, and other natural hairstyles they were proudly wearing on air. It's no wonder the photo went viral. It's as impressive as it is beautiful.

Unlike modern-day journalists of color or Melba Tolliver who came before them, Gabrielle Union was never a bona fide news talent but played one on TV in the hit BET series *Being Mary Jane*.

Throughout the series' five-season run, Gabrielle's character, Mary Jane Paul, wore her hair long and short, at times straight, and at times gloriously untamed. But during season 2, in a pivotal seventh episode called "Let's Go Crazy," Mary Jane removed her extensions before learning that her hairstylist needed to cancel her appointment and couldn't put them back in.

Ouch. I could feel Mary Jane's pain.

If you've ever worn a weave and gotten news that it couldn't be put right back in before you had to be back at work, then you've also probably had that same look of horror Mary Jane had when she looked in the mirror.

"Be comfortable and confident with your whole ass self. It might give others the fluuuxxx but never stop being you. You can shine on your own terms."

—GABRIELLE UNION, INSTAGRAM, DECEMBER 12, 2019

Gabrielle Union on the red carpet in Los Angeles at the *America's Got Talent* season 14 finale.

It was too late at night to call anyone else to sew in her weave. At that moment, Mary Jane had only one option. Eat crow.

The only one who could help her was her niece, whom she'd just ragged on hours earlier, calling her out for being fat, lazy, and not caring enough about her appearance to love and respect herself. Her reluctant niece eventually agreed to sew in MJ's weave. But then this—the always confident Mary Jane had a reckoning. She admitted for the first time that without the weave, she thought people would think she wasn't beautiful—because that's what she thought of herself.

Mary Jane's revelation in the "fictional" exposed sentiments in the "real" of linking our self-esteem to our hair. In the really real life, Gabrielle Union's hair woes during her stint as a judge on *America's Got Talent* taught us more about loving our hair and ourselves. In 2019, after just one season, *AGT* producers allegedly fired Gabrielle because her hairstyles were "too Black" for the show.

For the record—the network and producers denied the allegations. But that didn't stop this sister with more than 26 MILLION followers from posting her defense on all the socials, along with some encouraging words for others who might find themselves being victims of hair discrimination.

The happy ending here? Gabrielle's words encouraged more than six hundred thousand viewers—most of whom left comments and likes supporting the need to fight hair discrimination.

All good stuff! But that same year, our biggest step toward ending hair/race discrimination came gift wrapped in a piece of legislation called CROWN—calling for **C**reating a **R**espectful and **O**pen **W**orld for **N**atural Hair.

The CROWN 2023 Workplace Research Study surveyed 2,990 female-identifying respondents to find out the impact of hair bias and discrimination on Black women in the workplace. The survey found that 66 percent of women had changed their hair for a job interview, including 41 percent who had changed their hair from curly to straight. Black women are also 54 percent more likely to feel like they must wear their hair straight to a job interview to be successful.

Gov. Gavin Newsome (D-CA) with Sen. Holly Mitchell (D-CA) signs the CROWN Act in California on July 3, 2019.

The CROWN Act

This law was written in 2019 to make it illegal to discriminate against Black folks at work, in school, and in public spaces because of how we wear our hair. The bill was a huge victory for the culture and a long time coming considering that in the early 1970s there were hair discrimination in the workplace cases out the wazoo. But after decades of us getting reprimanded, missing promotions, and being eliminated from competitions, my state of California was the first to sign the bill.

The bill signed on July 3, 2019, by Gov. Gavin Newsome and sponsored by Sen. Holly Mitchell and the Crown Coalition—a national alliance comprised of the National Urban League, Western Center on Law and Poverty, Color of Change, and Dove—bans discrimination based on hair textures and grooming policies that disproportionately affect Black communities.

It took a couple of years for Congress to get on board, but the House finally passed the bill on March 18, 2022. Despite bipartisan support, Senate Republicans blocked the bill's passage nine months later.

Disappointed but not deterred, Dove doubled down on its commitment by partnering with LinkedIn—the world's largest professional network—to create an official campaign to end natural hair discrimination and foster a more inclusive and equitable space for Black women in the workplace and schools.

As of 2024, twenty-four states have enacted the CROWN Act. Woo-hoo!

Now there's a happy ending!

Along with the bill that will hopefully one day be passed in all fifty states, we can add this triumph to the list of other progresses made. Today there are TEDx talks, social media chats, conversations, children's books, video games, and music that will hopefully help others respect our crowns and are reminders to us that our Black hair is EMPOWERING. REGAL. And most importantly—OUR CROWNING GLORY!

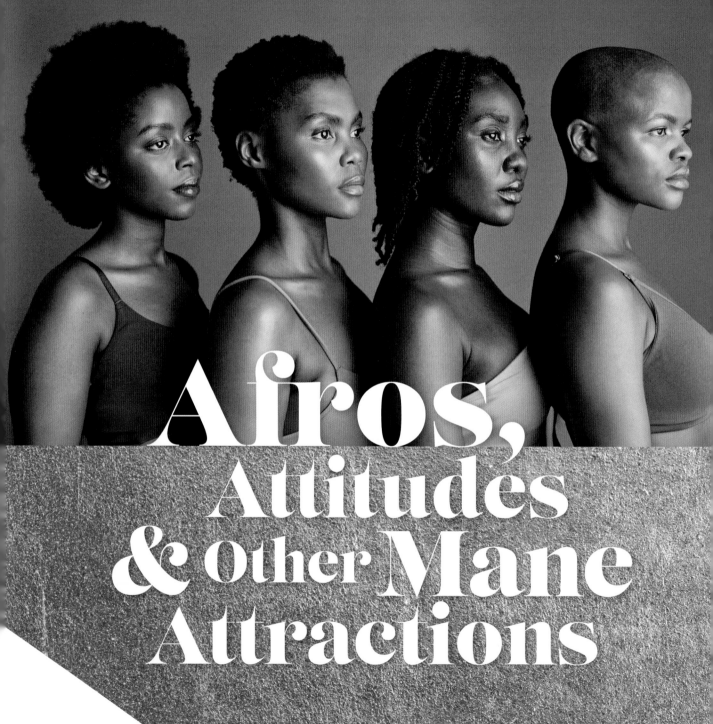

Afros,
Attitudes
& Other Mane
Attractions

From as far back as ancient Africa, our glorious and uniquely textured hair has been 'fro'd, loc'd, braided out, twisted, knotted, shaved, buzzed, mohawked, curled, coiled, straightened—the whole nine.

The more Afrocentric the style, the stronger our sense of racial pride. There was, of course, that one style Anthony Hamilton called a "drippy juicy" Jheri Curl. You know it—that so-called GQ "'do" from back in the eighties that left messy curl activator stains on the furniture and walls in the film *Coming to America*. While it proved to be more popular with men than women, I venture to say that few of us were sorry to see it go away.

There is one style, however, most all of us Black folks like to claim as ours. Though often emulated—er, appropriated by other races— it's a look that's had more ebbs, flows, and controversies than any other.

What some would call just another "'do," the Afro has been regarded as a signifier of radicalism since the Black Panthers wore it in the sixties; a fashion trend when the Jackson 5 sported it in the seventies; a badge of pride in the new millennium when Beyoncé crooned, "I like my baby heir with baby hair and afros"; and yet—it wasn't until a full, perfectly coifed one resurfaced in the Black Lives Matter environment that we were left questioning, "Do we wear it today for style? Cultural pride? Or to start a revolution?"

When Colin Kaepernick first joined the NFL, some folks couldn't even tell that he was Black. His fair skin and close-cropped hair made him safe, nonthreatening, and pleasing to the eye. A few years in, he wore his hair in neatly braided cornrows, despite being told by his white adoptive mom when he was a kid that his cornrows made him look like "a little thug." Ouch. *Really, Mom?* But the more he became immersed in his Blackness—ping! Out came his perfectly fluffed and shaped 'fro that he sported when he took a knee during the National Anthem to condemn systemic oppression and

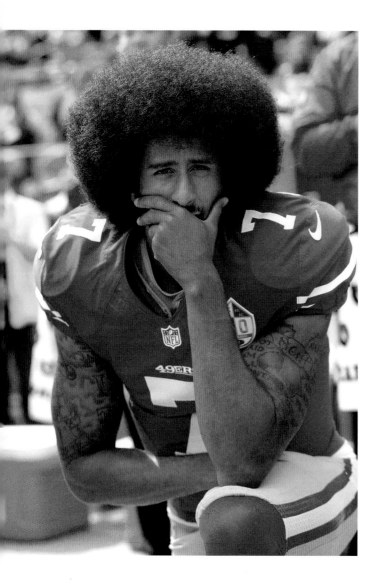

Then San Francisco 49ers quarterback Colin Kaepernick kneels during the National Anthem on October 2, 2016, before an NFL football game against the Dallas Cowboys in Santa Clara, California.

suggesting Colin "sell out" but rather trying to help a brother out. But guess what? He didn't. And so Colin never got re-signed. Though Vick's comments weren't the most PC thing to come out of the tell-it-like-it-is commentator's mouth, they reignited conversations about Black hair politics and frequent questions from the mainstream like, "Do Black people who wear Afros all have political agendas?"

Let's see—there was that time in 2020 when Taraji P. Henson rocked a blazing 'fro on an Instagram video, then two days later, she posted a video wearing her 'fro with James Brown's "I'm Black and I'm Proud" anthem playing in the background. With her post coming just months after the deaths of George Floyd and Breonna Taylor—both killed by police officers—yes, she was definitely making a statement but not just a political one. You see, Taraji has long been an outspoken proponent of natural hair.

police brutality. There were no mixed signals there. Colin was Black, proud, and up for a fight.

As the free-agent quarterback continued his silent protests, he failed to get signed by any NFL teams. Was it because of his ability? Race? His politics? What changed?

"Tame your hair!" is what former NFLer turned sportscaster Michael Vick publicly pleaded of Colin on a sports news channel. Weighing in on Vick's advice, the Undefeated defined it as "one of the oldest plays in the 'Black isn't beautiful' playbook." Vick doubled down on his rhetoric, calling for Colin to "try to be presentable." Eventually, Vick backtracked, clarifying he wasn't

"For so long, we have been told that our hair in its natural state is ugly, or it's nappy, or it's been given these horrible descriptions. How can we fight what is naturally ours? Embrace it. Our hair defies gravity, think about that. Our hair points to the heavens, that's powerful."

—TARAJI P. HENSON, *IN STYLE*, JANUARY 31, 2020

So, in Taraji's case, her 'fro was just as much about loving our manes as it was about politics.

But what about actress and recording artist Teyana Taylor?

In November 2016 Teyana boldly "walked up in da White House like . . . ✊? #WhoGoneStopUs," wearing her big ole 'fro and striking a power pose—the same day that outgoing president Barack Obama met with president-elect Donald Trump, who defeated rival Hillary Clinton, despite losing the popular vote. Uh, yeah—her 'fro was political.

The nation's mood had quickly turned from hopeful to hostile soon after the election, especially in Black communities. Not only had Trump's run been divisive—he vowed to dismantle much of the progress, programs, and platforms Obama had built over his eight years in office—but Trump's alleged support of white supremacy organizations didn't help bring unity to what was increasingly becoming a polarized nation.

Crowds took to the streets in major cities, protesting his win and chanting, "No Trump. No KKK. No Fascists USA." Teyana couldn't join the dissenters in the streets but wanted to find a way to let her position be known. The snap—taken by her then NBA-baller husband, Iman Shumpert—of her wearing a bold burgundy pantsuit à la Hillary Clinton in front of the White House portrait of Clinton did the job. It

got over two hundred thousand Instagram likes and nearly one thousand comments on social media.

And just in case you missed the symbolism of Teyana's Afro, she made it clear in a second IG post, quoting the very person she had channeled that day through her Afro style: ANGELA DAVIS.

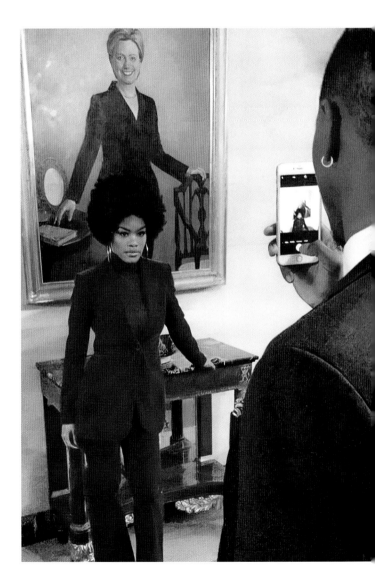

Teyana Taylor, wife of Cleveland Cavs star Iman Shumpert, strikes a Hillary Clinton-like pose dressed like Angela Davis during a visit to the White House in 2016.

"I am no longer accepting the things I cannot change.... I am changing the things I cannot accept."

—ANGELA DAVIS

The Angela Davis Hair Story

"Oh, Angela Davis—the Afro!" That's what one young Black man said after spotting Angela Davis at a local event. He wasn't the first or the last to connect Angela's identity with her hair-raising style. The exchange might have otherwise been okay if Angela hadn't already tired of that legacy.

In a 1994 essay called "Afro Images: Politics, Fashion, and Nostalgia," the former UCLA philosophy instructor and avowed Communist Party member found the young man's words not just unflattering but "humiliating and humbling that I'm remembered by a hairdo."

For more than five decades, Angela Davis and her "superhero" 'fro have been the focus of multiple documentaries, a feature film, several books, articles, and exposés. Her Afro'd image has been replicated on T-shirts, signage, and FBI Wanted Posters still circulating among collectors that were once plastered on Post Office bulletin boards all over the country and even on the FBI TV series, declaring her one of the country's ten most wanted criminals.

The legend of Angela's iconic and massive Afro began in 1970 after her registered .380 gun was used in the infamous California courtroom shoot-out meant to liberate imprisoned Black Panther George Jackson.

Jackson had been charged with two others, John W. Clutchette and Fleeta Drumgo, for allegedly killing a prison guard after several Black inmates were killed in a fight involving a different guard. George's brother, Jonathan, had entered the courthouse armed. He took the judge hostage and freed three Black prisoners. A shoot-out left Jonathan, the judge, and two prisoners dead. Under California law, as an owner of the gun, Angela, who was nowhere near the shoot-out that day, was a "party to murder."

She fled the state and became one of Black America's most infamous fugitives and a world-famous political prisoner.

While being hunted as a fugitive, Angela disguised herself by covering her beautiful Afro crown with a wig that she described in her eponymous autobiography as "straight and stiff, with long bangs and elaborate spit curls." She wore long false eyelashes and tons of eye shadow, liner, and blush. She even put a little black dot above the corner of her lip to create that glam, Eurocentric look—the very one that Black women activists of the seventies had been denouncing. Because of the times, Angela knew that looking Eurocentric would appear more acceptable to those hunting her down than looking the part of an untouchable revolutionary like most Black people with 'fros were perceived as back in the day. The disguise was so different from her previous look Angela claimed that even her own mother wouldn't recognize her. But the feds eventually did.

Once in court and awaiting trial—without the disguise—Angela was referred to by some media as a "nappy-headed, big-mouthed firebrand," according to her attorney.

Un huh, the N-word.

Angela Davis, circa 2006.

When denied bail because hers was a capital case, Angela's imprisonment sparked a national Free Angela campaign. The public lent their support by wearing tees, buttons, and large Afros, and by protesting in the streets.

Several musicians also supported Angela, including John Lennon and Yoko Ono, who recorded a song called "Angela." Likewise, the Rolling Stones recorded "Sweet Black Angel," written by Mick Jagger and Keith Richards.

In a 2018 interview Keith Richards talked to *Harper's Bazaar* about the motivation to write the song, saying, "We had never met her, but we admired her from afar." After reading the article, I couldn't help but wonder, where was Black America back then?

Where were the songs of support written for and about Angela from the Afro-wearing musicians who had copped her hairstyle with claims that they supported her but did little or nothing beyond just talk? Where was Sly? Where was Billy Preston? Where was Roberta Flack?

I later deduced it's likely that the record labels for these Black artists might not have been as open to letting them advocate for a Black artist in the same way the hippy-loving, straight-haired white artists could. To just record and release songs like "There's a Riot Going On, Stand!" (Sly & the Family Stone) and "War" (Edwin Starr) was probably a big ordeal. It could also be that few Black artists stepped up to the plate to publicly support Angela for fear of being associated with the Communist Party, to which Angela was affiliated.

However, there was one true soul sista who had no problem publicly lending her support.

In 1970, Aretha Franklin offered to put up as much as $250,000 for Angela's bail, which in today's currency would be close to $500,000. Even though she'd never met Angela, Aretha was willing to go up against her preacher

> ## "Angela Davis must go free. Black people will be free . . . if there is any justice in our courts. . . . Not because I believe in communism, but because she's a Black woman and she wants freedom for Black people."
>
> —ARETHA FRANKLIN, *JET*, DECEMBER 30, 1970

father's concerns to support the Afro-wearing activist despite her communist ties.

When Angela's bail came up, Aretha was out of the country, and her money could not make it in time. But Angela never forgot the gesture of R-E-S-P-E-C-T coming from the Queen of Soul.

Angela's eighteen months behind bars ended with an acquittal on June 4, 1972, by an all-white jury. She was found not guilty of the three charges of kidnapping, conspiracy, and murder.

Though Angela actively participated in the struggle against Black oppression, she was not what one would consider a violent revolutionary. Still, her 'fro became the symbol of militancy for an entire race.

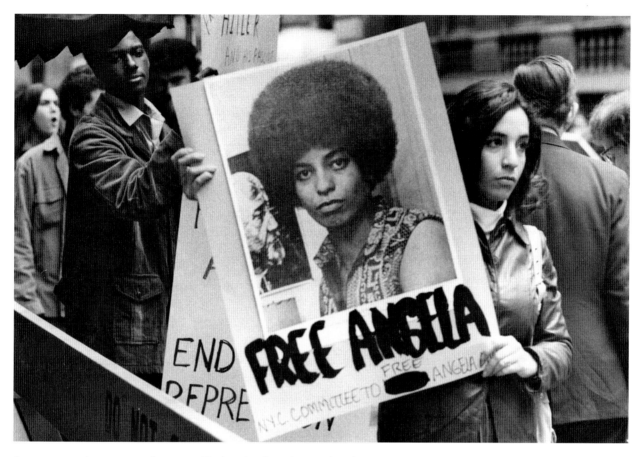

Protestors march in support of seventies Black civil rights advocate Angela Davis.

In her "Afro Images" essay, Angela revealed that one of her biggest regrets was that, because of her presumed militant look, hundreds if not thousands of Afro-wearing Black women in major cities were accosted, harassed, discriminated against, or arrested by police, FBI, and immigration agents during the two months she spent underground, and for years after. I could relate!

I wish I had a picture of myself circa 1975 when I wore an Afro right out of high school. I can't say I was harassed for doing so, yet it was problematic when I recorded a TV public service announcement for the Ohio Rape Crisis Center back when I was looking to build my chops on air. I recall being excited about

the statewide distribution of the ad. But after recording the spot, the ad agency rejected it. They claimed that my brown-skinned, nineteen-year-old, medium-height, curly haired, Afro-wearing self looked too much like the three-shades-lighter-than-me, thirty-something, huge 'fro'd Angela Davis.

Really?!!

Honestly, I never felt the Afro was a good fit for me—aesthetically speaking. But I was between a rock and a hard place like so many women.

If you didn't wear a 'fro back then, you weren't "Black enough." Wear it—"You're a radical." Or, in the case of actress Marsha Hunt, if it looked impressive, you could ultimately become a poster girl.

The Poster Girl of the Black Is Beautiful Movement

Long before Angela Davis's 'fro got plastered on walls of post offices around the country, the Afro was having a moment among woke Black people as a rejection of white beauty standards and a symbol of Black pride and self-esteem. The style became especially popular once embraced by singer-activists like Abbey Lincoln, Odetta, and Nina Simone.

Soon after the Black Power movement folded into the Black Is Beautiful movement, a Black actress named Marsha Hunt was cast in the original Broadway hippie counterculture rock musical *Hair*. It was 1968. She had only a few lines in the play that mesmerized audiences with its nudity, profanity, and free love and antiwar themes, but it was her Afro that made her a star. Marsha's perfectly rounded 'fro impacted audiences and inspired the double-headed artwork for the playbill.

Posters with the Afro art soon followed, then all manner of advertising. Once the poster art popped up in newspapers, magazines, and billboards nationwide, Marsha's 'fro became as iconic as the play itself.

Some say Marsha and her Afro were also the inspiration behind the Rolling Stones song "Brown Sugar," written by Mick Jagger—the father of Marsha's only child and Jagger's first—although, depending on who you ask, the muse for that song is still open for debate.

The same year *Hair* premiered on Broadway, the Black community was devastated by the assassination of Rev. Dr. Martin Luther King Jr. It was time for a new anthem and the crowning of a new era.

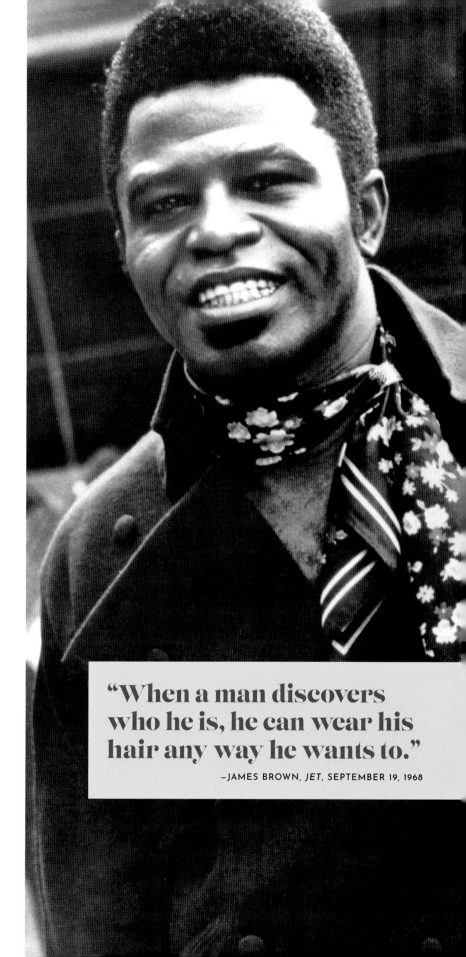

Opposite page left: *Vogue,*
January 1, 1969, portrait of
singer and writer Marsha Hunt
with her hands up to the sides
of her trademark Afro hairstyle.

Opposite page right: *Hair,*
1968-72 Broadway poster.

Right: James Brown sporting
an Afro instead of his
signature slicked-back
style, 1960s.

Say It Loud!

In August 1968, the Godfather
of Soul, Mr. Dynamite, Soul
Brother Number One, the Hardest
Working Man in Show Business
dropped his hit record, *Say it
Loud, I'm Black, and I'm Proud.*

James Brown hadn't been very
active in civil rights up to that
point, but once he got woke and
his single climbed to the top of the
Billboard chart, he transitioned
away from his signature processed
hair for a short time to don an
Afro. Why? So that he could set
an example for young brothers
who wanted to be like him. Brown
also instructed every man in his
band to wear a 'fro as well.

> **"When a man discovers
> who he is, he can wear his
> hair any way he wants to."**
>
> —JAMES BROWN, *JET,* SEPTEMBER 19, 1968

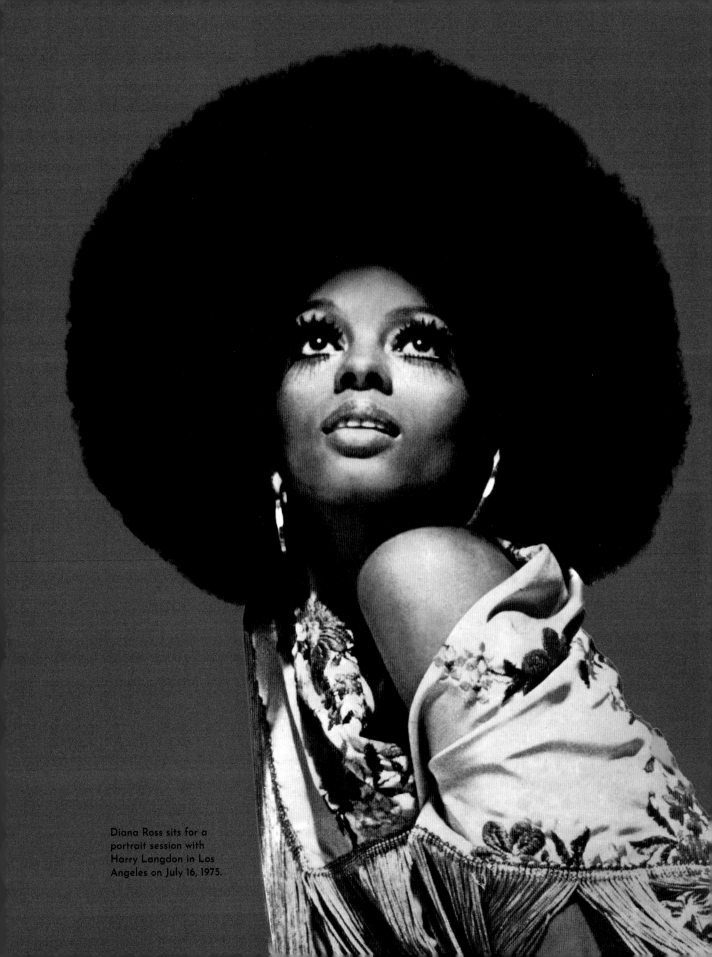

Diana Ross sits for a portrait session with Harry Langdon in Los Angeles on July 16, 1975.

Moving into a new decade, the Afro remained fashionable but had begun to lose its political and revolutionary swag. So, the Godfather retreated to his slick-backed signature style. But many Black people continued to embrace the 'fro for style's sake.

Photographer Harry Langdon's iconic photograph of an Afro'd Diana Ross is still one of the most stunning Afro images of the era.

Diana Ross's 'fro is significant because, for a long time, the Supremes were known for popularizing the "mile high" straight-haired bouffant wigs that were more acceptable to the crossover audiences they were trying to attract. But when white notables like film critic Gene Shalit, singer Art Garfunkel, and actors Gabe Kaplan and Barbra Streisand started sporting their versions of the style, it was looked upon as more of a fashion statement than politics.

On the big screen, however, Black exploitation films tried to keep much of Afro militancy alive in what I call Militant Lite. Once Afros, big and small, popped up in **Shaft**, **Foxy Brown**, and **Cleopatra Jones**, the style became synonymous with Black ass-kicking.

On the small screen, the FCC set limits on what could be beamed into households. So Black characters on TV who wanted to show they were as hip and raw as "the cat who won't cop out when there's danger all about"—but couldn't use profanity or be as violent—relied on their Afros to send the signal that they were badass! Linc, the original "undercover brotha"—played by Clarence Williams III on the groundbreaking *Mod Squad*—is one of the best examples. Without a doubt, he had one of the hippest Afros on TV back in the day.

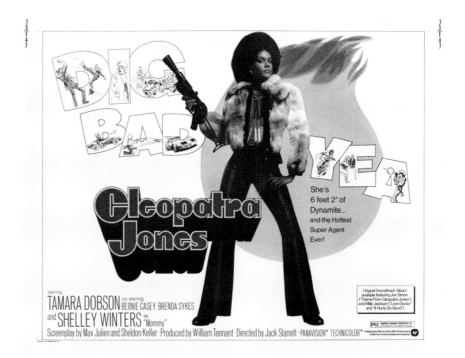

Cleopatra Jones starring Tamara Dobson, released in 1973.

161

Print ad from the
1970s for Afro Sheen,
a Johnson product.

Then, thanks to *Soul Train*—the hippest trip in America—we were exposed to a watering hole of sorts for the baddest parade of Afros on TV.

The iconic syndicated TV dance series that targeted a young Black audience launched in the seventies to rival the popular *American Bandstand*. A brainchild of former deejay Don Cornelius, the show featured Afro-wearing teens dancing to recorded music and live performances that ranged from Al Green and Gladys Knight & the Pips to the Jackson 5 and Rick James.

Like most teens of that era, I'd get amped for the *Soul Train* line, where the latest fashions and the biggest Afro styles were on full display. And, of course, what would *Soul Train* be without its number one sponsor, Johnson Products—the pioneering Black hair company and makers of Afro Sheen?

Don Cornelius, the creative genius behind *Soul Train*, shared with me in a 2000 interview

for a series of specials I did for TV Land called *African Americans in Television* that the Afro Sheen commercials helped elevate *Soul Train* to a national audience.

My favorite was the TV ad that featured a young brotha with an unkempt 'do getting ready for school. He hears a knock at the door, opens it, and sees the abolitionist Frederick Douglass standing there with his white beard, mustache, and 'fro parted down one side.

"Are you going to go out into the world with your hair looking like that?" Douglass asks.

The young student tries to school the scholar about how times have changed since the 1800s. "We wear the natural now," he explains.

"You call that a natural? That's a mess!" Douglass responds.

The commercial was hokey and hilarious at the same time! But the serious message Douglass imparted to the student, in the end, is even more relevant today.

"Our natural hair is an outward expression of our pride and dignity," Douglass explained. The student eventually heeds Douglass's words and reaches for his Afro Sheen—the one product we couldn't do without.

It was an iconic commercial for an iconic brand, and though Afro Sheen was touted as a product to keep our 'fros looking well-groomed, there was a misconception that it would make the Afro grow fast and large, which a lot of people I know believed to be true.

Having the biggest Afro was a badge of honor, which is why Afro Blow Out Kits started saturating the market.

Aevin Dugas never needed an Afro Blow Out Kit. Never! The 2022 US record holder for the Biggest Natural Afro by a Female in the Guinness Book of World Records came by hers "naturally."

Oh yeah, it was big! I'm talking Esperanza Spaulding, Erykah Badu, and Colin Kaepernick's 'fros all wrapped up into one big one!

Beating her own 2010 and 2021 records, Aevin's 'fro in 2022 measured 9.84 inches tall, 10.24 inches wide, and 5.41 feet in circumference. That's a lot of hair!

"I didn't decide to grow an afro as much as I decided to go natural," she told Guinness World Records. "It's about pride in textured hair, which leads to self-love."

I'm sure Aevin will be one of the first to tell you that to maintain your 'fro, you gotta pick it!

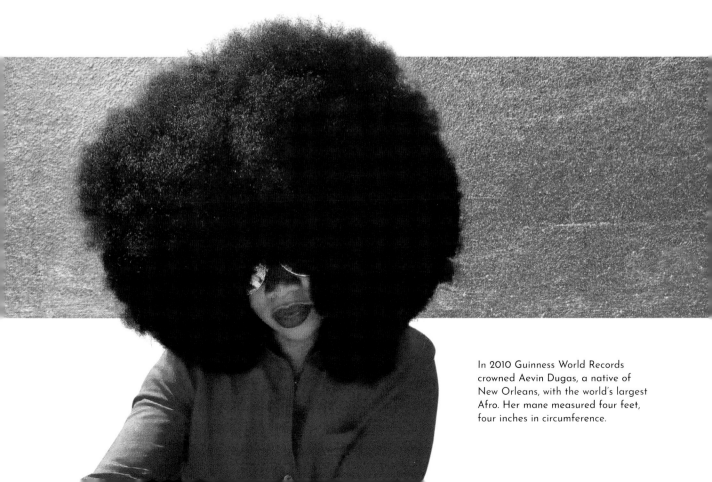

In 2010 Guinness World Records crowned Aevin Dugas, a native of New Orleans, with the world's largest Afro. Her mane measured four feet, four inches in circumference.

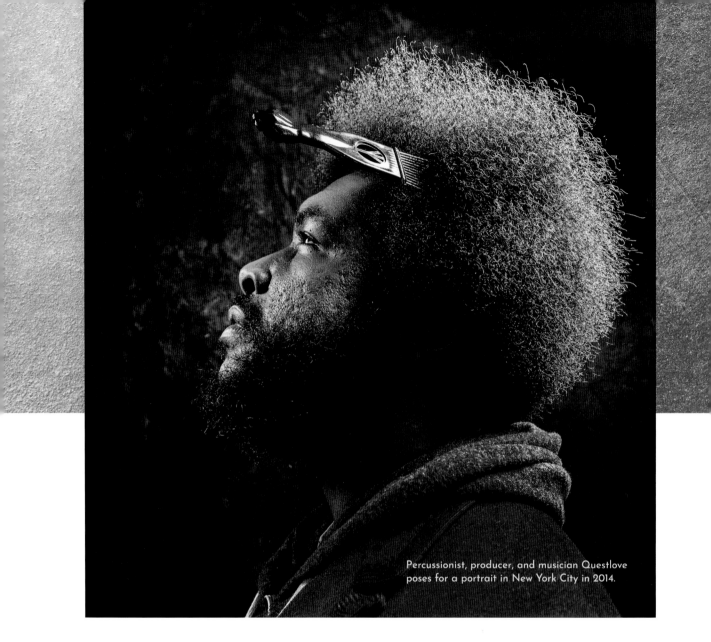

Percussionist, producer, and musician Questlove poses for a portrait in New York City in 2014.

Erykah Badu was the first artist I heard offer up that advice when she freestyled, "You need to pick your afro, daddy, because it's flat on one side . . ." on her 1997 "Afro" release. She was right. Besides, what's an Afro without the proper care tool?

Take Your Pick

Roots drummer Questlove has rocked a 'fro for as long as I can remember, and that includes accessorizing it with his ever-present Afro pick.

In a 2016 interview with the *New York Times*, Quest stated that he never intended for his Afro pick to be "his thing." But it definitely is. So much so that when he started his longtime gig on the *Tonight Show*, they ordered him four thousand Afro picks, which he mostly gave away to fans. Lucky them!

The Afro pick is so iconic that visual artists are finding creative ways to pay homage to what was once a grooming necessity.

In 2007, photographer Lauren Kelley created *Pickin'*, a self-portrait art piece made up of

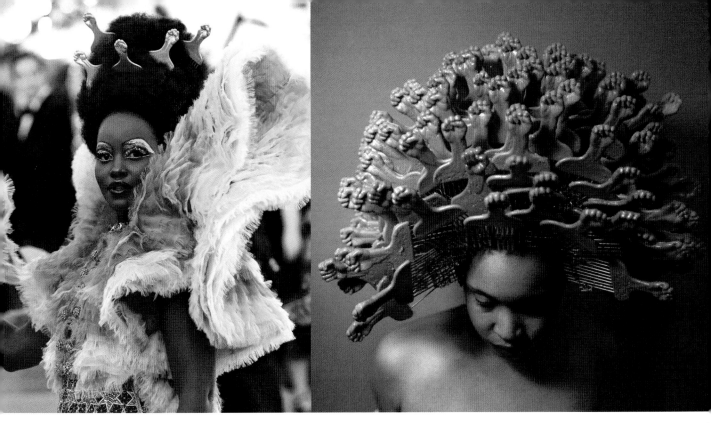

Lupita Nyong'o attends the Metropolitan Museum of Art's Costume Institute benefit gala celebrating the opening of the *Camp: Notes on Fashion* exhibition in New York, May 6, 2019.

Lauren Kelley's self-portrait *Pickin'* (2007) was part of *Posing Beauty*, an exhibit of photographs from three centuries at Northwest African American Museum in 2016.

dozens of Afro picks that fully covered her natural Afro.

She used only picks that were a similar shade of brown as her skin and the background. All the picks have fist-shaped ends as a nod to the Black Power movement of the sixties.

It's an amazing look you don't see every day—unless, of course, you frequent the Met Gala where Lupita Nyong'o beautifully flaunted the style.

Though Lupita Nyong'o slayed in her dress at the 2019 Met Gala, it was the Afro picks in her hair that got the most attention. So why did she choose the look? Was it for fashion, or was there a deeper meaning? Well, let's see—President Trump was in office then. There was a new wave of murders of unarmed Black people by police. We were living in a new Black Lives Matter environment. Hmmm.

After seeing Lauren Kelley's *Pickin'* art, Lupita's stylist Vernon Francois chose to adorn Lupita's towering Afro with five golden picks— complete with Fight the Power raised fist handles—to represent unity, solidarity, and Black Power at a time America needed the message most.

Interestingly, the roots of the Afro pick and Afro comb go deeper than the Black Power movement of the sixties.

The Fitzwilliam Museum in Cambridge, England, devoted an entire exhibit to cultural styling tools ranging from the predynastic period of Egypt to the twentieth century in the UK and US, including modern-day black fist combs referencing the Black Power movement. The exhibit also includes oral histories and personal testimonies that document attitudes toward hair and grooming in the present day.

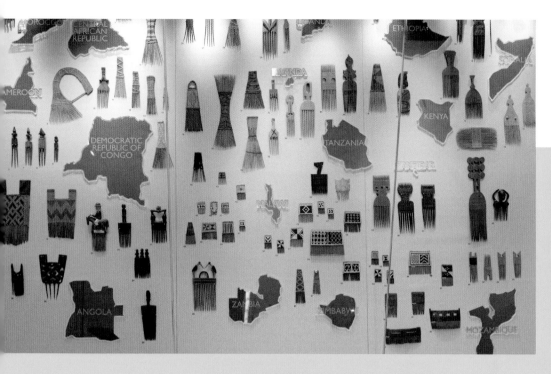

Installation photograph of a display in the *Afro Combs* exhibit at the Fitzwilliam Museum.

The oldest comb from the collection dates back more than 5,500 years, revealing how the pick and Afro comb carried a different meaning and purpose than we know today.

In northern Egypt, when women held the title of pharaoh, the Afro comb was used as a decorative hair dress made of gold. The significance of the comb was to show nobility; its markings depicted familial history. Because many northern African women around Egypt and Morocco wore sleek styles, braids, or wigs over braids (protective styles), the Afro combs were status accessories. Likewise, in western Africa, Afro combs remained a symbol of decoration among the tribes and were sometimes offered as gifts. They were primarily handmade with creative handles, representing the uniqueness and vibrancy of the culture and the tribes.

When the estimated twelve million Africans were taken from Africa between the sixteenth and nineteenth centuries due to the transatlantic slave trade, they took many African customs with them, including their specially designed combs.

Here's the rub—enslavers took away enslaved people's combs and wouldn't provide any other grooming items to care for our uniquely textured hair, which had been matted and mangled while on the many monthslong journeys. This was the enslavers' first attempt to strip us of our culture. But check this out—our clever ancestors started creating their own products and tools from whatever resources they could find.

It was more than three hundred years before the Afro comb was made commercially in the US. Teeth on fine-toothed combs weren't wide enough to go through our textured hair, so you can imagine the psychological impact that had on young kids who were left to believe something was wrong with their hair.

The Fitzwilliam had hundreds of these handmade combs and picks in its exhibit. From one of the earliest picks to one we know all too well from the sixties and even today, with its tightly fisted Black Power handle.

While most Afro picks are lightweight, durable, and made of plastic, I spied one in

Philly that weighed over eight hundred pounds. Oh yeah! And get this—it wasn't in a museum.

Imagine a construction team trying to mount an eight-foot-tall Afro pick with a power fist cast in aluminum, spray-coated in a high gloss black, with stainless steel teeth.

The pick designed by Philly native Hank Willis Thomas was initially mounted in his hometown, then later in other major cities, including Atlanta, Harlem, and Washington, DC.

"Why?" you ask.

All Power to All People was a public art intervention created to deal with racial identity and representation in Philadelphia. The artwork derives from a rallying call popularized in speeches by Black Panther Party activist Fred Hampton, who was later murdered in a raid by local and federal authorities in Chicago. In creating the massive structure, Willis Thomas stated in a press release that he wanted it to "highlight ideas related to community, strength, perseverance, comradeship, and resistance to oppression."

The pick mounted in DC coincided with the fifty-seventh anniversary of the March on Washington for Jobs and Freedom and was the largest at twenty-eight feet.

"We were looking to celebrate Black beauty and Black power," Willis Thomas said. "This sculpture symbolizes D.C., once known as Chocolate City—and a way to show the

All Power to All People
© 2017 Hank Willis Thomas, Thomas Paine Plaza; *Inset*: Installation of Hank Willis Thomas's *All Power to All People*, September 12, 2017.

Reggae singer Bob Marley, 1976.

monumental contributions of African Americans to this country with its growth and political evolution."

Though the Afro hairstyle generally requires a pick to maintain the look—especially in the sixties and seventies—not every natural Black hairstyle requires one—or even a comb, for that matter.

Dreadlocks, Locks, Locs, Ras

Almost as popular as the Afro was in the sixties and seventies, dreadlocks are one of the most favored natural hair looks in the 2000s era of Afrocentric style.

Ava, Lenny, Lauryn, Lisa, Whoopi—all the one-name notables have at one time adopted and rocked the look as their signature style.

I actually hate to call them dreadlocks because it suggests negativity that the style itself

gets enough of without it coming from the name. More often, they are referred to as "locs."

For the uninitiated—locs are essentially sections of hair that haven't been combed, brushed, or handled. Over time the hair becomes matted and knotted into itself, forming a look that most die-hard loc wearers consider to be more than just a style but an attitude, a way of life, and a symbol of Black expression.

The origins of locs are a little fuzzy and have been debated for centuries. In religious circles, they're said to have biblical roots—dating back to Samson in the Old Testament. The belief is that when his "locks of hair" were cut off by Delilah, he lost his incredible strength.

In Africa, locs were worn by warriors as a symbol of power. One version of the roots of "dreadlocks" coming out of the continent stems from when Ethiopian guerilla warriors refused to cut their hair until after their leader, Haile

Selassie I—the former emperor of Ethiopia—was released from exile. By not combing their hair, it became matted. As such, their hair and the overall look became "dreaded."

In the 1980s, Jamaican reggae artists Bob Marley and Peter Tosh of the Wailers were attributed with popularizing locs in mainstream America. They wore them to symbolize identity and devotion to spreading the Rasta philosophy.

In his song "Rastaman Live Up," Marley encouraged:

"Grow your dreadlocks. Don't be afraid of the wolfpack."

In *Twisted: My Dreadlock Chronicles* by Bert Ashe, novelist and social activist Alice Walker shares how she credits Marley with introducing her to the idea to "trust the universe enough to respect my hair." After watching him and Tosh perform, Alice had questions about how they maintained their locs and even what they smelled like. But her true obsession with the style grew while filming the original version of the film *The Color Purple* (released in 1985—not to be confused with the second film adaptation of the novel released in 2023) based on her award-winning novel, for which she won the Pulitzer Prize for Fiction. In a foreword to Francesco Mastalia and Alfonse Pagano's book *Dreads*, Alice Walker writes about how she saw an actress on *The Color Purple* set pull off her cap that had hidden her dreads. Alice watched intently as the

locs cascaded down her body, "soft and springy." From then on, she was hooked. Alice started growing her own. Small at first, sometimes long, more often comfortably just above shoulder-length.

Whoopi Goldberg, who starred as Celie in the original *The Color Purple*, didn't wear full-on locs back then, just matted braids. But, in the long run, locs became her fashion style. When she first started wearing them in the mideighties, they were still closely associated with Jamaican Rastas and rebellion. She is credited with helping to break those stereotypes and has been wearing them ever since.

Whoopi Goldberg during the footprint ceremony at Mann's Chinese Theatre in Hollywood, February 2, 1995.

Whoopi even had her locs famously enshrined at Mann's Chinese Theatre in Hollywood during her footprint ceremony on February 2, 1995.

Zendaya, who made history in 2022 by winning her second Lead Actress in a Drama Series statuette at the seventy-fourth Primetime Emmy Awards, was subjected to not-so-flattering remarks on live TV about her gorgeous locs—referencing them as smelling like patchouli oil or weed—while on the red carpet for the 2015 Oscars. But that didn't stop the then eighteen-year-old from snapping back online and silencing her detractors.

Whoopi's handprints, footprints, and dreadlocks in cement at Mann's Chinese Theatre, Hollywood.

Zendaya Coleman on the red carpet at the eighty-seventh annual Academy Awards held in Los Angeles, 2015.

"There is a fine line between what is funny and disrespectful. . . . Someone said something about my hair at the Oscars that left me in awe. Not because I was relishing in rave outfit reviews, but because I was hit with ignorant slurs and pure disrespect."

—ZENDAYA, INSTAGRAM, FEBRUARY 23, 2015

For many "dread heads"—as they often call themselves—locs are worn to symbolize cultural pride in the Black community. According to *Dreads*, it is a way of "freeing themselves figuratively and literally from the dictates of Western European fashion." But then look what happened—white folks started wearing them, opening a whole other can of worms. Tense physical encounters have broken out over

Rihanna in character as Nine Ball in the film *Ocean's 8*.

Halle Bailey as Ariel in *The Little Mermaid* (2023), directed by Rob Marshall.

whether it's okay to wear what Black people consider a cultural style that only Black people should wear. To that, non-Black people say, "Then stop appropriating our straightened hairstyles." Touché! Which side of the debate are you on?

Rihanna is one artist who chose to "show," not "tell," how she felt about keeping the cultural tradition of wearing locs alive.

In an October 2016 selfie she posted on Instagram, Rihanna shared with her 44.6 million followers her well-below-the-waist faux locs—

a preview of the look she chose to slay for the role of Nine Ball in her new movie *Ocean's 8*, which was filmed in the fall of 2016.

Nine Ball, whose real name is Leslie Jordan, is a pool shark and a technical genius from the islands. An island girl herself, Rihanna knew she could handle the accent and was confident of her acting chops but insisted on the faux locs to visually reinforce her character's ties to Africa and the Caribbean.

Rihanna's locs played a big part in who the character became. She wore them like a crown of pride as most loc wearers do.

Halle Bailey, Disney's first Black Ariel, wanted to stay true to her Black heritage for the 2023 film. Sooo—she requested that she keep her long locs. No wig. No straighteners. The producers supported her desire even though getting the right shade and maintaining her locs to withstand being underwater added a whopping $150,000 to the budget.

Locs are without a doubt cool and cultural. But for some—in the words of poet Geoffrey Chaucer—"All good things must come to an end."

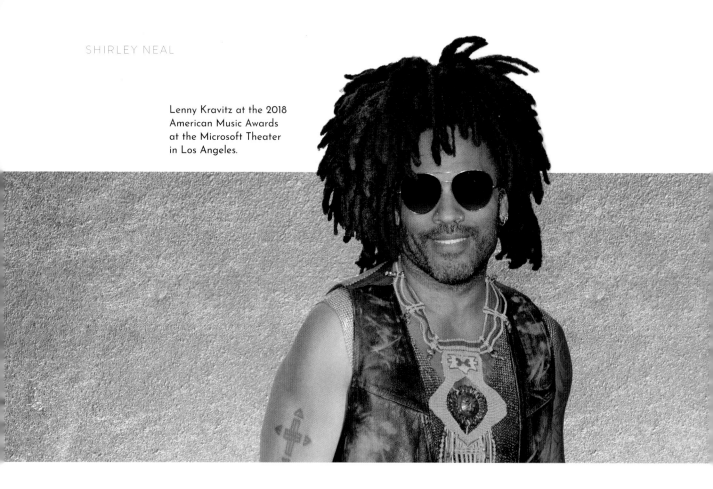

Lenny Kravitz at the 2018
American Music Awards
at the Microsoft Theater
in Los Angeles.

The Big Chop

In 2016, The Weeknd surprised us all when he
chopped off his signature dreadlocks.

**"It was actually very
uncomfortable. I could only
sleep on one side of my face.
Now the sleep is amazing, the
shower is amazing because I
don't have to spend two hours
cleaning it. I didn't know how
much I wanted it until I did it."**

—THE WEEKND, *THE WALL STREET JOURNAL*,
NOVEMBER 2, 2016

Actress Zoë Kravitz proudly sported her
signature locs for years. She shared in a 2023
Elle interview that during the pre-George Floyd
era she was asked to "do something else" with
her hair when cast in projects, to which she
replied, "No. Just pretend this is the way it grows
out of my head." Wearing locs was a family
affair in the Kravitz household until Zoë's mom,
Lisa Bonet, told her ex, music dread head Lenny
Kravitz—who'd worn them off and on for years—
that it was time to change his energy.

In an interview for GQ, Lenny tells the story
about how Lisa grabbed a razor blade, stood
in front of him, and gave him the Big Chop. He
called it an "emotional release" that allowed him
to let "stuff" bound up in his hair go and start
with a clean emotional slate.

Interestingly, in Indonesia, the ritual of cutting
dreadlocks takes place in the first month of

Jaden Smith at
the Metropolitan
Museum of Art's
Costume Institute
benefit gala, 2017.

the Arabic calendar. The belief is that it rids children of bad luck, disaster, and danger in the future. Here in the States, many celebs have different reasons and methods for their Big Chops. For cause, convenience, and sometimes a necessity.

Rapper Jaden Smith publicly had his locs cut online by his superstar dad, Will Smith, before heading to the 2017 Met Gala.

Tellingly, people wear wildly creative looks at the fundraiser that benefits the Metropolitan Museum of Art's Costume Institute in New York City. But we didn't expect to see Jaden carrying his freshly severed blond-colored locs as a fashion accessory.

The gesture was eyebrow raising for sure, but Jaden didn't do it solely for shock value. He did it to promote a role in his new film *Life in a Year*.

Younger sister Willow Smith wasn't sporting locs when she went for the Big Chop on a public stage—literally. She made headlines in March 2020 when she chose to lock herself in a glass room at the Geffen Museum of Contemporary Art in Los Angeles for twenty-four hours. Then, instead of whipping her hair as she did in her hit music video, she had it cut off by her music collaborator Tyler Cole. Mom Jada captured the act on video and posted it online for the rest of the world to see.

Willow's Big Chop wasn't as crazy as it sounded. The performance art piece that was a prelude to her *The Anxiety* album was also the conclusion to a larger exhibit meant to demonstrate the eight emotional stages of anxiety: paranoia, rage, sadness, numbness, euphoria, strong interest, compassion, and acceptance.

Young wrestler Andrew Johnson, who goes by Drew, has his locs cut in lieu of forfeiting a match in 2018.

For sixteen-year-old Andrew Johnson, keeping his locs wasn't an option.

In 2018 the Black high school varsity wrestler from New Jersey was told to cut his dreadlocks or forfeit the match. It was an important meet and Andrew wanted to compete. So he made the difficult decision to get into the game—fully aware of the consequences.

Twelve million viewers worldwide watched on YouTube and Twitter as a person who was not Andrew's mother, father, or even Black for that matter followed the orders of a white referee—with an alleged history of racist behavior—and cut Andrew's locs.

The Black Twitterverse exploded with accusations of abuse of power and racism. Big names in Hollywood joined the "Don't Touch My Hair" conversation that the incident sparked, including the proud loc-wearing filmmaker and social justice activist Ava DuVernay.

Ava wasn't just blowing smoke. She took her rage and support further than most by posting pictures of herself proudly wearing her long, lovely locs and inviting others to post snaps of themselves under the hashtag #loclife.

Call it karma or poetic justice, but the referee who called for Andrew to cut his *hair*-itage lost something too—his job. He got banned for two years. Well, there you go! Does this remind anyone else of the Bible verse, "What one meant for evil, God meant for good?"

Another one of the most publicized chops in Afro pop culture history had a sad beginning but a happy ending.

WNBA star and two-time Olympic gold medalist Brittney Griner was easily recognized by her signature locs that cascaded in the air with every dunk and sprint down the basketball court.

But after her arrest in Russia at Sheremetyevo Airport for allegedly transporting marijuana

vape cartridges in her luggage, Brittney endured a 294-day detainment in a Russian prison where she cut her lovely locs—but not for punishment's sake. No, no. It was Brittney's choice because they supposedly kept freezing in the showers, making prison life even more difficult.

So what's the good ending here you might ask? Once released from prison in 2022, after a prisoner swap for Russian arms dealer Viktor Bout had been negotiated, Brittney signed a one-year contract to reup with the Phoenix Mercury, where she had the luxury and FREEDOM to wear her hair any way she chose. She decided on a striking short cut with a slight fade on the sides.

Brittney Griner (center) playing for the Phoenix Mercury at Talking Stick Resort Arena in Phoenix, Arizona, June 14, 2019.

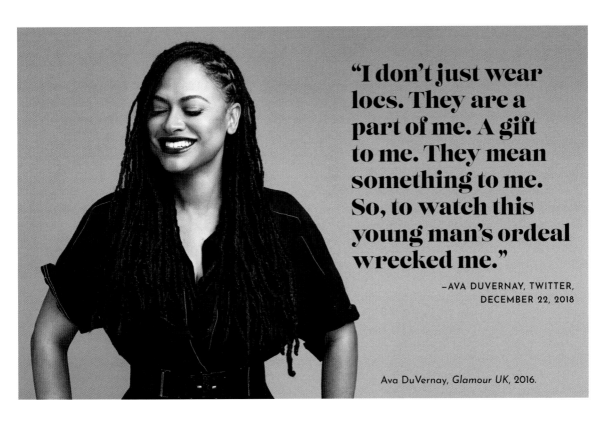

"I don't just wear locs. They are a part of me. A gift to me. They mean something to me. So, to watch this young man's ordeal wrecked me."

—AVA DUVERNAY, TWITTER, DECEMBER 22, 2018

Ava DuVernay, *Glamour UK*, 2016.

Heidi Klum out and about in New York with her son Henry Samuel.

Of course, I can't leave this area without revisiting the hair-chop pop story that blew up big time in 2013 when Heidi Klum made headlines by sharing how she keeps her biracial children's Afro hair in plastic bags after she cuts it. Nothing odd about that. Consistent stats show that it's one of the most common keepsakes of parents, with 71 percent reporting they collect it to show their children later in life.

What made Heidi's comments so newsworthy is that after revealing that she saved the hair of her kids she had with her ex, Seal, because she felt it was so beautiful, *The Talk* cohost Sheryl Underwood went on a tasteless unfunny comedy rant about Heidi's actions.

On live TV, Sheryl asked her cohosts, "Why would you save Afro hair? You can't weave in Afro hair."

The conversation got worse. Embarrassingly worse.

Sheryl added, "No one walks into the hair place and says, 'Look here, what I need is curly,

nappy, beady hair.' That just seems nasty."

Her rant got a laugh or two—mainly from Sheryl herself. But there was a lot of internet backlash.

Making fun at the expense of our culture is never a good idea.

But I say, don't hate too hard on Sheryl. Many of us have these hang-ups about this good hair versus bad hair myth. Think about how many times you've heard a Black person say to the Black parent of a newborn baby, "Oh look, she's got that good hair!" But they go silent once that same "good" baby hair kinks up in about three or four years.

And how about that old ruler test from the seventies and eighties where if your hair was not as straight as a ruler, you couldn't get into a particular church? Trust me, I'm not making this stuff up. Or the comb test that stipulated if you couldn't get a small tooth comb through your hair, you weren't allowed to join specific groups?

No, internal hair discrimination didn't start with Sheryl. What bothered us the most was that Sheryl mocked our kinky crowns in public and wouldn't let up as she sat there wearing a straight hair weave.

Of course, Sheryl was wrong, and she knew it, which is why she countered her claims on the 2015 premiere episode of *The Talk*. I'm not quite sure why it took two years to make the apology and why cohost Julie Chen read it—but at least it came.

That episode also gave us our first look at the wig-wearing Sheryl's natural hair, which she revealed at the top of the hour and wore throughout the show.

And yes, Sheryl looked great, exposing her natural crown.

There's the short chop and then there's the SHAVED.

Remember when R&B singer-songwriter India.Arie used her "I Am Not My Hair" song to make the point that all Black hair is beautiful and shouldn't define us? Well, in 2006, at the BET Awards, she took the message one step further by shaving her head. It was her way of emphasizing that though hair is a woman's crowning glory, we are still queens without it.

Then to clap back at haters, she added a cute little drawn-on curl on her forehead.

In Africa, shaved heads with designs were used to send messages, usually about status, like "I am single." Sometimes, the meanings behind the designs were only known within a particular tribe.

What kind of message do you suppose *Insecure* star Yvonne Orji was sending when she shaved a Black Power fist symbol into her hair ahead of her video appearance at the 2020 Emmy Awards?

Yvonne's 'do drew attention to the fact that it was hunting season for Black people and time to fight the powers that be.

Not only do Black pop icons do the chop or shave for choice or cause but also to satisfy a plotline in a motion picture. Like when Sanaa Lathan buzz cut her locs to play the title character in the Netflix flick *Nappily Ever After*—which she described to *Entertainment Weekly* in 2018 as "a love story about falling in love with your own unique self and your own unique beauty."

And then there are those who make the chop or shave for health reasons.

By now, most everyone knows the journey of Willow and Jaden's mom, Jada Pinkett Smith, who openly shared her bout with alopecia with the world. The disease, which causes hair loss

India.Arie at the BET Awards in Los Angeles, on June 27, 2006.

Yvonne Orji getting ready for the virtual Emmys, wearing a Black Power fist shaved into her hair in 2020.

> **"My twists have become such a synonymous and a conflated part of not only my personal identity and how I show up in the world, but my political brand."**
>
> —US REP. AYANNA PRESSLEY (D-MA), *THE ROOT*, 2020

when the body attacks its own hair follicles, is what led her to sport a bald look once her hair began to fall out.

That infamous slap her husband, Will, gave to Chris Rock onstage at the 2022 Oscars is how many people around the world first became aware of the disease even though Jada had openly revealed her alopecia diagnosis two years earlier. Then in 2022, Jada took to Instagram to share more of her alopecia story in a post that got almost two million views.

I first learned of the disease from a 2016 Black women's health study conducted at my alma mater Boston University's Epidemiology Center that surveyed 5,594 Black women, of which 47.6 percent reported hair loss from alopecia. The cause? Mostly from tugging at our roots to don our favorite hairstyles.

Hair in the House

When we got our first glimpse of US representative Ayanna Pressley's tightly coiled Senegalese twists, which she'd worn for years before moving into the House, we absolutely loved them. In a 2020 video she recorded for the *Root*, she shares that she knew that her hairstyle might be seen as a "political statement that was militant," but that didn't stop her from wearing them with pride. Her coils even inspired young Black girls who wore tees that read "My Congresswoman Wears Braids."

But then, one day, the congresswoman noticed her hair was shedding faster than usual. The night before the House of Representatives voted on articles of impeachment against President Trump, Pressley's last bit of hair fell

Rep. Ayanna Pressley (D-MA), who revealed she has alopecia, debuted her bald head in January 2020.

out. In a video interview with the *Root*, she shared how she'd worn a wig the day of the vote on December 18 but hid in a bathroom stall feeling exposed and vulnerable.

At first, the congresswoman chose to keep her baldness a secret. But then she started to worry about all those little girls inspired by her twists. So she went public with her story.

During that same *Root* interview, Representative Pressley took a bold step. She stripped off her wig to reveal her baldness to the public. When I first saw the video, I thought, *Whoa!* Then I shouted, "BRAVO!!!" Her move was a huge step for womankind!

The congresswoman's new look was so drastic, she had to update her official photo ID to be recognized by security staff. Her post on Insta got Michelle Obama-level likes in just one day.

In an equally heroic hair-gone move, sixties hair icon Marsha Hunt—best known for her huge Afro used to pattern the artwork for the Broadway musical *Hair*—found herself unexpectedly bald under different circumstances.

In 2004, after being diagnosed with breast cancer, she decided to shave her head bald before chemo destroyed the magic bullet that earned her the greatest fame.

Here's the thing, when you look at Marsha, Pressley, Jada, and other notable Black women who wear bald looks, it's evident that bald can be beautiful! And that's precisely what cover model Pat Evans tried to tell the world back in 1996 when she became one of the first Black women in pop culture history to shave her head for style and to confront white standards of Black beauty.

From the early days of her modeling career, Pat was troubled by the industry's preoccupation with straight hair and the pressure placed upon women of color to conform to white beauty values. So she figured that going bald would be the most vigorous aesthetic protest she could make. But with a failed marriage behind her and two small children to support, Pat still had to work. Fearing a shaved head on casting calls would hurt her chances, in *Black Beauty* Ben Arogundade quotes her as saying she kept her "cue ball covered with wigs." But then, one day, while trying on a dress at a Stephen Burrows runway show, Pat's wig accidentally slipped off. Busted!

To her surprise, Burrows liked her look so much that he asked her to keep it for the show.

Pat explained, "My agency would fire me if I took this wig off." But she did it anyway.

The bald beauty became an instant hit.

"I did all the TV shows, all the magazines," she said. "People were coming from Japan and Germany to photograph me." Pat appeared in *Vogue* and *Harper's Bazaar* and became the face of Astarté, a cosmetics line for Black women. Pat also became the muse of the R&B band the Ohio Players, who featured her on the covers of their suggestively titled

Model Pat Evans poses for photographer Anthony Barboza.

albums *Ecstasy, Pleasure, Pain, Climax,* and *Orgasm.*

But fashion's rejection of Pat's baldness, coupled with her stance on racism at the time, abruptly ended her career.

Flash forward to the 2020s, when other famous faces like Tiffany Haddish embraced the bald look and were applauded for their bald beauty. The actress credits the COVID-19 pandemic lockdown in 2020 for giving her time to contemplate the Big Chop—something she'd been thinking of doing for years. After posting her selfie online, Tiffany made it clear she didn't chop her hair off for public spectacle.

There were no hidden messages. She had no mental problem, and nothing was wrong with her brain. No emotional stuff going on. She just wanted to see what her scalp finally looked like.

Did she like it? Oh yeah! Women completely shaving their heads is nothing new in African culture. They have been doing it in Kenya for centuries, particularly the Maasai (also Masai) people—an East African tribe occupying southern Kenya and northern Tanzania.

Though the women are known to shave their heads bald, the Maasai men work to maintain hair length as a representation of power, protection, and masculine elegance—a role reversal of sorts.

"The best part is when water hits my head it feels like kisses from God."

—TIFFANY HADDISH, INSTAGRAM, JULY 18, 2020

Tiffany Haddish shows off her freshly shaven head in 2020.

While living in the motherland, our ancestors' intricate African styles were often elaborate and a source of pride that rivaled European styles. But then, throughout the Atlantic slave trade, enslavers used head shaving to strip the identity of our ancestors—to dehumanize and deprive us of our identities. Of course, that was centuries ago. By the late sixties in America, head shaving had become an exotic style choice—especially among Black men.

Maasai woman with child showing and selling traditional jewelry at a cultural ceremony near Maasai Mara National Park Reserve, Kenya, July 2, 2011.

Who can forget the sexy cue balls of singer, songwriter, actor, and composer Isaac Hayes and my dear friend Academy Award–winning actor Louis Gossett Jr.—the first sex symbol shaved-head brothas who paved the way to making bald heads acceptable in Hollywood. The real treat was when they were featured together in 1977 for an episode of *The Rockford Files*. It was the second appearance for Lou in the series, who wore a wig in the earlier episode to hide his receding hairline. But Lou sported his clean-shaven style full-time after teaming with the "hot-buttered soul" Isaac Hayes in the episode that served as a pilot for a spin-off series that never got off the ground. That move set the trend for other Black actors in Hollywood.

In his 2010 memoir, *An Actor and a Gentleman*, Lou tells of how he left a void in Hollywood for a bald Black leading man after he paused his acting career to deal with his substance abuse. Once he stepped out of the spotlight, in stepped the newly shaven

Academy Award–winning actor Louis Gossett Jr. (*right*) with Isaac Hayes (left) in a 1977 episode of *The Rockford Files*.

Samuel L. Jackson, who took the baton and never looked back.

By the seventies, it seemed that most of Hollywood's leading men, athletes, and TV stars were shaving their heads and sticking with it as their signature looks.

Evander Holyfield, Malik Yoba, Jim Brown, Ving Rhames, George Foreman. They didn't do it necessarily to make rebellious fashion statements. Some donned the look for easy maintenance. Others were trying to beat the thinning they couldn't control. But for most—they were just following what everybody else seemed to be doing.

I remember a time at the edge of the nineties and through the early 2000s after the trend had resurfaced—nearly every Black athlete in the NBA had his head shaved. From my seats at the Forum and the Staples Center, I observed a sea of baldness among the Showtime Lakers on the court. Kareem, Kobe, and Magic had all shaved their heads. Elsewhere in the NBA, there was Michael Jordan, Kevin Garnett, Charles Barkley—the list goes on and on.

For actor Cuba Gooding, who shaved his head for a role in *Jerry Maguire*, the look was more than just low maintenance and trendy— it got him an Oscar.

Sexy, sultry soul crooner Marvin Gaye shaved his head bald in 1975 to protest the treatment and controversial imprisonment of boxer Rubin "Hurricane" Carter. You know him, right? Carter was the middleweight prizefighter whose career was cut short when he was *wrongfully* convicted and imprisoned TWO TIMES for the same charges of fatally shooting two men and a woman in a Paterson, New Jersey, tavern in 1966. He served nineteen years before all charges against him were dropped in 1988, and he walked free.

Denzel Washington received an Academy Award nomination for his role portraying Carter in the 1999 movie *The Hurricane*. Bob Dylan wrote and recorded the song "Hurricane," which championed his innocence.

Though brother Marvin Gaye claimed he would keep his head shaved until Carter was released—that didn't happen. But at least he made the effort and even held a benefit concert to further support the boxer before his eventual prison release and exoneration.

Isaac Hayes and my dear friend Academy Award–winning actor Louis Gossett Jr. . . . paved the way to making bald heads acceptable in Hollywood.

Left: George C. Scott (*second from left*) and Cicely Tyson (*seated behind the desk*) in *East Side/West Side*, which aired on CBS from 1963 to 1964.

Right: Cicely Tyson's *Just As I Am* (2021) cover art.

Another pop icon who stunned us with her bald look is Cicely Tyson.

In 2021, she appeared with her head fully shaven on the cover of her memoir, *Just As I Am*.

The picture was taken in 1977 by photographer Lord Snowden while Cicely was in London to promote *Sounder*—for which she earned her first Oscar nod for her role as the wife of a jailed sharecropper.

In a 2014 episode of *Oprah's Master Class*, Cicely shares that before filming her role, she walked into a Harlem barbershop and asked the barber to shave her head so that she may better represent her character as she would

actually appear and not just how Hollywood imagined her. Now, flash forward forty-four years to a 2021 interview with *Newsday* where Cicely explains that she had forgotten about the photo until she started searching for cover ideas for her memoir. When she saw the photo with her shaven head, she told her book collaborator, "That's it. That will be the cover!"

Decades before her death in 2021, Cicely constantly changed the game of how we wore our hair on TV.

In 1963 she became one of the first Black actresses to have a recurring role on TV—playing a social worker on *East Side/West Side*.

"I got letters from hairdressers all over the country telling me that I was affecting their business because their clients were having their hair cut off so they could 'wear it like the girl on television.'"

—CICELY TYSON, *OPRAH'S MASTER CLASS* (2014)

#1 *NEW YORK TIMES* BESTSELLER

CICELY TYSON
JUST AS I AM

WITH MICHELLE BURFORD

The series was groundbreaking because it was the first to deal with America's growing racial problems. Cicely looked believable as a social worker in the community—not an actress playing one. She was Black, intelligent, classy, and proud. The writers were white, so the storylines weren't always authentic, but with Cicely crushing the role while sporting her baby Afro, she kept it "real," as they said in the sixties.

Not everyone supported Cicely's hair choice. In a 1972 interview with the *Boston Globe*, she shared that a handful of Black women found her hairstyle to be "embarrassing and humiliating" to Black women.

TV historian Donald Bogle writes in his book *Primetime Blues* that twenty-six southern TV stations refused to run the series because "a negro actress with a natural hairstyle was an integrated member" of the cast. According to producer David Susskind, CBS eventually dropped the show because "they just don't like it down there."

The South may not have liked the interaction between Cicely and her white costar, or her Black skin, but Cicely's coif was a hit for Black women in other parts of the country.

By the 1970s, when the trend of Afros, small and large, had ebbed, Black magazines like *Jet*, *Ebony*, and *Sepia* began running more photos of braid wearers on their covers. There was Cicely again, front and center sporting her Nigerian braided cornrows—the first to wear cornrows on TV.

In one of the many convos I had with Cicely, she complained about the intricate braiding process that took anywhere from six to ten hours out of her day for something that lasted just under two months. She admitted, "But it was

Cicely Tyson in Utrecht, Netherlands, 1973.

worth it. It got other Black women to do the same and appreciate our African traditions."

We can thank our West African brothers and sisters from Liberia, Ghana, Nigeria, Sierra Leone, and Senegal for bringing the styles and traditions that Cicely spoke about to the States, where they attracted a lot of Black pop culture icons.

The Braids & the Beads

We loved Janet Jackson's braids in *Poetic Justice*, Yvonne Orji's blond ones, Alicia Keys's orange ones, and Beyoncé's African-inspired ones in *Lemonade*. And who can forget that highly publicized pop culture moment when NBA bad boy Latrell Sprewell was getting his hair braided on a national TV commercial as he delivered his so-called message of freedom. Or when the Philadelphia 76ers NBA baller Allen Iverson's mom started braiding his hair midgame in the 2000s as he sat on the bench. LOL.

Then there were the braids adorned with beads. Cicely Tyson, Patrice Rushen, Stevie Wonder, Bern Nadette Stanis from the sitcom *Good Times*, and Solange donned some of the most striking braided bead looks. But the most memorable braids and beads styles came from two up-and-coming sister GOATs (greatest of all time) in the sports world.

The Compton, California–born Williams sisters were tennis and fashion phenoms on the court in the eighties, nineties, and for at least three decades later. It's only their hairstyles that have changed over time.

Who can forget their beaded loveliness when they first came on the international scene?

Back in the day, Venus and Serena Williams wore their colorful beaded braids to reflect a sense of Black pride and history. They followed in the footsteps of our precolonial African ancestors and wore beads and other hair ornaments as symbols of regalia and importance to the community.

During my 2006 visit to Kinshasa in the Democratic Republic of Congo, Africa, I witnessed women wearing some of the most

Venus Williams (*left*) and sister Serena (*right*) of Palm Beach Gardens, Florida, confer during a women's doubles match against Erika DeLone and Liezel Horn at the Australian Open Tennis Championships in Melbourne, Australia. The Williams sisters won 6-4, 6-2.

"I shouldn't have to change. I like my hair."

–VENUS WILLIAMS, DURING THE AUSTRALIAN OPEN SEMIFINALS, 1999

Serena Williams with husband Alexis Ohanian and their daughter Olympia Ohanian during a ceremony following her first-round victory on Day One of the US Open 2022, 4th Grand Slam Tennis Tournament at the USTA National Tennis Center in New York, August 29, 2022.

colorful braided and beaded styles I had ever seen. I also learned that among the Chokwe-related peoples, when decorative beads on the hair fall off during rituals, they are at risk of being collected by "antisocial individuals" and used against the owner. So the custom is that once beads drop from the head, they are to be immediately retrieved by the owner or a friend to ward off any evil spirits or actions.

Try telling that to a tennis phenom.

It seems like just yesterday that I watched Venus wearing hundreds of beads that gripped her kinky-textured braids on the tennis court—flapping in the air with every serve and volley. That is, until one day, something broke loose—at first, a few beads. Then all hell!

It was at the Australian Open semifinals in 1999. When Venus lost some of her beads on the court, she lost her cool right then with them. After the umpire called her out, Venus tried to argue that he was "splitting hairs." She argued that when the same thing happened at a previous match, she just swept them off the court and returned to her game. But on that day, the ref refused to play ball. He fined her for "causing a disturbance during play."

Oh yeah—she was livid!

I remember having mixed emotions watching Venus defend how her hairstyle was a part of her identity. I knew that wearing her beaded braids at a time when few were doing it had helped other Black women with their hair acceptance, and she should be allowed to wear whatever style she chose. But I also felt the reprimand from the ref was not race based but done for safety reasons.

Venus ultimately lost the match, but I was proud of her for admitting that it wasn't because of the braids and the beads.

"I didn't play as well," she is quoted as saying in a January 27, 1999, *Los Angeles Times* article. "I lost my focus."

Venus and Serena did away with their beaded look as time passed. But in 2022, Serena—the twenty-three-time Grand Slam winner—famously passed on her bead-wearing legacy to her four-year-old daughter, Alexis Olympia, during her farewell season in the sport.

Of course, wearing beads on braids should have no adverse effect on sports. However, according to a 2022 *New York Times* report, Black student-athletes like Nicole Pyles are still being called out for wearing them. She was asked to remove her beads or leave the game. Yes—in 2022.

Pop culture history reminds us that hair-related bans in amateur and professional sports have systematically targeted people of color. Not just hairstyles but also head rags.

Case in point—the durag bans of 2000 and 2005.

The Wrap That's Gotten a Bad Rap

First of all, the preferred spelling is D-U-R-A-G. Not "doo-rag." Not "due-rag." Not "dew-rag."

Like braids, durags are a staple of Black culture.

It was during the Harlem Renaissance of the 1920s and 1930s that the durag became a fashion statement and symbol of Black cool. Men wore them on the streets during the day to protect their conk styles and waves they flaunted in the clubs at night.

Flip five decades later to the eighties and nineties—the popular wrap rooted in the Black community got a bad rap in the mainstream when hip-hop artists like Nelly, 50 Cent, Cam'ron, Jay-Z, and Tupac popularized them in their music videos and on red carpets. Soon these talented, intelligent, educated rappers were labeled "durag-wearing thugs." That is

Guapdad 4000 arrives at the sixty-second annual Grammy Awards at the Staples Center in Los Angeles on January 26, 2020.

Above: Installation view of Kevin
Beasley's *Chair of the Ministers of
Defense* at the Hammer Museum, Los
Angeles, January 21–April 23, 2017.

Right: Huey P. Newton sitting in a
wicker chair for a Black Panther Party
public relations campaign served
as the inspiration for *Chair of the
Ministers of Defense.*

until white artists like Eminem copied their style.

In mainstream sports, around 1995 when baller Deion Sanders made wearing durags his trademark, the NFL claimed the headgear suggested an affiliation with street gangs and violence. But instead of an outright ban, they worked a licensing deal to keep durags more uniform. They only fined players for wearing the headgear that was not covered by the license.

But then, the NBA, in 2000 and 2005, and the NFL, in 2001, banned wearing durags during play. And who do you think was most affected by the ban? Yao Ming? Dirk Nowitzki? Tom Brady? Uh, no—it was Black ballers. This now demonized headgear had been part of many of the Black athletes' childhood, community, and heritage. They were worn not just for style but functionality. For some Black men, the durag has even been a rite of passage.

Always one to go his own way, NBA baller LeBron James started wearing a durag on the court during warm-ups before a game. But it was Sam Perkins of the Indiana Pacers who, in 2000, became the first to wear a durag *during* an NBA game. After that, guess what? They shut it down. The NBA identified our cultural wrap as a "potential safety hazard." But that ban didn't stop New Orleans Pelicans forward Brandon Ingram from continuing to add to his collection of more than one hundred durags. He wore a different color, texture, or patterned one to every game, earning him the nickname "Durag B.I."

By the mid-2000s, it seemed like durags were suddenly popping up everywhere and making waves literally, including on international runways in the collections of white designers like Tom Ford and proud Black designers like LaQuan Smith. This proved, once again, the influence of Black culture on high fashion.

Meanwhile, elsewhere, another durag-loving creative artist who wanted to pay homage to the garment while reminding us of its controversial roots created an exhibit to do just that in Kevin Beasley's *Chair of the Ministers of Defense*.

Looking at the *Chair of the Ministers of Defense* art installation next to the iconic photo of Black Panther Party (BPP) cofounder and Minister of Defense Huey P. Newton, you can probably guess where the conceptual artist got his inspiration.

Newton is seated in a rattan chair while clutching a shotgun and spear, exemplifying the right to self-defense. The portrait was one of many used in a BPP PR campaign to give focus to the movement. It later served as poster art to rally a Free Huey campaign after Newton was arrested for voluntary manslaughter following a deadly altercation with a police officer. The white cop pulled Newton aside for driving while Black.

By merging imagery from a Baroque altarpiece for Saint Peter's Basilica in Rome with an empty high-back chair and warrior shields like the one used in the photo of Newton, Kevin's large-scale installation calls into focus Black liberation movements and ongoing imbalances of power experienced by Black Americans and marginalized men and women of color. Kevin's shields are from the Maasai and Zulu African tribes positioned as if guarding the throne. But what makes Kevin's *Chair of Ministers of Defense* so intriguing is what hovers over the chair.

DURAGS—all colors and sizes.

Solange Knowles attends the Heavenly Bodies: Fashion and the Catholic Imagination Costume Institute Benefit at the Metropolitan Museum of Art in New York City, May 7, 2018.

"The durag, for me, becomes one of the most interesting garments because it's been relegated to present a very particular stereotype and image of Black men."

—KEVIN BEASLEY, *ID-VICE*, MARCH 28, 2017

By mixing imagery from two leaders, one iconic (Newton) and one divine (as in the papacy), Kevin's work also symbolizes two very different seats of power—in civil rights and religion.

In keeping with that spiritual altarpiece-imagery-meets-durag connection that Kevin had going on, Solange gave us a little something more to think about when she stepped out on the red carpet at the 2018 Met Gala. There, she modeled a durag with a braided blond halo and superlong train bearing the phrase, "My God Wears a Durag" along the hemline.

Solange's style was on point for the night's Heavenly Bodies: Fashion and the Catholic Imagination theme. But as we've come to expect, she kept Black culture in it!

Like Solange, Rihanna made some noise with her durag when she wore the first one ever on the May 2020 cover of British *Vogue*. The international fashion industry is still talking about Riri's insistence on wearing this symbol of Black culture, further making a case for the importance of the Black influence in high fashion. Before then, she stunned us in 2014 wearing a Swarovski crystal-encrusted durag when she accepted the CFDA Fashion Icon Award, then again when she performed in a durag at the 2016 MTV Video Music Awards.

On the small screen, in 2018, the durag had a cameo appearance in the "Apeshit" Louvre video from Beyoncé and Jay-Z, which featured two Black women wearing skin-colored body suits, giving the appearance they are nude, with white floor-length durags tied to their heads while sitting back-to-back underneath the *Portrait of Madame Récamier* by Jacques-Louis David.

Stunning!

On the big screen, actor Mahershala Ali

famously wore a durag for his role in the film *Moonlight*, which earned him an Academy Award for Best Supporting Actor. It's been said that having the lead character wear the durag was to communicate how his queerness clashed with traditional notions of Black hypermasculinity.

And while the durag had long become an important pop culture fashion accessory for many hip-hop stars, including Nelly, Jay-Z, and 50 Cent, Guapdad 4000 at the Grammy Awards in 2020 gets my vote for the most memorable. He slayed like nobody's business wearing a durag with a ten-foot-long train, a clear nod to how hip-hop and the cultural fashion accessory still go together.

Beyond creating social media buzz around his look, Guapdad 4000's durag inspired a drag queen. "I've always loved the aesthetic of a durag, especially on men," giggled Symone

(née Reggie Gavin) of *RuPaul's Drag Race* in a 2021 *Shadow and Act Live* interview. "And so, I was like, 'I want to bring that. . . . I just wanted it to be seen the way I see it in, which it is [a] beautiful, Black part of our culture and something to be celebrated.'"

For something that became quite the celebrated fashion garment on international runways and an expression of Black identity and style, it's worth noting that the durag was the iteration of a vestment created well over a century ago—during one of the darkest times in Black history.

Head Wraps

Throughout the transatlantic slave trade, head wraps, head rags, head kerchiefs, turbans— whatever you choose to call them—were among the few cultural pieces enslaved Africans were allowed to bring to the States. They had worn them in precolonial sub-Saharan Africa as symbols of marital status and to denote sexuality and family lineage. Even in Zulu culture today, women are expected to cover their heads with head wraps when in the presence of in-laws as a sign of respect.

Once our forebearers arrived in the Americas, they wore head wraps mostly to protect their crowns from the beaming sun while working in the fields. But more so, they were forced to wear them as a badge of enslavement.

Following emancipation, some states even made it illegal for freed Black and biracial women to be in public without some type of head wrap.

In 1735, South Carolina passed a Negro code that identified the clothing the enslaved were allowed to wear. It called for the cheapest

Rihanna at the 2014 CFDA Fashion Awards, New York City.

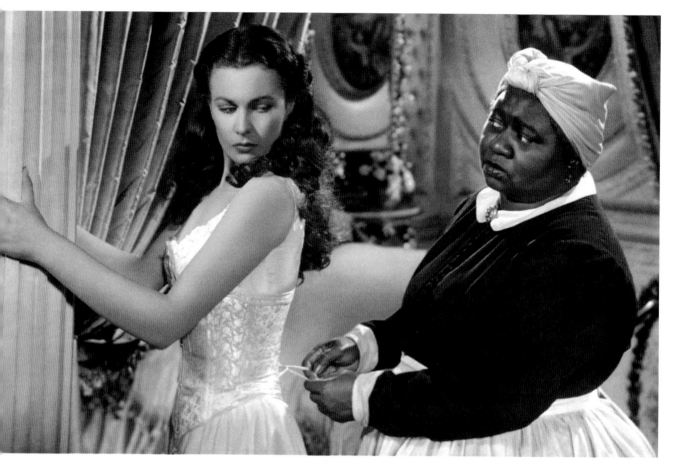

Hattie McDaniel (*right*) as Mammy with Vivien Leigh (*left*) as Scarlett O'Hara in *Gone With the Wind* (1939).

fabrics and kerchiefs to cover the heads of Black and mulatto women.

After emancipation, many Black women who worked for white families were still forced to cover their hair with a simple cloth; that's how we came to be stereotyped as the "Black Mammy" servant. You know—the dark-skinned, sassy, heavyset woman working for white folks while wearing a head wrap.

Hattie McDaniel was perhaps most widely known for perpetuating this stereotype based on her nearly one hundred roles in films that included *Gone With the Wind*.

Let's pause for a moment because there's a lot to unpack here, especially because Hattie McDaniel's story is sooo rich!

You see, Hattie never regretted playing Mammy roles despite her detractors. Herself a maid for many years, she shut down her critics when she famously said, "I would rather make seven hundred dollars a week playing a maid than be one." Despite the pushback she got from Black folks and protest the film got from the NAACP about its depiction of Black life in the antebellum South, Hattie earned an Oscar for her role in *Gone With the Wind*—becoming the first African American (male or female) to earn the statuette.

And though she was not allowed to attend the Atlanta premiere of the film because of her race, the proud head-wrap-wearing Black woman accepted her Oscar on behalf of her race.

Another proud Afrocentric legend who was unafraid to sport head wraps at a time when Black women were encouraged to wear wigs and hide their Blackness in white spaces was Nina Simone. Wrapping her hair in elegant African-inspired patterns was Ms. Simone's act of defiance.

Now worn by millions of women worldwide, the head wrap has become a uniform that, for its wearers, evokes a unified identity, a sense of community, and a sacred relationship with self. It's not unusual today to see Lauryn Hill, Alicia Keys, and Lupita Nyong'o wearing the headpieces. But don't expect to see it any time soon on songstress Erykah Badu, who at one time was best known for her signature head wraps.

In a 2017 interview with Essence.com, Erykah shared the story of why she ditched her head wrap from her *Baduizm* days.

As the story goes—in 2000, Erykah went for a Santeria reading while in Cuba. A Santeria provides its devotees with protection, wisdom, and success and guides them in times of crisis. Erykah showed up wearing what she described as "this white head wrap and this long dress and all my jewelry because it was a part of me," she said. "It was who I was." The woman she believed to be the Santeria was dressed similarly regally and wearing a head wrap as expected. But then, to Erykah's surprise, she learned that the woman she thought was the priestess was not. The man she had eyed in the waiting room with a beard and dirty nails and who was smoking a cigarette and guzzling beer didn't look the part of a Santeria priest, but he was an accomplished healer from a long line of healers. His appearance changed her perspective and her fashion. After that encounter, there were no more headdresses. Erykah was "freed and began to evolve." She said, "I began to focus on being [more] in here than out there."

So, there you have it, folks!

That, my friends, is a WRAP!

Erykah Badu at Jam in the Park pop concert, 1997.

Beauty
Queens
& Cover Girls

Oprah Winfrey wins the 1971 Miss Fire Prevention title in Nashville, her hometown.

The year 2018 was a banner one
for Black beauty!

For the first time, more than twenty—yes, TWENTY—popular magazines, including *Vogue*, *Elle*, *Marie Claire*, *Essence*, *Shape*, *Glamour*, and *Ebony*, featured Black women on their covers simultaneously, over thirty days—and it wasn't even Black History Month! LOL! This, my friends, was a pioneering moment that happened in September—the biggest magazine advertising sales month.

These covers didn't all feature professional models per se—but all were *role models*. Beyoncé, Rihanna, Tracee Ellis Ross, Lupita, Zendaya, Aja Naomi King, Tiffany Haddish.

They were all there! All shades of Blackness and beauty. BLACK GIRL MAGIC at its best!

That same month brought us another victory!

Tyler Mitchell became the first photographer of African descent to shoot the cover of *Vogue* in its 125-year history.

We had a lot to celebrate! We'd arrived! There was inclusion! The world could see what we already knew. BLACK IS BEAUTIFUL!

As many wondered if this notion of finally recognizing Black beauty in the mainstream was a one-time thing, the answer came less than a year later. The year 2019 proved to also be a banner year for us in beauty when

"Black queen of beauty, thou has given color to the world. Among other women thou art royal and the fairest of the fairest."

—MARCUS GARVEY, SPEAKING AT MADISON SQUARE GARDEN, AUGUST 2, 1920

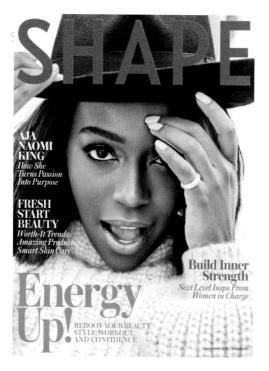

Aja Naomi King on the cover of the September 2018 edition of *Shape* magazine.

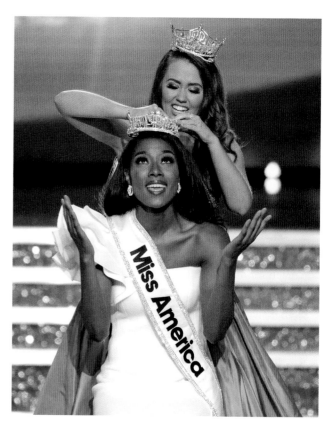

Former Miss USA Cara Mund places a crown on Nia Imani Franklin, the new Miss America, in New York at Boardwalk Hall.

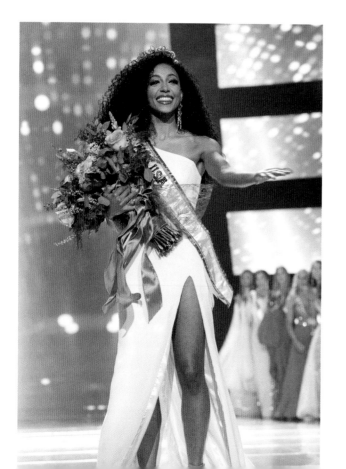

For the first time EVER in the history of mainstream pageants, there were five Black top-title beauty queens in one year.

Cheslie Kryst crowned Miss USA at the Grand Sierra Resort in Reno, Nevada.

not one, not two, but three Black, bold, and beautiful women were crowned with top titles in mainstream beauty pageants.

First, there was the crowning of **Miss America**, then **Miss USA**, then **Miss Teen USA**—a Black beauty trifecta!

Seven months later, we applauded a fourth titleholder, the Black **Miss Universe**, who was crowned at the Black-owned Tyler Perry Studios in Atlanta, Georgia. Woo-hoo!

And the wins kept coming—

Less than a week later, on December 14, we crowned a Black **MISS WORLD**.

Miss Teen USA—Kaliegh Garris
Miss America—Nia Franklin
Miss USA—Cheslie Kryst
Miss Universe—Zozibini Tunzi
Miss World—Toni-Ann Singh

While still on the subject of "queens," 2019 also brought us the first crown holder of African descent to win the top title at the Miss International Queen pageant—the trans community's most prestigious competition.

So what was going on that we were suddenly, abundantly, and finally recognized for our beauty in pageants, on magazine covers, and, quite frankly, in life? What led to us getting these universal beauty stamps of approval? How did we get here? Did times change? Did we change? Or did the institutions change? And frankly, why did we ever need them anyway to validate our beauty? We already knew we were kings and queens of African royalty. Yet, prior to 2018, there were still question marks over how we decide what beauty looks like. Is it

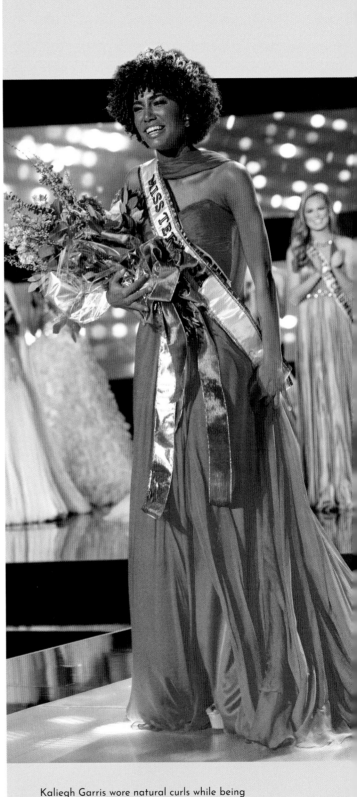

Kaliegh Garris wore natural curls while being crowned at Grand Sierra Resort.

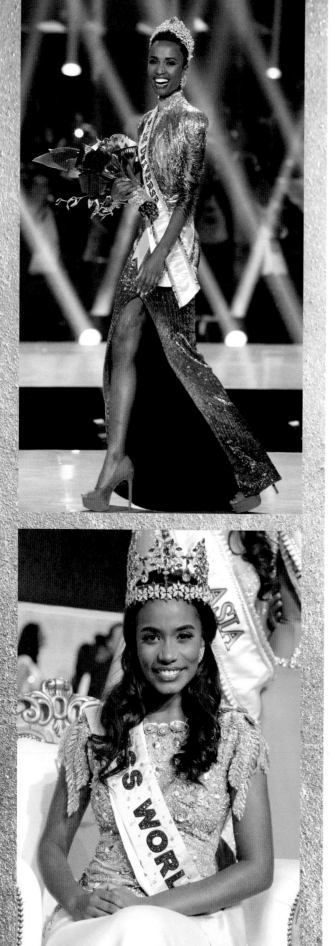

Top: Zozibini Tunzi crowned Miss Universe.

Bottom: Winner of Miss World 2019, Toni-Ann Singh of Jamaica, poses for photographers at the sixty-ninth annual Miss World competition at the Excel Centre in London, December 14.

based on biological factors? Societal? Personal? Cognitive? All of the above? Were we still living by beauty standards set by colonizers or, dare I say, advertisers? Fair questions. Complex answers.

What's crazy is that I can recall when Black folks were never even part of the debate.

In 2022, news broke of the shocking suicide of former Miss USA Cheslie Kryst who jumped to her death at the age of thirty. Hours before she passed, the beauty queen, attorney, and *Extra TV* correspondent had posted on Instagram, "May this day bring you rest and peace." The post received over twenty-three thousand comments that day.

Cheslie's tragic death is yet another wake-up call that mental health struggles among women and young people in the Black community are to be taken seriously.

The trans Miss USA Jazell Barbie Royale is crowned Miss International Queen. She is the first person of African descent to earn the title. Miss International Queen is the world's largest and most prestigious beauty pageant for international transgender contestants and is organized by Tiffany's Show Pattaya Co., Ltd., the world's first transgender cabaret show in Thailand.

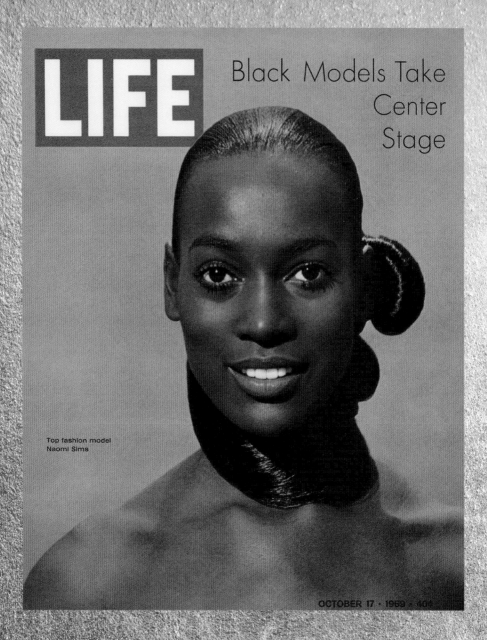

LIFE

Black Models Take Center Stage

Top fashion model
Naomi Sims

OCTOBER 17 · 1969 · 40¢

The '60s

Model Donyale Luna in plastic earrings.

A lot was going on politically during this period called "the turbulent sixties." There was racism in America, apartheid in South Africa, and Jim Crow segregation in the South. But by decade's end, Black beauty was in *Vogue*. Specifically, the March 1966 edition of British *Vogue*. American media evidently hadn't gotten the Black Is Beautiful memo, but the Brits were on it. They had eyes for American model Donyale Luna, who'd burst onto the scene, becoming their franchise's first Black "It" Girl.

The highly sought-after Donyale (the subject of the 2023 HBO documentary *Donyale Luna:* *Supermodel* that explores her life and influence) was an exotic, lanky homegirl from Detroit (née Peggy Ann Freeman) with beautiful green owl-like eyes, a "powerful stare," and a reputation for walking around shoeless. Her light-skinned complexion made it difficult for anybody but us to tell that she was Black.

Though British *Vogue* was Donyale's first cover, it wasn't her first rodeo. Earlier in January 1965, the six-foot-two model had expected to be on the cover of the American *Harper's Bazaar* in a photo by the renowned Richard Avedon. But when the mag hit the stands, it

"Back in Detroit, I wasn't considered beautiful or anything, but here, I'm different." –DONYALE LUNA, *TIME* MAGAZINE, 1966

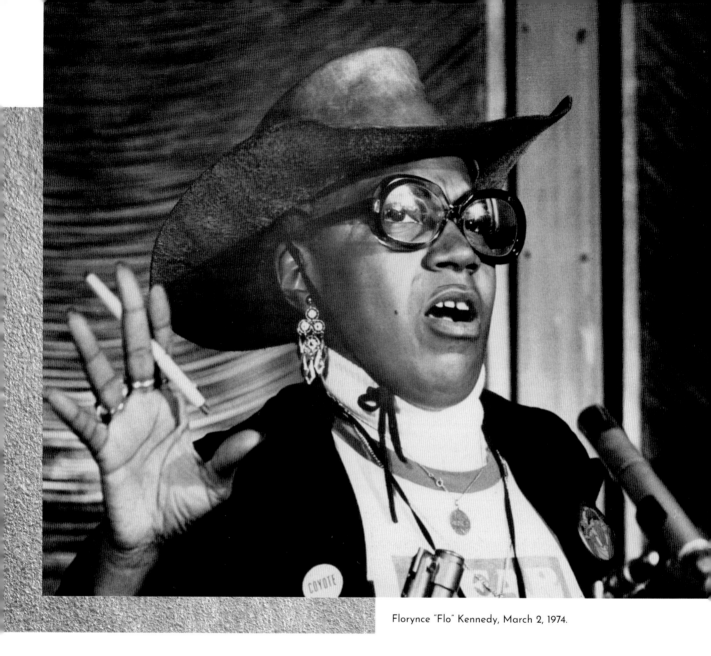

Florynce "Flo" Kennedy, March 2, 1974.

featured an artist's "interpretation" of Donyale rather than her photograph on the cover. Was she surprised? Considering the time, no—not really. But the incident was a huge blow to her already fragile ego. Unable to find respect for her beauty in the States, Donyale permanently relocated to Europe, where her Black skin was more readily accepted.

Ultimately, many other Black beauties, including Josephine Baker and Eartha Kitt, defected to Europe for the same reason—

looking for opportunities in a country that lacked the level of racism they experienced in America.

Back in the States, the tall, leggy Naomi Ruth Sims picked up the beauty baton to become the first Black model featured on the cover of the *New York Times Magazine* "Fashions of the Times" issue in 1967. To become one of the first symbols of Black beauty was groundbreaking for Naomi at a time when agencies still weren't interested in Black faces.

But the sixties were good to Naomi. She became one of the first models represented by the famous Wilhelmina Agency, the first Black model to appear on the cover of *Ladies' Home Journal* (November 1968), and the first Black model on the cover of *Life* magazine (October 1969).

Though she ultimately opened a tightly shut door for other Black cover girls like Grace Jones, Tyra Banks, Slick Woods, and Winnie Harlow over the years, Naomi was told at one point in her journey that her Blackness was a "novelty" that would wear off.

Few in the States were willing to bet on Black beauty in the sixties. This sad commentary extended to print, film, and, most especially, beauty pageants.

Beauty Pageants

In the late sixties, when I was seven or eight years old, I used to sit in front of the TV watching the Miss America Pageant like thousands of other young Black girls. I had totally bought into Bert Parks's rendition of the theme song, "There She Is, Miss America," which he serenaded to "ideal" beauty queens. Translation: White Girls. Lily-white girls.

When the song was written, there was a Rule 7 at the Miss America organization, which stated that all contestants must be "of good health and of the white race."

It didn't bother me that I wasn't seeing anyone who looked like me competing when I watched the pageants on our black-and-white TV, or even up through the seventies in living color. It was the civil rights decades. So, we weren't in a lot of things. You didn't see much

of us on TV. Other than Naomi Sims, that one time, we weren't on major US magazine covers. To me, that wasn't an exclusion. That was the way it was!

I was cavalier about the whole exclusion thing because I was so young. But not everyone took our absence lightly.

From Pageant to Protest

On September 7, 1968, in Atlantic City, New Jersey, a group of activists organized the first protest against the Miss America Pageant that had been drawing in so many advertising dollars and TV viewers like me. The protests stemmed not from just its antiquated attitudes toward women and beauty but from how the US treated women as a whole.

A key organizer was one of our most colorful and notable Black woman sheroes—Florynce "Flo" Kennedy, the fiery feminist civil rights lawyer whose clients included activist H. Rap Brown, singer Billie Holiday, saxophonist Charlie Parker, and the Black Panthers.

Since so little is known about this heroine of feminism and civil rights, I was glad to see a glimpse of her character dramatized in the FX limited series *Mrs. America*, which featured Niecy Nash as Flo. Niecy played the role just right, capturing the colorful, outspoken, and flamboyant heroine as someone all about "the visuals" and making noise.

Best known for her trademark cowboy hat and pink sunglasses, Flo wore what she wanted, where she wanted, when she wanted—purposely pushing the envelope, even in the courtroom. Dressing and fitting into a mold was an insane concept to her. She often told the story of when

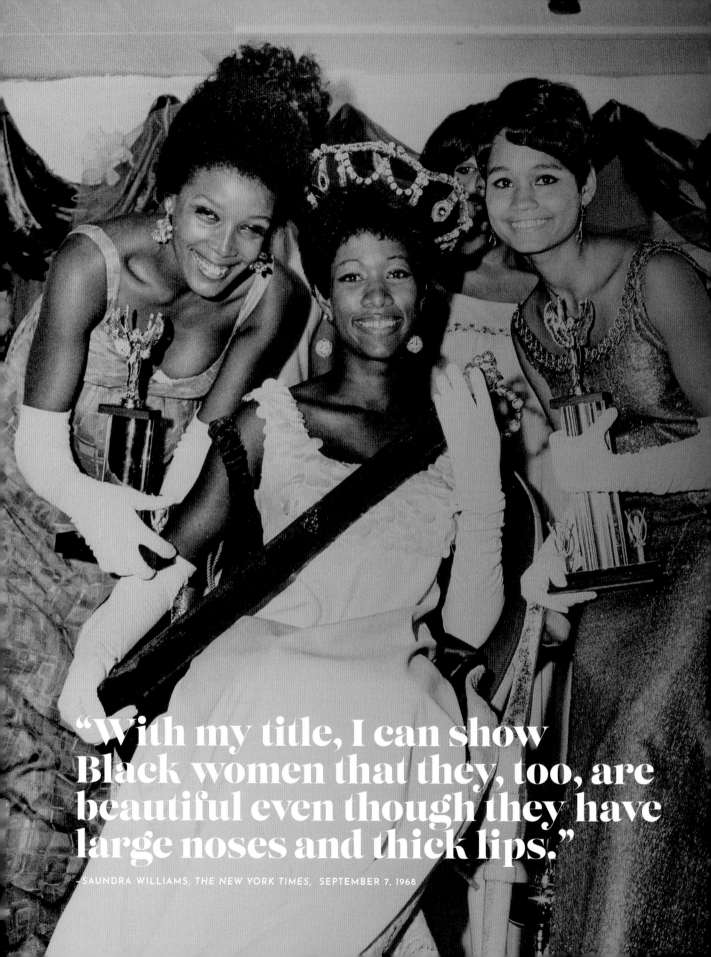

"With my title, I can show Black women that they, too, are beautiful even though they have large noses and thick lips."

—SAUNDRA WILLIAMS, *THE NEW YORK TIMES*, SEPTEMBER 7, 1968

police refused to let her cross a barricade to get to her house. "As nicely and conservatively as I was dressed," she said, "I was still just another nigger."

With sexism and racism at the core of Flo's activism, the 1968 Miss America Pageant protest she helped organize became her baby. "Don't agonize; organize" was her motto. And that she did—with one hundred women marching on the Boardwalk, they turned the civil rights anthem "We Shall Not Be Moved" into "We Shall Not Be Used" and made some real noise.

While the bulk of protestors were throwing girdles, bras, and false eyelashes in "freedom trash cans," the brash, razor-tongued Flo chained herself to a puppet of white Miss America as a metaphor for how women were enslaved to beauty standards.

Meanwhile—what was going on farther up the Boardwalk at the Ritz Carlton Hotel had been in the making for months.

A Black Philadelphia entrepreneur by the name of J. Morris Anderson had asked his two young daughters one day, "What do you want to be when you grow up?"

"MISS AMERICA!!"

Anderson knew he had his hands full after they went and said that.

Even though Rule 7 had been abolished by then, Miss America still had never had a Black contestant, let alone one to wear the crown. He wasn't trying to infiltrate the pageant just recognizing and honoring Black beauty. So he decided to start a pageant just for US.

Saundra Williams and her court at the 1968 first Miss Black America Pageant.

It was an ambitious, noble undertaking—one he was sure would get support from the brethren and the Black business community. But few stepped up to give him the financial support he needed to do it right. Even Black modeling agencies turned him down, unwilling to have their light-skinned girls participate because it would cost them opportunities.

Thanks to his connections as an active member of the NAACP, Anderson eventually got support from the local tristate affiliate to stage the first Miss Black America Pageant. Yes, it was on the same night of the Miss America Pageant. Their plan was quite ingenious. And get this, figuring that only the Black press would cover the event if it were held in the Black community, they decided to stage the pageant blocks away from the grandaddy of all pageants, with a start time just an hour or two later, allowing that same mainstream media to make the quick sprint down the street to cover their inaugural event.

Festivities for the first Miss Black America began after midnight.

Unlike the Miss America Pageant that featured contestants from all the states, the dozen or so participants in the Miss Black America Pageant were selected to represent "different types of Black women"—a cross section from around the country with different hair textures and skin tones. We were still in the thick of the Black Power movement, so Afros were quite prominent.

Among those competing was curvy, hazel-eyed Saundra Williams from Maryland State College. Instead of the traditional singing, dancing, and reciting poetry we'd come to see in most beauty competitions, the nineteen-year-

old performed a moving interpretive African dance that made her a favorite to win—which she did at 2:45 a.m. And as the organizers had hoped, the mainstream press was there to capture it all.

There she was—our dream of dreams, sporting her natural hair Afro and wearing the crown of Black beauty for the world to see.

During her media interviews, the college student shared that the crowning was her second major victory in a year. Earlier, she had been refused service at a restaurant in her college town because she was Black. Having never experienced that level of racism in her native Pennsylvania, she banded with other students to organize the Black Awareness Movement. Their silent protest march against the white businesses in the area resulted in the restaurant finally integrating.

Saundra's second victory as the first Miss Black America was exciting news for the Black reporters who covered the pageant. The mainstream media, however, kept pressing her and the pageant organizers to answer tough questions.

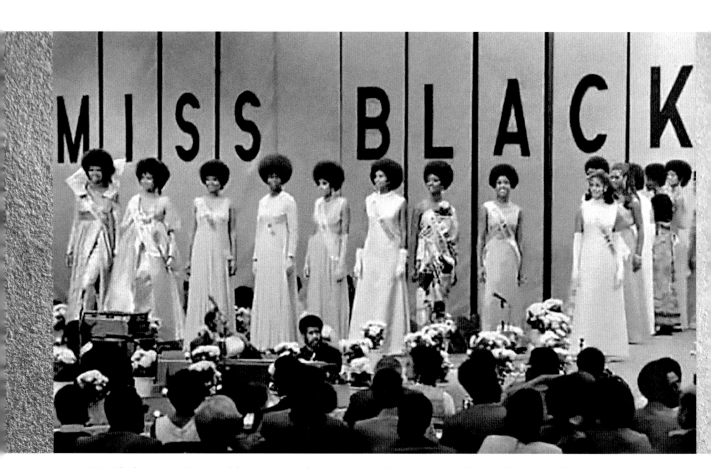

Miss Black America Pageant delegates pictured onstage at the 1969 pageant at Madison Square Garden.

"I honor the women of my race.
Their beauty, their dark and
mysterious beauty of midnight
eyes, crumpled hair, and soft,
full-featured faces."

–W. E. B. DU BOIS, *DARKWATER: VOICES FROM WITHIN THE VEIL* (1920)

"Aren't you just as hypocritical as the white pageant for objectifying women?"

"How are you any different?"

Never publicly offering a response to the misogynic aspect of staging beauty pageants, the organizers defended that they were merely exercising their right to show Black pride, celebrate our beauty, and honor our race. They were following the call of one of our leading Black scholars: W. E. B. Du Bois.

By the following year, the Miss Black America Pageant organizers gained greater support and financial backing from the Black community and a slew of political and social activists, including Congresswoman Shirley Chisholm and Malcolm X's widow, Betty Shabazz, who served as judges.

The pageant had moved to a larger space and booked top talent like the Jackson 5, who made their TV debut as musical headliners. That same year, Curtis Mayfield wrote and performed what would become the pageant's theme.

Loosely based on the contest's origins, the song began with the spoken words of a Black father asking his daughter what she hoped to be when she became a big girl. Instead of saying, "Miss America," the young voice shouted, "Miss BLACK America!"

The Miss Black America Pageant brought a much-needed and reachable hope for many Black and brown girls to fulfill their dreams—among them Oprah Winfrey, Toni Braxton, and *Good Times* actress Bern Nadette Stanis who competed in the pageant over the course of its first forty years.

By the end of the decade, Cheryl Adrienne Browne, from Iowa, broke the color line—becoming the first Black contestant in what had been looked upon as the "lily-white" Miss America Pageant. We had finally broken through the glass ceiling!

ESSENCE

PLAYTIME
VINES

REVOLT:
FROM
ROSA
TO
KATHLEEN

The
'70s

Barbara Cheeseborough graced the cover of the May 1970 inaugural issue of *Essence* magazine.

The start of the seventies in America looked a lot like the sixties. Racism was still prevalent. War was raging in Vietnam. The feminist movement was just as volatile. Still, there was progress. Black people had become more visible to the mainstream on TV, in film, and crossing over into music. So full of possibilities, the seventies was also the era where we saw the launch of two of our greatest publication institutions: *Black Enterprise* and *Essence* magazine, which is touted as the "premier magazine for Black women." In 2023, Oprah Winfrey's OWN Network recognized the significance of *Essence* in a five-

part docuseries called *Time of Essence: 50 Years of Defining Culture*.

The inaugural *Essence* hit the newsstands in May 1970, featuring on its cover "a beautiful, sensually, full-featured Black woman crowned by a glistening afro emerging from the shadow into the light of a new day." This is how *Essence* cofounder Edward Lewis described it in his memoir, *The Man from "Essence": Creating a Magazine for Black Women*. It was the first national magazine to reflect and celebrate Black womanhood.

The cover featured model Barbara Cheeseborough who, as NPR eloquently stated, was "the first to show an Afrocentric beauty standard when millions of young women were casting about for a kind of beauty they could identify with and replicate."

I remember being so excited about getting my hands on that first issue. My mom had laid out a whole sixty cents at the newsstand. Together, we thumbed through the eighty-two mostly full-color pages. Believe it or not, I've held on to almost every print edition of *Essence* I've had all these years. Sounds crazy, right? Not to me. It was really something to see Black beauty on a national level of that magnitude at that time.

With us prominently on magazine covers and finally competing in mainstream beauty pageants, the mindset about Black beauty standards shifted.

That same year *Essence* launched, we had two Black women participate in the Miss World Pageant held in London at Royal Albert Hall. It was 1970. A lot was going on in the world. More war. More apartheid. And in Europe—the British feminist uprising.

Just as protestors had swarmed the Miss America Pageant in Atlantic City two years earlier, so was the Miss World Pageant under protest on British soil. These angry feminist activists weren't against the contestants per se—but the pageant as a whole. They found it sexist to reward women based on just their "beauty." So they made sure things got ugly!

"You are selling women's bodies," they shouted before storming inside the hall to disrupt the beauty contest. They threw smoke bombs, ink bombs, stink bombs, and leaflets and caused many other interruptions, forcing host Bob Hope to be hustled off the stage.

Hours later, when it was safe for all the participants to return—with security guards in tow—it was announced that the title winner was not the favored blond Swedish contestant but the twenty-five-to-one underdog, Jennifer Hosten—the first Black Miss World crowned in the contest's nineteen-year history. It was a historic feat and another feather in our cap for the culture.

Headlines the next day read:

"Miss Grenada Crowned. Bombs Disrupt Pageant"
"West Indian Beauty Named Miss World"
"Furor Reigns as Beauty Queen Smiles"
"Miss World Is Black, and Is She the Most Beautiful Girl in the World?"

That last headline? Hmmm. The question mark was hostile. But so were the times.

So many people couldn't get over the notion that a Black woman could claim victory over fifty-eight white contestants as the most beautiful woman in the world.

The November 23 edition of the *Kansas City Times* reported that the British Broadcasting Corporation (BBC), which televised the competition, was bombarded by protests over Jennifer's win. The white promoter of the contest, Eric Morley, said, "I was rung up by a number of kinky callers who told me I was a nigger lover."

British actress Joan Collins, who we eventually came to know as Alexis Colby in the nighttime soap *Dynasty* and was one of the judges, said of Jennifer in the *Kansas City Times*, "She took the crown because most of the men judges fancied her. Her sex appeal bowled them over."

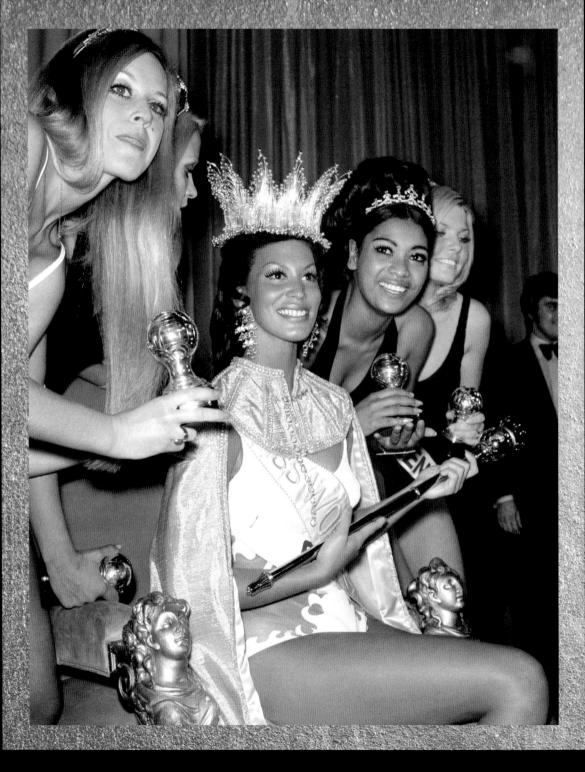

Miss World winner Jennifer Hosten, representing Grenada, Miss World Beauty Contest, London, 1970.

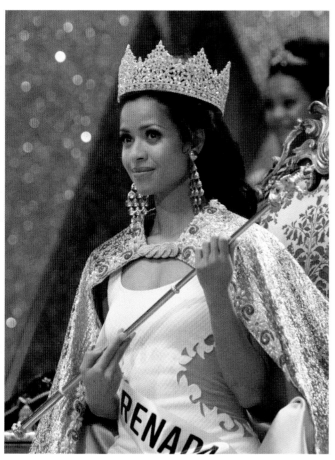

Gugu Mbatha-Raw as Jennifer Hosten, the first Black Miss World, in a scene from the film *Misbehaviour* in 2020.

Quite true. Jennifer was stunning, sexy, talented, and intelligent, and she came off as being comfortable in her Black skin.

As a side note, the other Black contestant in the pageant—who became the runner-up—was one of two representing South Africa. That nation was apartheid ridden and insisted that if a Black woman could compete, they also needed a white contestant. Deep, right?!

All that drama was part of the storyline in *Misbehaviour*, the British film inspired by the contest.

Released in September 2020, Gugu Mbatha-Raw starred as Jennifer Hosten in the film that tackled a large portion of London's women's liberation movement of the early seventies but also gave us a look at what we didn't know about what was going on behind the scenes of

the first Black Miss World's historic crowning.

My favorite line in the film is when Gugu, as Jennifer, defended why she was in the race, which I think should be the motto of every disenfranchised Black woman: "If you don't fight, you get the world you get."

Those words in the fictional were, in the real world, a sort of mantra for supermodel Beverly Johnson.

Best known for making history in 1974 as the first Black model to appear in American *Vogue*, she will tell you that she trekked a long, hard-fought road to get there. But it was all well worth the journey.

Making the cover of *Vogue* was Beverly's highest goal, particularly after being rejected for cover opportunities in Black magazines because she wasn't "ethnic looking enough."

Once she got the landmark cover, Beverly used her new celebrity to champion civil rights causes and open doors for other Black cover girls even while doors closed for her.

"That *Vogue* cover made me a legend. At the same time, I knew I was [a] token."

—BEVERLY JOHNSON, *PEOPLE*, JULY 17, 2020

No one from the general market came calling with more work for Beverly. Not the cosmetic brands. Not the luxury houses. Although she did earn notoriety as the first woman of color on the cover of *Elle France*. Then, nearly five decades after appearing on the cover of *Vogue*, she got further comeuppance as the subject of an off-Broadway show celebrating the fiftieth anniversary of her historic cover.

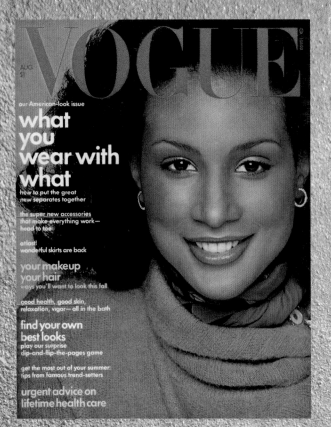

on the cover image is text reading:

VOGUE

AUG.
51

our American-look issue

what
you
wear with
what
how to put the great
new separates together

the super new accessories
that make everything work—
head to toe

at last!
wonderful skirts are back

your makeup
your hair
ways you'll want to look this fall

good health, good skin,
relaxation, vigor—all in the bath

find your own
best looks
play our surprise
clip-and-flip-the-pages game

get the most out of your summer:
tips from famous trend-setters

urgent advice on
lifetime health care

> "It really stood
> for something
> much deeper than
> a *Vogue* cover
> in the modeling
> world. It stood for
> the acceptance of
> Black beauty in
> America. It was a
> huge statement for
> Black America."
>
> —BEVERLY JOHNSON,
> *SUPREME MODELS: ICONIC BLACK WOMEN WHO
> REVOLUTIONIZED FASHION* (2019)

Beverly Johnson on *Vogue* cover, January 1974.

Like Beverly's prized *Vogue* cover, another Black beauty collectible premiered the following year in 1975. Anheuser-Busch created a tradition of a different kind of cover girl with a unique set of posters that honored Black beauty.

Queens of Africa

Beginning in 1975, Anheuser-Busch and Budweiser led us to celebrate "female powerhouses that shaped post-colonial Africa" when they commissioned their internationally acclaimed *Great Kings and Queens of Africa* art collection. It was a traveling exhibit of thirty works, beautifully painted by twenty-three Black artists to "provide a new and important dimension to the ancestral history of Black Americans."

The collection that was created over twenty-five years has been viewed by more than forty million people.

Among the queens in the series was **Queen Tiye**, one of the most illustrious queens of ancient Egypt and best known for her key diplomatic role at her husband's side and in her son's administration. There was **Queen Nzingha of Matamba**—a seventeenth-century Angolan queen who was the mastermind of the alliance of her nation with the Dutch to fight African foes. **Nefertari**, the Nubian queen of Egypt, is heralded as the first of the great royal wives. **Nandi,** queen of Zululand, is the mother of the great Shaka Zulu—the greatest of all Zulu kings. She was considered a woman of beauty and held in high esteem throughout ancient Africa. And of course, there was **Cleopatra VII** of Egypt, who rose to the throne at age seventeen and was credited with upgrading Roman culture.

A lot was said about Cleopatra following the

2023 release of Netflix's, *Queen Cleopatra*, a four-part docuseries produced and narrated by Jada Pinkett Smith. And not all of it was pretty. Soon after the trailer dropped that profiled Cleopatra, local academics in Egypt went nuts. They called foul when they saw *their* queen being played by a brown-skinned actress (Adele James of mixed heritage) rather than a white one. They maintained that the queen born in the Egyptian city of Alexandria in 69 BC belonged to a Greek-speaking dynasty and was not Black and so they demanded that the show be banned in the country.

A government-owned Egyptian broadcaster even went so far as to begin production on a big-budget Cleopatra film that would present to the world what they believe to be the "true story" and that casts a light-skinned actress in the coveted role.

For the record, the producers and the scholars they featured in *Queen Cleopatra* never said in the doc that Cleopatra was Black. In a statement from Netflix, they defended that a biracial actress was cast to "reflect theories about Cleopatra's possible Egyptian ancestry and the multicultural nature of ancient Egypt."

Netflix received so many racial slurs in posts related to the release of the trailer and Cleopatra's race that they had to turn off the comments section.

So, here's something to gnaw on—few were upset when Elizabeth Taylor, Vivien Leigh, and other white actresses who were not Macedonian, Greek, or Egyptian were cast as Cleopatra. Sooo—was the uproar among the Egyptians because Netflix portrayed Queen Cleopatra as Black or that many Egyptians chose not to see themselves as Africans? Hmmm.

Nandi Queen of Zululand by H. M. Rahsaan Fort II, part of Anheuser-Busch's *The Great Kings and Queens of Africa* collection of paintings in 1975.

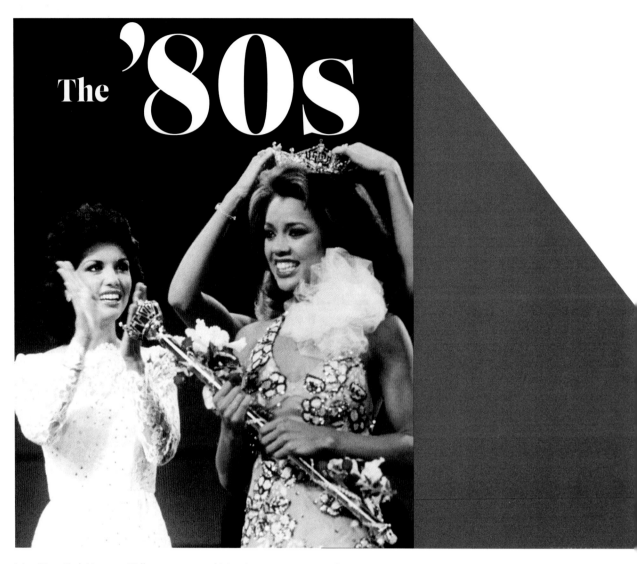

The '80s

Miss New York Vanessa Williams is crowned Miss America in 1983 at the Miss America Pageant in Atlantic City.

There were a lot of pop culture firsts for us in the eighties era of glamour, glitz, and politics.

Bob and Sheila Johnson launched BET, and *The Cosby Show* debuted, becoming the most successful TV series featuring a Black cast. Aretha Franklin became the first woman inducted into the Rock and Roll Hall of Fame. And, for those who thought Barack Obama was the first Black man to announce his candidacy for US president, here's a news flash: it was civil

rights leader Jesse Jackson on November 3, 1983.

But the decade's most celebrated Afrocentric pop event that still reigns supreme in pop history today happened on September 17, 1983, in Atlantic City at the Miss America Pageant.

It began when Suzette Charles—one of four Black contestants in the pageant—was voted the first runner-up, which on its own merit was exciting. But then came the news that the twenty-one-year-old aspiring actress, singer, and

216

dancer Vanessa Williams would be crowned the first Black Miss America in the pageant's sixty-two-year history. That was and still is BIG NEWS!

This wasn't just about a contestant winning a beauty pageant. It represented much more for Black America. It showed that rather than being excluded, we were worthy of inclusion.

But as historic as the moment was, it seemed to be just that—a moment. Vanessa's time in the spotlight ended abruptly after ten pages of sexually explicit photos of her surfaced in *Penthouse* magazine. The news was a massive blow to every young Black girl who rooted for Vanessa and wanted to be her.

to the publication or use of them in any manner. *Penthouse* publishers said otherwise, insisting that she signed a release.

Ultimately, Vanessa owned her stripes with grace, saying in a 1984 phone interview with the Associated Press, "It is obviously my own fault. But I trusted the photographer. With every experience, I've learned something."

Suzette Charles stepped in to assume the Miss America duties once Vanessa stepped down.

In 1987, I produced an NAACP Image Award–nominated TV special called *They Dreamed of Being First* that celebrated and profiled Black Americans who became the first

Having deemed that she no longer embodied Miss America's "purity and wholesomeness," the organization urged Vanessa to resign.

Having deemed that she no longer embodied Miss America's "purity and wholesomeness," the organization urged Vanessa to resign.

In a press conference ten months later, Vanessa defended how she had been pressured a year earlier by a New York photographer to pose nude. He'd assured her he would shoot her in silhouette with two other models—but for her eyes only.

Still grappling with the feelings of pain and embarrassment, Vanessa shared how enraged she was after viewing the photos in the magazine, maintaining that she never consented

in their fields and helped shape the direction of American culture. Vanessa was a first, so I wanted her to participate in the show. Tracking her down wasn't as difficult as I thought. In fact, I was amazed when she answered her home phone and even more shocked when she questioned why in the world I wanted to celebrate her accomplishments.

"Are you kidding?!" I asked. "You've created history! You still have an important story to tell." I was parroting similar remarks by Rev. Dr. Martin Luther King Jr. in a different but similar situation.

Nichelle Nichols, who in the midsixties starred as Uhura in the original *Star Trek* series for sixty-six episodes, often shared that she was proud of how her character—one of a handful of Black characters in a major dramatic TV series—was created to be someone who provided a little "color" on the bridge but grew into one that was much more significant. However, after the first season, Nichelle was ready to leave and explore other work offers.

While at an NAACP fundraiser, Nichelle was introduced to the Reverend Dr. Martin Luther King Jr. He was a big fan of hers and the show—the only program he let his kids stay up late to watch. When Nichelle told him she was considering leaving the show, he said, "You absolutely cannot. Don't you know that you're a part of changing television forever? If you leave, that door could close forever."

In a 2002 interview with me for a series I wrote and produced called *Inside TV Land: African Americans in Television*, Nichelle shared that Dr. King encouraged her to stay the course because, "For the first time, people worldwide, especially in the US, could see us as we're supposed to be seen—as intelligent, brilliant, wonderful human beings going forth in peaceful exploration, doing positive things." He said, "You exemplify not only African American womanhood but womanhood as an equal. You cannot leave."

The words I used with Vanessa may not have been as eloquent as Dr. King's words to Nichelle, but the sentiment was the same and they worked! Vanessa consented to my interview.

We covered several obvious questions about her win, like, "What did it feel like when you made history? How were you initially received? What did your win mean for Black womanhood?" I also asked the oft-repeated question about the claims that a Black woman won because of her light complexion, green eyes, and golden-brown locks.

Vanessa's words seemed rehearsed, but from the heart, when she defended how she was more than qualified to wear the crown because it was "character, not color, that counted."

She also shared what I suspected had occurred but was rarely spoken of in the media about the racism she experienced and threats she received even from *within* the Black community due to her win, which she eventually documented in her memoir, *You Have No Idea*.

Vanessa, of course, rebounded after relinquishing her title. She became a pop culture icon, enjoying a successful career in film, TV, stage, and music—opportunities befitting a Miss America with the beauty, talent, and drive to succeed, whether white or Black.

Interestingly, Vanessa's beauty queen journey came full circle three decades later.

The New Millennium

While there may always be a debate over whether it was fair to ask Vanessa to relinquish her crown over the nude photos, no one can deny that, during her ten-month reign and beyond, she carried herself with the grace and dignity expected of a beauty queen. So it was fitting that on September 13, 2015, the CEO

Scene from *Miss Juneteenth* in 2020.

of the Miss America Pageant offered a public apology to Vanessa.

> "I want to apologize for anything that was said or done that made you feel any less than the Miss America you are and the Miss America you always will be."
>
> —SAM HASKELL, CEO OF THE MISS AMERICA ORGANIZATION, SEPTEMBER 13, 2015

The new millennium also brought mainstream attention to an oft-forgotten beauty pageant in the Black community: Miss Juneteenth.

A year before Juneteenth—the day when Texas first learned of the end of slavery—became a federal holiday, the *Miss Juneteenth* film premiered at Sundance. Social media synopses describe the film as a touching mother and daughter story starring Nichole Beharie as a former Juneteenth queen prepping her daughter to enter the same pageant where she once participated.

What makes the film so compelling is that it's not just about a beauty pageant but Black life, the strong relationship between a down-on-her-luck single mom and her daughter, and the African ancestry that binds them together.

These Miss Juneteenth pageants have been popular in Black communities for decades, even

though they, like other beauty contests, are taking a lot of heat in the age of #MeToo.

For those who still put down the institution of beauty pageants and their relevancy, I urge them to consider five key benefits of these contests. Representation. Representation. Representation. Representation. Representation.

We fought way too hard not to participate. These contests open opportunities—like scholarships, contracts, TV exposure, cash prizes, speaking engagements, the whole gamut—for those who may not have other avenues for success.

The relevancy of beauty competitions applies not just to those held in the mainstream and communities but also to the ancient tradition of crowning homecoming queens.

Homecoming Queens

Long before I ever attended a homecoming weekend at a historically Black college (HBCU), I lived vicariously through friends, family, and the pages of *Ebony* magazine that highlighted activities at these supercharged events.

From the familiar "it's homecoming y'all" that played over the loudspeakers to kick off the festivities to the final football scrimmage, these weekends were meant to be fun, relaxing, and a celebration of the Black experience, pride, and fellowship.

You could always count on great food, parades, step shows, battles of the bands, fashion shows, and, of course, the most anticipated event—the crowning of the homecoming queen.

For generations, HBCUs, much like the mainstream beauty pageants, initially had their share of discriminatory practices. Light-skinned girls with long hair and Eurocentric features were likelier to wear the crowns.

By the Black Power sixties, soul sisters with 'fros and fight-the-powers-that-be mentalities were finally being selected, which led *Jet* magazine to print a story with the headline "Student Revolt Makes Dark Girl 100th Anniversary Homecoming Queen" on the cover of its November 10, 1966, issue.

In a complete break of an alleged "blue-vein" tradition at Howard University that elected homecoming queens from Eurocentric-looking candidates, a group of students calling themselves the Independents helped elect Robin Gregory for the title. Robin was a brown-skinned, Afro-wearing fine arts major who was articulate, poised, a supporter of SNCC (Student Nonviolent Coordinating Committee), had marched from Selma to Montgomery, was committed to the idea of Black pride and Black beauty, and met all other qualifications. She was crowned the school's first "dark girl" homecoming queen.

The move was one hundred years in the making, but it came as the country's political and racial tide had started to turn.

Even predominantly white schools were beginning to select Black queens, like nineteen-year-old Daphne Maxwell, whom we know now as "the second Vivian Banks" on *The Fresh Prince of Bel-Air*, and who married actor Tim Reid once she was all grown up. She became the first Black homecoming queen at Northwestern University in Evanston, Illinois, in 116 years. In a large school with a small Black enrollment, Daphne credited her victory to a sudden influx of socially aware students' intent on accepting people as people.

Courtney Pearson, the first African American homecoming queen at the University of Mississippi, participates in the homecoming events in Oxford, Mississippi, in 2012.

But the major news came in 2012 when the once-segregated University of Mississippi crowned its first Black Ole Miss homecoming queen.

It had been exactly fifty years since the school admitted its first Black student, US Air Force veteran James Meredith, amid violence and armed protestors.

Courtney Pearson wasn't a member of a sorority. She wasn't blond, six feet tall, or a size four. She was dark-skinned, curvy, heavyset, and short, with inner and outer beauty. Her win was significant.

In an interview with CNN's Don Lemon, who outright asked her what her win meant for bigger girls, she shared that it tells them to "be who you are and be proud of who you are. Make sure people are accepting of who you are. Be the best you can be and achieve anything you want."

She shared with NPR's Michel Martin that race never even crossed her mind when she won. "I never heard anything, honestly, nothing negative until after the election was won, and those comments, of course, were made by people who don't go here. And I'm honestly very confident with the way I look. I'm very happy with the way I look."

Courtney's homecoming queen win was a powerful step forward. But then, not so long after we started celebrating, came the controversy in 2023.

A Latina queen was crowned at an HBCU in Baltimore, kicking off a viral online backlash.

The discourse from critics was swift, saying the role should have been given to a Black woman, echoing that these positions are crucial in representing students who have been historically underserved at predominantly white institutions.

Here's the thing, she wasn't the first non-Black queen to be crowned at an HBCU. There was Elisabeth Martin at Kentucky State University—crowned Miss KSU in 2009. Her win, which came the same year Barack Obama took office as our first Black US president, was without controversy. On the flip side—the video of Keylin Perez posing with the Coppin State University king and the whole royal court in 2023 quickly gathered more than 430,000 views with just a little more than 78,000 likes and a barrage of hateful comments. The question of representation, race, legacy, and whether a non-Black person's crowning contradicts HBCU culture was debated ad nauseam.

What's left out of most of the reports about Keylin's win was the fact that she ran unopposed. So, with that, I say, if we wanna have a say, we have to show up.

The Post–George Floyd Era for Cover Girls

A 2023 Pew Research report states that almost two-thirds of Black adults (63 percent) say news about Black people is often more negative than news about other racial and ethnic groups. And yet, following the death of George Floyd, a report by the Poynter Institute indicated that a visitor to newsstands would have seen three times more Black subjects featured on magazine covers than in the previous ninety years! One hundred and twenty-six, to be exact. And in each case, the cover stories projected us in a positive and

Remembering Breonna from artist Amy Sherald is viewed by a spectator at the Speed Art Museum at the University of Louisville. Photo taken on May 23, 2021.

uplifting light—a definite cause for celebration. Those are the kind of stats I like to see!

Among those covers is one that will haunt many of us for a long time. It's the image of a young woman named Breonna Taylor, the twenty-six-year-old Black EMT, killed in her sleep on March 13, 2020, when Louisville, Kentucky, Metro Police burst into her apartment, spraying a hail of gunfire.

Breonna's iconic photo first appeared on the cover of a magazine that for twenty years featured no other cover girl than its owner and founder—Oprah Winfrey.

The September 2020 issues of O: *The Oprah Magazine*, which hit newsstands just several months following Breonna's death and only three months after the death of George Floyd, featured artwork created by self-trained twenty-four-year-old digital artist Alexis Franklin. She captured not only Breonna's likeness but also her soul. Oprah chose to relinquish the cover for that month because "we can't be silent. We have to use whatever megaphone we have to cry for justice."

Vanity Fair also featured Breonna on the cover of its September issue with a portrait by Amy Sherald, the artist who immortalized

VOGUE
AFRICA

Vogue showed its further commitment to diversity through its #VogueChallenge. This social media campaign welcomed women of all shapes, sizes, and hues to reimagine themselves as a cover girl on Vogue, then post the image online. Hundreds, if not thousands, responded to the call.

Mario Epanya's fictional *Vogue Africa* cover.

Michelle Obama. The stunning image labeled *Remembering Breonna* was framed as fine art and given a special place on the walls of the Speed Art Museum at the University of Louisville.

While some voiced concern on social media over the *Vanity Fair* and *O: The Oprah Magazine* covers, claiming "the aestheticization of #BreonnaTaylor is unacceptable," others supported the portraits as a fitting tribute to Breonna.

I get how critics might see the covers as exploitation. However, I saw them as a celebration and acknowledgment of a precious life lost. If there had been silence, there'd have been anger.

And as long as her family is okay with it all, then I'm good. In fact, I'm better than good. I'm elated overall with the whole magazine diversity progress we've made appearing on mainstream covers.

Vogue showed its further commitment to diversity through its #VogueChallenge. This

social media campaign welcomed women of all shapes, sizes, and hues to reimagine themselves as a cover girl on *Vogue*, then post the image online. Hundreds, if not thousands, responded to the call.

The DIY campaign also attracted photographers from around the world contributing images. Some of the most stunning image submissions were from Cameroonian photographer Mario Epanya, whose concept of creating a *Vogue Africa* edition of the fashion magazine gained hundreds of supporters once his faux covers hit social media.

But, like with any good idea, there were naysayers. There were those who were against the concept, stressing how the continent should focus more on building infrastructure.

In response, Mario wrote in a 2017 blog that "The time has come for Africans to come together and work for a better future. I think today's women would like to reappropriate their image. Beauty is diverse, and we aspire to have more diversity of choice. I say, why not?"

Time will tell if it happens. I feel it's only fitting that Africa has a magazine platform to showcase African beauty, whether it's part of the *Vogue* brand or the continent's own fashion and culture magazine. After all, it is from Africa that we inherit the beauty and legacy of our true Black queens.

This could be why heated debate erupted online in 2023 after Brooke Bruk-Jackson, a white woman representing the mostly Black African nation of Zimbabwe, was crowned Miss Universe. Those opposed to the win say she won because she was white, while her advocates voiced on social media that her win was well deserved because "she's gorgeous," because she showed

"exceptional ability to answer questions," and because of "her modeling prowess." The debate will likely drag on for years.

Still, I'm excited about the progress made for our Black beauty queens and cover girls. It demonstrates how accepting the world is of our Blackness and how much more we accept our own beauty. We enter contests and win titles. We vie for cover stories. We believe our Black is beautiful!

Oh, and remember that little girl who sat in front of her black-and-white TV watching beauty pageants? Well, she did a thing.

Yes! In 1979 I agreed to enter a beauty contest. And guess what? I was crowned the first Black beauty queen in the Cleveland suburb of Beachwood, Ohio, in a contest I never wanted to enter.

Full disclosure—by the time I entered that contest, I had grown weary of beauty pageants and other competitions that purported to define who was beautiful and who was not. I only participated in the Ohio pageant at the urging of my liberal white boss, who was incensed that there was no Black presence in the contest. So, at the last minute, he saw to it that I was entered as a contestant—totally convinced I would beat out the other white contestants and send an important message that would elevate the belief that not only is Black beautiful, but we're smart too!

Yep, I won! The judges were more socially aware than my white co-contestants and their parents—some of whom complained that my victory was a token win.

Believing that to not be true, I adopted a quote from poet and activist Nikki Giovanni as my mantra.

"Deal with yourself as an individual worthy of respect and make everyone else deal with you the same way."

–NIKKI GIOVANNI, *RACISM 101* (1994)

And though Nikki Giovanni's words don't speak specifically about Black physical beauty that wins pageant titles and graces magazine cover spreads, they speak volumes about how we should embrace our Black beauty within.

My throwback to 1979 when I was crowned beauty queen in my Cleveland/Beachwood, Ohio, hometown.

Shades & Shapes of Blackness

In his song "Complexion," Kendrick Lamar rapped about how we should love the Black skin we're in.

L izzo's "Booty vicious, mind yo business" and Drake's "I like my girls BBW" left us unapologetic about our curves. And let's not forget H.E.R.'s confidence-boosting "I Love My Hair," which she first performed in 2020 on the *Sesame Street* spin-off *The Not-Too-Late Show with Elmo*. The song got her well over one hundred thousand Insta likes. By 2021, enough songs, videos, films, memes, moments, and movements had us fully embracing our crowns, whichever way they are styled or textured to suit our sense of Black pride and identity. They had us accepting our features that other cultures adopted and appropriated. And we could finally celebrate being regularly featured on mainstream magazine covers and crowned beauty queens. Still, conversations about color bias, body shaming, and Blackfishing continue to dominate social media, with the largest and most heated debates consistently and predictably centered around our shades of Blackness.

Without fail—every two or three years, someone inevitably posts that old-school rhyme.

If you're white, you're right.
If you're yellow, you're mellow.
If you're brown, stick around.
But if you're Black, get back.

In this age of Black Lives Matter, Black Girl Magic, My Black Is Beautiful, and Melanin Poppin, where skin tone still plays a bigger role than it should, we're still having to navigate past some uncomfortable truths.

Carrie Mae Weems, *Untitled (Colored People Grid)*, 2009-10. Blackness falls into three categories.

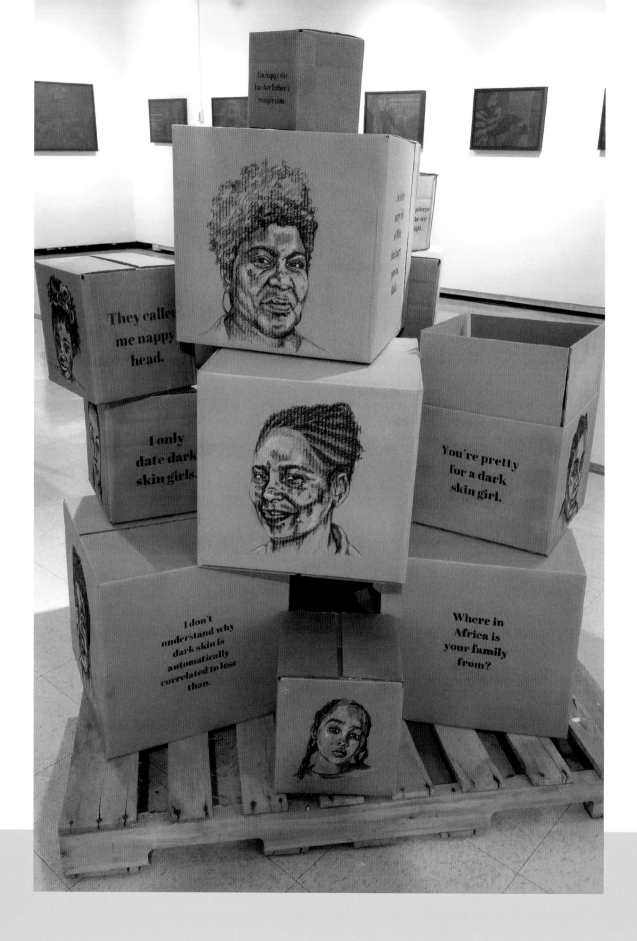

A 2020 Abrams study reflected that most Black women believe "lighter skin people were more beautiful, while dark skin was perceived as ugliness and defectiveness." Of course, we know where that belief comes from, right?

We've been educated about the sad and pitiful stories of how, during slavery times, plantation owners separated workers by skin tone. The darker enslaved people, or "field Negroes," performed manual labor outside under the scorching sun. In contrast, the lighter-skinned "house Negroes," who resembled the white ideal of beauty, worked in the master's house, tasked with cooking and cleaning. But that skin-color division took place more than a century ago. We should've moved waaayyy past that thinking by now. Yet, there are times today when we still allow people to label us and then put us in a box.

Ashley A. Jones's powerful *Stop Putting Me in a Box* exhibit invites us to celebrate our shades of Blackness and dialogue about how we perceive Black folks with darker skin hues—particularly women—and why so many of us buy into society's so-called definition of white beauty. Best known for her illustrations and portraits, which speak to the history and contemporary challenges of Black identity in America, the visual artist and art educator created her *Stop Putting Me in a Box* exhibit as part of a larger *Colorism Project.*

For this installation, Ashley used charcoal and chalk to draw portraits of Black infants, preteens, teens, twentysomethings, and thirtysomethings on more than thirty boxes of varying sizes.

Along with images of those featured on

Ashley A. Jones's exhibit *Stop Putting Me in a Box*, 2018.

each box were quotes about their experiences with colorism—hurtful comments they boxed up internally for years, like:

"Dark skin girls are always angry."

"You'd be really pretty if your skin was lighter."

"Other kids call me Blackie at school."

"You don't know the struggle; you have light skin."

Ashley shared with me how one woman was speechless when she visited the public exhibit and saw her face on the box along with the hurtful words spoken to her while on her journey of self-discovery. The visuals that stirred the woman's raw emotions brought her to tears.

By stacking the boxes atop each other, Ashley wanted to show how unity among the women would lift them up and provide a newfound peace. She succeeded.

While the entire installation was powerful, seeing the images and experiences of girls as young as nine or ten in the exhibit got me thinking about Nelson Mandela's well-known quote from his book *Long Walk to Freedom*, "No one is born hating another person because of the colour of his skin. . . . People must learn to hate." So I wondered, at what point in our lives do skin color and race begin to influence us? Can you recall the first time you could distinguish the differences between Black and white? I remember the day clearly!

It was the midsixties. I was watching an episode of the TV series *I Spy* that costarred Bill Cosby as Alexander Scott. In one scene, a little Asian boy reached out his hand to rub Scott's skin as though he'd never seen a Black person before.

"No, it doesn't rub off," Scott said. "It's not war paint."

I was just a kid, but I remember thinking, *What the hell? Doesn't that little boy know we can't rub the color off our skin? Hmmm. Or can we? But then again, who would ever want to?*

I didn't know much about skin color or race at that time. My school hadn't yet been integrated, and James Brown hadn't yet taught us to embrace being "Black and Proud."

Not long after watching that *I Spy* episode, my mom asked me if my teacher was Black or white.

I still couldn't grasp the concept. I knew she wasn't as black as the tar that filled the cracks in our driveway and wasn't as white as the sheets that covered my bed. I honestly had no clue what my mom meant until a kid in my class explained, "Oh, she just wants to know if Miss Collins is Chocolate or Vanilla!" I was still like, *Hunh? What?!*

Truth be told, my teacher was neither. More like a creamy butter pecan—if I were to buy into that whole ice cream metaphor.

Once I shared my revelation with my mom, she sat me down right-quick to have that "color conversation." You know—the one that starts with "there are different types of people in the world" and ends with a deeper discussion about racism. It was a lot like the one Anthony Anderson, as Dre on *Black-ish*, had with his brown-skinned daughter Diane after she appeared to "fade into the shadows" of her poorly lit classroom photo.

As we'd come to expect from the race-conscious Dre, he broke down all the stereotypes about Black folks' dark skin.

"Black people come in many shades, from Mariah Carey to Wesley Snipes," he said to Diane. "Because we look different, we get discriminated against differently. Sometimes we even discriminate against each other."

My mom took the race talk one step further. She emphasized that even though we come in different shades, no one shade is better than another—

We're Black. Not chocolate. BLACK. It's okay to say the word. "That's what we call ourselves now," she said. "Black Is Beautiful!"

By the time I'd reached adulthood, we had used so many labels to describe the spectrum of our Blackness—nearly two hundred! A sociologist named Charles Parrish had already come up with twenty-five of them for his study "Color Names and Color Notions" in 1946. But then, in 1992, William Curtis Banks from the Department of Psychology at Howard University identified over one hundred more. A few we hear on the regular like light-skinned, brown-skinned, dark-skinned, high yellow, black, blue-black, Africa black, ace of spades, skillet, ink black, and red bone. And then there's the one term it seems we can't ever escape—COLORED.

I'll never forget the first time I traveled to Johannesburg, South Africa, and someone asked me if I was colored. I was shocked. *Isn't it obvious I'm Black?* Then I learned that in South Africa if your skin is not dark brown or white, you're often assumed to be mixed race or C-O-L-O-U-R-E-D. More specifically, South African "coloureds" are multiracial with ancestry in more than one region, like Bantu, European, Khoisan, Asian, and so on. The term "coloured" was the official classification in the country during the apartheid era.

For a long time in the US, the term "colored" has been associated with denigrating Black and brown skin. In fact, calling someone "colored" in the age of political correctness can raise an eyebrow or even get you hurt.

There have, of course, been exceptions to the rule.

Are We Still Colored?

The NAACP (National Association for the Advancement of Colored People) still incorporates "colored" in its official name. And several pop culture movements and exhibits in recent years continue to reference the term—quite effectively, I might add. There was the Ntozake Shange play, book, and film, *For Colored Girls Who Have Considered Suicide / When the Rainbow Is Enuf*, which focuses on the lives and struggles of ten Black women of color. There was the George C. Wolfe play *The Colored Museum*, which was critically praised for satirizing Black stereotypes, identity, and culture. And in 2016, artist Victory Jones and wardrobe stylist Tori Elizabeth created *Colored Girl: I'm Black and I'm Enough*, a social media campaign that grew into a successful brand once it went viral. Intending to celebrate the beauty of all shades of our Blackness, they post incredible images of Black women of varying shades who look very confident and comfortable in their skin and share why they're proud of their Blackness.

Still, one of the most creative and thought-provoking spins on the derogatory word made into something beautiful comes from artist Carrie Mae Weems through her *Colored People* mixed-media series.

Colored People (1989–90)

If you don't know Carrie Mae Weems, you should. She's considered one of our time's most influential contemporary American artists, with much of her portfolio focusing on race, class, and gender. Her 1990 *Kitchen Table Series*, which features her trademark photographs of domestic Black life just sitting at the table, is perhaps her most lauded work for how it explores Black identity, experiences, and relationships in the context of a traditionally female domain. Like many of her other seminal works, it is presented in black and white, with film-noir-like overtones. But not her *Colored People* series. No, no, no! And for good reason.

Carrie Mae Weems's series features portraits of Black youths attached to familiar labels that highlight the beauty found in the range of skin colors encompassed within the term "Black." There's *Golden Yella Girl, Chocolate Colored Man, Magenta Colored Girl*. These were labels she grew up with when describing someone who was Black.

The one label that consistently gets the strongest reactions is *Blue Black Boy*. She expanded the *Blue Black Boy* image into a triptych that depicts the same portrait of a Black boy with a blue hue in three separate frames as if in a repeating mug shot.

Now, before you get offended by the image or the "Blue Black" moniker here, it's not meant to be derogatory. It's just true. Think about all the times you've seen a really dark brother and found out his nickname was Blue. He wasn't really blue, or blue-Black as they say, but

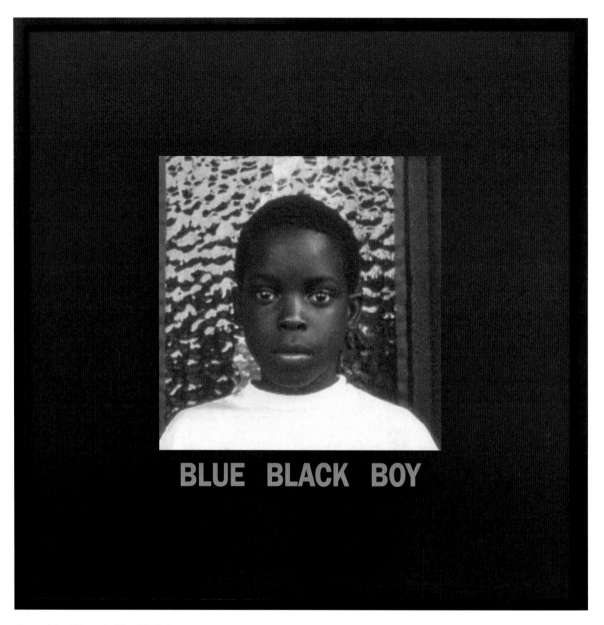

Carrie Mae Weems's *Blue Black Boy*, 1997.

"If my work encouraged you to ask, 'What is that, and What does it mean?' Then, I think I have done my job."

—CARRIE MAE WEEMS, *BRITISH JOURNAL OF PHOTOGRAPHY*, MAY 1, 2019

somewhere, somehow, that association with dark skin tone led to calling darker-hued Black men blue.

"In the moonlight, Black boys look blue" is a memorable line in the Academy Award–winning film *Moonlight*. The line is also the name of the play that inspired the movie. In this context, being blue-Black sounds more poetic than offensive.

With Carrie Mae Weems's *Blue Black Boy*, the artist wants us to question the boy's identity.

What do we see initially? A boy? A Black boy? A blue boy? Or a human being who deserves the right not to be judged by his shade of Blackness?

In the second offering of her *Colored People* series, which she calls *Untitled (Colored People Grid)*, Carrie placed *Blue Black Boy* into a grid with six other kids and then color dyed each frame as a reminder that "Black" people come in a wide variety of skin tones. As such, we all see the world through culturally determined filters.

From my perspective, Carrie also makes the point that even with the whole spectrum of our natural skin tones, our shades of Blackness fall into three categories:

Dark-skinned

Brown-skinned

Light-skinned

Model Nyakim Gatwech is known as the Queen of the Dark.

"I consider myself a queen, and I am dark."

—NYAKIM GATWECH,
TORONTO STAR, JULY 27, 2018

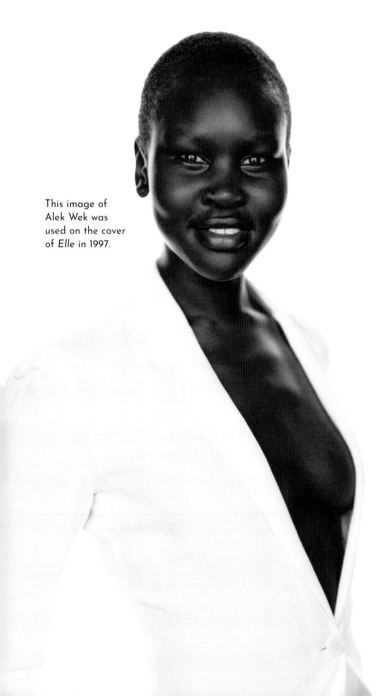

This image of
Alek Wek was
used on the cover
of *Elle* in 1997.

Dark-Skinned

If "the darker the berry, the sweeter the juice"
is true, as Pam Grier said in the 1974 film *Foxy
Brown*, or Tupac's rework of the phrase "the
darker the flesh, then the deeper the roots" is true,
how is it that in the current "My Black Is Beautiful"
era, dark skin is more often stereotyped,
discriminated against, and deemed synonymous
with "evil," "ugly," or "unworthiness"? Nyakim
Gatwech isn't accepting that negative logic.

When an Uber driver asked her if she would
accept $10,000 to bleach her skin because she
was too dark, Nyakim took to social and posted
his snide question with one of her own.

"Too dark for who or for what exactly?"

–NYAKIM GATWECH, INSTAGRAM, APRIL 23, 2018

Soon after the Ethiopian-born Sudanese
millennial posted what the driver said, along
with a picture of her beautiful dark self,
Nyakim's Insta followers skyrocketed to nine
hundred thousand. She loved that they crowned
her Queen of the Dark.

The stunner with flawless skin who once hated
her dark hues but learned to embrace them
has parlayed her Black beauty into a successful
modeling career and now uses her platform to
inspire other women of color to celebrate the
skin they're in.

And yes, this is the same Nyakim about
whose "dark skin" a Columbia University
department chair posted racially insensitive
remarks in 2022 and lost his job for doing so.
Un hunh. Can you say karma?

With roots in Sudan—home to some of the darkest people in the world—Nyakim's story parallels that of another Black Sudanese who once suffered from self-esteem issues but gained fame because of her natural beauty. And it is *because of*, rather than *despite*, her darker-than-most hues that Alek Wek became one of the fashion industry's most in-demand supermodels.

Alek stunned on the November 1997 cover of *Elle* magazine with her deep dark brown skin. Posed against a stark white background and wearing white, she defied all past, whitewashed beauty standards!

While photographer Gilles Bensimon got praise for Alek's look, and even Oprah went on record on August 31, 2021, in the *Financial Times*, saying that if Alek had been on the cover when she was growing up, she'd have a "whole different concept of who I was," there were still troubling comments coming out of our Black community on Lipstick Alley in 2013 like, "How does someone that dark get the cover? She's not even pretty!" *Really?!* That backward thinking in the late 1990s, and yes, in the early 2000s, affirms how internal racism within the Black community is like a cancer that is lethal when it spreads. Despite those degrading sentiments, Alek laughed all the way to the bank. That same year, in 1997, she opened Ralph Lauren's spring/summer show and was named Model of the Year by MTV. Her career took off!

What I found amusing, though, is that even with her dark skin, Alek was consistently confused by mainstream media with supermodel Naomi Sims, who was not as dark, not as tall, and had features that were more Euro than Afro. So, what does that tell us? Do all Black people look alike no matter the shade?

Academy Award-winner Lupita Nyong'o is another high-profile talent who admits to having been uncomfortable with her dark skin.

At *Essence* magazine's 2014 Black Women in Hollywood luncheon, Lupita revealed that as a child, she was "teased and taunted about my night-shaded skin." Until she earned the Oscar for her performance in *12 Years a Slave*, she had a long journey before arriving at self-love.

In a viral post, Lupita admitted for the first time how it was Alek who inspired her to embrace her dark hue—something Alek learned for the first time when she read Lupita's post online.

To reach one, teach one, is what Lupita did when she authored the book *Sulwe* to help other Black and brown girls celebrate the beauty of dark skin and build self-esteem.

Sulwe, which means "star" in Lupita's native Luo language, tells the story of a five-year-old Kenyan girl with darker skin than anyone she knows. She wants to be beautiful and bright. Through Sulwe's journey, she recognizes her innate beauty and value.

And for those who have bought into the myth that Black people with lighter skin have higher education and more intelligence than those with darker skin, here's a little useful stat: according to the 2008–12 American Community Survey conducted by the US Census Bureau, 61.4 percent of Nigerian Americans hold a bachelor's degree or higher, which means these traditionally dark-complected brothers and sistas have more postgraduate degrees than any other racial or ethnic group in the world. Dark. Black. Brilliance!

Actor, director, and activist Bill Duke literally wrote the book on dark-complected achievers in his *Dark Girls* publication and documentary.

While the documentary explores colorism within the Black community and features interviews with people like Viola Davis and others sharing how they've been affected by the taboo subject, the book is full of imagery and testimonials from Lupita Nyong'o and others speaking intimately about what their dark skin means to them.

In the fictional literature realm, Toni Morrison's *The Bluest Eye* gave us much to think about dark-skin drama. If you know the book, then you know there were a lot of weighty themes going on there, including how dark skin affects self-esteem—a big issue when the book was published in 1970 and parallels issues we face today.

When I first read *The Bluest Eye*, I thought, *OMG, this is seriously deep!* Along with that whole skin color/self-hate theme, Toni Morrison wrote about incest, rape, and a mother's rejection of her daughter. This may explain why it's been on the American Library Association's (ALA) Top Ten Most Challenged Books list and banned-book list as recently as 2023.

Yet, despite its controversial subject matter, mixed reviews, and low sales, *The Bluest Eye* made it to Oprah's Book Club thirty years later and still serves as one of the finest novels that show how white perspectives can shape Black self-esteem and identities.

The story explores one year in the life of a Black family. Young Pecola is content with her dark skin until she starts watching Shirley Temple films. You know, the cute little girl with the long golden locks, white skin, and blue eyes. Suddenly, Pecola is exposed to the world's ideal of white beauty. Pecola convinces herself that all the taunting she gets from boys, her new so-called bestie, and even the grocer who ignores her is all because of her Black-skinned ugliness.

She posits that her life would be better if she only looked like Shirley Temple with lily-white skin and blue eyes.

Realizing her dream to be like Shirley Temple is an unobtainable goal, Pecola is driven to madness.

It's fair to ask why Morrison wrote about such a destructive and self-loathing theme during the Black Is Beautiful cultural era, going against everything the movement was trying to espouse.

In a 2012 *Interview* magazine story, Morrison stated, "Before the guys get on the my-beautiful-black-queen wagon, let me tell you what it used to be like before you started that! You know, what racism does is create self-loathing, and it hurts. It can ruin you." In other words, she was writing truth, using the story of *The Bluest Eye* to open our eyes to how tragic interpersonal racism and internalized racism can be. So there you go!

The Bluest Eye is still a classic worth going through all the gut-wrenching emotions to get to her powerful message.

My Ohio-hometown literary hero, who died in 2019 at the age of eighty-eight and was memorialized on the USPS Forever stamp in 2023, earned a slew of honors for her works, including the Pulitzer Prize for Fiction (1988 for *Beloved*); the Nobel Prize for Literature (1993), becoming the first African American woman to receive the honor; the National Book Critics Circle Award; and the Presidential Medal of Freedom (2012), which is the highest civilian award of the US. She also penned a novel fierier and more provocative than *The Bluest Eye*.

God Help the Child (2015), a national bestseller, was Morrison's eleventh novel. It was her first to be set in our current moment when

Artwork supporting Toni Morrison's *The Bluest Eye*.

conversations about hostility and racism were at the forefront following the killing of twelve-year-old Tamir Rice in Cleveland, Ohio, and other unarmed Black people throughout the US at the hands of police.

Haven't read it yet? Okay, where do I start? How about that opening passage?

> **"It's not my fault. So, you can't blame me. I didn't do it and have no idea how it happened. It didn't take more than an hour after they pulled her out from between my legs to realize something was wrong. Really wrong."**

–CONFESSION FROM A LIGHT-SKINNED MOM IN MORRISON'S *GOD HELP THE CHILD* (2015)

Those are the confessional words of a light-skinned Black mom who birthed a dark-skinned baby. Morrison ends that opening passage in her novel with the young mother prophesying that her daughter Lula Ann's "midnight black" skin color is "a cross she will always carry." Ouch! Further in the story, we learn that Lula Ann's dark skin prevented her light-skinned mother from ever truly loving her. But don't feel too sorry for the young protagonist. In Morrison's own words, the best thing we can draw from the novel is that Lula Ann's "stunning blue-black skin is only one element of her beauty, her boldness and confidence, her success in life."

Interestingly, Morrison started writing *God Bless the Child* as a memoir. Halfway through, she flipped the script and made it into a novel—which makes one wonder how much is truly fiction?

Great literature has always been a robust platform for disseminating messages about the links between the range of our Black hues and self-love—much like music.

Brown-Skinned

Growing up feeling down on herself and ridiculed for her looks is what led India.Arie to write empowerment songs like "Brown Skin" and "Video" on her very first album in 2001. Through them, she helped us see ourselves as visions of beauty, celebrate Black men, and make us Black women feel like queens. She lifted our levels of self-esteem and self-love by helping us realize that "strength, courage, and wisdom are inside of all of us."

India hadn't expected the Grammy nomination sweep she earned for her songs and album—a record seven! More than any other Black artist that year.

These were not just any award noms, but the biggies, including Best New Artist, Album of the Year (*Acoustic Soul*), Record of the Year ("Video"), and Song of the Year ("Video").

Millions of us were rooting for India the night of the Grammys and expected she'd be a shoo-in to win. She was about to make history. She deserved it because her music was inspiring and necessary. But at showtime, we watched India lose one category after another, and another, and another—all seven. It was a huge blow for India and Black America.

We felt her pain and disappointment.

Years later, India shared with Oprah on *Super Soul Sunday* that right after her Grammy shutout the rumor mill speculated that her loss for Song of the Year came not because she sang about brown skin but because she had browner skin than most winners that night.

Her loss reignited the debate over whether light-skinned Black people have more privilege than their darker brothers and sisters.

Nearly two decades after India.Arie recorded "Brown Skin," the lighter-hued Beyoncé came out with her own ode to darker hues called "Brown Skin Girl"—the centerpiece for her *Black Is King* movie.

The song and video written by Beyoncé and her daughter Blue Ivy Carter served as a celebration and affirmation of the beauty of brown skin in general and dark brown skin in particular. The song directly challenges the idea that dark brown skin is less beautiful than lighter skin tones. The lyrics encourage young girls to love their skin—particularly in a culture that often upholds lighter skin as the standard of beauty.

In one verse, Beyoncé tells her daughter, "Your skin is not only dark, it shines, and it tells your story."

I love that the song also did a lot to stop haters from questioning if light-skinned people have the same Black pride as darker hues. Beyoncé proved that the answer is "yes!" The very fact the question stills comes up is what W. E. B. Du Bois identified in 1903 in *The Souls of Black Folk* as "the problem of the color line" that pits lighter shades against darker shades. He says it began "the social construction of what we now refer to as light-skinned privilege."

Light-Skinned Privilege?

We're all aware of the privileges of dark versus light skin in slavery times. But in modern times, actress, dancer, singer, and civil rights activist Lena Horne was a walking billboard for reverse discrimination within our race. She actually lost out on opportunities because of her light skin. You see, Lena came along in the 1940s when Hollywood was ill prepared for Black actresses who didn't fit the mold of Mammy or slave girls.

"I was unique in that I was the kind of Black that white people could accept." —LENA HORNE, *LENA* (1986)

It wasn't until the studios realized they couldn't put Lena in a box that they finally started creating roles that suited her.

Not only did she get her way, the title of her first low-budget movie, *The Duke Is Tops*, was changed to *The Bronze Venus* when it was reissued, and her name was listed above the title to make sure everybody knew who the title was referencing.

Here was a fair-skinned sista so proud of her Blackness she refused to wear makeup that would make her darker just to get a role. Instead, she forced the studios to create makeup that allowed her to remain faithful to her roots regardless of her shade of Blackness. And so—Light Egyptian makeup foundation by Max Factor was born.

Despite Lena Horne's pioneering efforts with motion picture studios, Lena's haters still

Over the next six or seven decades, we Black women spent BILLIONS on cosmetics that still never perfectly matched all our skin tones, as well as those that matched us perfectly like **Flori Roberts** (1965), **Fashion Fair** (1973), **Iman Cosmetics** (1994), plus a few others. But it wasn't until Bad Girl Riri's Fenty Beauty came to the rescue with more than fifty shades and counting that covered dark skin, albinism, and all the skin hues in between. Fifteen months after launching the brand, Fenty Beauty was valued at three billion dollars, giving Rihanna her hard-earned membership into the Billionaires Club. Respect 👋🏾👋🏾.

BLACK SKIN REMOVER

BEFORE. AFTER.

A WONDERFUL FACE BLEACH.

This preparation, if used as directed will turn the skin of a black person four or five shades whiter and that of mulattoes perfectly white. Any person using it can see th result in forty-eight hours.

It does not turn the skin in spots but bleaches out white. It is a very good hing for the eyes if allowed to get in the eye while washing the face.

One box of this preparation is all that required if used as directed, the skin re maining beautiful without continual use, and is perfectly harmless.

Will remove wrinkles, freckles, dark spots, and pimples from the face without harm to the skin.

Direction preparation will be sent to any address on receipt of $2.00 C. O. D. or send money order. Packed so that no one can know contents except the receiver.

Thomas B. Crane,
122½ W. Broad St. Richmond, Va.

Skin Bleaching

We've all seen those damning then and now photos of some of our fav icons—who shall remain nameless. One day, they're dark-skinned. Months later, they're two to three shades lighter. Even worse, there was once a product in the marketplace called Black Skin Remover.

Yeah, I wish I had made this up. But it's true. Black newspapers in the 1900s printed an ad for this product that, for two dollars, would "turn the skin of a Black person four or five shades whiter, and that of mulattoes, perfectly white." It also promised that results could be seen in as little as forty-eight hours.

Ironically, skin bleaching of darker hues is still a huge practice in the motherland, even though some of the most beautiful shades of Blackness can be seen on our African sisters. Many women in Kenya, Ghana, Nigeria, the Democratic Republic of the Congo, and Rwanda believe lighter skin is more beautiful despite the risks of using whitening products that can cause liver and kidney damage, psychosis, brain damage in fetuses, and cancer.

When I traveled to Rwanda in East Africa, I witnessed how skin bleaching was so off the chain that, at one time, the products that contained the chemicals hydroquinone and mercury were banned from coming into the country, just as it was in South Africa in the early nineties because of such a vibrant and lucrative black market.

Yellow Fever, released in 2012 by Kenyan filmmaker Ng'endo Mukii, is a six-minute animated short film that gives us great insight into the growing skin-bleaching market in Africa.

The film features two brown-skinned young

criticized her for not being Black enough. What I find ironic is how often a lot of those who criticize light-skinned Black people for not being Black enough are the very ones who, under the cover of darkness, resort to artificial skin lightening.

Oh yeah, it's a sad but true dirty little secret that has reared its head more than once, especially among Black entertainers and athletes.

girls getting their hair braided in a neighborhood salon. Along the walls are pictures of blond white women. One of the young girls clutches a white Barbie doll as her hair is tugged. But then something strange happens. The camera reveals that the woman's hands tugging and pulling are at least four or five shades lighter than the rest of her dark brown skin.

Though the *Yellow Fever* script is fictional, the themes of skin bleaching are very real in Africa.

According to a November 2018 World Health Organization report, 77 percent of women said they used some form of skin-lightening products on a regular basis, but this is not just confined to female users.

When darker Black folks first started bleaching their skin to look whiter and "righter" and when the lighter-skinned enslaved people, who worked in the big house instead of the fields because of their skin color, felt more privileged in 1860s America, we didn't have a name for this disturbing "color hierarchy." Today, we call it COLORISM—"Prejudicial or preferential treatment of same-race people based solely on their color." That's the definition from Pulitzer Prize-winning author Alice Walker who is credited with coining the term in her 1982 essay, "If the Present Looks Like the Past, What Does the Future Look Like?"

Colorism

Long after slavery ended—well, historical slavery, that is—interracial colorism reared its ugly head within the Black community.

Academy Award-winning director Spike

Still from *Yellow Fever* (2012).

Lee pulled back the covers on it in 1988 with his controversial film *School Daze*, where he satirized color and class conflict *within* rather than *outside* of the Black community at a time when we were aware of what was going on but kept silent.

Set in a fictitious historically Black college (HBCU), Spike called one group of primarily light-skinned, middle-class Black students with long, straight hair who wanted to assimilate "The Wannabees." He labeled the darker-skinned coeds who generally came from the working class or underclass and wished to maintain their Black cultural identity as "The Jigaboos."

Spike was criticized for exaggerating our dirty secrets on the big screen. But he maintains that his mission was to accurately address the issues that divide us, hoping to evoke conversations about how to cure them.

Good for Spike! At about the same time he released *School Daze* in theaters, TV introduced me to a controversial color bias practice I'd heard nothing about before.

The Brown Paper Bag Test

You've likely heard of it by now. The Brown Paper Bag Test is that unscientific test that started in the 1900s and was issued to gauge acceptance and grant or deny privileges based on how close your skin tone was to a paper bag.

It was in 1987, while watching an episode of the comedy drama series *Frank's Place*, that I first learned about the practice.

In the episode "Frank Joins the Club," actor Tim Reid (a creator and executive producer of the series) played Frank, a recent transplant to New Orleans, who gets invited to join a club called the Capital C.

Little did Frank know that at one time part of the club's initiation process included a test whereby if, after holding a paper bag next to your face, you are the same color of the bag or lighter (a.k.a. capital-C "Creole") you are guaranteed acceptance into the club. Otherwise, "Don't call us; we'll call you."

When Frank, who is darker than a paper bag, learns about the rule, he wonders why he was asked to join in the first place. His friend shared that he used Frank as a guinea pig to change the club's policies.

I was impressed that a comedy drama on TV was used to blow open that whole "secret" practice that was/is prevalent in many Black clubs, organizations, and, yes, even at some of our beloved HBCUs.

When I interviewed Tim Reid years after the controversial paper bag episode aired, he shared how that episode got the most feedback, hate mail, and queries about whether the test was real or fictional. Many people hadn't heard of the test and didn't want to believe it really happened.

Several creatives have taken up the charge to create exhibits around the subject, including Kevin McCoy, a talented artist who uses his gift to address narratives that explore racial inequality, erasure, and redacted histories. He and Danielle McCoy, a.k.a. WORK/PLAY, created the *Brown Paper Bag Test*, which features framed paper lunch bags of varying shades that bear the same text, and does an excellent job of exposing a sad reality.

WORK/PLAY, *Brown Paper Bag Test*, 2018, 14.75" x 10" each, nine letterpress prints on paper lunch bags, wood.

Then there's my girl Ashley A. Jones, whose *Hair Identity* and *Stop Putting Me in a Box* exhibits we applauded as tools for learning about our prejudices and building self-esteem. She created a version of the Brown Paper Bag Test as part of her overall *Colorism Project*.

Although colorism affects attitudes about self for both men and women, Ashley targeted women in her series because we tend to suffer more psychological and emotional damage from colorism than men.

Once again, choosing charcoal and chalk as her medium, Ashley featured portraits of Black women of different skin colors drawn onto 150 brown paper bags to show the contrast between a Black woman's skin tone and a simple brown bag.

Each bag included a name she collected from online surveys of words, phrases, and terms that have persisted in the Black community, like house slave, Aunt Jemima, tar baby, high yellow, and Negress.

The whole experiment explored whether contemporary African Americans would judge and stereotype a woman whose skin tone was the same color as a brown paper bag.

Ashley shared with me that the impetus for creating the exhibit came after she was given the Paper Bag Test while at a cookout, unaware she was being considered for membership into

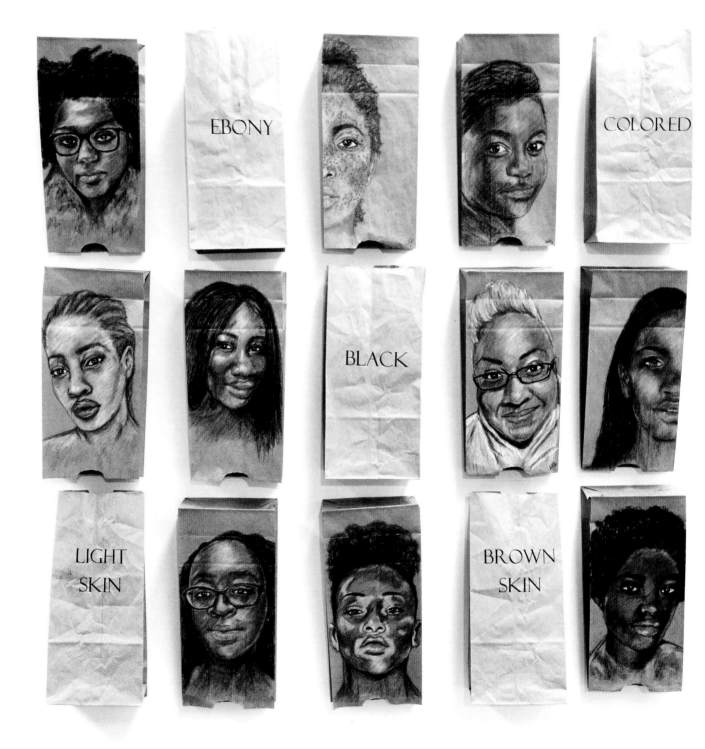

Ashley A. Jones, *The Brown Paper Bag Test* (individual portrait bags), charcoal and colored chalk pastel drawing on 5-¹/₈˝ x 3-¹/₈˝ x 10-⁵/₈˝ brown paper bags, 2016-18.

an elite club. Now get this, usually, you must be lighter than the bag to pass the test, but Ashley says, "I failed because I wasn't dark enough." Clearly, the pendulum swings both ways.

Shades of Blackness & Identity

You've likely met at least one brown-skinned person in your life who has said, "I want to marry someone lighter than me so my kids will come out with a pretty complexion." I've heard it so many times. And yet, many times, the kids end up looking darker than their parents. But people think that way. Remember when Prince Harry shared in his interview with Oprah how the royal palace worried about the color of his and Meghan's baby because she was biracial? Meghan's estranged father is white. Her mother, Doria, is Black. I'm sure whoever said or thought the heir to the throne might have Black skin had a sigh of relief when Baby Archie was born with skin tones and features that resembled Harry more than Meghan.

My dad was a perfect example of the old-school adage "You can't judge a book by its COLOR." He was a medium-brown-skinned man. Not really dark and certainly not light. His hue would likely have registered between 410 and 430 on Rihanna's Fenty shades of the color wheel. After tracing my maternal ancestry line using a DNA test from AfricanAncestry.com, I found my roots in Sierra Leone with the Mende tribe and the Kru of Liberia. I needed a man (father or brother) to take the DNA test to discover my paternal roots. Having no biological brothers, my dad

was my only hope. But he wasn't interested.

I assured him the test was simple and wouldn't require more than me swabbing his cheek.

"No!" he insisted.

It took some begging and pleading, but he eventually relented. Sadly, my dad died before the results came back, which tied him to European ancestry rather than African. I was disappointed but not surprised. There was so much going on during enslavement times including white enslavers taking advantage of the Black female enslaved. My mom confirmed that he likely knew that there was a white ancestor in the low-hanging limbs of his family tree, which is why he didn't want the confirmation from a test. As I dug deeper, I traced my medium-brown-complected dad's ancestry not to Africa but to Poland, of all places!

So, here's my point—skin color alone does not prove ancestry or heritage. A dark person can have European ancestry. A light-skinned person can have African ancestry. This raises that uncomfortable un-PC trend of "passing."

Passing the Test

Passing is what Rachel Dolezal, a white woman with kinky hair and white skin, tried to do in 2015 when she pretended to the world and herself that she was Black. That is, until her white parents outed her. Usually, it's light-skinned Black people trying to pass as white, but whatever.

It's never been clear to me the motive behind Rachel's "passing," unlike Black people who've admittedly "passed" for marketing opportunities,

to better their chances at job opportunities, to break away from their race, or to search for an identity they think they'd assimilate to much better.

I was really young when first exposed to the disturbing pattern, which I refer to as the "Imitation of Life" concept. I call it that because of the classic film *Imitation of Life*, which came out in 1934 and again in 1959 and is based on Fannie Hurst's novel of the same name. The subplot of both films, as *Jet* magazine wrote, is that of "a light-skinned 'colored girl' rebelling against enforced assignment in the 'Negro World.'" In other words, a light-skinned Black girl passing for white.

The film version I saw featured biracial actress Fredi Washington in the role of a young, light-skinned Black woman who was ashamed of her Black roots. Louise Beavers played her dark-skinned mother, who worked as a maid in the white folks' home. Fredi "passed" for white while at school and everywhere else when she was away from home.

Fredi was sooo believable in the role of Peola Johnson, who denied she was her mother's child. There's that one scene where she gets outted after her mother pays her a visit at school and everyone in her class discovers her true race. After denying her mother in another scene in the film, Peola tells her, "You don't know what it's like to be Black and look white." So she decides to permanently pass for white—even going so

far as to tell her mother that she can never contact her. If they should happen to pass each other on the street, they can't acknowledge being mother and daughter. Ouch!

While that's a hard pill to swallow, here's the toughest part: shortly after abandoning her mother, Peola is told that her mother has died. At the funeral she learns that the cause of her mother's death was a broken heart. OMG. Talk about a tearjerker. I wept so hard when I saw that scene for the first time. Even now, I can't bear to watch it despite knowing that it was just a movie.

In real life, Fredi, the biracial actress with light skin, thin lips, straight hair, and green eyes who played the part of a daughter denying her Black mother in the film, refused to pass. She was adamant about identifying as Black.

When approached to play the older version of the same character in the 1959 remake of the film, Fredi turned down the offer because she didn't want to be known as the Black actress who was always passing for white.

Like Lena Horne, Fredi was proud of her heritage, even though roles for light-skinned Black women—particularly pretty ones—were slim pickings.

In 1945, Fredi told the *Chicago Defender*, "Frankly, I do not ascribe to the stupid theory of white supremacy and try to hide the fact that I am a Negro for economic or any other reasons. If I do, I would be agreeing to be

"I am a Negro, and I am proud of it."

—FREDI WASHINGTON, QUOTED IN *A CHOSEN EXILE: A HISTORY OF RACIAL PASSING IN AMERICAN LIFE* (2014)

Imitation of Life (1934), directed by John M. Stahl. Louise Beavers (*left*) and Fredi Washington (*right*).

a Negro makes me inferior and that I have swallowed whole hog all of the propaganda dished out by our fascist-minded white citizens."

In the early days, Hollywood always had a place for darker-skinned actresses. They'd get cast as maids, mammies, or in some other type of servile role. Truth be told, unless a movie called for actresses with "white" characteristics, light-skinned and mixed-heritage girls didn't stand much of a chance of getting cast.

Who would've thought that decades later, shades of Blackness in the film industry would still be at issue—in reverse?

In 2016, actress Zoe Saldaña—a light-skinned, American-born actress with a Dominican father and Puerto Rican mother and with Lebanese and Haitian roots who identifies as Black—got a lot of backlash for not "passing" up a role that should have gone to a darker-skinned actress.

Some say that for every step forward Lena Horne took to have Hollywood devise a makeup

In this composite image a comparison has been made between Nina Simone (*left*) and actress Zoe Saldaña (*right*). Saldaña played Nina Simone in a film biopic by writer and director Cynthia Mort and executive producer Jimmy Lovine.

for us in film, Zoe took as many steps backward by agreeing to wear dark makeup and a nose prosthetic to secure the plum role of dark-hued singer and civil rights activist Nina Simone in the 2016 *Nina* biopic.

All this happened at a time when protests about the lack of diversity in front of the camera were a hot-button issue in Hollywood.

Seeing pictures of the women side by side only added fuel to the already roaring fire.

Looking at the two pics, do you think Nina would have approved?

Uh, no. According to a May 19, 2016, *Vulture* article, Nina once scoffed that she was so dark that she would never make it on the cover of mainstream magazines, not even the covers of *Ebony* or *Jet*, because they only wanted what

"I should have never played Nina. I should have done everything in my power with the leverage that I had . . . to cast a Black woman to play an exceptionally perfect Black woman."

—ZOE SALDAÑA, INSTAGRAM, AUGUST 3, 2020

she referred to as "white-looking women like Diana Ross—light and bright."

So, no! I don't believe Nina would have approved of Zoe being cast to play her in the biopic. Nina's estate certainly didn't like the idea. They cried foul, not only for Zoe accepting the role but for the powers that be who cast her over so many other capable darker shades of Blackness.

To Zoe's credit, she later posted her regrets for accepting the role on IG.

Bravo, Zoe. And to be clear—life is no crystal stair for many multiracial people who identify as Black.

The "What Are You?" Multiracial Conundrum

In a 2016 interview with *Allure* magazine, Zoe Saldaña stated, "There is no one way to be Black." Actually, there is—that one drop of what used to be called "Negro" blood.

The one-drop rule is a legal principle of racial classification that was prominent in the twentieth-century US. It asserted that any person with even one ancestor of Black ancestry ("one drop" of "Black blood") is considered Black.

Most multiracial people like Zoe, President Obama, Meghan Markle, Mariah Carey, and Kamala Harris, who have that one drop of Black blood somewhere in their family lineage, identify as Black, unless they're ESPN anchor Sage Steele, who expressed she didn't understand why Obama only identified as Black. "You do you. I'm gonna do me," she said. And then there's Tiger Woods, the golf phenom, who is of Black, white, Indian, and Asian heritage and famously announced in 1997 that he was Cablinasian. Hmmm. Okay. But I don't think there's a box on the US Census or employment form for that. And it's a good thing there isn't. The Equal Employment Opportunity Act (EEOA) prohibits employers from asking questions like that, which might lead to discrimination or the appearance of bias.

Rapper Ye (formerly Kanye West) evidently didn't get the memo before he cast his 2016 Yeezy Season 4 fashion show—putting out a call for MULTIRACIAL WOMEN ONLY. This comes from the artist who wrote the lyrics, "I tell a dark skin chick I'm allergic to chocolate."

As it turns out, Ye wanted models for his season 4 show to have Black features but not necessarily Black skin. What he got was an angry Black Twitter tweetstorm.

His defense was that he didn't need all the models to be fair skinned; he just didn't know any better way to suggest that he wanted a variety of hues.

Strange as it may sound, I tend to believe him. Ye's messaging was wrong, but his mission of representation was right. The multiracial women he cast had varying hues, from very light to dark. Well, sorta dark. Why are some multiracial people very dark-skinned and others are not?

MELANIN.

We all have melanin. They are the special cells that determine our skin color. Everyone has these cells, but some people make more melanin than others. Darker-skinned people have more. Biracial people have less. People with albinism have none.

Mixed-race models pose
on the runway at Ye's
Yeezy Season 4 fashion
show in New York City on
September 7, 2016.

Nailah Davis's *Mojo Disco*, 2018, photo collage, mixed media (*left*); and *Jason*, 2018, photo collage, mixed media (*right*).

Black folks are pretty good at recognizing when someone has that one drop of Black blood in their veins. We know our people. Even when the skin color gives us pause, our features often give us away—especially those big eyes, luscious full lips, high cheekbones, and rounded hips. For some of us, these features define our beauty; others can't wait to surgically alter them.

The Big Giveaway

What about you? When you look at images from artist Nailah Davis, are you disgusted, offended, or humbled?

Yes, the images above are of real people, not AI, with features deemed grotesque or undesirable, which have been purposely exaggerated in Nailah's art series, which she calls *Confrontation*. Her intent was to allow us to confront our preconceived racialized notions.

When I look at Nailah's work with exaggerated big features, I think about how other cultures have co-opted our Afrocentric features to the disdain of a whole lot of Black women. Instead of calling out cultural appropriation (a.k.a. Blackfishing), I posit that we should do as the prolific poet Lucille Clifton did—celebrate our biggest ASS-ets!

264

homage to my hips
By Lucille Clifton

these hips are big hips
they need space to
move around in.
they don't fit into little
petty places. these hips
are free hips.
they don't like to be held back.
these hips have never been enslaved,
they go where they want to go
they do what they want to do.
these hips are mighty hips.
these hips are magic hips.
i have known them
to put a spell on a man and
spin him like a top!

Lucille Clifton's "homage to my hips" was published in 1980 as part of her fourth poetry collection, *Two-Headed Woman*. In it, she wasn't exaggerating our features; instead, she celebrated them and demanded dignity in the face of oppression.

The poem is timely today because society is fixated on our thick, toned curves. So much so that we no longer try to hide them—like I used to do as a kid—even though some institutions wished we still would.

Remember the viral image of Patrice Brown in the news? She was the young African American teacher minding her business teaching her primary school class when some folks argued that her dress was waaayyy too sexy for school because it showed off too many of her curves. Then someone posted a picture of a white teacher wearing the same dress to make the point that the white teacher never got reprimanded. This hypersexualization of Black women's bodies is nothing new.

Sara Baartman

Sara Baartman (also spelled Sarah, Saartje, Saartjie, and Bartman, Bartmann) of Xhosa lineage was born in 1789 in what is now the Eastern Cape province of South Africa. By her early twenties, she had what a whole lot of us refer to today as one of a Black woman's greatest ASS-ets—our enviable curves. But Sara's unusually protruding buttocks were due to what was known as steatopygia, a hormonal condition common among women in arid parts of southern Africa.

As Sara's story goes—she was unable to read and so was tricked into signing a contract with a British colonizer under the guise that she would be working abroad in a respectable job akin to being a servant. Instead, while in England, she was trafficked and exploited. She was forced to participate in erotic shows—wearing sexually suggestive clothing or nothing at all—where wealthy men paid to grope her. She was displayed as a freak show attraction—all this because of her prominent butt and extended labia.

People came from miles around to ogle the "Hottentot Venus," much like Ota Benga, who was brought from the Congo for display in monkey cages at a New York zoo.

Sara was promoted throughout England as the "missing link" between animals and humans—eventually arriving in Paris in 1814.

Like Ota, Sara's story is the prime example of

SARTJEE, THE HOTTENTOT VENUS.

Exhibited in London, 1810.

colonial racism, exploitation, and objectification of people of color.

Sara died in 1815 at the age of twenty-six from an unknown disease—though some records state that it was from syphilis. Others claim it was a result of "excessive tippling." Sadly, her death was not the end of her exploitation.

Her body was eventually dissected, and her genitalia was displayed in floating chunks inside glass jars of formaldehyde at the Museé de l'Homme in Paris for 150 years.

At Nelson Mandela's request, Sara's remains were returned to her native South Africa where she was finally laid to rest with dignity in 2002.

Since her death, Sara has been the subject of many art exhibits, not in a negative light as she was exhibited in life but to dignify and commemorate her.

One such exhibit titled *Sarah "Saartjie" Baartman, A Call to Respond* was created from steel objects welded together by South African artist Willie Bester, who became fascinated with Sara's story after viewing her remains at the museum in Paris.

In creating the exhibit, Bester also wanted it to represent his own struggles with racism and racial inequity.

The exhibit was well received by the curators and the public but not so much by students at the University of Cape Town, where the sculpture lived for a time as it was bicycled to museums throughout South Africa. As an act of rebellion, the student body there clothed the statue and pinned notes to the cloth that covered Sara's body:

"It's not just a sculpture. It's not just a piece of cloth."

"The psychopathy of colonialism."

"Sara Baartman, once again in a series of body parts."

The handwritten notes ultimately became a permanent part of the exhibit, though not covering the sculpture but on an image of Sara on an opposite wall, where visitors were also invited to write their comments and reflect in the space.

Sara was indeed an important figure representing "not just the stories and experiences of women, particularly Black women in South Africa, but also the point at which racism was legitimized through science," said Nomusa

Sarah "Saartjie" Baartman, A Call to Respond exhibit at the University of Cape Town.

Makhubu, an associate professor of art history at the University of Cape Town, during an interview at the exhibition in 2018.

Of course, sister Sara's story was tragic but also served as a source of empowerment for us Black women decades later. Even Beyoncé had to give her props when she sang, "Stunt with your curls, your lips, Sarah Baartman hips," from her "Black Effect" track on her *Everything Is Love* album.

Yes, today we LOVE and CELEBRATE our hips. And whenever I share Sara's story, I always think, *Shame on those who exploited her,* and shame on those who shame our young women today because of their curves and shapes.

Shaming on You

I shall never forget what singer-songwriter India. Arie, who taught us to love our bodies, once said in an interview with *Jet* magazine.

"You might not look like a model, but does that mean you are going to actually hate yourself? Just say, 'Hey, this is how I look.'"

—INDIA.ARIE, *JET*, JANUARY 28, 2000

Simone Biles, the most decorated Olympic gymnast in US history, stars in SK-II's #NoCompetition campaign where she speaks out on toxic competitiveness.

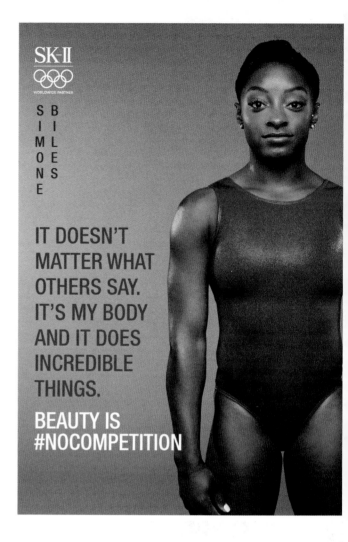

SK-II

SIMONE BILES

IT DOESN'T MATTER WHAT OTHERS SAY. IT'S MY BODY AND IT DOES INCREDIBLE THINGS. BEAUTY IS #NOCOMPETITION

Sadly, the 2000s proved to be an era of body shaming for many of our Black pop sheroes—mainly from the music and sports world. The good news is those who were shamed haven't been shy about telling their stories of low self-esteem and how they overcame body shamers to help us all love our shapes of Blackness.

In an interview with *Harper's Bazaar* UK, Serena Williams confessed that at age twenty-two, she wrote that among her highest goals was to be a size four. But when attacks about her supposedly having "manly" arms and claiming she was "built like a man" came from media critics and her competition, she overcame her childhood insecurities pretty fast. Eventually, the criticisms no longer bothered her; they made her stronger and a voice for the disenfranchised.

In 2019, she penned a letter to her mother on Reddit revealing that her daughter has the same "strong, muscular, powerful, sensational arms and body."

"We are curvy, strong, muscular, tall, small, just to name a few, and yet we are women and proud!"
—SERENA WILLIAMS, IN "LETTER TO MY MOM," REDDIT, SEPTEMBER 19, 2017

Simone Biles, another Black GOAT (greatest of all time) in sports, and the most decorated Olympic gymnast in US history, declared in 2020 that she, too, was tired of being judged by toxic beauty standards. The bullying around Simone started in 2016 after she posted a picture of herself relaxing in shorts and a high-neck tank.

It didn't take long for the haters to post mean remarks like, "Ur so ugly, Simone Biles, even I look better than u." It happened again, then again, and again.

Simone had had enough. On Insta, she posted, "I don't know why others feel as though they can define your beauty based on their standards."

Taking a stand for herself led Simone to take a stand for others. She used her platform to call out toxic competitiveness in beauty with SK-II's campaign titled #NoCompetition.

As reported in *People* magazine on February 13, 2020, Simone made clear, "Today, I say I

Lizzo performing at Little Caesars Arena, Detroit, Michigan, on October 6, 2022.

"When I was a little girl, all I wanted to see was me in the media. Fat like me. Black like me. Beautiful like me. . . . If I could go back and tell little Lizzo something, I would be like, 'You are gonna see that person, but b*tch, it's gonna have to be you.'"

—LIZZO, EMMY AWARDS, SEPTEMBER 12, 2022

Bodi tribe fat men
during a Jaek
ceremony, Hani Mursi,
Omo Valley, Ethiopia.

am done competing vs. beauty standards and
the toxic culture of trolling when others feel
as though their expectations are not met . . .
because nobody should tell you or me what
beauty should or should not look like."

That mentality comes not just from athletes
called out for being muscular but also the BBWs
(Big Black Women), as rapper Drake calls them
when making clear that they are his preference.

In 2019 one fan challenged Drake on that
proclamation during his London concert. She
held up a sign that prompted him to stop
midperformance to acknowledge.

The sign read: "I Heard You Like BBWs."

Without question, one of the most prominent
champions for BBWs is the multi-Grammy
Award-winning artist "Big Grrrl" Lizzo, who in her
2020 cover interview for *Vogue* touts herself as
the first "Big Black Woman on the cover of *Vogue*."

In that same article it's clear that Lizzo is
all about loving our Black bodies and pumping

up who she describes as "Girls with back fat,
girls with bellies that hang, girls with thighs
that aren't separated—that overlap. Girls with
stretch marks. You know, girls who are in the
18-plus club."

Tired of the discourse about big Black
women's bodies, Lizzo created the Emmy
Award-winning TV competition series *Watch
Out for the Big Grrrls*.

In a tearful acceptance speech at the 2022
Emmys, she shared why she's so adamant about
advocating for BBWs.

In a January 2023 IG post, Lizzo further
slammed body shaming by posting a selfie—
while on vacation at an undisclosed tropical
location—rocking a multicolored two-piece
bathing suit with a caption that read "This Body
is Art."

Notice how in this section of the book, I
didn't use the term "body positivity"? Lizzo
slammed that label in the fall of 2020 after

the movement evolved and the messages got "hijacked" by thin chicks who don't need it.

And for you sistas out there who don't want to see curves on your man because it suggests he's lazy, unhealthy, not sexy—the Bodi people of Ethiopia will tell you that "Big Is Beautiful!" In fact, the bigger a man's belly, the *more* desirable he is.

The young men from this tribe based in the Omo Valley of East Africa compete to see who has the largest belly. They even go so far as to drink cow's blood and milk to vie for the title of the fattest man. Okay, no one advocates trying this at home or putting on so much weight that it interferes with one's health. The point here

and of this entire chapter is to reinforce that loving our own Black bodies and skin tones should be the beauty standard for all of us. That goes for big-boned, skinny, short, tall, dark-skinned, light-skinned, brown-skinned, albino, and multiracial people.

Carrie Mae Weems has a piece that speaks perfectly to loving every part of ourselves. It's called *The Considered, See Bergman*, created in 2012. It shows a radiant Weems smiling into a mirror held by an admiring girl. You can take from it what you like, but I find it a fitting close to this chapter, reminding us that no matter the shape or shade of our Blackness, the beauty in all of us is the reflection of how we see ourselves.

Carrie Mae Weems, *The Considered, See Bergman*, 2012.

Acknowledgments

The first three I want to acknowledge and thank are God, Jesus, and the Holy Spirit. Yes!

I couldn't have gotten this far without them! I thank my husband, Rev. Dr. Edward L. Cryer, for loving me the way only he can do and having my back every single day, especially through this writing journey. Even though my mom didn't live to see the publication, I'm glad I could read parts to her from the manuscript weeks before her passing and hear her prophetically say, "It's gonna be good!" I thank her, my dad, and my family (Connie, Debbie, Duward, Dana, Eric, Fanice, Tyrone, Winfield Jr.), for cheering me on this faith walk. Thanks to Regina Brooks of Serendipity Lit who believed in my pitch when it was just a germ of an idea, then helped me to get it to this point of publication. I thank Savannah Bowen from Regina's team who helped me shape the book in the early stages by offering direction for what interests millennials and Gen Zers. To Desiréa Valteau, I say thank you for helping with the arduous task of licensing images—more than one hundred of them. That was no easy task, but you crushed it. To Kiyah Wright, Cheryl Fox, and Tay Rivera—my glam team—I thank you for getting me through another author media kit photo shoot. I love the results and I love you (and Casey) for caring enough to keep me at ease and looking good. I thank my editor, Patrik Henry Bass. He and his team—yes, that includes you, Francesca Walker—believed in me and the book through COVID, cutbacks, rewrites, and strikes. So many times, you could've dropped the title, but you kept it alive and kept me encouraged, and I am forever grateful. To Robin Dodge of the Fashion Institute of Design (FIDM) in Downtown Los Angeles who aided me by phone and email when COVID-19 forced all the libraries on lockdown. Lastly, I thank my friends Brenda, Donalee, Nancy, and Maria; my SPBC Oxnard church fam; my colleagues; everyone who has said, "I can't wait to read it"; and everyone who buys, reads, or borrows *AfroCentric Style*. It warms my heart to know that I've written a book that appeals to you. I pray that through reading it you learn something new, reminisce about what you like, and share with others new insights you've gained from this labor of love.

CREDITS

Grateful acknowledgment is given to the following for the use of their work in this publication:

Page 122: Viola Davis at the Academy Awards: Rick Rowell, courtesy American Broadcasting Companies/Photofest, © American Broadcasting Companies, Inc.; Viola Davis at Cannes: Julien Reynared, courtesy of AbacaPress/Alamy Live News
Page 123: Courtesy of Guinness World Records Limited
Page 124-25: Klara.Kristina on Visual Hunt/ Creative Commons
Page 126: Courtesy of Ashley A. Jones
Page 127: Courtesy of CreativeSoul Photography
Page 128: Patrick Lewis/Starpix/Shutterstock.com
Page 129: Courtesy of Kelly Rowland and Dove
Page 130: *Good Hair*: Courtesy of Photofest/ Roadside Attractions, © Roadside Attractions. Gabrielle: © 2022 Sesame Workshop®, Sesame Street®, and associated characters, trademarks and design elements are owned and licensed by Sesame Workshop, all rights reserved
Page 131: Courtesy of Mattel
Page 132: Courtesy of Mattel
Page 134: *Nappy Hair*: Courtesy of Penguin Random House; *Crown*: Courtesy of Agate Bolden
Page 135: © American Broadcasting Companies, Inc., all rights reserved
Page 138: Courtesy of Matthew A. Cherry Entertainment, LLC/Sony Pictures Animation
Page 139: David Fisher/Shutterstock.com
Page 140: Courtesy of the author and Danny of Master's Barbershop, Ventura, CA
Page 143: Jordan Strauss/Invision/AP/ Shutterstock.com
Page 144: Mike Segar/Reuters Pictures
Page 145: Susan Wood via Getty Images
Page 146-47: Jose Villatoro, the Villas Channel Production
Page 148: © carrie-nelson/ImageCollect.com
Page 149: Courtesy of the CROWN Act and the Office of Governor Gavin Newsom
Page 150: Jacob Wackerhausen/iStock
Page 152: Marcio Jose Sanchez/AP/ Shutterstock.com
Page 153: Teyana Taylor: Courtesy of Teyana Taylor; Emoji hand © Stalvalki/stock.adobe.com
Page 154: © Globe Photos/ZUMAPRESS Inc./ Alamy
Page 157: Photofest
Page 158: Marsha Hunt: Patrick Lichfield/ Conde Nast/Shutterstock.com; *Hair* poster: Photofest
Page 159: Photofest
Page 160: Harry Langdon
Page 161: Licensed by Warner Bros. Entertainment, Inc., all rights reserved
Page 162: Courtesy of Vince Vullers Group
Page 163: Courtesy of Jessica R. Sullivan
Page 164: Deborah Feingold/Corbis via Getty Images
Page 165: Lupita Nyong'o: Evan Agostini/ Invision/AP/Shutterstock.com; Lauren Kelly: Courtesy of Lauren Kelley
Page 166: Courtesy of the Fitzwilliam Museum and Museum of Archaeology and Anthropology

Page 167: Steve Weinik
Page 168: Photofest
Page 169: SGranitz/WireImage
Page 170: Whoopi Goldberg prints: iStock/ Meinzahn; Zendaya: © KGC-11/StarMax Worldwide/ImageCollect.com
Page 171: Halle Bailey: Courtesy of Walt Disney Studios Motion Pictures/PhotoFest, © Walt Disney Studios Motion Pictures; Rihanna: Warner Bros./Photofest, © Warner Bros.
Page 172: © Featureflash (Paul Smith)/ Depositphotos.com
Page 173: © Christopher Smith/AdMedia/ ImageCollect.com/
Page 174: Courtesy of *SNJ Today*
Page 175: Brittney Griner: © galecophoto (Keeton Gale)/Depositphotos.com; Ava DuVernay: Danielle Levitt
Page 176: Broadimage/Shutterstock.com
Page 177: India.Arie: © Michael Germana/ StarMax Worldwide/ImageCollect.com; Yvonne Orji: Wendell Weithers
Page 178: Courtesy of the Office of US Rep. Ayanna Pressley
Page 179: Courtesy of the Office of US Rep. Ayanna Pressley
Page 180: Anthony Barboza
Page 181: Tiffany Haddish: Courtesy of Tiffany Haddish; Masai woman with child: ©sinnie32 (Sandra van der Steen)/Depositphotos.com
Page 182: Universal Studios/MovieStillsDB
Page 184: CBS/Photofest, © CBS
Page 185: Courtesy of Amistad, HarperCollins Publishers
Page 186: Courtesy Filmstar Press Conference Stock Photos
Page 187: AP Photo/Steve Holland/ Shutterstock.com
Page 188: Independent Photo Agency/Alamy Stock Photo
Page 189: Jordan Strauss/Invision/AP/ Shutterstock.com
Page 190: Kevin Beasley's *Chair of the Ministers of Defense*: Brian Forrest, jointly owned by the Joyner/Giuffrida Collection and the Rennie Collection, courtesy the artist and Casey Kaplan, New York; Huey P. Newton: Eldridge Cleaver, courtesy of the National Museum of African American History and Culture
Page 192: Kevin Tachman via Getty Images for *Vogue*
Page 193: © Dennis Van Tine/StarMax Worldwide/ImageCollect.com
Page 194: Courtesy of M-G-M/Photofest, © M-G-M
Page 195: Hayley Madden/Shutterstock.com
Page 196: ARCHIVIO GBB/Alamy
Page 198: *Shape* magazine cover: Ben Watts/ Trunk Archive, courtesy Meredith Corp; Nia Imani Franklin: John Angelillo/UPI/ Shutterstock.com; Cheslie Krist: Courtesy Miss Universe Organization/IMG Replay
Page 199: Courtesy Miss Universe Organization/IMG Replay
Page 200: Zozibini Tunzi: Courtesy Miss Universe Organization/IMG Replay; Toni-Ann

Singh: Joel C. Ryan/Invision/AP/Shutterstock.com
Page 201: Courtesy of Tiffany's Show Pattaya Co. Ltd.
Page 202: Yale Joel/The LIFE Picture Collection/Shutterstock.com
Page 203: Woodgate/ANL/Shutterstock.com
Page: 204: Courtesy Bettye Lane Photos and Schlesinger Library, Harvard Radcliffe Institute
Page 206: Courtesy America Institute of Positivity/dba Miss Black America Pageant
Page 208: Courtesy America Institute of Positivity/dba Miss Black America Pageant
Page 210: Courtesy of *Essence* magazine
Page 212: Bill Zygmant/Shutterstock.com
Page 213: © Pathe Productions limited, all rights reserved
Page 214: Francesco Scavullo, *Vogue*, © Conde Nast
Page 215: Used with permission of Anheuser-Busch, LLC, all rights reserved
Page 216: Anonymous/AP/Shutterstock.com
Page 219: Courtesy of Leyline Productions
Page 221: Robert Jordan/Ole Miss Communications
Page 223: sniggie/VisualHunt.com, courtesy Don Sniegowski
Page 224: Mario Epanya
Page 226-27: Courtesy of the author
Page 228: © Carrie Mae Weems, courtesy of the artist and Jack Shainman Gallery, New York
Page 230: Courtesy of Ashley A. Jones
Page 234: © Carrie Mae Weems, courtesy of the artist and Jack Shainman Gallery, New York
Page 235: Stanley Babb
Page 236: Courtesy of Gilles Bensimon
Page 239: Courtesy of Elizabeth Lada
Page 241: Lobby Card: Collection of the Smithsonian National Museum of African American History and Culture; Clapping hands © Gopal/stock.adobe.com
Page 242: *Afro-American Citizen*, January 17, 1900, page 3, courtesy Newspapers.com
Page 243: Still © Ng'endo Mukii, 2012
Page 245: Courtesy of Shabez Jamal
Page 246: Courtesy of Ashley A. Jones
Page 249: Courtesy of Universal Pictures/ Photofest, © Universal Pictures
Page 250: Nina Simone: John Minihan/ Evening Standard via Getty Images; Zoe Saldaña: Frederick M. Brown via Getty Images
Page 252-53: Bryan Bedder via Getty Images for Yeezy Season 4
Page 254: Courtesy of Nailah F. Davis
Page 256: British Library/Science Photo Library
Page 257: Sculpture by Willie Best, courtesy of the University of Cape Town Works of Art Collection
Page 258: © Matt Holyoak Productions, Ltd., courtesy of Procter & Gamble
Page 259: Brandon Nagy/Shutterstock.com
Page 260: Eric Lafforgue/Alamy
Page 261: © Carrie Mae Weems, courtesy of the artist and Jack Shainman Gallery, New York
Page 262: Cheryl Fox